Images of Romanticism

IMAGES OF ROMANTICISM

Verbal and Visual Affinities

EDITED BY KARL KROEBER
AND WILLIAM WALLING

New Haven and London
Yale University Press
1978

Published with assistance from the Kingsley Trust Association Publication Fund established by the Scroll and Key Society of Yale College.

Designed by Sally Harris and set in VIP Baskerville type. Printed in the United States of America by The Murray Printing Co., Westford, Mass.

Published in Great Britain, Europe, Africa, and Asia (except Japan) by Yale University Press, Ltd., London. Distributed in Australia and New Zealand by Book & Film Services, Artarmon, N.S.W., Australia; and in Japan by Harper & Row, Publishers, Tokyo Office.

Library of Congress Cataloging in Publication Data

Main entry under title:

Images of Romanticism.

Includes index.

1. Romanticism in art—England—Addresses, essays, lectures. 2. Ut pictura poesis (Aesthetics)—Addresses, essays, lectures. 3. Arts, Modern—19th century—England—Addresses, essays, lectures. I. Kroeber, Karl, 1926– II. Walling, William.
NX543.I52 700'.9'034 78-6151 ISBN 0-300-02209-3

Contents

List of Illustrations

All illustrations follow page 232.

Introduction

•

In recent years the joint study of literature and art has made a number of significant advances. Gone, for example, are the old compulsions toward enumeration of simplified iconographic patternings and the instinct to escape from specific problems into vague speculations about aesthetics. Literary history and art history remain distinct disciplines, to be sure, each with peculiar powers and limitations. But scholars on both sides now seem reasonably confident exploring unfamiliar domains without pious invocations to "cultural unity" or that hoary chimera, the *Zeitgeist*. Delighted by this movement away from unprofitable generalities, we present a book which attempts to define aspects of literature and the visual arts essential in any assessment of their interrelations during the Romantic era in Britain. We have tried, further, to outline at least some of the central issues involved in multimedia study of this sort.

A book of this length can only touch upon the larger context— European and historical—within which the accomplishments of British Romanticism must ultimately be evaluated. Nevertheless, the opportunity to focus upon the achievement of J. M. W. Turner in the five essays which conclude this collection has seemed to us to offer some consolation of depth for the considerable breadth we have been obliged to sacrifice. Turner is thoroughly and consistently a painter—despite his many literary subjects, his "Fallacies of Hope," and even the antecedent linguistic structures which so shrewd a critic as Paulson finds in his art. The works of Turner, unlike those of Blake, do not lend themselves to the methods of literary criticism most in fashion, for these methods, as we have come increasingly to see, are intensely, even desperately, verbal. As the *doyen* of the deconstructionists Jacques Derrida has recently written, after four epigraphs and a cryptic pseudo-prefatory paragraph:

All that can be said against a preface, I have already said. The place of what absence—of what of whom of what lost text—does the preface claim to take? Thus disposing and predisposing (of) a first word that does not belong to it, the preface—a crypt in its turn—will take the form of what preserves (and ob-serves me here), the irreplaceable.*

Little wonder, then, that contemporary critics require an archive, a grammatology, and, above all, a text. Turner's sheer physical commitment to painting seems to us useful for confronting a deepening split in current aesthetic scholarship, a chasm no longer to be concealed by calling it chiasma. The humanistic approach dominant in this collection points toward increasing concern with works of art in whatever medium as complexly engaged in a cultural density of particular time, place, and circumstance. The other approach leads into ever more critical abstraction in the Blakean sense of separation.

This abstraction began to be important in the New Criticism, which was, however, literal and empirical. The New Critic prided himself on being able explicitly to point to ambiguities, ironies, paradoxes, *there,* in the actual words and sentences of his text. For succeeding myth-schematizers, of whom one may regard Frye as an archetype, what he calls "diagrammatic patterns" are sought *among* words and sentences: criticism becomes fitting particular verbal phenomena into structural categories, for example, the four seasons, the four elements. But the structures are still *there,* in the text: it is the "green" in the text that *manifests* the "spring category," even though the important matter is the "hidden" or "deep" pattern which organizes the "surface" phenomena. For subsequent critics, however, the text becomes a phenomenon provoking mental constructions not to be localized literally in the text. Instead of, say, four elements (reasonably substantial, after all), one searches out an abstract principle such as a binary opposition, static vs. dynamic, presence vs. absence, etc. The focus of critical ingenuity shifts from the text to a model of it, following Lévi-Strauss's definition of a model as "not related to empirical reality" but "constructed according to that reality." The myth critics' relatively visualizable diagrams are replaced by what Todorov calls the structuralists' "abstract principle or

*"Fors," *Georgia Review* 31 (Spring 1977): 64–116, 65. The admirable translator is Barbara Johnson.

rule," *not* manifest on the phenomenal level of the text and realizable only in a new, affiliated "fiction."

Interest in historical relations between literature and the visual arts (a common interest of all our contributors though not the focus of every chapter) implies an inclination away from such intellectual abstracting. So the following pages create a different picture of British Romanticism from that popularized by recent formalist critics. Evaluation of differences may safely be left to each reader, but one or two absences of popular clichés deserve notice. We have no reports of decreased deities or despair at the loss of divine order—favored constructs of anxious modern readers. The Romantics tended to believe the eternally active order of the cosmos evidenced a dynamic divinity that had been only degraded by Newtonian mechanists or rationalists, all too likely themselves to end up as nihilists. Nor will a reader find here discussion of "organicism," a term that has come to mean the kind of clockwork functionalism which the Romantics, concerned with growth, vital energies, and continual transformations, associated with the rigid structuralizing of sterile rationalism. And probably because any attempt to deal with more than one art at a time forces a scholar into seeking unities admitting many discontinuities (as well as alertness to several uncertainty principles), the descriptions in this volume are usually of some aspect of the experimental, the provisional, the changing, which from our humanistic perspective appear the central domains of Romanticism.

Without undue polemicism, then, we present our material in an arrangement which not only follows a relatively chronological progression into, through, and beyond British Romanticism but also may serve to highlight some problems and possibilities of method in studies not self-limited to a single art. The order of chapters, to be sure, has not been our primary concern, which from the first has been to represent adequately the wealth of valuable subject matter available to any Romanticist who wants to extend his research from literature into the fine arts, or vice versa. But as we sought representativeness, a developing order of presentation took shape. We begin with Arnheim's theoretical exploration into relations of time and space as perceptual, mnemonic, and imaginative modes—as a groundwork for both the methodological and metaphysical suggestions in subsequent chapters. In elucidating how time may be conceived through synoptic images of space (thus extending the approach given popularity by Joseph Frank), Arnheim observes that

the nature of such images is culturally conditioned. And Eitner investigates an important instance of this conditioning. He enables us to understand Romanticism's libertarian impetus by demonstrating from what Enlightenment conflicts it sprang, a drive toward authoritarianism, manifested both in attitudes of mind and edifices, encountering the resistive idealism of liberation from restrictions of arbitrary power. Starobinski then subtly traces an individual emergence of this process in depicting Chénier's tragically exemplary arrival at the Romantic/modern affirmation of imagination as sole origin of the poetic impulse.

These chapters constitute a cultural, artistic, and metaphysical background for the subsequent critiques of British Romantic art and literature. Blake is the obvious beginning, and Hagstrum details the precise network of affiliations of attraction and antipathy by which he was linked to his aesthetic culture. In so doing, Hagstrum makes possible a balanced assessment of Blake's achievements in the visual arts and, incidentally, sets up a dramatic contrast in method as well as subject to Swingle's analysis of Wordsworthian pictorializing. Distinguishing between the poet's picturing of the mind and his representation of the mind's act of picturing, Swingle not only illuminates Wordsworth's unusual practice but opens a new line of attack upon the intricacies of Romantic psychologies of art. Woodring then works from Coleridge's critical comments, reminding us of what we so often forget we need to know: where and when and how Romantics might see which paintings. Woodring orders these facts to elucidate Coleridge's sensibility to painting, a sensibility perhaps startling to us today because founded on premises so contrary to our concepts of aesthetic sensitivity in the visual arts. Differences between then and now are further developed in Walling's discussion of Wilkie, which urges us to recognize how much the creativity of the Romantics depended on "provincials" and "provincialism," uncongenial to many of our fundamental critical presuppositions.

Chapters four through seven, then, ask one to think about a painter-poet, a poet, a poet-critic, and a painter in new ways, thus preparing for the strong claims of originality and uniqueness made in subsequent chapters. In all these chapters, each built around Turner's art, though only one, Paulson's, is concerned solely with him, "sublimity" is a recurrent term. Our authors evaluate it diversely, but the range of these analyses proves that the sublime must be a focal point for any general assessment of British Romantic arts and their interrelations.

To Heffernan, Turner is specially useful in showing how pervasive

was that Romantic artistic unity which, while not denying the independent integrity of individual elements, permitted coherence of the whole through a fusion impossible in Augustan aesthetics or philosophy. Kroeber, studying the same phenomenon of the supersession of Augustan line by Romantic color, finds a new temporal sublimity in Romantic historicism. Paulson approaches some of the same pictorial material from a different angle, concentrating on the interplay of verbal and visual *within* some of Turner's famous paintings. He judges these near to the neoclassic in their intrinsic literariness, an interpretation which deserves testing against the vast extent of Turner's total *oeuvre*. Storch then boldly argues for a more radical revaluation of Turner's accomplishment through application of psychological analysis. Not only does Storch challenge the significance of Heffernan's, Kroeber's, and Paulson's interpretations, but through consideration of Shelley's analogous, and Constable's and Wordsworth's quite different, artistries, he raises questions about fundamental directions of Romantic art. That in the near future we will hear more about distinctions between narcissism and sobriety is foreshadowed by Meisel's concluding essay, which traces tangled developments of "subjective" and "material" sublimity through revealing embodiments in early nineteenth-century theatrical art. This art, so seldom considered by either literary critics or art historians, through the very simplifications incidental to its popular nature yields unusual insight into the forces working beneath the often too dazzling surfaces of great Romantic paintings and poems. Most readers, we imagine, will be surprised at how profoundly Meisel's final words recapitulate central issues of the four preceding, Turner-oriented chapters.

This volume, then, attempts something other than either a comprehensive survey or a polemical illustration of one methodology. We have tried to open out the diverse yet interconnected riches of British Romantic art and literature and to exemplify ways in which these riches may be enjoyed.

A number of people and institutions have generously contributed to the creation of this volume. We wish especially to thank the Research Council of Rutgers University for its support, Paula Horvath and Jan Hoffman for their splendid secretarial assistance, Jeffrey Carr for valuable research assistance, and Cynthia Walling for her aesthetic council.

Karl Kroeber
William Walling

30 June 1977

RUDOLF ARNHEIM

Space as an Image of Time

For Wolfgang Zucker

Man is given the task of coping with mortality—not only his own but also that of all other constituents of his world. All events are transitory by nature. They come and go; and among the events there is man's own being and doing. Many works of his own hands and those of nature are sadly perishable.

The ephemeral character of things is of two kinds. As physical objects or happenings they hold their place in the chronological history of the world. A continent, an animal, a work of art is generated and lives out its span of existence. Additionally, however, a physical thing can enter a person's consciousness by being seen or heard, in which case any moment of its existence is limited to a corresponding moment in the observer's mind. Since only one of those moments is accessible to observation at any time, existence as a target of direct perception is only the differential of time we call the present moment.

As a small element, picked more or less at random from a context, such a moment of observation tends to be extraneous to the nature of the observed event. The moment at which I happen to look at a plant is probably as undistinguished a phase in the flow of its growth process as any other. A snapshot taken during the performance of a dance may capture the highspot of the composition; but if nothing were known beyond what that picture contains the information would be meager indeed. Therefore, in order to do justice to events extended in time and

A shorter version of this paper was presented as the annual Agnes A. and Constantine E. A. Foerster Lecture on *The Immortality of the Soul* at the University of California, Berkeley, on October 23, 1975.

space, the nervous system needs an equivalent power to integrate succes-
sive apprehension in order to reconstruct the wholeness of those events.
This is evident even in the simplest perceptual tasks, such as that of
grasping a single movement of a dancer. Merely to discover the direction
of the movement, the differential of time must be extended to encom-
pass more than one location, since it takes at least two locations to
establish a direction.[1] What is more, however, the two locations must be
given together in order to become relatable. It follows that memory
serves not only to preserve, like a tape recorder, the inputs of the fleeting
moments as a sequence but must also convert that sequence into simul-
taneity, time into space.

We are led to the startling conclusion that any organized entity, in
order to be grasped as a whole by the mind, must be translated into the
synoptic condition of space.[2] This means presumably a translation into
visual imagery, since the sense of sight is the only one that offers spatial
simultaneity of reasonably complex patterns. Accordingly a musical
composition, a choreography, a novel, a play, or a film, in order to be
conceived as a whole, must be available in the form of a synoptic image,
although the medium may be aural and the structure to be scrutinized
not an immobile picture but a succession of happenings in time. This
becomes obvious if we consider that one cannot even establish the center
point of a line without knowing its total length. Correspondingly, if a
musical composition were made up moment by moment without any
conception of a larger whole, it could only be a loose improvisation, raw
material perhaps for something to be organized later; and a listener who
perceives only what strikes his ear at any particular instant cannot com-
prehend anything of the whole piece, except perhaps its overall texture.
Note here that the so-called *Urlinie*, the term by which Heinrich
Schenker described the fundamental structure underlying a musical
composition, is an eminently visualizable notion.[3]

At early levels, a composer's conception of a work of music or litera-
ture tends to be a rather abstract pattern, and probably largely a synoptic
one. Only when the conception approaches the particular properties of

1. Kurt Lewin, "Defining the Field at a Given Time," in Lewin, *Field Theory in Social
Science* (New York, 1957), pp. 43–59.
2. Rudolf Arnheim, *Art and Visual Perception* (new version) (Berkeley and Los Angeles,
1974), p. 373.
3. Heinrich Schenker, *Fünf Urlinie-Tafeln* (Vienna, 1931). (*Five Graphic Music Analyses*
[New York, 1969]).

the final medium does the synoptic simultaneity of the total pattern, whose overall structure is by then established, begin to recede. More and more explicit sequences are now established, and by the time the music is played, the play performed, the printed novel read, the work has entered the dimension of time. It now offers, in turn, to the listener, viewer, or reader the task of comprehending the sequence as a coherent whole.

The task of the recipient is the reverse of that of the creator of the work. He must integrate the temporal succession and translate it into a spatial image. This sort of operation takes place not only when one listens to a piece of music or reads a novel but in a broader sense also when one copes with the mortality of the present moment quite in general, in regard to anything one wishes to understand: the events of history, the relations between things distant in time and space, the course of one's own life and work. In each case, the peephole vistas, the pointsized observations must be gathered in a surveyable whole. The instrument by which the mind accomplishes this translation of time into space is what psychologists call memory.

The physiological basis of memory is still poorly understood even in its most elementary features. Are the traces of specific experiences located in specific places of the brain, as some clinical observations suggest? Are they field processes spread over broad brain areas and dependent on overall organization? Or is the totality of memory holdings perhaps completely represented in every particular area like a hologram? Whatever the answer, one fact is indisputable: that the inputs, arriving in temporal succession, are stored in some sort of spatial arrangement and that correspondingly the human mind can confront and compare images in simultaneity. Memory enables a person not only to perform in his head an entire symphony for the mind's ear—in which case the sequence is preserved—but also to survey the structural pattern of the whole composition like a landscape spread before the eyes with all its formations. Surely this second ability is the more admirable one. It is less mechanical. Rather than a simple replay, it is an abstraction and translation, which alone enables us to overcome the instant mortality of time and to view relations.

The term *memory* does not cover very well the various mental feats it designates. In its more primitive version, memory does not enable the mind to look back into the past but merely modifies presently given facts

by what has been learned about them. For a cat or a dog, experience imbues the sight of the open coat closet or the sound of the refrigerator door with a sense of pleasure. There need not be any reminiscence of the past events that justify the joyful anticipation. The trace survives in its modified form as though it had been marked as a releaser by an innate instinct, a deposit of evolution. Similarly a painting of which one has been told that it is a forgery or that, instead of being the work of a minor Dutch portraitist, it is by Rembrandt changes into a different perceptual object; and again, in principle, this can happen although the historical event that caused the change has been forgotten. This ongoing modification of the things and events constituting the present is the effect of trace survival but not of memory in the sense of reminiscence.

As far as we can tell, man is the only creature capable of doing better, namely of moving from the present to some remembered event of the past, to conjure up the image of an absent or deceased person or of a distant or lost object and consider it presently, although as something absent. This facility for storage and retrieval enables a person to deal actively with a vast amount of his past inputs as though they were constituents of his world even now.[4] But even this superior feat of survival is insufficiently described as memory, because what the mind actually possesses is not simply a reservoir of images but rather what we usually call imagination—an inner world generated largely from experiences of the past but not limited to their reproduction. Imagination uses such material for creating images of its own. It is not limited to the chronology of the dates of arrival in memory. In fact, it can dispense with the time index entirely and treat its images as timeless.

This is surprising. Since information arrives in sequence, one might expect the mind to preserve this sequential character somehow. The more automatic and elementary the storing process, the more that should be the case. Actually, more nearly the opposite is true. The more elementary form of imagery consists of static configurations. Being is a simpler concept than becoming, and any notion involving change, such as a sense of history, calls for a more sophisticated level of the mind. The understanding of a situation tends to develop from an image of static

4. A similar distinction between two kinds of memory is made by Henri Bergson in chapter two of *Matière et mémoire* (Paris, 1946): "The past survives in two distinct forms: (1) in motor mechanisms, (2) in independent reminiscences." (*Matter and Memory* [London, 1950]).

coexistence to one involving causal relations. At early stages of learning a student of art history may conceive of the painters of the Quattrocento as a mere set of individuals: Mantegna and Raphael, Gentile da Fabriano, Piero della Francesca—all in the same container. Only gradually does he begin to see the causal relations that require a sequential order.

Nonsequential conceptions, however, also may be highly structured. They may be complex classifications, such as the Aristotelian or Linnaean systems of living creatures, which precede the sequential notions of evolution or progress. In art history, the confrontation of the two types of image-making which Wölfflin finds embodied in classic and Baroque art is essentially nonsequential, yet by no means simplistic.[5] And it is also true that nonsequential configurations are not only the early ones but also the late ones. The early ones do not yet conceive of sequence; the late ones transcend it and neglect it as ephemeral. Hence the power of such visions as that of Plato's *eidola* or that of Dante's architectural structure of vices and virtues, which classifies human types regardless of historical location.

The difference between the sequential and the nonsequential use of imagery brings to mind the curious history of what Frances Yates has described as the art of "artificial memory."[6] It was developed in antiquity as a mnemonic crutch for orators to help them remember the correct sequence of their argument. On the dubious assumption that the location of items in a perceptual setting is more easily remembered than are the links of a logical disquisition, rhetoricians proposed the use of an imaginary architectural environment. The orator was to picture in his mind the various components of this environment—doors, windows, walls, furniture—in order to deposit on each of them a fictitious object, characteristic of a particular aspect of his presentation. An anchor reminded him to speak of naval operations, a weapon of military matters. As he scanned the imaginary setting, he safely proceeded from item to item, in the order in which he had deposited them.

This method transforms the temporal sequence of the argument into spatial simultaneity, but without taking advantage of the opportunity for synopsis. Rather the spatial elements are processed one by one as a means of reconstructing the sequence. It is a mnemonic trick, different

5. Heinrich Wölfflin, *Kunstgeschichtliche Grundbegriffe* (Munich, 1920). (*Principles of Art History* [New York, 1950]).
6. Frances A. Yates, *The Art of Memory* (Harmondsworth, 1966).

in principle from the medieval practice exemplified by Ramon Lull. There, memory serves to visualize a cosmological and philosophical system, a spatial pattern, whose relational aspects are explored by the searching mind.

Note here further that the difference between nonsequential and sequential images of the world is also a matter of stylistic preference, which induces observers to see reality in either the one or the other way. Thus Schopenhauer commits himself to a classicist ontology when he writes: "There is no greater contrast than that between the irresistible flight of time, which carries with it its entire content, and the rigid immobility of the actually existing, which remains one and the same at all times."[7]

Nonsequential configurations do not necessarily lack dynamic relations between their constituents. All interplay is, by its nature, nonsequential but dynamic. For example, the relations between father and son can be described in a highly dynamic way, even when the chronology of that relationship is neglected. Hierarchic relations, however, tend to be semi-sequential, which can be seen not only in genealogical trees but also in the personnel structure of business, academic, or government organizations. In the latter examples, the configurational pyramid is heavily overlaid with the directed flow of influence and command, which makes the forces of the power structure act from above toward below.

It pays to study the nature of the dynamics in such semi-sequential systems. For example, when Thomas Mann at the beginning of his biblical novel *Joseph and his Brothers* tells the story of the Hebrew forefathers, he compares the sequence of generations from Abraham through Jacob to Joseph with that of promontories appearing one after the other as one walks along a sea coast—an intrinsically spatial image in which similarity, repetition, and imitation are as relevant as the temporal sequence.[8] In fact, the sequence of the sights can be reversed or otherwise altered: tradition and prophecy are exchangeable. In Mann's story, the sequence derives its dynamics from the emphasis on the progenitor, the man from Ur of the Chaldees, the first embodiment of a pattern that is reenacted in the behavior of his descendants. But the arrows run the other way when the emphasis is on the end of the series rather than the

7. Arthur Schopenhauer, "Ueber den Tod, etc." in *Die Welt als Wille und Vorstellung*, additions to book 4, chapter 41.
8. Thomas Mann, *Die Geschichten Jaakobs* (Berlin, 1933), prelude.

beginning as, for example, in the prefigurations of Christ drawn from the Old Testament.[9] Here the dynamics of the power structure is not that of an imitation of what has been but of an anticipation discovered in retrospect.

It will be evident that in all these examples the image is essentially spatial. The conception of the patterns presupposes the simultaneous presence of all components, which thereby become available for a synoptic overview. Historical situations are perceived as though they were landscapes or paintings—a comparison that helps us understand the nature of dynamic relations within spatial configurations. The overall pattern of a painting is pervaded by strongly dynamic forces, which hold the composition together. They relate the parts to one another and animate the whole display of pictorial matter by a system of variously directed vectors. All these forces operate within the spatial simultaneity and are quite independent of the exploring glance of the viewer's eyes, which moves in a time sequence unrelated to the structure of the painting.

In the same way the mental image of a historical period, a musical composition, or a novel is pervaded by a spatial equivalent of the time arrow. For example, the image may be laid out as an expanse readable from the left to the right like a musical score. This directedness is experienced as a feature of the image and is, as in a painting, unrelated to the scanning action by which it is scrutinized at will.

Since memory is a biological instrument, developed in evolution for a definite purpose, it cannot collect things indiscriminately like a wastebasket. It must operate intelligently. Freud once compared the human mind with the city of Rome as it would be if all its historical shapes, from the oldest settlement on the Palatine hill to the metropolis of today, continued to coexist, nothing having ever vanished from the site.[10] It seems evident that such a spectacle of interpenetrating phantasms would constitute a functioning image only if each pattern of memory traces either kept its autonomy or organized its relation to the other patterns in a new, more comprehensive whole.

Also, accession must depend on the value of the item for the organism,

9. On prefigurations, cf. Erich Auerbach, "Figura," section 2, in *Scenes from the Drama of European Literature* (New York, 1959).
10. Sigmund Freud, *Das Unbehagen in der Kultur* (Vienna, 1930). (*Civilization and Its Discontents* [Garden City, 1958]).

and the length of the item's survival in the mind must depend on its impact and usefulness. If at this point of our consideration we glance at the religious doctrine of the survival of the soul in the afterlife, we realize that the ontological difference between the purely psychological survival in the memories of posterity and the independent persistence of an entity after death in the physical world is not of fundamental importance for our purpose. What does matter, however, is whether the belief in survival operates as a mere primitive extension of a biological instinct and therefore grants unlimited persistence beyond death automatically to every specimen of mankind, or whether survival is made dependent on some respectable value for the surviving entity itself as well as for the rest of the world.

If the images of human memory are governed by intelligent discrimination, they are constrained nevertheless by the biological and physical facts that control the world of things to be perceived and remembered. By the standards of reason many of these facts look arbitrary and meaningless: why did a certain person live a long life, another a short one? Why did someone make his entrance on the stage of history when he did, and neither earlier nor later? There is always a temptation to read rational sense into physical events. Thus when Goethe was sixty-four years old, he once startled a visitor by talking as though death were an intentional act of the organism.[11] He said that "Raphael was barely in his thirties, Kepler hardly in his early forties [sic] when both suddenly put an end to their lives, whereas Wieland [lived to be eighty]." When the visitor objected to this notion, Goethe replied that it was a liberty he often permitted himself to take. He then proceeded to improvise a natural philosophy according to which "the ultimate constituents of all beings" persist in time according to a hierarchical order. It is tempting enough for an artist like Goethe, accustomed to shaping imaginary worlds in conformity with an underlying meaning, to treat the entrances and exits of human beings as though they were the behavior of players.

Goethe's view is not mere fancy. It is a fact that Leonardo's *Last Supper* survives in full glory despite the precarious flakes of much adulterated color of which the painting consists today. On the other hand, the

11. Report by J. D. Falk on January 25, 1813. In *Goethes Gespräche*, ed. Flodoard Frhr. von Biedermann (Leipzig, 1909), vol. 2, p. 169. Raphael lived from 1483 to 1520, Kepler from 1571 to 1630.

durability of works that do not deserve it is almost offensive. Within reasonable limits, our image of the world—and particularly of history—shapes itself according to values we attribute to its components. I need not rehearse here the ways in which, for example, the history of art bases its account of a particular century on the work of a few individuals, chosen variously because of their excellence, typicality, influence, and their relevance to the chronicler's own taste and concerns. The spatial relief of heights and lowlands an observer sees in his mind as he thinks of the Quattrocento has changed considerably since the worship of Raphael, Fra Angelico, or Botticelli gave way to the admirers of Mantegna, Masaccio, and Piero della Francesca.

Less obvious are the ways in which history is subdivided into periods and styles, depending on how their characteristics are defined and to whom they are attributed. In relation to these periods we envision individuals placed centrally or as transitional bridges, we pair and group them, see them as companions, adversaries, or followers. All these relations are not so much chronological as structural, and the structural relations tend to be experienced as spatial. It would be interesting to study the answers of semi-educated people to questions about the birth and death dates of prominent persons or the years in which certain events took place. Mistakes, that is, deviations from the correct dates, often derive not from random guessing but from the placement assigned to the person or fact in the historical image. I myself remember having often been surprised to discover that great men were still alive while I was a student. The independence and completeness of their work and their identification with a period of the past seemed to militate against any overlap with my own place in time. How could an Impressionist or the founder of psychoanalysis or a leader of the Russian Revolution still be around while I was living in the next chapter of history?

By the same token it will seem anachronistic to some that Claude Monet still lived and painted in the years of Cubism, whereas others will locate him comfortably in our century because they consider his influence on the abstract impressionists of the forties. If someone conceives of Michelangelo as having had a substantial part in the early Renaissance it may come as a surprise to him to find that in 1500 the artist was only twenty-five years old. Similarly, if someone thinks of Michelangelo and Leonardo as a pair of parallel figures, he may be disturbed by the fact that one of them was born twenty-three years

earlier than the other, while the other lived forty-five years longer. Structural relations suggest spatial configurations within our image of history. If the chronological dates do not fit them—too bad for the dates! Depending on which role one attributes to the Council of Trent, the earthquake of Lisbon, or the invention of photography, one will assign them their places, correctly or more or less incorrectly.

Let me return for a moment to Goethe's tempting thought that a person's lifespan is determined by a rational decision. Viewed in that way, long and short lives appear not so much as biological accidents but as displays of various structures, whose character depends on their length, just as a short piano piece or *lied* offers different opportunities from those of grand opera. The long lives of a Titian or Cézanne are experiments with extended structures, as distinguished from the short ones of a Van Gogh or Seurat. A long life of activity, by its dependence on the biological curve of youth, maturity, and decline, suggests distinctive qualities for each phase of the work, whereas the short life goes with the incompleteness of a fragment or the rapid unfolding of an early but final flower. We tend to impose a curious interaction on the relation between the chronological length of a person's life and the substance he invested in it. Thus although both Beethoven and Proust lived about fifty years, we may think of the composer's life as incredibly compacted because it reaches from the courtly music of the eighteenth century to the tragically modern discords of his late work, whereas Proust's life may seem spread like a gossamer if we see it as given to a single work, toned to a persistent key.

Posterity surveys a person's life in simultaneity like a picture. The person himself or herself, however, had no such overview. Only rarely does the person operate under the guiding image of one surpassing task to which he will devote his whole life. The appropriate analogy to a lifetime's growth by accretion is a spatial image that gives each annual ring its completeness but puts no limit on the range to which the tree may expand. Even an occasional work of art may succeed in growing in this time-bound fashion of accretion and thereby acquire an epic affinity to life itself. To be sure, the geometrical design of Dante's *Divina Commedia* cannot have come about that way; but the series of novels constituting Balzac's *Comédie Humaine* probably did.

Since I began with a reference to man's coping with the perishable nature of all physical presence I will conclude by mentioning two con-

ceptions that continue to offer serenity to believer and unbeliever alike. One of them transcends the limitations of the individual by embedding the single lifespan in the perpetual being or flow of a superordinate existence. This image takes the form of a relay pattern in the doctrine of the transmigration of souls or, less dynamically, proposes a permanent world soul, of which the individual is a partial manifestation. A psychological version of this view was alive in Marcel Proust when he wrote: "For a man of genius can never give birth to works that will not die unless he creates them in the image not of the mortal being he is, but of the example of mankind he carries within himself. In some way his thoughts are loaned to him during his lifetime, of which they are the companions. At his death they return to humanity and teach it."[12] And translated into the philosophy of a scientist, a similar view is reflected in the reply given by Albert Einstein when he lay gravely ill and was asked whether he was afraid of death: "I feel so much solidarity with every living thing that it makes no difference to me where an individual begins or leaves off."[13]

The other source of serenity I have in mind derives from the translation of temporal events into the spatial realm of imagery. I have pointed out that only the coexistence of things in space enables us to see them in their wholeness, to put them in relation to others, and to organize them in systems. Such spatial images of small configurations or of worldwide ones serve the man of action as a means of orientation, a kind of map by which he finds his bearings in the sequence of events. A person given to contemplation, however, a thinker or artist or simply someone whose life internalizes itself through the effect of advancing age, can afford to say with Husserl that "for the consideration of essences the difference between direct perception and mere reminiscence is irrelevant."[14] He tends to cultivate the world of his images as the real one, a world in which presence and persistence depends on value and in which the access to his masters, friends, lovers, and loved-ones no longer requires that they be among the living. It is a world in which past events are available for retrieval and where precious objects are safe from

12. Marcel Proust, "En mémoire des églises assassinées," part 3, in *Pastiches et Mélanges* (Paris, 1919), p. 148.
13. *Briefwechsel 1916–1955 von Albert Einstein und Hedwig Born und Max Born* (Munich, 1969).
14. Edmund Husserl, *Die Idee der Phänomenologie* (The Hague, 1950). Lecture 5, p. 69. (*The Idea of Phenomenology* [The Hague, 1964]).

vandals and from the acids of the chemical industry. Apples and peaches may rot in peace once their portrait has been painted, and what the bee collects from the frailty of flowers turns into the substance from which the hive is built. In the safety of the timelessness of space one appreciates the ancient words of Alcmaeon, a pythagorean philosopher, who taught that "men die for this reason that they cannot join the beginning to the end." [15]

15. G. S. Kirk and J. E. Raven, *The Presocratic Philosophers* (Cambridge, 1963), p. 235.

LORENZ EITNER

*Cages, Prisons, and Captives
in Eighteenth-Century Art*

"Romanticism, so often badly defined . . . is nothing other than liberalism in literature," declared Victor Hugo in his preface to *Hernani* (1830). Despite its grandiose simplicity, this claim contains an element of truth. The trend of progressive emancipation from every sort of constraint—thematic, aesthetic, or technical—was a steady undercurrent beneath the surface turbulence of Romanticism, unaffected by its contradictions and inconsistencies. This libertarian impetus was perhaps the only pervasive force in Romanticism, and the best reason for considering it, despite its lack of unity and coherence, as one movement.

The early symptoms of changing attitudes toward authority, artistic as well as political, are to be found in the imagery of eighteenth-century art. The following observations concern a few of the many themes through which the quest for liberty found expression. Some of these have roots in earlier and quite different circumstances. It is in the diverse uses and modifications to which they put these pictorial symbols that artists of the time, reflecting contemporary attitudes or speaking their own minds, gave expression to new ideas of personal freedom.

A basic difficulty these artists faced must be mentioned at the start, because it helps to explain the rarity and poverty of visual representations of "Liberty" as such. Goddesses of Liberty, Phrygian caps, and similar properties played a rather minor role in eighteenth-century art, chiefly as the heraldic advertisements of political causes. Artistically, these lifeless relics of Baroque allegorical traditions lingered on as mere encumbrances, although, at the height of revolution, they were sometimes taken up by artists of real ability (fig. 1). It was not until a much later time that the genius of Delacroix momentarily breathed fresh life

and drama into these stale forms, in his *Liberty Leading the People* (1830), almost as if to confirm Hugo's dictum.

The artistic barrenness of the subject of "Liberty" springs from its very nature: an ideal abstraction, it resists representation. When personified as a goddess or symbolized in the form of an object, it becomes a rhetorical figure, too loftily remote from life or common experience to strike the imagination. Freedom needs the contrast of constraint or captivity to define it and make it vividly apparent: it is best seen through prison bars. Cages, prisons, and scenes of incarceration therefore can become powerful devices for dramatizing notions of Liberty, especially when these are to have a sharp emotional impact. Two examples, one from literature, the other from the visual arts, may serve to illustrate the point.

In Sterne's *Sentimental Journey*, written in 1767–68, Yorick, a British traveler in hostile France, finds that he has neglected to bring along a passport. A police lieutenant calls for him at his hotel in Paris, the frightened hotel-keeper speaks of the Bastille, but Yorick at first refuses to worry. Having no experience of imprisonment, he cannot imagine it. "The terror is in the word," he thinks, and sophistically tries to persuade himself that to be locked up in prison is, in principle, no worse than being immobilized by an attack of the gout. At this point, he is interrupted by "a voice which I took to be that of a child, which complained 'it could not get out' . . . looking up I saw it was a starling hung in a little cage—'I can't get out, I can't get out' said the starling." The spectacle shocks the lighthearted Yorick into a sudden awareness of the sufferings of captivity. He tries in vain to liberate the bird. "I vow I never had my affections more tenderly awakened; nor do I remember an incident in my life, where the dissipated spirits to which my reason had been a bubble, were so suddenly called home."[1]

The complaint of the imprisoned bird "in one moment overthrew all my systematic reasonings upon the Bastille." With the prisoner's cry ringing in his ears, Yorick walks up to his room, pausing on the stairs to kneel in prayer to the Goddess of Liberty. The thought of the caged bird pursues him. He tries to "figure to myself the miseries of confinement" by thinking of the "millions of my fellow-creatures born to slavery," but this is an idea too vast and abstract for his imagination, and so he takes "a

1. Laurence Sterne, *A Sentimental Journey through France and Italy*, ed. W. R. Cross (New York, 1926), p. 102 ff.

single captive, and having first shut him up in his dungeon, . . . looked through the twilight of his grated door to take his picture." In one brief passage, Sterne has brought together three images that vividly recalled the notion of captivity to readers of his time—the caged bird, the Bastille, and the individual prisoner—and set them, in all their graphic distinctness, beside a much fainter embodiment of Liberty.

A wash drawing by Hubert Robert (fig. 2),[2] datable around 1794, shows a massive building set in a wide landscape. It is clearly meant to represent a prison. From beneath the heavy grill of its portal emerge a young woman and a man, both carrying cages from which they release birds. Three children jubilantly greet the birds' flight, while a cluster of cats watch from the roof and three guard dogs look on from beneath the stairs. The inscription over the prison door, *Carcere tandem aperto,* and an open shackle suspended like a garland leave no doubt about the artist's intention: this is a scene of liberation in which the escaping birds signify the release of human prisoners. A counterpart to this drawing[3] shows the delivery of caged birds to a prison gate. The lounging guards in this second drawing wear the costume of *sans-culottes*, and exotic birds fastened to the railing of the prison's roof evidently represent its aristocratic inmates. The historical context of these images is fairly obvious. To Robert, who suffered imprisonment during the Terror and, unlike Yorick, knew the reality of prison, they clearly had a personal significance. He may, in fact, have drawn them in prison: a third drawing of this kind,[4] very similar to the liberation scene described above, is inscribed *H. Robert in spem libertat*[*is*] *delineavit in S. Laza*[*ri*] *carcere, 1794.*

Caged Birds and Sheltered Innocence

Caged birds are a common symbolical device in the art and literature of the eighteenth century. The remoter origins of the image do not

2. Formerly in the collection of the Duke of Vallombroso, present location unknown; see Pierre de Nolhac, *Hubert Robert* (Paris, 1910), illustrated opp. p. 82, captioned *La sortie de la prison, ou les oiseaux en liberte (Carcere tandem aperto).*
3. Formerly in the collection of the Duke of Vallombroso, like the preceding drawing; present whereabouts unknown; cf. de Nolhac, *Hubert Robert*, illustrated opp. p. 80, *L'entrée de la prison, ou la mise en cage (Captivitas, captivitas, et omnia captivitas).*
4. In the Musée Atger, Montpellier; cf. Hubert Burda, *Die Ruine in den Bildern Hubert Roberts* (Munich, 1967), p. 94, pl. 123. Burda refers to a similar drawing in the Pushkin Museum, Moscow, and illustrates a further prison fantasy by Robert, *Prison in Ruins*, pl. 124, that passed through the London art market in 1957.

concern us here. In the art of the Rococo it had a remarkable variety of meanings. It was, above all, a stock accessory in scenes of sentimental love, flirtation, or seduction, and a favorite of the French painters of erotic genre who followed in the traditions of the *fete galante* and the shepherd idyll, Lancret and Boucher in particular.[5] What sentimental effect this elegant commonplace managed to preserve, in the course of a long vogue that reached its peak in the first half of the eighteenth century and languished on well beyond 1800, derived from the pathos of captivity. But this pathos was of a rather trifling sort, it suggested nothing more than the bittersweetness of erotic bondage. The charming prisoner is the hostage of love. The young women who, in paintings by Lancret (fig. 3),[6] fondly contemplate the bird in its cage express the bliss of secure possession, while those who weep, or sometimes smile, over empty cages seem preoccupied by something other than the flight of a pet. The polished cant of erotic art and literature of the eighteenth century abounded in birdlore, in snares, bird-catchers, happy captives, and sad escapes. Papageno, loaded with cages, represents the genially bumptious hunter, Richardson's Lovelace the refined and cruel jailer: "We begin, when boys, with birds; and when grown up, go on to women; and both perhaps, in turn experience our sportive cruelty."[7]

In the latter part of the eighteenth century, with the waning of the Rococo, the form and significance of the image changed. The amorous playfulness of the conventional type gave way to a variety of serious meanings; the captive bird was made to play a more affecting and more distinctly human role. In Joseph-Marie Vien's early *Loves for Sale* (fig. 4)[8] winged putti in a basket take the place of caged birds, but the picture's

5. Cf. particularly Georges Wildenstein, *Lancret* (Paris, 1924), p. 100, nos. 445 ff. and p. 120. For a brief discussion of the motif in works by Boucher and Lancret, see also J. L. Bordeaux, "The Epitome of the Pastoral Genre in Boucher's Oeuvre *The Fountain of Love* and *The Bird Catcher* from the Noble Pastoral," *The J. Paul Getty Museum Journal* 3 (1976): 75 ff.

6. Wildenstein, *Lancret*, p. 120, no. 742, pl. 174. The picture, a mirror decoration, was once in the collection of the Count de Chezelles, and in 1921 was owned by Th. Agnew and Sons, London.

7. Samuel Richardson, *The History of Clarissa Harlowe*, Letter IX, Mr. Lovelace to John Belford Esq.

8. Vien's painting is based on an engraving by Nolli in *Pitture antiche d'Ercolano* 3 (1762) of a Roman painting that had recently been unearthed in Herculaneum. It is curious that Vien substitutes a basket for the cage shown in his Roman model. Cf. R. Rosenblum, *Transformations in Late Eighteenth Century Art* (Princeton, 1967), p. 3 ff.

subject is in fact a witty adaptation of the familiar Rococo type to a recently discovered, classical antecedent. In Vien's less well known *Love Fleeing Slavery* (fig. 5), painted in 1789, though apparently planned as early as 1772 and intended as a pendant to the earlier picture,[9] the derivation from the conventional subject is still unmistakable. But while in this instance the theme is purely Rococo and without classical precedent, the cold grandeur of the setting, the monumentality of the figures and their urgent pantomime change the action from mock-drama to something close to real tragedy. Stated with such ringing emphasis, the notion of *slavery* acquires a somber cast, more appropriate to political ideology than erotic play.

When writing of Yorick's adventure in the Parisian hotel, Sterne must have taken for granted his readers' familiarity with the symbolism of the caged bird. What gives fresh poignancy to his variation on the old commonplace is the telling innovation that Sterne's bird cries for help with the voice of a child. In Hubert Robert's drawings (fig. 2), the release of birds from cages is understood to symbolize the liberation of real prisoners from real jails. No vestige remains of the original erotic meaning of the image. Though, as a victim of the Terror, Robert used the symbol to express anti-revolutionary sentiments, his choice of it nevertheless reflects the new, primarily political significance it had acquired during the Revolution. In the iconography of revolutionary propaganda, the freed bird, perched triumphant atop a cage, stands for Liberty (fig. 6). Reduced to this emblematic form, it entered the popular vernacular of the period, and is often found as a decoration of objects of everyday use.

The curious versatility of the image in eighteenth-century art becomes especially apparent in its secondary and more limited application, as a symbolic accessory in scenes of childhood or portraits of children. This frequent connection may in part be accounted for by the fact that pet birds actually played a prominent role among the toys and entertainments of the nursery. But the image often has an evident moral significance and is introduced into such pictures in order to make a point about childhood as a state of sheltered innocence, and occasionally to

9. The picture was painted for the Duc de Brissac who gave it to Mme. Dubarry for the Chateau of Louveciennes; cf. P. Rosenberg et al., *French Painting 1774–1830: The Age of Revolution* (Paris, Detroit, and New York, 1975), no. 194.

hint at the precariousness of the shelter. In Joseph Wright's *Synnot Children* (1781),[10] a prominent open cage stands in the center; the little boy behind it has, rather recklessly, taken the fluttering bird from its prison. The sister at his side assumes an attitude of alarmed modesty, while the responsible older brother extends his arm, as if to protect her or to recapture the bird (fig. 7). The common implication of the image, when it occurs in this connection, is that unspoiled childhood exists in a charming cage, behind barriers that parental care and natural purity have set between it and the world. Outside the cage, dangers lie in wait. Time will open the door, and youth and innocence will fly.

William Hogarth's portrait *The Graham Children* (1742) offers an especially vivid dramatization of this transient security (fig. 8). A boy plays for his sisters on a bird-organ decorated with the scene of Orpheus charming the beasts. The caged bird above him responds with a song of its own, while from the darkness behind the chair, unseen by the boy, emerges a fierce cat, its eyes fixed on the bird, its claws ready for the kill—except for the shelter of the cage, the bird would meet an instant end. In the opposite corner, meanwhile, a heavy clock ticks away; it is surmounted by a small cherub who swings the scythe of Father Time. The children play on, unaware of the ominous happenings behind them, or of the passing of time. They are sheltered for the moment in the invisible cage of their innocence.

Goya's *Manuel Osorio* (c. 1788), a boy about four years old, stands between a cage well filled with magpies and a pack of cats that glower from the shadows at the single bird he has taken from the cage and holds on a leash (fig. 9). Defenseless, the bird droops its head. In contrast to the noisy jollity of Hogarth's *Graham Children*, a painful suspense characterizes Goya's picture, a stillness like the quiet before an execution. Very unlike the jubilant bird of Revolutionary emblems (fig. 6), Don Manuel's tethered magpie portrays a joyless release from the cage. Jean-Baptiste Greuze's *Jeune fille qui pleure son oiseau mort* (1765)[11] dwells on the senti-

10. Benedict Nicolson, *Joseph Wright of Derby* (London and New York, 1968), vol. 1, p. 70 and p. 223, no. 135; vol. 2, pl. 221.

11. Another version of this painting, not the one shown at the Paris Salon of 1765, is in the Louvre. The Victoria and Albert Museum in London has a painting by Greuze, *Girl with Bird Cage*, inv. F.10, which treats the same theme in a more explicit genre manner: in a garret room, a girl sits on a rumpled bed, her clothes in disarray, one breast exposed. Her right hand rests on an open cage; the bird has flown. Her left hand, in a rhetorical gesture, addresses the viewer as if to underline the lesson implicit in her situation.

mental conclusion of the drama foreshadowed in Hogarth's and Goya's portraits (fig. 10). The bird, no longer imprisoned, lies dead on its cage, mourned by an adolescent girl whose physical charms roused the critic Diderot to excited exclamations. She grieves over her pet with an excess of feeling that awakens doubts about the true cause of her distress. Diderot, for one, felt certain that she does not mourn the death of her canary, but a more serious loss of which the dead bird is merely a reminder. The story which Diderot, in his review of the Salon of 1765,[12] wove round the picture, to justify his reading of it, may or may not exactly reflect the artist's intention, but Diderot was surely right in pointing to the parallel of Greuze's slightly earlier *Broken Mirror* (1763), where a different set of symbols signifies the loss of virginity. The original, erotic connotation of the image thus reemerges in Greuze's use of it, though it does so in the special context of childhood and innocence, in which the cage represents security, and escape means danger or death.

A curious variant of the theme of sheltered childhood, which explicitly identified innocence with erotic repression, is to be found in Louis Gabriel Blanchet's *Age of Innocence* (1731).[13] Instead of portraying happy children playing with caged birds, Blanchet incarcerates the children themselves in a prison (fig. 11). One of them, very cupidlike, wears chains on legs and arms, while having his hair combed. The window of this strange nursery is strongly barred. Two of the little inmates are being naughty, eating fruit, no doubt forbidden, and delving into a jar. A scourge, diminutive but evidently used, lies among the toys that litter the floor.

Prison Fantasies and Monuments of Power

From the nursery-prison of the infant Eros to the *Carceri* of Piranesi[14] (figs. 12–14) the road is long, but it does not lead us closer to reality. The

12. Denis Diderot, *Salons*, ed. J. Seznec and J. Adhemar (Paris, 1960), vol. 2, p. 145 ff. According to Diderot, the bird died of neglect while the girl, taking advantage of her mother's absence, entertained a lover.

13. Louis Gabriel Blanchet, 1705–72, won the Prix de Rome in 1727 and spent the remainder of his life in Rome. I have been unable to discover a literary text for this strange picture.

14. The original set of fourteen plates, entitled *Invenzioni capric di carceri all acqua forte datte in luce da Giovanni Buzard* [subsequently changed to *Bouchard*] *in Roma mercante al Corso*, was etched after Piranesi's return from Venice, in 1745, and before 1751. About

fourteen imaginary prisons that Piranesi etched around 1745 are no more to be taken literally than the caged birds in Rococo idylls. They, too, are metaphors, though they impress themselves on us with disconcerting immediacy, as emotional experience rather than intellectual play.

Piranesi's *Carceri* have in fact only the most indirect relationship to real prisons of their time.[15] In the early eighteenth century the vast majority of felons inhabited improvised cells located in the basements, garrets, and towers of old buildings originally destined for other uses. Prisons showed considerable variety, from the stifling *piombi* under the roofs of the Ducal Palace in Venice, to the humid dungeons of the Bastille, to the many smaller jails tucked away in town halls, fortresses, and disused monasteries throughout Europe. Whatever their particular shapes or locations, however, nearly all these human cages were cramped, dark, and foul. Prisons had not yet assumed any typical architectural form and were still of little interest to architects. It fell to the lot of scenic designers, strangely enough, to give a recognizable and impressive form to the notion of prison. On the Baroque stage, backgrounds representing vaulted halls or fortress courts, made more sinister by the addition of grills, spikes, and torture instruments, conventionally suggested the idea of prison whenever the scenario called for such a setting.[16] These imposing theatrical fictions were as different from the shapeless squalor of real

1760, Piranesi reissued the series under a changed title, *Carceri d'invenzione di G. Battista Piranesi Archit Vene*, adding two new plates and thereby increasing the set to sixteen. For this second edition Piranesi thoroughly worked over the plates, darkening them, adding many details, and giving the imaginary structures an appearance that is both more substantial and more obviously prisonlike than in the original edition. He also took pains to clarify the perspectives, in an evident attempt to mitigate the spatial ambiguities so marked in the earlier states. For a discussion of Piranesi's revisions of the plates, see A. Robinson, "Giovanni Battista Piranesi: Prolegomena to the Princeton Collection," *Princeton University Library Chronicle* 31 (1970): 165 ff. The literature concerning the *Carceri* is too vast to be listed in detail. The two basic catalogues are H. Focillon, *G. B. Piranesi, essai de catalogue raisonné* (Paris, 1918), and A. M. Hind, *G. B. Piranesi, A Critical Study of his Published Works* (London, 1922). Ulya Vogt-Göknil, *G. B. Piranesi, Carceri* (Zurich, 1958), contains the bibliography to that date; P. M. Sekler, "G. B. Piranesi's *Carceri* Etchings and Related Drawings," *Art Quarterly* (Winter 1962): 357, takes critical issue with previous interpretations; and J. Scott, *Piranesi* (London and New York, 1975), p. 45 ff., is the most recent extensive discussion of the series.

15. N. Pevsner, *A History of Building Types* (Princeton, 1976), p. 159 ff., discusses the early history of prison architecture and considers several exceptional early structures, such as Carlo Fontana's S. Michele House of Correction in Rome, built in 1703/4; cf. also H. Rosenau, *Social Purpose in Architecture* (London, 1970), p. 77 ff., and M. Foucault, *Surveiller et punir, naissance de la prison* (Paris, 1975).

16. Cf. H. Tintelnot, *Barocktheater und barocke Kunst* (Berlin, 1939), and the discussion of influences on Piranesi's designs in Vogt-Göknil, *G. B. Piranesi*, p. 24 ff., and J. Scott, *Piranesi*, p. 45 ff.

prisons as the heroics on the stage from the actual miseries in the jails. But to the popular and artistic imagination, the unknown reality of prison undoubtedly appeared in the more familiar forms of stage scenery.

Piranesi certainly knew of scenographic prison designs, by Juvarra, Valeriani, and the Bibiena, but his own inventions in this vein, in the fourteen plates of the *Carceri*, were not meant for the theater. They are daringly original variations on stage imagery, and thus twice removed from practical reality—fantasies derived from fantasies. The striking irrationalities in their presentation of space and structure, their abrupt incoherencies of plan and elevation, their lapses of perspective and clashes of light rule them out as models for the stage or, indeed, for practicable construction of any kind.[17] Yet these violations of visual logic in no way lessen their expressive force.

But what do they express? In their original states, as published about 1745, few of the *Carceri* are immediately recognizable as prisons. The extravagant spaces, the pomp of broad stairs and sweeping arches, the teeming passageways and bridges in these light-filled interiors strike one as being perversely inappropriate to their supposed function. Piranesi's prisons seem designed for the circulation of crowds, for pageantry rather than confinement. Several of these structures could easily be mistaken for palaces,[18] were it not for the rough nakedness of their masonry and timbers, reminiscent of military or industrial construction. The views are taken at such close range that only portions of the enormous buildings appear, implying vast extensions beyond the field of vision. Those forms that the eye can grasp have a strangely fragmentary aspect, huge details negligently joined, yet without any suggestion of the unfinished or the ruinous; they seem untouched by time. In contrast to their oppressive nearness, the figures that move about them seem remote, mere spots or blurs for the most part, lost in the immensity of the interiors whose dimensions they magnify by their smallness. In only a few of the plates[19] are some of them brought close enough to become recognizable as prisoners laden with chains.

The enigma of the *Carceri* has long been a challenge to interpretation.

17. On Piranesi's spatial ambiguities, see Vogt-Göknil, *G. B. Piranesi*, p. 26 ff., and Sekler, "G. B. Piranesi's *Carceri Etchings*, p. 334 ff.
18. Sekler, "G. B. Piranesi's *Carceri* Etchings," p. 342, pl. 15, illustrates a drawing by Piranesi, in the British Museum, of an ornate, palatial structure that served as the model for the prison in *Carceri* pl. 11.
19. Specifically the plates 1 (frontispiece), 2 (second edition), and 10.

Few critics have resisted their romantic temptation, though a tough-minded minority has argued that their subject matter is not significant in itself. "They tell no tale, they do not lend themselves to discussion, and they have no associational appeal," wrote William M. Ivins incisively in 1915.[20] More recently it has been suggested that Piranesi's real interest was centered on formal problems: ". . . the goal toward which Piranesi was working in this particular series developed, as the series progressed, into the goal of a mastery of spatial ambiguities."[21] The majority of commentators, however, from de Quincy, who thought that the *Carceri* "record the scenery of [Piranesi's] own visions during the delirium of a fever,"[22] to Aldous Huxley, who saw in them "reference . . . to things existing in the physical and metaphysical depths of human souls—to acedia and confusion, to nightmare and *angst,* to incomprehension and panic bewilderment,"[23] have interpreted them as expressions of traumatic personal experience and emotional disturbance.

But there are clues in Piranesi's early works and writings, and in the *Carceri* series itself, that admit a different reading. In 1743, about two years before he etched the *Carceri,* Piranesi had published his first independent work, a set of twelve plates entitled *Prima parte di architettura e prospettiva,* in which he demonstrated his precocious mastery of perspectival devices to create the illusion of buildings of stupendous size.[24] He cast some of his inventions in a modern style, and in others recalled Roman temples (fig. 15), tombs, and fora, but all the designs were in fact pure exercises of the imagination, unrelated to architectural reality.[25] Their grandiloquence brings to mind Horace Walpole's com-

20. W. M. Ivins, "Piranesi and Le Carceri d'Invenzione," *Print Collector's Quarterly* (London, 1915), p. 191 ff.

21. Sekler, "G. B. Piranesi's *Carceri* Etchings," p. 357.

22. T. de Quincy, *Confessions of an English Opium Eater,* ed. E. Sackville-West (London, 1950), p. 330. De Quincy, writing in 1821, remembers a conversation with Coleridge, held about 1802/3: "I describe only from memory of Mr. Coleridge's account."

23. A. Huxley, *Prisons* (Los Angeles, 1949), p. 21.

24. The series originally consisted of a title page and twelve plates (Focillon 1–13). Piranesi reissued the series, from about 1750 on, as part of the *Opere Varie,* adding titles and five new plates (Focillon 14–18).

25. The plates of the original set of 1743 and the somewhat later additions comprise three stylistically quite different groups, the first consisting of structures of fairly moderate scale, executed in a fairly dry and pedestrian manner (exemplified by *Sala all uso degli antichi Romani,* Focillon 8), the second of grandiose structures drawn in a very precise, linear technique (*Mausoleo antico,* Focillon 14; *Tempio Antico* [fig. 15], Focillon 17), and the third of very disordered still-lifelike arrangements of architectural and sculptural fragments, conceived in a richly tonal style that appears to be distinctly Venetian in character

ment that Piranesi "has imagined scenes that would startle geometry, and exhaust the Indies to realize. He piles palaces on bridges and temples on palaces, and scales Heaven with mountains of edifices."[26] The exuberant energy that expressed itself in these architectural fantasies fed not so much on the study of Roman remains as on a passionate creative urge; the designs of the *Prima parte* are the overflow from the brain of an unemployed architect. In his prefatory dedication of the plates Piranesi explained the enormity of his inventions as having been excited by his impressions of Roman grandeur and his despair at the impotence of modern builders:

> . . . these speaking ruins have filled my spirit with images that accurate drawings . . . could never have conveyed. . . . That is why I conceived the idea of making some of these images known to the world, knowing that it is futile to hope that an architect of our time would carry them out, no matter whether the blame lies with architecture, fallen from its high perfection in the period of the Roman Republic's splendor and the times of the all-powerful Emperors who came after, or with the men who should be the patrons of this noblest of the arts. The fact is that we have not seen in our day buildings equalling the cost of the Forum of Nerva, the Amphitheater of Vespasian, the Palace of Nero . . . There is no other way open to me and other modern architects than that of explaining our ideas in drawings. . . .[27]

The fantasies of the *Prima parte,* it is worth noting, are conceived in the most concretely descriptive terms and are "unrealistic" only in a purely practical sense. Their forms are rational, hence structurally possible. Among them, conspicuous by its compact sobriety and moderate scale, figures the *Carcere oscuro* (fig. 16), a prison interior evidently inspired by stage scenery.[28]

(*Vestiggi d'antichi edifizi*, Focillon 5; *Ruine di sepolcro antico*, Focillon 6; *Ara antica*, Focillon 16). Stylistically related to this third group is the plate entitled *Carcere oscura* (fig. 16), Focillon 4.

26. Preface to the fourth volume of *Anecdotes of Painting in England*, written c. 1770; cf. edition by R. N. Wornum (London, 1876), vol. 1, p. xvi.

27. For a recent publication of the original text, see the exhibition catalogue *Giovanni Battista Piranesi* (Low Memorial Library, Columbia University, New York, 1972), p. 115.

28. Cf. the engraving of a Prison by C. A. Buffagnotti after a drawing by P. G. Abati, based on a design by Ferdinando Galli Bibiena, published in *Varie opere di prospettiva* (Bologna, 1703/8), illustrated in Scott, *Piranesi*, p. 60, fig. 70.

The *Carceri,* following two years after the youthful *Prima parte,* mark a revolution in Piranesi's development. Imaginary compositions, without pretense of antiquarian scholarship or architectural utility, they resume in a more radical form the fantastic strain of the earlier publication, but the brutal spontaneity and subjectivity of their execution is without precedent. Piranesi has discarded the graphic conventions that had heretofore governed architectural publications, abandoned the stiff pre-cision of his own earlier work,[29] and resolutely thrown himself into the opposite extreme of inspired slovenliness and energetic self-expression. His compositions, no longer architectural designs in the strict sense, are freely expressive improvisations in which architectural effects serve as emotional stimuli. Having declared, in the dedication of the *Prima parte,* that his mind was filled with "images that accurate drawings could never convey," he proves in the *Carceri* that within two years he has made himself the master of a personal, graphic style capable of expressing his boldest inventions.

The *Carceri,* seen in this light, appear as a gesture of artistic emancipa-tion, a challenge thrown by a young man of fervent ambition to what he thought an enfeebled age. They show him possessed by ideas for which he is about to find an outlet, exchanging conventional draughtsmanship for a vigorous pictorial manner, liberating himself along the way from the baggage of technical routines, shaking off the restraints of perspec-tive, logic, and perhaps common sense as well. Far from presenting a spectacle of acedia, *angst,* and "panic bewilderment," as Huxley and others have supposed, Piranesi asserts himself in these prints of unusual size and original spirit as an artist determined to astound his contem-poraries. His posture is that of a turbulent, self-conscious genius of *Sturm und Drang,* not of a brooding Romantic.

Like the "speaking ruins" of Rome that had inspired Piranesi's begin-nings, the *Carceri* compositions are meant to speak, but their voice is that of the self-determined artist, in the fantasy role of omnipotent builder. Lacking the patronage of a Nero, Vespasian, or Nerva, the architect himself turns tyrant and uses the power of his imagination to conjure up buildings, vast beyond human effort, that "startle geometry" and out-reach reason. The theme of prison was ideally suited to his needs: it

29. That is to say of his earlier *architectural* designs; the ruin still-lifes in the *Prima parte* (Focillon 2, 5, 6, and 16) are in a notably freer, more richly tonal, "Venetian" manner, and so are two other plates, the scenographic *Carcere oscura,* Focillon 4 (fig. 16) and the archaeological *Camera sepolcrale,* Focillon 18, both of them premonitions of the *Carceri.*

called up no very definite structural type and allowed him to play with colossal forms and obscurely terrifying suggestions. While the declared subject of the *Carceri* is prison, the underlying meaning these images insistently express is authority. Their point is not the pathos of captivity, the suffering of prisoners, but the timeless grandeur of the prisons themselves, and hence the potent will they embody: they are, in de Quincy's words, "expressions of enormous power put forth, and resistance overcome."[30] Other types of architectural grandeur, palaces, temples, bridges—Piranesi had sampled them in *Prima parte*—can have an impressiveness of their own, but the idea of prison represents authority in its essence, as naked force, intended to dominate and to arouse fear. There is no sign of revulsion in Piranesi's treatment of the subject. He clearly identified himself with these triumphs of power, to which the prisoners are merely a dramatic accessory, not unlike the chained nudes that kneel at the bases of Baroque victory monuments.

Only a little more than twenty years separate Piranesi's imaginary prisons (c. 1745) from Sterne's fantasy of the captive bird (1767), but the difference in attitude between them is profound. Yorick, fearing for his own liberty, identifies himself with the imprisoned bird. His readiness to sympathize, even with a trivial object, marks him as a man of feeling and associates him with a sentimentalizing strain in the art of the later eighteenth century. Piranesi declares his artistic independence by inventing spectacular structures that are all the more satisfying for hinting at confinement and suffering. Unlike the tender-hearted Yorick, he is able to exult in the greatness of the prison and has no pity for the imprisoned. The sentiment as well as the style of his *Carceri* reflect Baroque tradition, the old alliance between art and power, with the difference that Piranesi does not serve any interest other than his own. His assertion of independence in the *Carceri* is also an act of usurpation. He borrows the trappings of tyranny for his artistic purpose, and makes himself the prison-keeper, not only of the shadowy humanity that inhabits his fantasies but also of the viewer's imagination. His intention is to produce agreeable terror, not tears.

"Uncertain, confused, terrible," like Milton's image of Death, which Burke found "sublime to the last degree,"[31] the *Carceri* perfectly anticipate Burke's definitions of the sublime, bearing out his contentions that

30. De Quincy, *Confessions*, p. 330.
31. Edmund Burke, *A Philosophical Enquiry into the Origin of our Ideas of the Sublime and Beautiful*, ed. J. T. Boulton (London, 1958), p. 59.

there is "nothing sublime which is not some modification of power" and
that "power derives all its sublimity from the terror with which it is
generally accompanied."[32] They are the most impressive instances, in
the pictorial art of their time, of the conscious use of colossal size to
convey a sense of terrifying power. Other artists of the period sought
such effects in nature, in mountain scenery and storm-lashed coasts. The
Carceri are manmade chasms; they owe nothing to nature. The source of
their sublimity is the exaltation of human energy, made manifest in
architecture. "When any work seems to have required immense force
and labor to effect it," Burke was to write in his *Enquiry* (1757) in a
passage that irresistibly calls to mind certain of Piranesi's compositions
(fig. 14), "the idea is grand. Stonehenge, neither for disposition nor
ornament, has anything admirable, but those huge, rude masses of
stone, set on end, and piled each on the other, turn the mind on the
immense force necessary for such a work. Nay the rudeness of the work
increases this cause of grandeur. . . ."[33] Piranesi's sublime prisons sur-
pass, in sheer grandeur, the landscapes of Marco Ricci, Magnasco, and
Salvator Rosa, to which, in some respects, they are as comparable as to
the traditions of scenery design. In the *Carceri*, invention, artifice, and
the artist's relentlessly self-assertive ego seem to compete with nature's
power and immensity in a search for something even more awesome. "I
have a need to produce great ideas," Piranesi said, according to his
biographer, J. G. Legrand (1799), "and I believe that if someone asked
me to plan a new universe, I should be mad enough to try."[34]

Piranesi's other set of *capriccios* from the time of the *Carceri*, the four
so-called *Grotteschi* (fig. 17),[35] have a subject that is, significantly, in direct
opposition to that of the *Carceri*. When seen together, the two series help
to define one another by their contrasts. The *Grotteschi* are decorative
arrangements in the manner of Rococo cartouches, composed of inco-
herent elements—sculptural fragments, shreds of vegetation, hints of
rocaille, and drifts of smoke—wildly, perhaps humorously, tumbled

32. Ibid., pp. 64–65.
33. Ibid., p. 77.
34. J. G. Legrand, "Notice historique sur la vie et sur les ouvrages de G. B. Piranesi,
architecte, peintre et graveur," 1799, Paris, Bibliothèque Nationale, MSS nouv. acq. fr.
5968, p. 146; cf. Vogt-Göknil, *G. B. Piranesi*, p. 22.
35. The four *capriccios* known as the *Grotteschi* (Focillon 20–23) regularly form part of
the *Opere varie*, published in 1750, but were evidently etched earlier, possibly just before
the *Carceri*, c. 1745.

together.[36] The difference in effect between this thriving disintegration and the massive permanence of the *Carceri* is extreme, and no doubt intentional. Compared to the enigmatic language of the prisons, the *Grotteschi* are profusely loquacious. Every element in them is transparently allegorical and clamors to be read. The individual plates are composed as picture-riddles; their seemingly chaotic imagery in fact contains a meaning which, once recognized, gives a kind of order to the whole and coherence to the parts. The one idea constantly repeated in each of the compositions is that of perishability. Hour glasses, the zodiac, devouring worms, and grinning skulls point to time as the agent of a general decay which reduces everything, and especially man's work, to rubbish. Each plate illustrates the transience of some form of glory: the ruined tomb of an emperor, the mossy statue of Hercules, the disused trophies of fame, of war, and of art; even the attributes of the gods— they are useless debris on the verge of nothingness, like the quiver of Amor that, in one of the plates, lies forgotten on the edge of a sarcophagus. In the *Carceri*, power expressed by art triumphs over time; in the *Grotteschi*, time involves art and power in common destruction. The twin themes of grandeur and transience which appear reconciled in Piranesi's later work here are stated separately, in perfect antithesis.

From a subject for pictorial fantasy and stage illusion, prison architecture in the latter half of the eighteenth century turned into a practical reality. The movement for penal reform, led by influential philanthropists such as Cesare Beccaria and John Howard, stimulated the construction throughout Europe of places of confinement that were intended to be less cruel, unhealthy, and degrading than the old makeshift jails.[37] Architects found the novel task a fascinating opportunity for experiment. It is not likely that the *Carceri* had any direct influence on the work of the early prison builders, but some of them shared Piranesi's predilection for expressive monumentality and wel-

36. In theme and style, *Ara antica* (Focillon 16) of the *Prima parte* directly anticipates the *Grotteschi*, proving that the idea was in Piranesi's mind at an early date.

37. See the general discussion in Rosenau, *Social Purpose*, p. 78 ff., and Pevsner, *History of Building Types*, p. 161 ff. E. Kaufmann, in *Architecture in the Age of Reason* (Cambridge, 1955), concisely describes the contributions of such individual architects as Blondel, Cuvillies, Daubanton, Desmaisons, Neufforge, and Gondoin. Among the early prison designs are several of austerely utilitarian form, notably the Maison de Force at Ghent, by Malfaison and Kluchman (1772/5), and Jeremy Bentham's Panopticon (1791). These are in marked contrast to the symbolical and monumental structures dealt with in the following remarks.

comed the emotion-charged theme of prison as an outlet for original
and sometimes eccentric ideas. In planning the interior arrangements of
the new jails, the cells, the courts, and rooms for work, their imagina-
tions were cramped by unavoidable requirements of security, hygiene,
and humanity, though they often managed to use a degree of artistic
license in dealing with such details. But in the composition of dramatic
and significant exteriors they could indulge their fantasies to the full.
Without definite models to follow or prescriptions to obey, builders of
real jails were almost as free to exercise their powers of invention as
Piranesi had been when he drew his *Carceri*. It was a rare chance for
making forceful architectural statements in the rhetoric of sublime
grandeur and terror, and in their enthusiasm for the colossal and sym-
bolical, prison planners occasionally lapsed into stagey effects that re-
called the theatrical origins of the genre. The effort to make prison
facades symbolic of the majesty of the law, the heinousness of crime,
and the stern necessity of punishment produced some odd hybrids,
combining elements of palace, fortress, and tomb.

George Dance's Newgate Prison in London (fig. 18), designed in 1769,
was one of the earliest and most ambitious enterprises of its kind,
masking a drily utilitarian interior with an imposing outer shell of
powerfully rusticated walls.[38] The forbidding blankness of the facade
and the brooding cubic masses of the building declared with the most
terrifying solemnity the prison's character as tomb for the living. When
John Howard, the prison reformer, inspected the recently completed
Newgate, of which on the whole he approved, he was told by an atten-
dant that "criminals who had affected an air of boldness during their
trial, and appeared quite unconcerned at the pronouncing sentence
upon them, were struck with horror, and shed tears when brought to
their darksome solitary abodes." Charles-Nicolas Ledoux's *Prison for
Aix-en-Provence* (fig. 19),[39] begun in 1784 but never completed, was of
rather similar inspiration and even more eccentric design, presenting
the appearance of a fortified mausoleum, with low columnal portals that
had the look of entrances to the nether world. But it was in Etienne-

38. J. N. Summerson, *Architecture in Britain, 1530–1830* (Baltimore, 1954), p. 449. A
photograph of the building, taken shortly before its destruction in 1902, is to be found in
H. Hobhouse, *Lost London* (London, 1971), p. 155.

39. C. N. Ledoux, *L'architecture considérée sous le rapport de l'art, des moeurs, et de la
legislation* (Paris, 1804; republished by De Nobele, Paris, 1961), vol. 2, pls. 188 and 189; cf.
G. Lavallet-Haug, *C. N. Ledoux* (Paris, 1934), p. 103 ff.

Louis Boullée's design for an enormous Palace of Justice (c. 1785) that terroristic prison symbolism reached its height.[40] Planned for dimensions that far surpassed Piranesi's boldest dreams, the project remained on paper, like most of this gigantic breed. Boullée's feeling for the "poetry of architecture," as he put it in his note of explanation, gave him the idea of burying his prison in the foundations of the Palace: "It seemed to me that in presenting this august Palace as elevated above the gloomy dens of Vice, I should be able not only to emphasize the nobility of its architecture by means of the resulting contrast, but also to present an imposing metaphor of Vice crushed under the weight of Justice."[41]

It is remarkable that in an enlightened age architects interested in social reform should have occupied themselves with symbolic monuments of penal justice, modernized Bastilles, generators of despair, and shown little concern for the human consequences of their architectural poetry. There are some fundamental similarities between the prison *capriccios* of Piranesi and the monstrous plans of Ledoux and Boullée. Piranesi's designs are egotistical, self-expressive fantasies, flashes of inventive genius, while the projects of the so-called visionary architects present themselves in pseudo-rational, pseudo-utilitarian guise, as instruments for the improvement of the human race. But they, too, are only self-indulgent fantasies, games of the "Imagination, which, in truth, / Is but another name for absolute power."[42] Their designers, driven by artistic ambition, so enormously exceeded all practical limits as to leave no doubt that they preferred the elation of pure planning to the frustrations of building and felt liberated, not unlike Piranesi, by the social inutility of their ideas. On the brink of reality, they chose the impossible. Their drawing boards contained an ideal world which they could rule as autocrats and fill with symbolic monuments of their choice, temples of new religions, tombs, museums—and prisons. Mankind, the beneficiary of this grandeur, appears in the distances of their designs, minute figures gathered about the bases of pyramids, waiting to be formed into processions.

40. The design is preserved at the Bibliothèque Nationale, Paris, Est. Ha 56, no. 25; cf. the exhibition catalogue, *Visionary Architects* (University of St. Thomas, Houston, 1968), p. 49, no. 26.

41. H. Rosenau, *Boullée's Treatise on Architecture* (London, 1953), p. 65, gives the French text, written about 1790/5. Very similar ideas are expressed by Ledoux in the introduction to his *Architecture* (see note 39): "Le temple éclairé de la justice forme une opposition salutaire avec les lieux sombres destinés au crime . . ." (vol. 1, p. 3).

42. W. Wordsworth, *The Prelude*, book 14, 189–90.

The Prisoner's Plight

As sources of sublime emotion, prisons are best appreciated in artistic perspective, at a distance which makes it difficult to distinguish the individual prisoner. But in the course of the eighteenth century the interest in the prisoner himself steadily increased and gave rise to yet another strain of prison imagery, the sentimental-picturesque or pathetic, which came to rival the terrific-sublime without ever quite displacing it. In contrast to Piranesi, Sterne's Yorick felt the need to take a closer look at the captive in the prison:

> . . . through the twilight of his grated door . . . I beheld his body half wasted away with long expectation and confinement. . . . Upon looking nearer I saw him pale and feverish: in thirty years . . . he had seen no sun, no moon . . . nor had the voice of friend or kinsman breathed through his lattice:—his children—
>
> But here my heart began to bleed—I was forced to go on with another part of the portrait.
>
> He was sitting upon the ground upon a little straw. . . . a little calendar of small sticks were laid at the head, notch'd all over with the dismal days and nights he had passed there. . . . I heard his chain upon his legs, as he turned his body to lay his little stick upon the bundle—He gave a deep sigh—I saw the iron enter into his soul—I burst into tears. . . .[43]

Although drawn from fantasy, Sterne's "portrait" attempts to seize the emotional and physical reality of confinement as a prisoner might experience it. It is in this respect still rather exceptional for its time (1767). Realistic views of prisons, whether imaginative attempts or actual observations, were rare, sympathetic descriptions of prisoners rarer still. The ordinary, anonymous prisoner was scarcely an object of interest. The pictures taken of particular criminals tended to be portraits of celebrities, drawn to satisfy public curiosity rather than to arouse pity. Sir James Thornhill in 1724 drew a portrait of the condemned robber John Sheppard, who had achieved notoriety by a daring escape from Newgate Prison. Thornhill's son-in-law, William Hogarth, painted the murderess

43. Sterne, *Sentimental Journey*, p. 108.

Sarah Malcolm in her cell before her execution in 1732.[44] These are fairly literal portraits in which the prison setting plays only a minor part and the pathos of imprisonment is not stressed, but their documentary sobriety may be symptomatic of an interest in the actuality rather than the melodrama of prison. The artist works from observation, and in this perspective the prisoner is apt to occupy the foreground.

Hogarth's *Beggars' Opera* (1728)[45] records a performance of Gay's play on the boards of the Lincoln's Inn Fields Theatre against a painted backdrop representing the interior of a prison. The modest dimensions and functional simplicity of the scenery, strikingly different from the elaborate fantasy prisons of the Bibiena, have been noted by Hogarth with equal sobriety. In the same spirit, he soon after represented an actual prison setting in his painting *Meeting of the Oglethorpe Committee in the Fleet Prison* (1729),[46] a composition very likely based on studies made on the spot. Realistic views of prisons recur in the Bridewell scene of *A Harlot's Progress* (1732) and the scenes in Fleet Prison (fig. 20) and Bedlam in *A Rake's Progress* (1735). Each specifies a particular kind of prison—workhouse, debtor's prison, or madhouse—in sharp, prosaic detail, without exaggeration or obtrusive stage management. In these cells and corridors Hogarth recalls the look of particular places with topographical objectivity: his prison interiors have the banality of unhappy truth. It is apparent that he had visited prisons, not in his "fancy," like Sterne's sentimental traveler, but in person, to observe them with a keen and tearless eye. The dramatic scenes which he composed for these settings are staged with theatrical skill, but the actors in them and the action itself represent a credible social reality, arranged to fit a moral. Imprisonment, in Hogarth's biographical narratives, is deserved punishment, the consequence of folly and vice. He shows little pity for the Harlot or the Rake, but keeps their humanity in view. Unlike the distant human wreckage in Piranesi's grandiose prisons, the vivid personages that crowd Hogarth's dismal jails are on the threshold of our sympathy.

44. R. Paulson, *Hogarth: His Life, Art, and Times* (New Haven, 1971), vol. 1, p. 137, fig. 39, reproduces the engraving by George White after Thornhill's portrait. The portrait of Sarah Malcolm is in the National Gallery of Scotland, Edinburgh.

45. Hogarth painted six versions of *The Beggar's Opera* between 1728 and c. 1731. The two last versions, in the Paul Mellon collection and the Tate Gallery, show somewhat more elaborate prison settings. Cf. Paulson, *Hogarth*, 1:180 ff.

46. The final painting is in the National Portrait Gallery, London, a sketch in the Fitzwilliam Museum, Cambridge; cf. Paulson, *Hogarth*, 1:196 ff.

The need for accurate documentation that had sent Hogarth sketching in the Fleet and in Bedlam obsessed John Howard, the philanthropist, with almost manic intensity. Having resolved to work for the improvement of prisons, at first merely in the county of which he was sheriff, ultimately in all the kingdom, he felt compelled to visit every jail in Britain, not once but two or three times, and to take five long trips on the continent, for the sole purpose of gathering information for his monumental reports *State of the Prisons* (1777, 1780, 1784).[47] Between 1773 and 1784, when he turned his attention from jails to hospitals and "lazarettos," he traveled forty-two thousand miles and spent thirty thousand pounds of his own money to do what Yorick had done so effortlessly in his imagination—look at the captive in his cell. Howard's purpose was to assemble evidence for legislative reform, but he brought to his enterprise an obsessive collecting zeal. No jail escaped his notice, "though but a solitary prisoner should be confined within its walls." There was little of the sublime about most of the prisons Howard inspected in his incessant travels, except terror. Nearly all were small, some minuscule: "At Flint felons and petty offenders were confined in two dark closets, five feet by four, very properly called 'black holes.' " The offenses for which prisoners suffered, and sometimes died, were usually on the same scale: the prison in Whitechapel held debtors sued in the manor courts of Stepney and Hackney for debts above two and under five pounds. "For these paltry sums, he found no less than five and twenty of his fellow mortals incarcerated, in a prison out of repair."[48]

Howard's descriptions are as impersonal, concise, and factual as catalogue entries. As a systematic collector he took careful note of numbers and dimensions and had a good eye for character and condition. His verbal pictures are dry, they lack Hogarth's hard wit and Sterne's sentiment, his heart never seems to bleed, but he finds his way to the reader's nerve with the same quiet insistence with which he penetrated into prisons, often over the keepers' objections. For the bridewell at Fakenham, two sentences suffice: "Damp rooms, no chimney; small

47. J. Howard, *The State of the Prisons in England and Wales, with Preliminary Observations, and an Account of Some Foreign Prisons* (Warrington, 1777); an abbreviated edition, edited by Kenneth Ruck, was published in London in 1929.

48. J. Baldwin Brown, *Memoirs of the Public and Private Life of John Howard the Philanthropist* (London, 1818), pp. 157, 160.

yard; no pump; no sewer. Yet the keeper said, a woman, with a child at her breast, was sent hither for a year and a day: the child died."[49]

To Howard, all prisoners were apparently made equal by the fact of their captivity. He generally does not mention offenses, except to contrast their slightness with the severity of the punishment. More puritanical than Hogarth, he held strong views on morality and by no means disapproved of prisons. But in his inspections he attended, without making distinctions, to the sufferings of all prisoners. There are no Harlots or Rakes in the jails he describes. Like Sterne, who gave no thought to the Captive's possible guilt, Howard looked on the men, women, and children who crowded the squalid cells as human beings equally in need of relief. His undiscriminating benevolence, though carried to lengths that some thought eccentric, reflected a growing current of feeling and was much admired. "He treads," wrote Erasmus Darwin,

> . . . inemolous of fame or wealth,
> Profuse of toil, and prodigal of health,
> With soft assuasive eloquence expands
> Power's rigid heart, and opes his clenching hands;
> Leads stern-ey'd Justice to the dark domains,
> If not to sever, to relax the chains;
> Or guides awaken'd Mercy through the gloom,
> And shews the prison, sister to the tomb![50]

From this point it was not difficult to take the further step of considering the Captive simply as Victim. The mercy that Howard had helped to awaken recoiled from "stern-ey'd Justice" and called it oppression. Howard himself never fell into such emotional generalizations, but Sterne's portrait of the prisoner seems based on them. Like the birdcage in Rococo iconography, the notion of prison in later eighteenth-century art came to be associated with innocence. This twist of meaning undoubtedly opened new possibilities to artistic expression. Prosaic descriptions of prisons, however interesting as documents, have a limited emotional power and are not easily read as symbols. A thief behind bars is a less affecting spectacle than a victim of oppression in chains. Hogarth's

49. Howard, *State of the Prisons*, p. 301.
50. *The Loves of the Plants*, canto 2, 439 ff.

realistic prose found few imitators at the century's end, but Sterne's sentimental portrait directly inspired several artists, among them John Hamilton Mortimer and Joseph Wright. The latter painted two versions of *The Captive from Sterne* (1774 and 1775–77)[51] that are early examples of a new type of prison picture in which the whole emphasis falls on the pathos of man-inflicted suffering, witnessed at close range (fig. 21). The figure of the solitary captive now dominates the scene with something of the stillness and solemnity of an *Ecce Homo*. The prison setting of heavy vaults and iron bars, plausible enough but unspecific, serves merely as a foil to the captive's naked misery. The thought that the sufferer might be a felon is not likely to trouble the sympathetic beholder. The conception of the prisoner as Man of Sorrows and of the jail as a kind of Golgotha, very different from Hogarth's noisy hells for petty offenders, is the absolute opposite of Piranesi's Baroque fantasies in which the humanity of the prisoners is of no consequence. In the end it was Goya who raised the image of the prisoner-victim to the highest level of tragic intensity. In the years between 1793 and 1800 he repeatedly painted "realistic" prison and madhouse scenes, treating them as many-figured genre subjects, remotely comparable to Hogarth's *Bedlam*.[52] But in addition to these, he drew and etched in the time of the *Caprichos* (1797–99), and again around 1810/20, powerfully concentrated scenes of imprisonment in which single prisoners are shown oppressed by an unexplained, irresistible persecution, to which they succumb as in an evil dream. The earlier works of this kind (fig. 22) dramatize the prisoners' captivity by the darkness and weight of the surrounding structures.[53] In some of the later compositions, Goya omits all bywork and suggests the compressive weight of the unseen masonry by the tormented stoop of the chained

51. The earlier of these, painted in 1774, is lost, but recorded in a print by Ryder, published in 1786 (fig. 21), the second, painted in 1775/7, is in the Derby Museum and Art Gallery, cf. Nicolson, *Joseph Wright*, p. 242, nos. 216 and 217, pl. 162. Wright also painted other prison subjects, described and in part illustrated by Nicolson, p. 241 ff.

52. The *Courtyard of a Madhouse*, 1794, in the Virginia Meadows Museum, Dallas, based on scenes Goya had witnessed in Saragossa; the well-known *Madhouse*, c. 1800, in the Academy of San Fernando; and the *Interior of a Prison*, of about the same date, in the Bowes Museum, Barnard Castle; cf. Jose Gudiol, *Goya* (Barcelona, 1971), vol. 1, p. 276, no. 343, fig. 485; p. 297, no. 464, fig. 741; and p. 299, no. 470, fig. 755.

53. As, for example in the *Caprichos* 32 and 34, and related drawings; later compositions of this kind are the *Interior of a Prison*, 1819, in the Prado, and *Two Prisoners in Irons*, c. 1820, in the Metropolitan Museum, as well as several drawings in the Journal Album "C" of c. 1810–20, in the Prado. Cf. P. Gassier, *The Drawings of Goya, Sketches, Studies, and Individual Drawings* (New York, 1975), and the same author's *Francisco Goya, The Complete Albums* (New York and Washington, 1973).

prisoners (fig. 23).[54] The humanization of the image of imprisonment here is realized with unsurpassable concision.

If philanthropic rationalists like John Howard looked on prisons as basically useful though imperfect instruments of civilization, ordinary people were both frightened and fascinated by them. This apprehensive curiosity was further stirred by an abundant literature of gothic prison terror, more widely read and therefore more influential than all the writings of the reformers. The taste for the uncanny, mysterious, and subterranean,[55] very common in this period, must have contributed to the vogue for tales of prison torture, live burials, and secret executions, as it certainly sparked the popular interest in archaeological exploration and in delvings into the darker recesses of the mind. The Enlightenment had destroyed many old superstitions, but it had not quite done away with the need for some form of hell. Prison, "l'enfer des vivants," held a sinister fascination to which political liberals and religious traditionalists could respond in their different ways with equally strong feeling. Goya's prison imagery, for all its anticlericalism so reminiscent of Baroque martyrdoms, owes much of its force to this convergence. The iconography of prison in some respects continued religious iconography. It had its own devils, saints, and saviors. When, about 1793–95, George Romney planned a monumental painting of John Howard visiting the prisons[56] (a subject Francis Wheatley had earlier treated as a sentimentally theatrical genre composition[57]), he quite naturally fell back on the traditional scheme of Christ's Descent into Hell (fig. 24).

But prison was a manmade hell; it was possible to destroy it, or to escape from it. Yorick's fumbling attempt to liberate the caged bird in

54. Particularly the three etchings of chained prisoners, *Tan barabara la seguridad, La seguridad del reo no exige tormento,* and *Si es delinquente* P. Gassier and J. Wilson, *The Life and Complete Works of Francisco Goya* (New York, 1971), nos. 986, 988, 990); and some of the figures of prisoners in Journal Album "C".

55. In the work of Joseph Wright, for instance, a fondness for prison subjects ran parallel to an interest in grottoes and caverns that are, in fact, prisonlike landscapes. See Nicolson, *Joseph Wright,* pp. 81 and 256 ff.

56. Inspired by William Hayley's *Ode to Howard* and *Eulogies of Howard, a Vision,* Romney drew a very large number of compositional sketches for a monumental history painting of *Howard Visiting the Prisons* (c. 1790–95), reverting to this subject again and again over a period of time, without actually developing the composition or translating it into the medium of paint. The scattered fragments documenting his obsessive preoccupation with the subject are in the Fitzwilliam Museum (Cambridge), the Yale University Gallery, the Stanford Museum, the British Museum, and many other collections.

57. Wheatley's *Mr. Howard Offering Relief to Prisoners,* exhibited at the Royal Academy in 1788, is in the collection of the Earl of Harrowsby.

the Parisian inn expressed a characteristic readiness to help the impris-
oned. Prison escapes, in life as in literature, met with universal sym-
pathy. Prisoners, plotting escape in the darkness of their cells and pitting
their courage against the brutality of their jailers, were among the
favorite heroes of the time. Much of the literature of prison escape was
fictional, but among its guiding models were the stories of actual escapes,
often told by the heroes themselves. An early example of the kind, the
account of the Abbé Bucquoy's flight from the Bastille, first published in
1715,[58] set the pattern for a thriving production that reached its peak
just before the outbreak of the French Revolution. Casanova's compli-
cated flight from the Piombi (1756) was the talk of Europe long before its
publication in 1788,[59] when it competed with a spate of similar works,
Linguet's mendacious *Memoires sur la Bastille* (1783),[60] Baron von der
Trenck's reminiscences of his long imprisonment and daring escape
attempts (1787),[61] and, most sensational of all, the saga of Henri Masers
de Latude's thirty-five years of incarceration during which he fled once
from the Bastille and twice from the donjon of Vincennes (1787).[62] The
popular sympathy for prisoners and detestation of jails as bastions of
authority made prisons the favorite targets of mob violence in times of
riot. In one of London's most spectacular outbreaks of this kind, the
Gordon riots of 1780, Protestant mobs broke open virtually all the jails
and set fire to the recently finished Newgate Prison. The storming and
subsequent demolition of the Bastille in 1789 was a culminating event of
the most compelling symbolical significance.[63] No other event could so
clearly have signalled the decline of autocratic power.

Surprisingly, the fall of the Bastille inspired few painters and resulted
in no work of art worthy of the occasion, possibly because the essentially
military aspect of the operation made its meaning difficult to express in
visual terms.[64] The moment most pregnant with symbolical possibilities,

58. Anne-Marguerite Petit de Noyer, *L'histoire de l'abbé comte de Bucquoy* (Amsterdam,
1719) (second edition).
59. Giovanni Jacopo Casanova, *Histoire de ma fuite des prisons de la Republique de Venise
qu'on appelle les Plombes* (Leipzig, 1788).
60. Simon Nicholas Henri Linguet, *Mémoires sur la Bastille et sur la détention de l'auteur*
(Dublin, 1783).
61. Friedrich von der Trenck, *Der Gefangene Friedrichs des Grossen*, ed. F. Wencker,
(Dresden, 1922).
62. Henri Masers de Latude, *Le despotisme devoilé* (Amsterdam, 1787).
63. Cf. Victor Brombert, *La prison romantique* (Paris, 1975), p. 46 ff.
64. Charles Thévenin's *Arrestation de M. De Launay, Gouverneur de la Bastille*, Musée

the liberators' descent into the dungeons and the opening of the cells, proved to be anticlimactic, since the Bastille's prisons were nearly empty. The dramatic potential of that episode, however, was to haunt the imagination of artists for decades to come. The final act of *Fidelio* (1805) recalls the event as it might have been, had the Bastille been better stocked, and as late as 1823 Géricault sought to recreate the scene of deliverance in his project for a monumental painting *Opening of the Doors of the Inquisition* (Fig. 25).[65] In the iconography of Romanticism after 1800, the image of prison and prisoner gradually lost its more general, humanitarian, and political significance and came to be applied specifically to the situation of the arts: the prisoner's plight became a favorite metaphor of the isolation or persecution of artists by society. Reminiscent of the way in which Piranesi had converted to highly personal use the obsolete trappings of Baroque imagery, Romantic artists appropriated the outworn image of the prisoner-victim to dramatize their own difficulties.[66]

The fall of the French Academy followed that of the Bastille, by way of slightly parodistic epilogue. From about 1789 the lower ranks of its membership had fretted under the authority and privilege of their officers. The painter Louis David made himself the spokesman of the dissidents, whose aim at first was only to liberalize the Academy to suit their interests, but who were swept by the momentum of revolution into increasingly radical positions. The Academy was discovered to be a form of prison and its teaching a deliberate oppression, a "monkish vengeance" wreaked on young talent. Under David's direction, a revolutionary Commune of the Arts was constituted, to replace the old Academy, that "last refuge of aristocracy." In February 1793 the rooms of the Academy were invaded by a crowd of artists crying "La voila donc renversée, cette bastille academique." On August 8 of that year David delivered the Academy's death sentence from the bar of the National

Carnavalet, exhibited at the Salon of 1795, appears to be the only history painting of some ambition to have been based on the event.

65. Géricault's project concerned an event of the Peninsular wars, but was modelled compositionally after popular images of the opening of the dungeons of the Bastille; cf. the wash drawing by Houet, *Les prisonniers enchaînés delivrés par les patriotes*, Musée Carnavalet, in Ph. Sagnac and J. Robiquet, *La révolution de 1789* (Paris, 1934), p. 125.

66. An example of this later use of prison imagery is Delacroix's recurrent preoccupation with the subject of *Tasso in the Madhouse*. Cf. also Brombert, *La prison romantique*.

Convention: "In the name of humanity . . . let us destroy, let us an-
nihilate those sinister Academies."[67]

At about the same period a young German painter made a precipitous
nocturnal escape from the academy of Stuttgart. Using a rope ladder to
get over the walls, in the dramatic style of Masers de Latude's flight from
the Bastille, Joseph Anton Koch hurried across the French border like a
hunted criminal. The son of peasants who dwelled in a remote Tirolese
valley, Koch exemplified the *type* of natural genius as his period under-
stood it. While tending sheep in the high Alps, he had drawn his first
pictures with charred twigs on the naked rock. His precocious talent
earned him admission to the Hohe Karlsschule in Stuttgart, a princely
academy of art and science run in the manner of a military school.
Koch's untamable spirit rebelled from the start against the school's
mechanical routines and against the slavish obedience demanded of the
students. In a caricature of this academic prison (fig. 26), he represented
himself in the act of defying the director who raises his stick against him.
Above their heads appears a Baroque monster, the embodiment of
antiquated, aristocratic taste, trampling a statue of Apollo; it wields a
thunderbolt and a sign that reads *Penitentiary*. True Art sits weeping at
her easel, threatened by a drill master, while a student languishes in the
stocks. Koch made his nocturnal escape in December 1791. Crossing the
Rhine bridge, in sight of liberty, he cut off his regulation pigtail to mail it
to the Stuttgart Academy. "I felt," he later confided to a friend, "like a
bird that has just flown its cage."[68]

67. J. L. Jules David, *Le peintre Louis David* (Paris, 1880), p. 127 ff.
68. O. R. von Lutterotti, *Joseph Anton Koch* (Berlin, 1940), p. 4 ff.

3

JEAN STAROBINSKI

André Chénier and the
Allegory of Poetry

Youthful Poetry

In one of the poems intended for his *Bucoliques*, Chénier portrays the personified figure of Poetry as she makes her appearance at the banquet of the gods, soon after their victory over the Titans. The poem merits our attention for a number of reasons: for the role that Chénier assigns to Poetry, for the means by which he chooses to shape the image of this youthful divinity, for the nature of the song that Chénier imagines his personified figure as singing. In short, what we can find here is the potential embodiment of a poetics—an emblemized definition as it were of the proper function of poetry:

> Vierge au visage blanc, la jeune Poésie
> En silence attendue au banquet d'ambroisie,
> Vint sur un siège d'or s'asseoir avec les Dieux
> Des fureurs des Titans enfin victorieux.
> La bandelette auguste au front de cette reine
> Pressait les flots errants de ses cheveux d'ébène;
> La ceinture de pourpre ornait son jeune sein.
> L'amiante et la soie en un tissu divin
> Répandaient autour d'elle une robe flottante
> Pure comme l'albâtre et d'or étincelante.
> Creux en profonde coupe un vaste diamant
> Lui porta du nectar le breuvage écumant.

This essay has been translated from the French by William Walling.

Ses belles mains volaient sur la lyre d'ivoire.
Elle leva ses yeux où les transports, la gloire,
Et l'âme et l'harmonie éclataient à la fois,
Et de sa belle bouche exhalant une voix
Plus douce que le miel ou les baisers des Grâces,
Elle dit des vaincus les coupables audaces,
Et les cieux raffermis et sûrs de notre encens,
Et sous l'ardent Etna les traîtres gémissants.[1]

A poem of "antiquity," even a "mythological" one (or perhaps, for Chénier, simply a fragment waiting for insertion in a larger work), the passage reverberates with echoes from Homer, Hesiod, and Ovid,[2] from, that is, all the "banquets of the gods" of literary tradition. Chénier thus puts into play the material that his own age characterized as "fabulous." But we can also see that Chénier is hardly content with the conventional usage that his predecessors had made of this ritual of classical mythology. Rather, he wants to enliven it, to "regenerate" it, to restore to it as much as he can of its original energy.[3] The setting he proposes to us then not only has the effect of projecting the image of "Poetry" into the region of classical myth, it suggests as well the intention of revitalizing inherited themes, now grown stale and repetitious, by evoking the vision of a *"youthful* Poetry" making her appearance at the banquet. Hence the issue becomes fully as much one of repoetizing the classical past as it is one of lending the sanction of a classical past to poetry. Throughout the entire passage, by means of a series of strokes whose effects are demonstrable through literary analysis, we can perceive a sustained effort toward reconciliation: on the one hand, there is the clear underpresence of powerful and violent energies; on the other hand, there is the unmistakable desire to encompass this potential turbulence within the framework

1. *Ouvres complètes de André Chénier*, ed. from mss. by Paul Dimoff, 3 vols. (Paris, n.d.), 1:29–30. I have restored the punctuation of the manuscript, which breaks up the flow of the sentence less. In the edition of the *Oeuvres complètes* appearing in the Pléiade series, under the editorship of Gérard Walter (Paris, 1940), this poem appears on page 3.
2. Thus, although in a different context, the appearance of Calliope evoked by Ovid in book 5 of the *Metamorphoses*, lines 338–40.
3. On this point I refer to my study "André Chénier et la mythe de la régénération," in *Savoir, faire, espérer: les limites de la raison*, a volume appearing on the occasion of the fiftieth anniversary of the School of Philosophic and Religious Sciences and in homage to Monseigneur Henri Van Camp (Brussels, 1976), pp. 578–91. There I analyze the philosophy of history that animated French neoclassicism in the prerevolutionary period.

of a consecrated solemnity, at a level as elevated as any our cultural tradition has yet imagined.

Let us consider only a single aspect of this effort at reconciliation, the one we find reflected in the simultaneous effects of distancing and proximity. As we have already seen, the vision of Poetry is placed far back in a theogonic past, in the context of the mythic near-beginning of an ancient world (the battle of the gods against the Titans); furthermore, the passage conveys to us so many details concerning the attire worn by the allegorized figure that we are probably justified in asking whether the poet, as in other passages inspired by the *Anthologie* or the *Imagines* of Philostratus, is not really offering us the description of a fictitious work of art (a painting, carving, or something similar): a verbal representation, in short, of a figurative one. For the single image Chénier creates for us out of the many representations of youth (Hebe) and of epic poetry (Calliope) seems to be based on a particular figure. Of course it would be difficult to offer absolute proof of this: let us therefore begin prudently by remarking that the narration conveys to us traits which are allied to *ekphrasis*, and which suggest, in the implied movement back from the "real" scene of the passage to one already represented by an earlier artist, a mimetic analogue to the distancing into prehistoric time and mythic dimension we have just glanced at. But one of Chénier's commentators has not hesitated to maintain further that "in his stay at Rome, Chénier surely must have seen Raphael's famous *Poetry* in the Stanza della Segnatura at the Vatican. Her forehead bound with a laurel crown, she is seated on a chair of white marble. A great blue cloak reaches down to her feet."[4] Nevertheless, in response to what we can

4. Gérard Walter, in a note appearing on p. 777 of his edition of *Oeuvres complètes*. There one finds, in *l'Iconologie* of Cesare Ripa, this description of Poetry (*Iconologie . . . enrichie et augmentée d'un grand nombre de Figures avec des moralites, tirées la pluspart de Cesar Ripa*, by J. B. of the French Academy [Amsterdam, 1698], 2 vols. 1:203–05): "She has a face a little enflamed, the pose of a pensive figure; a crown of laurels on her head, her breasts naked and plump, as if they were full of milk; a robe of celestial color all strewn with stars, a lyre in her left hand. . . . One paints her as young and beautiful because there is no man so barbarous nor so insensible who is not charmed by her sweetness and won over by her movements." The same description appears in the article "Poésie" in the *Dictionnaire de la fable* by Noël (1810), who also cites the figure by Raphael. Concerning the interest of the theoreticians of neoclassicism in the *Helicon* of Raphael, see, among others, the English translation and posthumous publication of the notes of Baron d'Hancarville, by Wolstenholme Parr, *Dissertation on the Helicon of Rafael* (Lausanne, 1824). See as well Quatremère de Quincy, *Histoire de la vie et des ouvrages de Raphaël* (Paris, 1824).

then describe as a threefold impulse towards distancing—temporal, mythic, *and* aesthetic—a process of sensuous evocation is also taking place, in the very style of the description, so that the result is a corresponding *transposition to the present* of everything which appears to be relegated to a distant past.

What is this process? In the largest sense it resides in the content of the stated subject (in the choice of objects and of words) and in the very syntax of the verse. Not content with those figures ("of thought" or "of words") which indicate a *noble loftiness* according to a system of traditional signs (for example, the Homeric epithet: "vierge au visage blanc"), Chénier proliferates evocations of *touch* and of *undulation*. The descriptive part proper of the poem (lines 5–13) emphatically evokes the body's contacts with ornamentation, with dress, with a musical instrument: the "bandelette" pressing back the "flots errants" of the hair; the "ceinture" adorning a "jeune sein"; the "robe flottante" spread around the personified Poetry; last of all, her fingers flying across "la lyre d'ivoire" thereby evoking a flourish both light and rapid. Yet as subtle and as fleeting as they seem, these contacts between the body's surface and the objects which that surface touches have all, in varying degrees, a caressing quality about them: undoubtedly they suggest Chénier's plastic attitude towards the idea of "costume." At the same time, to the extent that they are experienced not merely in their visible aspect but in their tactile, epidermal sense as well, these encounters produce in the reader's imagination a palpable heightening of response to the synesthetic appeal wherein the *sinuous* (the visible) and the *caressing* (the tactile) are joined together.[5] The rounded and the undulant are particularly evident in this conjunction, whether in the horizontal form of the bandelette and the ceinture, or in the "flottante" form which characterizes the fall of the hair or that of the robe, or even in the explicit mention of the *creux*—the very hollowness—of the "profonde coupe."

The description, then, tends to combine what the aesthetic notions of the period designated as the grand and the elegant styles: the solemnization granted by the antique, mythic quality of the setting, and the succession of sensual occurrences that, in the immediate moment of

5. That Chénier deliberately pursued the tender, caressing effect is shown beyond question by his rough drafts where, before he had found the word he was looking for, he qualified it in advance by revealing his intention that it *would* be "caressing." Thus, in *Oeuvres complètes*, 1:4 (Dimoff), this sketch of an invocation: "Viens, ma . . . épith. caress . . . ma . . . Muse."

pleasure (or of desire), expand into a self-contained reality. Moreover, this fusion of styles is intensified by the manner in which Chénier either combines or juxtaposes images of *minerality* and *fluidity*. The technique of solemnization, for example, resorts largely to hard and precious materials (gold, ebony, alabaster, diamond); from this it extends to the enriching qualifiers that further define the fluid or supple substances (the girdle is "de pourpre"; the "breuvage écumant" is nothing less than "nectar"). But it is not simply contact or intimate contiguity between the hard and the fluid (for example, between the diamond cup and the foaming beverage); we can also sense the fluid substances becoming hard themselves: an implicit solidification takes place when the "cheveux" are said to be of "ébène," or when the "robe flottante" assumes the attributes of "albâtre" and becomes of glistening gold ("or étincelante"). Woven together, the amianthus and the silk ("l'amiante et la soie") that make up Poetry's garment unite into a fused splendor, the product of a living process joined with that of a mineral substance. As in so many other poems of Chénier's, the text finally makes us hesitate between two impressions: is it a question of a hard substance "softened" and endowed with the illusion of suppleness by the work of the chisel? Or, on the contrary, is it living flesh that has taken on a firmness and a grandeur no longer entirely alive? Without attempting to insist on a final, incontrovertible reading, I do call attention to the poem's flexible syntax, to its noticeably light punctuation, to its fluid and sinuous movement, all of which coexist with a pattern of "noble" materials and of "elevated" figures so separated from "common" language that this latter pattern inevitably evokes the counterpoise of a monumental and even *lapidary* effect.

Poetry appears during the course of a banquet celebrating the triumph of the Olympian gods in battle. The *moment* of Poetry is therefore situated at the point when the forces of evil have been conquered and the harmony of the world reestablished: Poetry comes to consecrate a peace and a moral order assured for the first time. But note that what she sings is of a time of disorder, of the struggle that preceded the banquet—of the revolt of the Titans, their defeat, their punishment. Her song, in short, recapitulates the violence of battle.

It is easy to understand why Chénier should attribute these contents to the song he has Poetry sing. The Muses are the daughters of Memory.

And from this it follows that a figure who bears so much resemblance to Calliope should choose as her theme the epic struggle between the gods and the Titans, thereby offering the triumphant gods the opportunity to relish still again, in a distilled form, the joy of their victory. The combat mentioned at the opening of the passage as a recent *event* thereby assumes, by the close, the semblance of a *work of art*, given shape by the utterance of a sublime mouth. We participate in an aesthetic transformation that raises to the level of art material which, a few lines earlier, was only naked violence and bloody struggle. In the song of recollection that Poetry sings the battle is placed firmly at a distance. And, coming from the pen of Chénier, the poem we read suggests in turn a still further distancing by establishing a point of view of the banquet scene which resembles that of a final *witness*. Primitive violence is thus evoked at the farthest end of an aesthetic reflex that repels, attenuates, and softens the fury of a mythic and brutal struggle. When the poem begins, the battle already belongs to the past, the triumph of the gods has already been assured, and their subdued opponents are named only at the subordinate level of syntax, in a final apposition to the first sentence ("des fureurs des Titans enfin victorieux"), a sentence one could easily show to be arranged according to a regressive temporal sequence (the appearance of poetry, the banquet, the Titans). Near the end of the poem, to be sure, a more explicit mention is made of the "coupable audaces," but it is an indirect mention, the poet putting the phrase in the "belle bouche" of Poetry and imposing upon the episode of revolt the swift concluding rhythm of a series of nominal complements to the verb *dire* in which the favorable outcome ("cieux raffermis . . . traîtres gémissants") is immediately reemphasized. The conflict is resolved, all opposition has been surmounted, and our attention is now set free to trace out, seductive in spite of her allegorical quality, the envisioned feminine figure as she carries to its highest pitch the joy of the conquerers. The disappearance of the Titans and of their violence has left a clear space for the undulant, orelike image of an "être de beauté."

This triumphant feast, then, finds its apogee in the implicit evocation of an epic poem. Already, personified Poetry has something about her of a bas-relief or of a painted figure, and the passage culminates in a "poem within a poem"—a brief song implying an earlier, grander Song. It is surely here that we find a characteristic trait of Chénier's imagination. Among his projects other banquet scenes are represented which are

equally given their culminating point in poetic performances—more precisely, in songs celebrating art objects—chiseled cups portraying mythological scenes, chalices molded on the bosom of the loved one, etc.[6] The poet, in representing the serene joy of the banquet, introduces there the suggestion of a more-than-verbal description (ekphrasis) of a finished event—and this suggestion of a "second" representation gradually becomes itself an art object placed before us for our admiring contemplation.

The Triumphant Alcaeus

At the end of the fragmentary *République des lettres*, Chénier meditates upon the political power of poets. He names in succession Tyrtaeus, Aeschylus, Alcaeus. All three knew how to leave their "sweet repose" when danger threatened their country's liberty. And after they proved victorious, they took their lyres up again to sing of the wars of liberation. The example of Alcaeus, placed at the very end of the fragment, is the most revealing:

> Les tyrans sont vainqueurs; leur audace hautaine
> Va sous des jougs de fer accabler Mitylène.
> Que fais-tu, fier Alcée? Elle attend ton secours.
> Il a vu sa détresse; il quitte ses amours,
> Ses Muses, et ses bois, et ses fraîches Naïades;
> Son bras secoue au loin le thyrse des Ménades.
> Le bouclier, l'épée, et la lance, et le dard,
> Eclatent dans ses mains et servent d'étendard.
> Déjà tout est vaincu; déjà la tyrannie
> Sous un glaive pieux meurt honteuse et punie.
> Tout trempé de sueurs et tout poudreux encor,
> Couvert de Son armure, il prend sa lyre d'or.
> Il dit ces fiers Titans, leurs fureurs

6. Among Chénier's projects, we should recall the one of the "repas dan une grotte ou chacun chantera ce qu'il a sur son vase" (*Oeuvres complètes*, ed. Dimoff, I, 256). Writing of his project in greater detail, Chénier alluded to carvings depicting the abduction of Europa or the loves of Pasiphaë: works of art that depict scenes of animal passion, divinized and transfigured (*Oeuvres complètes*, ed. Dimoff, 1:251). Chénier also composes separate "scenes" dealing with Europa and Pasiphaë. On *ekphrasis*, see the chapter devoted to the "Ode on a Grecian Urn" in Leo Spitzer, *Essays on English and American Literature*, ed. Anna Hatcher (Princeton, 1962).

Les meurtres, le carnage et les morts glorieuses,
Aux citoyens tombés les justes cieux ouverts,
Et l'ardent Phlégéton devorant les pervers;
Et l'avenir fameux promis à la vaillance.
On se presse, on accourt. Tout Lesbos en silence
Admire son génie égal à sa vertu
Et l'écoute chanter comme il a combattu.[7]

In the poem that dealt with the banquet of the gods we noted three stages in the temporal sequence; here we encounter them again, but this time on a human scale: (1) intrusion of evil and violent combat; (2) victory and unanimous rejoicing; (3) a poetic flight into song that celebrates the recent struggle, represents its pattern in terms of the mythic war against the Titans, announces the eternal reward reserved for heroes and the certain punishment of evildoers. As distinct from allegorized Poetry (who appeared in the role of traditional epic poet), the Alcaeus conceived by Chénier is himself one of the combatants; he is the savior of his country, and, at the moment of triumph, he is the central figure, absorbing into his single person the roles which previously were assigned, in separate fashion, to the victorious gods and to the bardic singer of the triumphal song. Listened to and acclaimed by an entire people, Alcaeus is at once the originator of a new civic order and the harmonious "genius" who, safeguarding the memory of the battle of liberation, charms the multitude by celebrating a cosmic order that provides confirmation of the moral law. Justice, reestablished by the force of arms, becomes word and song, and thereby achieves its highest manifestation. "Jeune Poésie," we know, had come to adorn a divine celebration; now, the human celebration arranges itself around the poet, who himself assumes the twofold dignity of heroic liberator and prophetic voice, disclosing in his second role the great truths concerning the ultimate destiny of "citoyens" and of "pervers." (Note how Chénier politicizes moral categories, assimilating the good to civic involvement.) The poet appears as the legitimate holder of power because he is capable both of striking down tyrants *and* of uttering the founding words of a new order—words which are themselves the melodious recollection of the battle for justice against violence and evil, and which therefore, by recapitulating the recent victory, make even clearer the eternal order of

7. *Oeuvres complètes*, ed. Dimoff, 2:234–35; ed. G. Walter, pp. 470–71.

things. In this light, the aesthetic distancing here is not at all less pro-
nounced than in the Olympian scene. The battle becomes the subject
matter for a song. And if we take account of the poet who is holding the
pen, we are obliged to say that Chénier sings of a poet who, temporarily
abandoning poetry for the sword, becomes a victorious hero, then reas-
sumes "sa lyre d'or" in order to sing of his own struggle. In setting this
entire scene in a remote classical landscape, Chénier is able to meditate
lyrically on the ideal function of the poet—by showing him capable of
fighting for liberty and then of reflecting that victory in the universality
of song and of law. The premise for this transformation of violence into
an object of beauty (song, sculpture, carving) operates within the present
text very much as it does in the earlier passage. Closely allied to the
optimistic faith that was the heritage of the Enlightenment, the premise
is one that anticipates the inevitable defeat of tyrants and the forces of
darkness; and it is the poet who is expected to realize in his own fate this
twofold accomplishment, rewarded by the acclamation of the entire
community. The readiness to encounter danger, and the no lesser bold-
ness to envision truth, are the privileges of "genius," and in human
language they translate themselves into ethical superiority and aesthetic
distance. To speak poetically of the law which has prevailed against the
Titans and the tyrants is to reveal the power that can establish the
authority of the poet above his fellow citizens, especially if they recognize
in him the hero who has taken active part in the military struggle itself.
Chénier makes Alcaeus the central figure of the city, without whom it
would remain enslaved and ignorant of its own existence. Beginning
from classical material, and in a prerevolutionary imaginative context,[8]
we can see one of the modern myths of the poet and of Poetry taking
shape in outlines as elegant and as insubstantial as those of a purely
linear drawing.

The Well-received Poet

Chénier's long bucolic poem *L'Aveugle* deserves to be read as an even
more fully developed myth of the central function of the Poet.

Readers have generally chosen to see in this work, one of Chénier's

8. On this point, one should consult the important work of Paul Bénichou, *Le Sacre de
l'ecrivain, 1750–1830* (Paris, 1973), especially the first chapter, entitled "En quête d'un
sacerdoce laïque," pp. 24–77.

most "accomplished," only its idyllic element: three young shepherds welcome and then revive an old blind man, abandoned on the shore of Syros by brutal sailors; this old man, immediately recognized by the reader, shows his gratitude in a song which tells of the origins of the world, then of the wars of classical mythology. A crowd runs up to surround and acclaim him: he is Homer who, among just and sensitive men, has finally found his true homeland (see fig. 27).[9]

The opening of the poem, to be sure, develops an account of a warm welcome modeled on classical scenes of hospitality, but now the welcome is imbued with a rather affected sentimentality characteristic of the prerevolutionary fondness for displays of "benevolence": clearly the effect of pity is being sought. Much the same occurs in several other bucolic poems constructed around scenarios where misunderstandings and misrecognitions end by being resolved: everything culminates in reconciliation, joyous acceptance, reestablished harmony.

What we must recognize, however, is that the moving depiction of Homer's warm reception is inserted between two moments of violence: an unjust violence endured by the blind poet aboard the ship, and a righteous violence, situated in the mythic past, which Homer offers as the final subject of his song. And what we should recognize even further is that the transformation of the Poet into "hero"—as the principal figure in an idyllic poem—is a *modern* fact, despite the classical coloring that pervades *L'Aveugle*. The ancient world had its "biographies" of Homer, of course (such as the pseudo-Herodotus's), but never to my knowledge had Homer himself been chosen for the hero of an extended composition. In Chénier's idyllic poem, Homer enters as if issuing from Poetry herself, the embodiment of her earliest manifestation. At the level of significant meaning, then, this reconstruction of a striking episode in the life of the first poet scarcely differs from the process which portrayed "jeune Poésie" in Olympus: both suggest Chénier's attempt to come closer to the world's own youth, whether by giving shape to the essence of Poetry or by envisioning the appearance of the unsurpassable first poet—unsurpassable precisely because he remains so close to the origins

9. This long poem (*Oeuvres complètes*, ed. Dimoff, 1:65–74; ed. G. Walter, pp. 42–48) has had a celebrated history in France. It inspired Corot's heroic pastoral *Homère et les bergers*, 1845 (Musée municipal de Saint-Lô), a painting which, in its own dignity and grace, complements a serene and harmonious view of the hospitality given to the poet by the three shepherds.

of poetry. And this nostalgic gaze towards a world ideally and historically "first"—towards, in short, a lost poetry—characterizes an age which was conscious of its own creative inferiority and wanted to transcend it. Out of this neoclassic regret, in fact, along with the self-generated reaction to it, was born that romantic and modern affirmation in which the *imagination* itself becomes the very origin at the heart of all of us, here and now.

Beyond doubt, the initial violence suffered by the blind poet is characterized as arising from economic and social injustice. Cast ashore by greedy merchants who had demanded from him the price of his crossing either in silver or in frivolous entertainment, the poet, who is too poor to pay the requested sum, is equally too proud to debase his art. The anachronism is evident; the base treatment inflicted upon Homer corresponds to the image Chénier presents of the degraded condition of the poet in the society of his own time. Thus in the fragmentary *La République des lettres*[10] (although the indictment there is presented wholly in terms of the contemporary world) we encounter the same anger against wealthy people, indifferent to the poverty of the poet unless they can enslave him to their own amusements.

The naive welcome of the tenderhearted shepherds erases this sense of humiliation and reestablishes human bonds. The atonement for past evil finds expression first in the elementary communion symbolized by the simple fare: bread, olives, almonds, cheese, "figues mielleuse"— foods too sensual to correspond to the *species* of the Christian communion.

In this atmosphere of a new-found homeland where confidence has been restored, a song bursts forth, and this song quickly gives birth to a collective celebration. For not only has the poet's exile been effaced, solitude itself is deprived of its scattered individuals as even supernatural creatures (nymphs and sylvans) gather around Homer. The truly poetic song is shown to be capable of effecting the *fusion* of the social unit, at the same time that it achieves a spontaneous reconciliation between the forces of nature and those of human civilization. As with all songs of origin, this one turns back to a primordial time, to the beginnings of the world ("Commençons par les Dieux" [line 143]); then it evokes legendary wars and mythic adventures. In an earlier version, the narration by

10. *Oeuvres complètes*, ed. Dimoff, 2:207–40; ed. G. Walter, pp. 456–77. See also the text in prose edited under the title *Essai sur les causes et les effets de la perfection et de la décadence des lettres et des arts*, pp. 590–649 in the G. Walter edition.

Homer was reported in an indirect style and ended in lines that serenely celebrated the powers of forgetfulness found in certain hypnotic herbs (in a direct reminiscence of the *Odyssey*):

> Ensuite, avec le vin, il versait aux héros
> Le puissant népenthès, oubli de tous les maux;
> Il cueillait le moly, fleur qui rend l'homme sage;
> Du paisable lotos il melait le breuvage.
> Les mortels oubliaient, à ce philtre charmés,
> Et la douce patrie et les parents aimés.
>
> [lines 208–12]

But Chénier seems to have felt that the song attributed to the blind man could not end satisfactorily in so calm and placid a fashion. Making use of a piece imitated from Ovid[11] that he had first composed independently, he now has the song culminate in a battle scene of extreme violence. The song Homer sings thus ceases to be an indirect report; it becomes a direct narrative account, with an abundance of brutal details, of the murderous fight between the Centaurs and the Lapiths. Once more the outbreak of violence sets into fierce engagement an evil force, an obscure animal passion, and retributive heroes. Theseus's victory, known in advance, has no need to be mentioned: what prevails is the image of disorder and tumult. The tense of the narration, which here takes on an epic dimension, is the present: the poet's intention, through the speech of his hero-poet, is to give as much aesthetic clarity as possible to a scene near the beginning of time. The extraordinarily distant past (in terms of historical chronology) becomes, in the song, an illusory present which actualizes the completed violence. But this present is the artifice which results from a series of distancings: the learned and studious writing of the neoclassic poet puts into the mouth of the first of poets the scene where the monstrous Centaurs—representing desire in its elemental form—are monstrously destroyed.

Then the unanimous acclamation breaks out: "Come live on our Island." Together, as one man, his audience has perceived the aesthetic and politico-moral "message"; they give proof of it by attributing to Homer the twofold qualifier of "aveugle *harmonieux*" and of "prophète *éloquent*" (line 267). The epilogue of the poem reverses, through its scene

11. *Metamorphoses* 12.210 ff.

of universal recognition, the unjust rejection that the merchants had inflicted on Homer. The idyllic welcome of the three shepherds has become the civic welcome of an entire population. Named finally in the last line—in a place which corresponds to a final major chord of music— the poet finds himself granted the highest authority among men. In this "happy isle" (line 129) which circumscribes, at the heart of an idealized past, an even more highly idealized and sheltered space, the dream of the triumphal advent of the poet takes on the form of an achieved event. It is the romantic theme of the poet's "mission" which receives affirmation here (as in the episode of Alcaeus we discussed earlier), an affirmation pervaded now with images from the springtime of the art that blossomed in Greece during her earliest period. From a moving representation of the past, our imagination is led to envision an imminent future, both for poetry and for the city of men.

The Return of Darkness

All three texts we have discussed so far have been characterized, in their respective fashions, by the central role played either by Poetry or by poets; and all three have culminated in the act of song—that is to say in a work of art (or the image of a work of art) inserted in the poem itself. Further, we have seen that the contents of this "poem within a poem" have been an account of violence (in an elevated, "epic" style), and that the account of violence suggests the *aestheticized* return of a violent struggle experienced by the audience (the gods) or by the poets themselves (Alcaeus, Homer). It scarcely matters whether the "poem within a poem" is an exact verbal representation of earlier events: Homer, in *L'Aveugle*, first describes the violence he has himself endured, but *sings* about the violence that burst forth in the mythic past. What especially deserves our attention here is that tripartite structure in which elemental brutality, after having been subdued, reappears as the theme of the "poem within the poem." The moment of violence is recalled, but within the context of a *form* which guarantees an ultimate harmony, and which, like the Hegelian notion of synthesis, preserves as it transcends.

Up to now we have been insisting particularly upon the effect of distancing. Transformed into an *object* within the song, violence is rendered inoffensive, even exorcised. No longer menaced by it, we are entirely free to experience a sense of the sublime, relishing it in security.

But the inverse (and correlative) aspect deserves to be emphasized at least as much. For the serene and happy tranquility—achieved by a benevolent welcome, an atonement for past injustice, and the destruction of a monstrous evil—can hardly be realized without art running the risk of a loss of energy and intensity. Chénier, who knew and admired the thought of Winckelmann, still sensed the danger that threatened art when it attempted to conform to the ideal of harmonious repose and noble inexpressiveness. If he happened to share with Winckelmann (although he was a good deal less spiritual and neoplatonic about it, tempering his views with a sensuality less hypocritical) the taste for pure forms and for a *design* which rejects obscurities, he understood, along with the best artists of his time, that art courts pallidness and insignificance if it insists on repressing the mysterious.[12] Thus, when the "poem within the poem" appears, violence can occur in it as a "return of the repressed," under conditions of aesthetic play that attenuate any threat. Indeed, the *aggressive forces* are now able to burst forth more freely precisely because they are contained within the framework of a constructed poem and are therefore separated from life. Of course, for the sake of the general effect, they must remain active and seemingly capable of destroying the human order established against them: the "poem within the poem," which tells of their defeat, preserves them in an aesthetic present, in order to better celebrate the triumph of serene justice.

The ode concerning the so-called Tennis-Court oath, Chénier's *Jeu de paume*, suggests the idea of regeneration—even of resuscitated life—for a recent historical event, very much as the poem evokes in its own turn the "jeune et divine Poésie."[13] Calling upon David to take his paint brushes in hand once more, the poem proposes the original occurrence of the oath as the subject for a painting, that is to say, for a "work of art within a work of art." To be sure, Chénier does not describe a finished picture; rather, he merely sets forth the plan for one. All the same, it remains true that the entire development of the ode puts into perspec-

12. In order to break up the lethargy of delineated figures, Flaxman often has them engage in battle and in aggressive gestures. Canova does as much with his idealized heroes; he brings them in juxtaposition with death, or he represents them in the paroxysm of fury. Concerning the "retour de l'ombre," I refer the reader to my *1789: Les Emblèmes de la raison* (Paris, 1973).

13. *Oeuvres complètes*, ed. Dimoff, 3:230; ed. G. Walter, p. 167.

tive the historic event so that it can take shape as a grand *image*. And this image, like those earlier ones of the Olympian banquet, the triumphant Alcaeus, and the struggle of the Lapiths with the Centaurs, is portrayed as the dawning of liberty, triumphant over tyrants and darkness: "La tyrannie . . . sous son pied faible sent fuir la terre, et meurt" (lines 204–08); "l'enfer de la Bastille, à tous les vents jeté, vole" (lines 213–14); "et de ces grands tombeaux, la belle Liberté, altière, étincelante, armée, sort" (lines 215–17). But Liberty, allegorized in its turn, is only a derivative figure—or, more accurately, a fraternal double of "jeune et divine Poésie." To follow the somewhat contradictory images of the second stanza, Liberty goes out and "vole" from the "lèvres seduisantes" of Poetry; or she successfully "arme" the "fraternal secours" of the latter figure, "pour dissoudre en secret nos entraves pesantes" (lines 38–39). We can easily recognize in this Poetry of liberation, and in this Liberty propagated by art, the dream of the social centrality of the poet, a dream which appeared to us so clearly in the examples of Alcaeus and Homer. And the atmosphere of the unanimous celebration in the ode of the *Jeu de paume* substantiates still further these correspondences. Nevertheless, under the constraint of an aesthetic and politico-moral necessity of the time, Chénier concludes his ode by warning his fellow citizens against the resumption of violence. And, this time, it is no longer the issue of a "work of art within a work of art," or of a violence represented by an image, but of a real danger present in actual history. Indeed, the ode, which began in a rush of triumphal jubilation, takes on, beginning with its fifteenth stanza (there are, in all, twenty-two), the tone of a most solemn concern for the future. Chénier fears the stubborn persistence of evil. Thus, having celebrated the collapse of gloom-ridden dungeons and the triumphant entrance of light, he is still aware of an increasing internal danger, menacing to all free men:

> Ne craignez plus que vous . . .
>
>
> Trop de désirs naissent de trop de force.
> Qui peut tout pourra tout vouloir.
>
> [lines 277, 284–85]

He fears, in short, that the people will be led to "venger la raison par des crimes" (line 311), and that, now sovereign, they may allow themselves to be swayed by the eloquence of "orateurs bourreaux" (line 315). The

kinglike people, like the monarchs of old, will be seduced by "flatteurs" (line 336); they will then become a new kind of oppressor. But "l'oppresseur n'est jamais libre" (line 335). Violence is thus capable of being reborn in the heart of the victorious third estate. Moreover, elsewhere the forces of old have not been conclusively disarmed: "Le fanatisme se relève" (line 370). The kings, at the frontiers of France, have still not heard the voice of Reason; they have still not awakened to the light. Chénier addresses them: "Ouvrez les yeux: hâtez-vous" (line 394). "Apprenez la justice" (line 407). Chénier echoes here, solemnly, the note that Virgil caused to be heard in the depths of Hell: *Discite justitiam moniti*.[14] Confronted with the imminence of a twofold return of darkness—in the revolutionary camp and in the monarchical—Chénier elevates the tone of his ode so as to give a universal lesson of political morality. Ultimately, the final words of the ode direct themselves against the monarchical tyranny on the frontiers, announcing the victorious march, across Europe, of the "Liberté legislatrice," of the "sainte Liberté fille du sol français." She "va parcourir la Terre en arbitre suprême" (lines 411–14). This threat addressed to the kings ("Tremblez . . ." [line 415]), this prophecy of the wars of liberation and of a time of judgment for monarchs, appears as a kind of prophetic flight of its own from the terrible internal struggles to come, with darkness winning across every part of France. For the light brought by revolution *is* precarious. The violence which returns is now directed towards this external war, as if in an attempt to renovate, by the promised defeat of enemy kings, the moment of triumph which was earlier thought decisive in the taking of the Bastille. In this sense, we can say that the quasi-mythic battle, celebrated by the dawn of the Fourteenth of July (at a distance of two years) in the opening of the ode, appears at the end of the poem as a struggle that has to be begun once more, but this time beyond the frontiers. Violence *returns*, not in the achieved form of a past violence, final, primordial, but as the announcement of an imminent war, destined to bring to completion a work of justice yet unachieved in all of its potential plenitude. "[La liberté] entendra le peuple et les sceptres d'airain / Disparaîtront, reduits en poudre."[15]

The irony of history, we know, was that the return of darkness oc-

14. *Aeneid* 6.620.
15. These lines (424–25) are the last in the ode.

curred among those who had initially celebrated a victory over darkness—a victory they themselves had believed to be conclusive. Violence, under its Jacobin form, made its reappearance not as an aestheticized commemoration of a primordial event, but as the desire to suppress, within the camp of the victors themselves, a malfeasance obstinately reborn. What poetry had imagined as the beginning reign of an authority at last legitimized—of an authority inseparable from poetry herself—takes on the form of a new confrontation, wherein the victor discovered in his own ranks the opponent against whom the mythic struggle would renew itself. André Chénier, who had sung with such fervor of the advent of the "première revolution," found himself rejected by the new masters of the nation, obliquely designated as an evil opponent, and condemned to death for his presumed complicity with the kings that he had himself stigmatized.[16]

The Evicted Poet

What we could consider here as a tragic episode (in the kind of struggle between factions that subsequent revolutions have made all-too-familiar) has the decisive effect above all in Chénier's mind of destroying the dream of the poet at the center of communal celebration and at the origin of regenerated institutions. The poet, dealt with now as an opponent, is brutally dispossessed of the prerogatives—both old and new—that he believed he had achieved. In his eyes, power is again usurped by tyrants, and if there exists an official art (of such a sort that its product now leads Chénier into calling David "stupide"[17]), it is hardly the art of a creative *originator* but rather a simple instrument in the hands of new masters.

In truth, this reduction of the role of artists (who had believed themselves to be legislators) to the rank of simple servants of the collective will Robespierre affirmed vigorously in the name of the highest equality among citizens. But actually he did so in order to place himself at the center of the communal celebration and to assign to political eloquence—as embodied in his own person—the orphic centrality that Chénier had laid claim to—certainly before the Revolution—for the poet

16. For the exact circumstance of the arrest, the trial, and the execution, see Jean Fabre, *Chénier* (Paris, 1965) and Francis Scarfe, *André Chénier* (Oxford, 1965).
17. *Oeuvres complètes*, ed. Dimoff, 3:250; ed. G. Walter, p. 542.

and for poetry. Let us note these lines from Robespierre's *Discours* of the 18 *floréal* of year II:

> L'homme est le plus grand objet qui soit dans la nature, et le plus magnifique de tous les spectacles, c'est celui d'un grand peuple assemblé. On ne parle jamais sans enthousiasme des fêtes nationales de la Grèce; cependant elles n'avaient guère pour objet que des jeux où brillaient la force du corps, l'adresse, ou tout au plus le talent des poètes et des orateurs. Mais la Grèce était là; on voyait un spectacle plus grand que les jeux, c'étaient les spectateurs eux-mêmes. . . .[18]

It is to Rousseau that Robespierre owes this idea of the reciprocity of minds and the transparency of hearts, both the substance and the only object of a collective celebration. And if it is true that there have to be "des hymnes et des chants civiques,"[19] composed by the "Tyrtée de la Révolution,"[20] Robespierre hardly wishes that the poets-prophets be at the center of the festival. In truth, although Robespierre proclaims the principle of equality for all participants, as a political man he assigns to himself the role of chief celebrant, of eloquent priest. For him—and Robespierre is convinced of it—his own proper place is to occupy the incandescent center of the celebration (precisely as we know what role he played, a few days before his downfall, at the Fête de L'Etre Suprême).

In the neoclassic dream of the past, the *name* of Homer was acclaimed by an entire people, in an enthusiastic outburst that literally *divinized* the artist:

> Viens, prophete eloquent, aveugle harmonieux,
> Convive du nectar, disciple aime des Dieux;
> Des jeux, tous les cinq ans, rendront saint et prospère
> Le jour où nous avons reçu le grand HOMÈRE.[21]

In the *Iambes* that Chénier composed at Saint Lazare, the act of *naming* is

18. My source for this passage is *Discours et rapports à la Convention* (Paris, 10/18: 1965), p. 276. See also A. Aulard, *Le Culte de la Raison et le culte de l'Etre Suprème, 1793–1794* (Paris, 1909); Mona Ozouf, *La Fête révolutionnaire, 1789–1799* (Paris, 1976).

19. *Discours*, p. 285.

20. The formula, applied to Gossec, is cited by Julien Tiersot in *Les Fêtes et les chants de la révolution française* (Paris, 1908), p. 104.

21. This is the triumphal conclusion to *l'Aveugle*, where atonement is made for all the poet's earlier humiliations.

again mentioned, but in an altogether different sense; now it is a question of *l'appel nominal*[22] which indicates, day by day, who are the figures condemned to climb into the fatal cart. A complete inversion of the human qualities imagined in the heroic idyll has taken place, as this juxtaposition of texts will show. Homer sings, and the crowd runs up:

> Et pâtres oubliant leur troupeau délaissé
> Et voyageurs quittant leur chemin commencé
> Couraient . . .
>
>
>
> Et Nymphes et Sylvains sortaient pour l'admirer,
> Et *l'écoutaient* en foule, et n'osaient respirer.[23]

In the prison, another kind of audience *listens* to another kind of voice:

> Et sur les gonds de fer soudain les portes crient.
> Des juges tigres nos seigneurs
> Le pourvoyeur paraît. Quelle sera la proie
> Que la hache appelle aujourd'hui?
> Chacun frissonne, *écoute*; et chacun avec joie
> Voit que ce n'est pas encore lui.[24]

The general act of listening is no longer directed towards a voice which joins people together, but towards a voice which separates them from one another, which accentuates their sense of solitude, which destroys the solidarity of captives as a group, reviving, in each, the concern for his own personal safety. And the voice that *bears authority* is that of the "pourvoyeur," not of the poet.

And the poet, lost among the prisoners, unknown, disregarded, composes for himself alone, and for the sake of a distant posterity, verse to which he entrusts his "vengeance." Once again Chénier has taken his model from the classical world—from Archilochus in this case; he intends to "nouer le triple fouet,"[25] he hopes to "attendrir l'histoire." But he composes in secret and in silence. He has his manuscripts circulated in a clandestine fashion, on strips of paper, along with his dirty linen. The situation of the poet now is one of subjective withdrawal. His work is

22. *Oeuvres complètes*, ed. Dimoff, 3:265, line 40: ed. G. Walter, p. 188.
23. *L'Aveugle*, lines 150–56.
24. *Oeuvres complètes*, ed. Dimoff, 3:276, lines 15–20; ed. G. Walter, p. 193.
25. *Oeuvres complètes*, ed. Dimoff, 3:279, line 83; ed. G. Walter, p. 195.

condemned to incompletion, to fragmentation; it exists neither for his companions in captivity nor, of course, for the one who, in coming *to name* Chénier for the scaffold, will "suspend" the solitary work:

> . . . Peut-être en ces murs effrayés
> Le messager de mort, noir recruteur des ombres,
> Escorte d'infâmes soldats,
> Ebranlant *de mon nom* ces longs corridors sombres,
> Où seul dans la foule à grands pas
> J'erre, aiguisant ces dards persécuteurs du crime,
> Du juste trop faibles soutiens,
> Sur mes lèvres soudain va suspendre la rime.[26]

Designated for execution, interrupted in the secret composition of his poem of vengeance, the poet suffers, in inverse proportion to his earlier dream of centrality, a radical decentralization. In a present that rejects the ideal of the poet-legislator, Chénier, describing his own situation, defines his place: the "longs corridors sombres." It is the absolute reversal of the open space, the luminous skies, under which, "les rameaux à la main," the crowd gathered together for a communal celebration, transported by the song of the poet. To be sure, Chénier is not the first to have suffered captivity and death. Socrates and Boethius are paradigms from the distant past whose memories are still with us. But their destiny could be interpreted, in the eighteenth century, in the simple terms of a combat between light and darkness—in terms, that is, of the characteristic optimism of the Enlightenment, whose philosophers were convinced that once the obstacles of fanaticism and tyranny were overturned, the perpetual reign of day was assured. Rousseau alone, demurring from this overconfident optimism, had experienced within his own fantasies the solitary anguish of being rejected by a universal conspiracy of evildoers, after having first imaginatively projected himself into the role of benevolent legislator, surrounded by the jubilation of a reconciled community. Less an innovator and less audacious in the nature of his thought, Chénier lived out this reversal in the reality of history. He has therefore come to symbolize the impotence of the poet faced with the arbitrariness of power. Placed by Vigny in *Stello* (1832) on the same footing as Gilbert and Chatterton (who had suffered and perished under

26. *Oeuvres complètes*, ed. Dimoff, 3:276–77, lines 12–19; ed. G. Walter, p. 193.

absolute monarchy and parliamentary monarchy), Chénier, a Chénier to be sure largely romanticized, came to represent self-evident proof that revolutionary regimes do not improve the poet's lot. But whatever the *political* lesson that one pretends to derive from the destiny of Chénier (and there is still no lack of partisans on either side in a France where, between adversaries and supporters of the Revolution, the religious wars of the past have continued unabated), what we ought to note above all is the distance that separates the two *situations of poetry* which Chénier exemplified in his imagination and in his life: the triumphal situation, where the voice of the poet-soldier or the poet-prophet gives voice to the authority that the entire community will make use of; and the situation of incarceration, where even the possibility of composing and of being read becomes problematic, and where the *self* can make use in solitude only of the authority it discovers within itself, in the hope of a justice which will be granted to it, beyond humiliation and death, by other generations. In this "final" poetry, it is no longer a question of reanimating, for a "regenerated" people, the great images of an original harmony, but of confronting the worst obstacles—solitude, death, the hostility of the powerful—while continuing the attempt of making prevail what is most fragile: the interior murmur of revolt, the poor clandestine scrawlings, the hope that the future will reveal the hidden force of language and will confer on the poet the *second life* to which he has a right. The situation of the prisoner, sustained by the conviction of his innocence, lodging an appeal in the name of the *infinite* worth of his own conscience, has the effect of introducing, at the very last moment, the dimension of a hoped-for future, in a body of work that for so long had imagined the happiness of men as the fulfillment of a nostalgic longing, in the form of a resuscitated past. For it is precisely the future (even if formulated through a diction "antiquated" in style) that becomes the only imaginable recourse, once consciousness has perceived itself to be deprived of any refuge in the past and of all welcome in the present. And in this identification with the future, what matters is no longer the advent of *allegorized* poetry, but (in spite of all the inherited literary figures and all the latent allegories) the *tautégoric* survival of the self—the chance to exist in person and as a person in the consciousness of a new generation. Then a poetry arises that is no longer the "enlightened" poetry which—in naive hope—had placed the blame on despotic authority and the dark will to evil, symbols of a chaos not yet entirely subdued.

It is now an ill-omened poetry that perceives darkness reborn among those who had believed themselves to be carriers of light, and injustice increase even in the heart of righteous angers. It is now poetry that knows she can only base her legitimacy on a law not made use of by the holders of power. The one resource left is in the movement of language that conveys to the posthumous reader the actuality of suffering. And it is here (rather than in the musicality and "softness" that captivated Balzac and Sainte-Beuve) that the romantic aspect—as well as the modernity—of Chénier's work appears. Poetry, in this final manifestation, renounces the search for the secure foundation of a rooted past where the Titans and the Centaurs were conquered; she now attempts, gropingly, to traverse the night which comes to meet her, and, in incertitude, attempts to save, by her own isolated force, the little of life that she holds in her power.

JEAN H. HAGSTRUM

Blake and British Art:
The Gifts of Grace and Terror

Like the human brain itself, the subject of Blake and British art is largely
an uncharted terrain. In an essay that will end with a discussion of a
specific indebtedness and particular parallels of subject and style, it is
well to begin synoptically, with an overview of the scene that in its totality
is still to be fully mapped. Fortunately, a consideration of Blake and his
pictorial contemporaries and immediate antecedents, though complex
and difficult, can be simplified at the very outset by important exclu-
sions. Blake was not given to portraiture, in practice the favorite genre of
the monumentally typical Sir Joshua, and in theory that of the equally
monumental Dr. Johnson[1]—a genre practiced by the great Van Dyck
and by the greater Titian and Rembrandt, whom Blake disliked, but also
by Romney, whom he admired, and by Raphael, whom he adored.
Although Blake did some heads (a few of them could be called portraits
but most of them move quickly into traditional and recognizable icon or
into an almost private emblem), he is eccentric as an English painter in
slighting one of the glories of English art, the art that Johnson said
diffused friendship and revived tenderness.[2] Blake not only ignored it
but attacked it, finding some of its most eminent practitioners hirelings
of the rich and the titled, a condition doubtless arising from the nature
of the art itself.

Nor was Blake attracted to another genre that brought glory to the
English school, the landscape. To the achievements of Wilson, Gains-
borough, Turner, Constable, and most of the great Continental artists

1. See *Idler* No. 45.
2. Ibid., par. 5.

who preceded and influenced them Blake seemed to remain indifferent or hostile.[3] Nature put him out, and so did natural romanticism, particularly in its artistic form. The great *poesie* of Titian, landscapes highlighted by the white goddesses and nymphs of classical mythology, formed the imagination of Keats; but Blake called Titian an "Idiot," capable only of "unorganized Blots & Blurs,"[4] and went on to create his own mythology, seeking in Judeo-Christian sources the animation of his natural scenes, like the lovely second plate of "Night" in the *Songs of Innocence*, where the poetic and allegorical landscape is visited by preternatural and mysterious angels who produce an effect vastly different from that produced by Titian's or Claude's sensual or dainty beings.

Finally, to complete our purely negative considerations, Blake was not often a portrayer or satirist of contemporary manners or of the contemporary political or social scene, except in indirect, symbolic ways. In other words, he was not a Hogarth—whom, however, he admired, for Hogarth was an angry man and in his own way a reformer—nor was he akin to Rowlandson, although that exact contemporary, who shares with Blake the honor of being one of the few authentic masters of tinted drawing in the history of English painting, does now and then bear a resemblance to the poet-painter.

When we turn to the positive and attempt to say what Blake *was*, we find that further separations need to be expressed, though these are of a different kind. An uncompromisingly Christian, biblical painter who produced dozens of Christs and who everywhere in word and design is guided by biblical inspiration, Blake is even here unique. His period and the immediately preceding one did of course produce many biblical illustrations, but no great religious artist. And Blake, radical though he is, is much more closely related than are his more conservative colleagues to the Western tradition extending from the Middle Ages through the secularization that began in the Renaissance and continued in the eighteenth and early nineteenth centuries, a tradition which is held together by its relation to sacred and profane texts. As an emblematist and as an illuminator and illustrator of his own and other people's

3. Blake admired Poussin, perhaps because that painter used ancient fable as his subject and because his manner was "dry" and linear. Salvator Rosa he called "the Quack Doctor of Painting." Annotations to Reynolds in Geoffrey Keynes, ed., *Blake: Complete Writings* (Oxford, 1969), pp. 468, 469, 477.

4. Annotations to Reynolds (Keynes, *Complete Writings*, p. 467) and "Public Address" (Ibid., p. 596).

writings, Blake also stands in a venerable European tradition of verbal-visual art that includes some English practitioners of distinction but has a much broader base than the little island which gave him birth and which he never left physically.

But having made all these divisions, one cannot escape the somewhat paradoxical fact that Blake was in no way isolated from the contemporary and immediately antecedent art scene. In fact, he was related to it in a network of complex and elusive ties. The difference between the contemporary English and the earlier extra-English affinities is this: the earlier relationships involve masters by whom Blake is sometimes dwarfed; the contemporary connections involve artists who are usually dwarfed by Blake. Nevertheless, these contemporary connections are important and appear in many ways, large and small, often where one least expects them. It was a minor, now almost forgotten painter and designer, Edward Francis Burney (a member of a family remembered now because of a music historian and a novelist but not because of the visual artist), who, in his illustrations to *Paradise Lost,* was an important inspiration for one of Blake's greatest achievements, his illustrations to Milton's great epic.[5] Convincing and specific parallels prove that Blake was indebted to a caricaturist of the contemporary political scene, James Gillray.[6] But perhaps even more important than specific indebtedness for details is a possible communion of spirit, for Gillray in his finest work was an apocalyptic cartoonist; he unites heaven and earth in an organic union achieved by powerful, swirling, and organizing lines. Consider his *The Disciples Catching the Mantle,* in which Pitt, a modern Elijah, goes to heaven in a chariot made of moving fiery clouds as his mantle falls on the new Portland ministry standing on the Rock of Ages, while the priests of Baal, huddled together in a frightened lump, are dominated by a sooty-faced, diabolical Fox, a spirit of darkness who Urizenically spreads a black republican mantle over his minions. That spirit wears the bat wings which Blake often gives to his malign and mischievous agents. Gillray has given us a version of the Last Judgment as well as an ascent of Elijah—both eminently Blakean themes. One finds in a putative Reynolds an eminently Blakean visual idiom: Eurydice is a nude woman, surrounded

5. Morse Peckham, "Blake, Milton, and Edward Burney," *Princeton University Library Chronicle* 11 (Spring 1950): 107–26.

6. David V. Erdman, "William Blake's Debt to James Gillray," *Art Quarterly* 12 (Spring 1949): 165–69.

by darkness, leaning backward, her arms outstretched, her legs crossed; she strikes a Blakean pose and wears an ambiguous expression of either grief or ecstasy or both.[7] Finally, consider the portrait (now in the Art Institute of Chicago) by Sir Thomas Lawrence of Mrs. Jens Wolff, which at first glance, with the brilliant satin stuff of the dress and the modish turban, looks fashionable and seems to sparkle with social grace. But a closer look reveals Mannerist elongation; and the seated woman's profile suggests, despite the conventional high carnation of the cheek, a trance-like state as she looks intently but also vacantly at a large illuminated book which lies on a pillow and a rug, both of them rich stuffs like the gown itself. What does she contemplate? Michelangelo's sibyls, those beings that powerfully influenced Fuseli and Blake. Thus even the creator of "Pinky" does not let us forget that he too lives in the age of Blake, that Michelangelesque master of profound emotions and supernal insights.

If one thinks of Blake as man and thinker, as a practicing member of a fraternity of artists and engravers, and casts an eye on his social status and his religious affiliations, one finds perhaps more parallels with his contemporaries than not. It was of course standard from antiquity on for painters to be considered artisans and not humanists. But Blake as the son of a hosier, living a life far from any kind of aristocratic regime, *ancien* or *nouveau,* is peculiarly the spiritual brother of many, many other artists in his age who were without social or intellectual pretensions or position. James Ward was the son of a drunken Thames-side grocer. Turner's father was a barber, and Cotman was the son of a barber turned drapier. David Cox of Birmingham was the son of a smith, while Stubbs was the son of a tanner and remained his father's assistant until he was fifteen years of age. John Brown was born in Edinburgh of a goldsmith and watchmaker, while Bewick descended from a farmer who also owned a colliery. Fuseli was, to be sure, a member of the clerical and intellectual circles of Zurich, a student of literature and philosophy long before he came to England. But it was Blake who was typical in his social affiliations. And Blake, whether one considers him as being touched by a Baptist inheritance or by an early Swedenborgian interest, always spoke

7. The attribution to Reynolds is made in *A History of the Works of Sir Joshua Reynolds*, 4 vols. (London, 1899–1901), p. 1151, by Algernon Graves and William V. Cronin, whose scholarship must be treated with caution. I have seen the photograph at the Huntington Library.

a recognizable dissenter's idiom, an accent by no means untypical of the artists of his time. Ward was a strong Irvingite, moved by the great preacher's sensationalism and himself capable of violent religious ecstasy. Girtin, born in Southwark, was of Huguenot stock, and the Varley brothers were descendants of Oliver Cromwell through their mother. Benjamin West was the son of Quaker parents, Gillray came from a Moravian family, and Flaxman remained a Swedenborgian *pratiqant.* Thus socially, temperamentally, and economically, as well as in icon and style, Blake was very much at home in the artistic milieu of late eighteenth- and early nineteenth-century England.[8]

By asserting that Blake was related to his age I have by no means simplified or organized interpretation, for the age of Blake was one of conflicting styles and tendencies, a veritable babble of voices shouting contradictory and paradoxical directions and meanings. So complex and varied were the artistic and spiritual tendencies that most cultural historians are content to align them on a continuum. T.S.R. Boase's extends from the homely to the horrific, and he places Fuseli and Blake in that extreme which he calls "the world of frenzy."[9] One may applaud Boase for his perception of variety while deploring his unhistorical and unsophisticated terminology; and of course it will not do to confine Blake to a madhouse. As modern critics and scholars keep multiplying the terms to express range and contrast, it may be useful to go back to the eighteenth century itself for a set of antithetical critical terms that will account for much if not everything in Blake and that will in fact establish a set of opposites not entirely unlike those that he himself expressed in the terms *innocence* and *experience.* Burke's terms *sublime* and *beautiful,* if we are permitted to refine and extend them, still remain useful, because they are endowed with richer meanings than is often realized. Burke's sublime expresses not only elevation and joyful ecstasy but danger, terror, wonder, and overwhelming power. It can without strain be adapted to include the romantic grotesque of supernal horror. His conception of beauty includes the small, the lovable, the delicate, and is clearly related to the delights of sexual love. But it too can be extended—to include grace (that is, beauty in motion). One compelling

8. The facts in this paragraph are mostly drawn from the fine catalogue prepared by Frederick Cummings and Allen Staley, *Romantic Art in Britain: Paintings and Drawings 1760–1860* (Detroit and Philadelphia, 1968), under entries for the artists mentioned.
9. *English Art 1800–1870* (Oxford, 1959), p. 5.

reason for applying these aesthetic terms to Blake is that behind each of them stood a prototype who happened to be one of his artistic heroes— for the *sublime,* Michelangelo, and for the *beautiful,* Raphael. Moreover, each term drew to itself exemplifications not only from the visual arts but from literature as well. Johnson found "sublimity" to be the "characteristick quality" of *Paradise Lost*;[10] and the many illustrations of Shakespeare, not least those in the Boydell Gallery, show, however awkwardly, that Shakespeare too was considered sublime. The application of the term to Michelangelo, to the Milton of *Paradise Lost,* and to the Shakespeare of *King Lear* allows us to organize around Blake a group of painters who exemplified the new meaning of the Burkean sublime and who bore close relations to Blake in idea and idiom. James Barry's etching after Michelangelo's *Jonah*[11] may be called "sublime"—a nude figure who leans back on a stone seat, his shoulders high, his mouth open, his face viewed from below as he looks up, anticipates the famous "plowman" posture of Blake, his visual shorthand for the reception of inspiration. Mortimer also created examples of the grotesque sublime and was in fact criticized by Edward Edwards[12] for producing "a Set of Monsters, and other capricious subjects"—scenes that personify "Horrible Imaginings." One of such "imaginings" is perhaps the representation of a poet, in which Mortimer, inspired by the famous passage in *A Midsummer Night's Dream,* shows the poet's eye in a fine frenzy rolling.[13] That figure—in part dandified, in part wild—is forced and meretricious. Terror of course consorts better with tragedy than with comedy, and it is Lear himself who most often induces the sublime—sometimes in those who ought not to have accepted the challenge. Consider the engraved Lears that appear in the Turner Shakespeare in the Huntington Library.[14] Reynolds makes a brave attempt but does not get much beyond Guido Reni—which is to say that pink tries to be purple and that the sublime ends up as venerable delicacy. The one by E. F. Burney is not very interesting. But Mortimer's

10. *Life of Milton* in *Works* (Oxford, 1825), 7:131.

11. I have consulted the photograph at the Huntington of Barry's etching.

12. *Anecdotes of Painters* (London, 1808), pp. 62–64. Edwards does concede that many of the works of Mortimer he deplores are, however, done "in a very masterly style of execution, particularly the heads of the figures" (p. 64).

13. Engraved May 20, 1775; the drawing is reproduced in Robert R. Wark, *Drawings from the Turner Shakespeare* (San Marino, 1973), p. 14.

14. See ibid., p. 79, for a checklist of drawings for *King Lear.*

massive head,[15] without landscape setting, may surely be called sublime even though there is a touch of the theatrical, while Barry's is a figure of titanic power that combines a recollection of lost greatness and the fear of future madness. Both in the study at the British Museum and in the completed oil at the Tate, Barry in *Lear Weeping over the Dead Body of Cordelia* has achieved a head of great power that must have been in Blake's mind when he created his figure of Urizen, and the cluster of druidic architecture in the background looks ahead to famous pages in *Milton* and *Jerusalem*. The sublime of danger even touched the spirit of one of the mildest members of Blake's circle, the neoclassical John Flaxman, who in *Thomas Chatterton Taking the Bowl of Poison from the Spirit of Despair*[16] has created a manic, wild-eyed poet rising from his gloom-encircled bed to receive the potion from the fierce, black-haired figure of Despair, swathed in darkness.

But it is Henry Fuseli who gives to the Burkean sublime the particular accent and idiom of the demonic grotesque, having worked out its visual vocabulary during his stay in Rome and having done so with such power and originality that it left a lifelong impression on those who came within his orbit in the Eternal City—the Scots artist John Runciman, Sergel the Swede, Karstens the Dane, and Runge the German. Fuseli's influence on Blake has been much discussed; but the subject is of such complexity that it has by no means as yet been fully enough explored. We will not take up this subject now, beyond observing that Fuseli and his influence cannot be understood until one gets beyond regarding him as a Michelangelo *redivivus* or as chiefly a transmitter of that great master's influence. What Fuseli embodied and transmitted was not so much unadulterated Michelangelesque sublimity as a grotesque of demonic power that was adapted out of Michelangelo; and that grotesque—which we have placed in the large category of the sublime of terror—owes much to the Mannerists and particularly to Pellegrino Tibaldi, about whom Fuseli wrote and who gave the particular direction that the Swiss-English artist's style took. Indeed, the language Fuseli used to describe Tibaldi can be applied to Fuseli himself: they both possess "grotesque terribilità"; they both possess "conglobation and eccentricity, an aggregate of convexities

15. Compare the powerfully realized pen, ink, and wash drawing by Mortimer at the Huntington, in which the hair is blown into a blaze of glorious, apocalyptic light.
16. Reproduced in David. G. Irwin, *English Neoclassical Art* (London, 1966), pl. 114.

suddenly broken by rectangular and cut by perpendicular lines." Fuseli called Tibaldi "the greatest designer of the Bolognese and Lombard schools" and found in his paintings in Bologna figures of "savage energy" unrivaled by Michelangelo.[17] The fructifying filiation, then, transmits energy from Michelangelo to Tibaldi to Fuseli to Blake. The work of Tibaldi anticipates Blake sufficiently for one to feel certain that Fuseli's enthusiasm rubbed off and that the younger artist must have been shown designs, engravings, and perhaps even pictorial copies that the Swiss painter carried with him from Rome to England. The violent action, the muscular bodies, the horses in "romantic" attitudes, bat-winged demons, the downward plunging of bodies through air, the human hand making a span, an angel with a scroll hovering over a mother and child, clothes clinging to the body, the helmeted warriors— all these Tibaldi motifs gives one a sense of being in Blake country. Tibaldi tempts us to add another to the long list of proto-Urizenic figures, one that has as good a claim as almost any to being an antecedent of Blake's complex and compelling anti-man: the figure of Aeolus from the Palazzo Poggi in Bologna, nude, large-limbed, with a staring eye, and with beard and hair that stream in the wind. Tibaldi was a visionary painter who rose to prophetic heights from the lower realm of emblem and allegory. He was also a creator of the grotesque: one figure in particular anticipates Blake—a serpent-woman who is woman to the waist and serpent below it, a woman who wields a bow and who is led by a child whose legs also become serpentine.[18]

The circle in Rome upon which Fuseli so successfully impressed a Michelangelesque mannerism that was twisted into the grotesque of Tibaldi included, as I have said, Johann Tobias Sergel, whose caricature of Fuseli in front of a Roman building is highly revealing. A grotesque with a large head and spidery limbs, Fuseli possesse. eyes that are as "mystical" as those Blake was thought to possess; and what a Blakean sky Sergel gives us! Diagonal effluvia extend to the earth; menacing crea-

17. The Fuseli quotations come from Matthew Pilkington, *A Dictionary of Painters*, 5 vols. (London, 1805, Huntington extra-illuminated ed.), 4:560, in Fuseli's enthusiastic article on Tibaldi, and from Boase, *English Art*, p. 7, quoting John Knowles, *Life and Writings of Fuseli* (London, 1831).

18. See section on Tibaldi in Giuliano Briganti, *Il Manierismo e Pellegrino Tibaldi* (Rome, 1945), esp. figs. 117, 175. I have consulted the photograph at the Frick of *The Perides changed into Magpies*, now at the Academy of Fine Arts, Bologna, and the drawings and engravings at the British Museum.

tures, some perhaps riding horses, aim arrows of destruction at the hapless artist from Zurich and point accusing fingers in his direction, as hair streams in the wind and as clouds "swag" above the Roman piazza.[19]

George Romney was also a member of Fuseli's Roman circle, and the impress of the mannerism that directly affected Sergel and indirectly affected Blake made itself apparent in hundreds of drawings into which Romney poured his neurotic and turbulent agitation in the years immediately before his death. It is an eloquent fact that Edward Edwards, who censured Barry, should also have censured Sir Joshua Reynolds's rival in portraiture when he strayed from his lucrative métier. Edwards says that George Romney "made some attempt in historic painting, but his compositions in that line are conducted too much upon those eccentric principles which have lately been displayed in painting as well as in poetry."[20] In our own day, which is of course acquainted with the fashionable portraits and the seemingly endless variations on the face of Emma Hart, the layman has forgotten the Romney of Burke's terrible sublime. But Hayley knew of it, referring to "those excesses of impetuous and undisciplined imagination"[21] that needed guidance—a guidance that the hermit of Eartham tried to impose on the posthumous reputation of his painter-friend by eliminating from the biography some of the most interesting work that Flaxman and Blake urged him to include. For Romney, Rome must have been, after the fashionable purlieus of London, a redemptive release, however intoxicating to a neurotic imagination. Here he came under the spell of Fuseli; here he studied the paintings of Giotto and Cimabue; here he met Wright of Derby and began, like Fuseli, to illustrate Gray's sublime poetry. Richard Payne Knight also became an acquaintance, in 1777 writing Romney a letter on emotion and sublimity in painting. All these stimuli sent his spirits into a ferment that was to continue when he came into the Hayley circle in 1777, making it impossible for that ineffable poet—avant garde in taste but cold and clammy in spirit—to dampen the painter's aroused spirit. From now on Romney seized subjects from Milton, the Greek dramatists, and the more violent episodes of Greco-Roman mythology. He delighted in darkness, threat, mystery, the weird, and the super-

19. Sergel's *Portrait of Johann Heinrich Füssli* is reproduced in *Drawings from Stockholm*, compiled by Per Bjurström (1969), pl. 122.
20. *Anecdotes*, p. 278.
21. *Life of George Romney* (Chichester, 1809), pp. 72–73.

natural. Violence, battles, the storming of cities attracted his always facile pencil, and the gentle tutelage of Cowper in a poem like *The Task* sensitized him to the great humanitarian movements of the day. John Howard's reports on conditions in English and Continental jails led Romney to portray in many versions mysterious and suffering people lurking in dark and gloomy dungeons—privately preserved records of a *sensibilité* touched by terror, sublimity, and humanity.[22]

Some of the most notable of Romney's sublime drawings are the classically inspired black chalk drawings now in the Walker Art Gallery, Liverpool.[23] These, fully described and occasionally illustrated by reproduction in the Walker catalogue, are early enough to have influenced Blake from the very beginning of his career. But an affinity of spirit between the two artists may be better established by those drawings made in response to Howard's jail visits (drawings perhaps done in the early 1790s). Here humanitarian feeling joins the sublime of horror in a response to palpable human misery—a combination that must have stirred the very depths of Blake's spirit, a spirit that manifested itself in the supernatural-human horrors of *The Lazar House*. Romney's formula, as it seems gradually to have emerged, becomes simple but powerful: toward the left-hand side, lightly sketched figures, sometimes touched with dark wash, may represent the outside examiners. In the middle foreground huddle the bodies of suffering prisoners, often disposed of in ways that anticipate or recall Blakean attitudes. Over the huddle of despair and suffering presides a genius, malign but neither supernatural, like the ghost of Darius in Romney's other work, nor an aged tyrant, like Blake's Urizen. But this figure does extend his arms in the Urizenic parody of the Crucifixion; sometimes he stares menacingly at the visitors, his mouth twisted into an angry snarl (fig. 28); and sometimes, a more youthful figure, he resembles Blake's Satan, the successor to Urizen as anti-man, as he hovers over the dead and dying, his masklike mouth expressing chagrin at discovery, not pity for his victims (fig. 29). Romney has in the figure of the warden done powerfully what Blake also did: elevate, in a simply but eloquently drawn human figure

22. Ann Crookshank. "The Drawings of George Romney," *Burlington Magazine* 99 (February 1957): 47.

23. See *The Infant Shakespeare attended by Nature with the Muses, Tragedy and Comedy*, *The Ghost of Darius appearing to Atossa*, and *The Dream of Atossa*, all described and in some cases illustrated in a catalogue produced by the Walker Art Gallery, *Early English Drawings and Watercolours* (Liverpool, 1968), pp. 46–49 and figs. 40, 41, 43.

and face, human malignity to the level of "sublime" malevolence. That malevolence is powerful enough to preside over human suffering as a prime mover, as a *causa causans,* without losing the sense of physical palpability as he floats above the scene and defies the laws of gravity.[24] If we think of influence rather than affinity of spirit, however, it cannot be denied that the mantled, bearded, crowned, and mysterious ghost of Darius in *Atossa's Dream* (fig. 30) or in *The Ghost of Darius* (fig. 31), both early works, are more directly the antecedents of Urizen than the beardless hovering prison warden, to say nothing of the Aeschylean figures who respond in Blakean ways to the supernatural visitation.

These—and many other illustrations could be given—must be allowed to stand for Romney's expressions of the Burkean sublimity of terror. The drawings in black chalk given by Romney's son John to the Liverpool Institution and now in the Walker Art Gallery, the drawings in the Victoria and Albert Museum, and the Romney sketchbook in the Fitzwilliam are among the most striking anticipations of or parallels to Blake in existence, equal in relevant power to the better-known influences from Fuseli and in some ways more central because they lack the angular and perverse neuroticism of the Swiss painter's achievement. No one would say that the drawings of Romney that express his hidden and private nature rank in quality with the Michelangelos, Raphaels, Giulios, and Tibaldis that also influenced Blake. But they are closer to Blake in time, and hence they possess a kind of *Zeitgeist* authority that the remoter pieces lack. They also have on them the impress of personal suffering and thwarted choice. Romney, a brilliantly successful painter in daily contact with the fashionable world, perhaps experienced conflicts which even Blake, himself a sufferer, did not and could not know but which may have leapt like an arc of fiery inspiration from Romney's drawings to the poet's spirit.

When William Hayley wrote that the cartoons of Romney "were examples of the sublime and terrible, at that time perfectly new in English art,"[25] he told only part of the story, the part that I have just

24. I owe to Professor Jeffry Spencer the tentative opinion that the series of six related drawings at the Victoria and Albert, two of which are reproduced in this article, illustrate Howard's visits to prisons and not classical subjects. Dogmatism is premature until further iconographical work has been done, but the suggestion seems plausible. If so, the V & A drawings may belong to the period 1790–94. See Ellen Sharp, "Drawings by George Romney at Yale," *Antiques* 86 (November 1964): 598–603, figs. 13–14.
25. *Life of Romney,* p. 309.

discussed under the rubric of the Burkean sublime and the grotesque of Fuseli. The story remains incomplete without consideration of another Burkean quality, the antithetical one of beauty. Supported by the enormous pioneering prestige of Raphael and by the more graceful examples of Correggio and Guido Reni, beauty was one of the dominant strains in the eighteenth century, one that could be lightened into grace and deepened—the word may seem too strong but the development was profound and complex—into delicacy. Both grace and delicacy are applicable alike to Blake and to certain members of his English circle. *Grace* was conceived of as beauty in motion. One of the inescapable characteristics of the art of Blake is that light and beautiful forms are everywhere set into appropriate movement. And the word *delicate,* with all its old and its changing nuances, throws a revealing light on Blake and on his artistic milieu.

Who were the "graceful" members of the English school of gentle beauty most closely associated with Blake? One of these was his friend and sometime colleague Thomas Stothard, whose elegance Sir Anthony Blunt describes as "sweet." Stothard's merits, which must have seemed much more compelling to Blake and his contemporaries than to us, derive in part from his revelation of the child "in its unconscious simplicity." The lyrical temperament that made him illustrate, with so many of his contemporaries, the biblical precepts "ye must be born again" or "a little child shall lead them" appears everywhere in his work—in his many, many illustrations of English authors and in work in several media. His was a temperament that made him, like Blake, transform the patriarch Jacob, having his vision, into a youthful shepherd boy with staff and script. That temperament lay behind an undated Blake-like engraving entitled *The Blind Hermit,* in which a sweet-faced, light-haired boy leads an old man by the hand into a cave. In creating more than one version of a dominant pre-Romantic theme, *Milton Dictating to his Daughters,* Stothard usually presents a gesturing poet looking heavenward, whence beams of light stream down between the clouds, directing our attention to the daughters on earth who receive the message. But Stothard, for all his charm, allows an insistent conventionality to stifle his freshness. A tribute to the work of charity schools, entitled *Children Rescued from Want and Misery, to be Clad and Educated,* succeeds in arousing neither sympathy for the ragged urchins and older beggars nor respect for the personifications of charity and religion. Blake's simpler

but bolder design and verse *Holy Thursday* in the *Songs of Innocence* far surpasses Stothard in force and originality. The same transcendence by Blake of mere conventionality is discernible when we compare the two artists' representations of the Pauline virtues of faith, hope, and charity. In Stothard, all the iconic signs are inherited and conventional, and over everything there rests a pall of timid acceptance. Blake transforms convention by penetrating to the harsh social realities that lie behind the conventional symbols of tenderness and make them necessary. The veil of Religion becomes in Blake's parallel painting ominously sibylline; the open book is not instructive but Urizenically enslaving; the seated posture suggests unwelcome authority; and Faith is presented as an unwholesome and sinister old man. Blake often recalls the soft beauty of Stothard, as countless examples would show. But tender beauty in Blake is seldom sentimental, and it sometimes even leads to a devastating institutional indictment. The complex exploration to which Blake subjects the concepts of pity and mercy is a notable example of his advance beyond the sentimental school to which he initially belonged.[26]

Flaxman, a more considerable figure than Stothard, is identified with the school of beauty primarily for his sculptures, linear drawings, and engravings; but his spirit was touched by the terrible-sublime to a degree that Stothard's was not. A Urizenic being floats over scenes of human conflict and suffering; Oedipus, Tiresias, Pharaoh, Oceanus, Zeus, the giant Despair from Bunyan, and other mythic or literary beings give Flaxman an opportunity for the sublime of fear if not the grotesque of terror. But his prevailing mood is one of linear chastity and rhythmically harmonious motion. Flaxman's mentors, in his creation of sky-borne, earth-transcending, economically drawn figures in flight, were not those of Fuseli and Blake—Michelangelo, Tibaldi, or Goltzius—but, as he himself says, Raphael and Correggio, who exemplify "the most pathetic, energetic, and graceful attitudes."[27] The Flaxman-Blake relation is too complex for us to explore here in all its ramifications. But just as Blake transcended the demonic grotesque of Fuseli, so he transcended the delicate linear beauty of Flaxman, and he transcended it almost to the same degree that he rose above the tender and sentimental beauties of

26. The Stothards referred to are reproduced in Joseph Grego, "Bartolozzi Tickets for . . . Charitable Institutions," *Connoisseur* 3 (May–August 1902): 245–49.

27. *Lectures on Sculpture* (first ed., London, 1829). Cited from 2d ed. (London, 1838), p. 119.

Stothard. The Dante of the parochial Blake is a work of a bold genius that continues to inspire; the Dante of the internationally known Flaxman now seems time-bound and of primary interest as an historical phenomenon.

Flaxman was a contemporary, Thomas Banks a precursor of Blake. And because Banks has so seldom been discussed, there is some justification for giving him more attention than the more famous Flaxman, who was so intimately associated with Blake. Like Flaxman, Thomas Banks was a sculptor; he has been called along with Flaxman the leading neoclassical worker in stone that England produced. But the word *neoclassical*, here as elsewhere, is not very helpful, except to alert us to the fact that Banks like so many others was attracted now and then to classical themes. He was like Flaxman capable of sublime effects: one of his statues (1786) shows a curly-headed, classically delicate nude placed in a Michelangelesque posture, while two large gravity-defying rocks hang precariously over him as he tenses his body to push them back with his feet.[28] It is natural that this artist, who was in Rome, close to Fuseli, should be capable of his own kind of energetic grandeur. But other work done in Rome during the early 1770s, particularly his relief sculptures, also reveals him to be an immediate precursor of Blake in expressing delicacy and grace. Both Romney (in sepia over pencil on paper) and Banks (in a low-relief sculpture shaped like an oval dish) treated an infrequently used subject from Ovid, the story of Alcyone and Ceyx. Romney's is the more realistic version; Banks's work, even though here and there it does anticipate Blake, is much more prophetic of what is to come. The subject, full of what the eighteenth century called "the pathetic," has as its main theme the finding of a drowned body and the reactions to it. It is chiefly in disposing of the bodies of the dead husband and the grieving wife that Banks suggests the Blakean visual idiom. The nude body of the husband, modestly covered at the genitalia, is curved to recall Christ's body in a deposition, though the line direction is opposite. The wife's hair streams electrically into tufts at the ends. Her arms and hands are spread out. She is clothed, but only partially and very lightly. Her profiled head shows an intensity of grief about the eyes, and the curves of her body parallel those of the dead husband. The effect is at once classical and intense, and the hovering of the woman's body over

28. *The Fallen Titan*, a diploma piece, is on display at the Royal Academy.

the lifeless male with an obvious desire to restore animation is of course one of Blake's obsessive arrangements.[29]

Another sculpture of Banks, *Thetis and Her Nymphs Consoling Achilles* (fig. 32) (begun during the 1770s but never completely finished), was regarded by Flaxman as work of "the epic class." But the prevailing quality of this oval bas-relief strikes us as closer to a graceful delicacy which arises not so much from the body of Achilles, tensed in grief as it lies facing us, as from the beautiful nymphs, whose nude bodies form an elegant circle around the central figure. Once again Banks has anticipated an obsessive Blakean arrangement: delicate bodies, nude or semi-nude, flowing in graceful rhythm from the bottom in a clockwise movement up the left-hand side, all very lovely and very smooth, some facing us, one in profile, and one, as in Blake's "Introduction" to *Experience*, rising as she presents her back to the beholder. Having called this action "epic," Flaxman goes on to praise it as "beautiful and pathetic," the composition being "unlike any work ancient or modern." Such grace and originality evokes Blake, and Banks's disposition of female bodies reappears obsessively from the *Songs of Innocence* to that great masterpiece of graceful and energetic motion, the Paolo and Francesca illustration to Dante's *Inferno*.[30]

As I have said, discussion of Fuseli could confine itself to the Michelangelesque and the grotesque sublime without doing violence to the subject. And discussions of Flaxman, Stothard, and even Banks would lose little if I discussed only grace and delicacy. But for Romney, like Blake, *both* the sublime-grotesque of Michelangelo and Tibaldi *and* the beauty and grace of Raphael must enter the discussion as central qualities—a consideration suggesting that the intellectual relations of these two English artists were vastly more seminal than has hitherto been realized.

In illustrating the Michelangelesque sublime of Romney, I drew upon the charcoal drawings in Liverpool, particularly those concerned with

29. See Stainton Lindsay, "A Re-discovered Bas-Relief by Thomas Banks," *Burlington Magazine* (June 1974): 327–29 and plate 53 (repr. of Romney's sepia).

30. Flaxman's comment appears in his "Address" on Banks, printed at the end of his *Lectures on Sculpture* (1838), p. 292. In noting the parallel between Flaxman's bas-relief and Blake's brilliant illustration of the Paolo and Francesca episode in Dante, I have been anticipated by F. Saxl and R. Wittkower, *British Art and the Mediterranean* (London, 1948), p. 83, figs. 2, 6. Flaxman says further of this work, ". . . the sentiment and character is beautiful and pathetic, the composition is . . . unlike any work ancient or modern . . ." (*Lectures*, p. 292).

themes from Aeschylus, and the prison scenes at the Victoria and Albert Museum. From the Walker collection I now draw examples of the kind of grace and delicacy that Stothard, Flaxman, and Banks have exemplified and that Romney brought to a pre-Blakean climax.

When he was in Rome with Fuseli, Romney did more than investigate Michelangelo and Mannerists like Tibaldi and absorb the neurotically grotesque and demonic idiom that characterized the circle I have already discussed. In Tennyson's dramatic monologue "Romney's Remorse" (the artist lived apart from his wife during almost his entire and highly successful career), the title-character says that in Europe he "stood / Before the great Madonna-masterpieces / Of ancient art in Paris, or in Rome." Ignoring Tennyson's Victorian censure of Romney's marital behavior, we must agree that the artist did respond during his Italian stay to the delicacies of Raphael, Correggio, and other members of that school. But living in the latter part of the eighteenth century, Romney inherited a *complex* conception of delicacy, one to which the whole course of English literature and English sensibility had made its contribution and one with which his exposure to fashionable life and to successful portraiture and even to a bland but still avant-garde intellectual like Hayley would have acquainted him. Romney does not simply take over "the grace beyond the reach of art" of Pope, who had admired the "graceful" painters, especially the famous "air" of Guido. In the novels of Richardson and Rousseau, and even in the "Gothic" situations of Mrs. Radcliffe, he could have encountered one of the newer obsessive concerns of the age, the threat to virginal delicacy in physically or psychologically dangerous and unknown environments. And in fact what some of the drawings that we shall now see demonstrate beyond any cavil is that the painter, like many literary predecessors, has associated delicacy with mystery, grace with the threat to innocence. He has presented innocence trembling on the edge of experience or entering it or triumphing over it or withdrawing from it. Greek-like, delicate, virginal maidens stand in danger, sometimes of abhorrent sexual assault, but sometimes, it would seem, they feel threatened by half-desired and fully sanctioned sexual experience. So intense is Romney's expression of such explicit and implicit meanings that one feels he is being mastered by materials that arise from deep within his buried life.

Threatened innocence is also a great Blakean theme, and Blake might have observed in Romney visual forms that expressed it successfully and

suggestively. Romney's free-flowing line, gathering drapery into grace-ful folds, outlining the human body and partly exposing it, is illustrated in innumerable drawings. The *Cassandra,* the *Study for the Viscountess Bulkley as Hebe,* and several figure studies exhibit qualities of graceful motion in the arrangement of body and drapery; the facial expressions reflect distress, pity, freshness, naiveté, wonder, and beauty (those Miranda-like qualities that made Shakespeare's heroine a favorite in the period), qualities that recall Botticelli and the Quattrocentists. In *Captive or Dejected Woman* (a pen-and-ink drawing now at Yale) the subject's profile is delicately Grecian, the flow of her body and drapery ex-tremely graceful, the figure reminding us of Blakean virgins standing on the edge of experience.[31] Romney's use of the King Lear motifs remind one less of the terrible sublime than of Blake's *Songs of Innocence* and *Songs of Experience.* Consider *The Death of Cordelia* (fig. 33), in which the dead daughter lies on a flat bed surrounded by six mourning figures— an example of one of the powerful pre-Romantic themes, the lamenta-tion over a dead body, a secularized version of the sacred lamentation over the body of Christ removed from the cross. Cordelia's posture is that of a mortuary figure and anticipates the title page to the *Songs of Experience.*

Romney illustrated the story of Orpheus and Eurydice in at least three black chalk drawings, all of them anticipating *The Book of Thel.* The first (fig. 34) shows Eurydice fleeing from Aristaeus, the son of Apollo and the father of Actaeon, who fell in love with the wife of Orpheus and pursued her. Here Eurydice is depicted crossing a stream on a plank, failing to see the water snake that will administer the fatal bite. The land-scape, resembling that of *Thel* and *Tiriel,* is mysterious and misty. The young lady is delicately beautiful but frightened, her hands spread in horror, her gown gauzy, her feet bare, her filleted hair flowing back-wards. In the second of these drawings (fig. 35), Orpheus, youthful, Grecian, and handsome, embraces his wife, attempting to pull her back from the forces that inexorably bear her away. The two figures in the sky who point towards Hades suggest the forward motion of Blake's sightless couriers of the air in his color-printed drawing *Pity,* and the swirls and vortexes in the atmosphere remind one of the two nudes and the arcs

31. The Romney drawings referred to in this paragraph are reproduced in Robert R. Wark, *The Drawings of Romney* (Alhambra, Calif., 1970). These also appear, along with *Miranda*, in Sharp, "Drawings by George Romney."

that they describe in the grain on the ninth plate of *Europe*. In the last of the drawings (fig. 36) Orpheus loses Eurydice, who, like Thel, shrinks back to the place of her origins, already a wraith as she vainly reaches out her arms, impelled by the fates to the misty region and pathetically withdrawing from her horrified husband's arms, which are held out to receive her. The stretching of arms that almost touch and that strive to end separation and restore harmony is a characteristic Blakean signature, beginning with his earliest relief engravings where the child reaches out toward a bird or a mother toward a child. It is profoundly anticipated by Romney in this series.

It has been noted by more than one scholar that traces of the Cupid and Psyche legend from Apuleius appear in Blake's *The Book of Thel*.[32] It has not, so far as I am aware, been suggested that the *visual* antecedents of the main character may lie in Romney's black chalk drawings. If in fact Romney's series did kindle Blake's imagination (they were created around 1776), it was perhaps because they represented a highly original response to the famous legend, which had been illustrated innumerable times in more than one epoch and which was obsessive among the pre-Romantics. Romney breaks sharply with the erotic-uxorial treatment of the theme, of which the best early example is Giulio Romano's *Sala di Psyche* in Mantua. Nor does Romney share the drive toward unisexuality, in which Cupid and Psyche are mirror images of one another, a vision of androgynous love best exemplified by Canova's and Thorvaldsen's renditions in marble.[33] Romney instead concentrates on the theme of innocence in danger, delicacy threatened by hostile natural, social, or supernatural forces. In all of the drawings Psyche is a modest, gauzily-dressed, Grecian girl—like the classical shepherdess Thel—caught in a misty and mysterious landscape which evokes from her responses of passive wonder, sad acceptance, or kneeling submission and supplication. Seven drawings survive (one is missing and may have treated the nuptials of Cupid and Psyche; if so, that joyful scene would have been out of harmony with the remaining works in the series). In one scene (fig. 37) a worried Cupid kneels before Psyche, who has escaped from

32. Kathleen Raine, *Blake and Tradition* (Princeton, 1968), vol. I, chap. 7; Irene H. Chayes, "The Presence of Cupid and Psyche," in David V. Erdman and John E. Grant, eds., *Blake's Visionary Forms Dramatic* (Princeton, 1970), pp. 214–43.

33. See Jean H. Hagstrum, "Eros and Psyche: Some Versions of Romantic Love and Delicacy," *Critical Inquiry* 3 (Spring 1977): 521–42.

the palace and who modestly covers one breast as she bows her head. Back of the lovely girl lies a black cave, and threatening clouds and swirls of mist suggest danger. In another scene (fig. 38) Psyche supplicates a proud Juno and kneels, very much in the posture of the Lily in *The Book of Thel;* the goddess reminds one of Blake's representations of classical marbles. A very striking anticipation is *Psyche by the River Styx* (fig. 39). The figure of Psyche, seen in profile, suggests strongly the somewhat more static and placid Thel from the title page, who is also seen in profile contemplating an object of curiosity. But perhaps the deepest equivalent in Blake of Romney's present scene is the final page of poetic text in *The Book of Thel*, where the virgin contemplates her own grave plot (that is, future sexual experience) and flees from it with a shriek. In Romney Psyche stands before a black hole, from which a wind blows her hair and mantle—a somber but haunting portrayal of innocence trembling on the edge of the unknown. Here the victory of desire over fear may be said to be in doubt. In Blake the shriek and the flight show that fear has conquered.

I observed above that what may have given Romney's private vision of threatened innocence its exemplary and even mythical force is that it recalled an important tradition which the eighteenth century brilliantly and charismatically exploited, both in sentimental and Gothic fictions. I further suggested that Romney, by translating that obsessive literary theme into visual expression, may have made a profound impact on the imagination of Blake, whose central problem was to bring the psychological, moral, religious, and aesthetic concerns of his age into a visual and verbal ideogram. Outside the series in Liverpool, in a drawing (fig. 40) that is only in the sketch stage (now at the Fitzwilliam, Cambridge), Romney once more—and in a sharply focused way—exemplifies this theme. Psyche does not here so much contemplate the Styx as Charon. Nude, angry, his *membrum virile* visible, the rower is faced by Psyche, who sits in the prow of the boat looking toward him. Her back is nude, she seems to be covering her breasts, she looks chaste and prim and confident in these fearful surroundings on the way to the underworld. Blake has nowhere exactly duplicated this design, but his vision of women entering experience here finds concentrated visual anticipation. The calm and unruffled fortitude of Charon's delicate and graceful passenger is, however, sophisticated into greater drama and variety by the Blake who created Thel, Ona, Oothoon, and Vala.

Discussions of Blake's context—of the intellectual and spiritual milieu from which he sprang—must distinguish carefully between the impact of giants like Raphael and Michelangelo and the stream of suggestions that flowed into his fertile mind from innumerable sources, some sympathetic to him, some repugnant. Milton, Dürer, and a very few others contributed words, phrases, images, visual configuration, but, most of all, vision and inspiration, challenge and palpable and inescapable presences. No British artist provides Blake with what he received from these intellectual heroes. But it would be wrong to say that the gifts from Barry, Mortimer, Banks, Fuseli, Flaxman, Stothard, and Romney were inconsiderable. These gifts consisted of more than single motifs or suggestions, which could have been seized upon from any source and made to serve any use pertinent to Blake's purpose. Fuseli provided a Mannerist idiom of striking originality; Banks, a neoclassical energy that approached the intensity of motion we find in Blake at his best; Romney, at least two powerful visual symbols that grew out of Blake's troubled age and sank roots deep in his psyche: (1) the oppressor, the Urizenic anti-man who partakes in the power of the terrible sublime, and (2) the delicate, Thel-like virgin standing on the threshold of experience, now crossing it to prophetic achievement, now withdrawing from it to regressive arrest. From what has been said in this paper one might conclude that Fuseli and the Romney of the hidden drawings were Blake's closest spiritual *confrères*. But it is still too early in the study of Blake and English art to propose a hierarchy of influences or indeed any definitive or final judgment. The most appropriate note to sound in conclusion is a call for further study of Blake in relation to each of his contemporaries and predecessors and to hope for a Panofsky *redivivus* to lead us into the gardens of Romantic iconography.

L. J. SWINGLE

Wordsworth's "Picture of the Mind"

Whereas a picture on canvas is usually an all-in-all, an analysable totality in itself, the picture that a poet "paints" in a poem is commonly part of a greater poetic whole. The rest of the poem affects, sometimes determines, what we see in and how we think about the poetic word-picture. Studying poetic pictorialism, then, involves considering pictorial functions: how and why the poet employs pictorial elements in his larger poetic contexts. Fundamental questions should be asked, not simply about qualities of the poet's pictorial imagination, but about the poet's interest in and manipulation of pictures as such. The importance of asking this latter sort of question emerges when one investigates the pictorial impulse in William Wordsworth's poetry, a subject that has attracted increasing attention in recent years.[1]

Generally critics can find what they look for in Wordsworth's pictorialism. Those devoted to notions about unity and reconciliation of opposites in Romanticism can contemplate passages like the famous introduction to *Tintern Abbey:*

> Once again
> Do I behold these steep and lofty cliffs,
> That on a wild secluded scene impress
> Thoughts of a more deep seclusion; *and connect*
> *The landscape with the quiet of the sky.*[2]

1. See, for example, Alec King, *Wordsworth and the Artist's Vision* (London, 1966); Russell Noyes, *Wordsworth and the Art of Landscape* (Bloomington, 1968); R. F. Storch, "Wordsworth and Constable," *SIR* 5 (1966): 121–38; Karl Kroeber, *Romantic Landscape Vision* (Madison, 1975).
2. Lines 4–8; italics mine. I have used the 5-volume Ernest de Selincourt and Helen

Such scenes of connection are easily found in Wordsworth. But critics who approach him looking for romantic isolation more than unity can also find what they seek. There is, for example, Wordsworth's solitary leech-gatherer: "In my mind's eye I seemed to see him pace / About the weary moors continually, / Wandering about alone and silently."[3] While Wordsworth is fond of word-pictures which portray interfusings, he is equally fond of bringing into focus starkly isolated objects:

> Nor should I have made mention of this Dell
> But for one object which you might pass by,
> Might see and notice not. Beside the brook
> Appears a straggling heap of unhewn stones!
>
> [*Michael*, ll. 14–17]

Our ability to find what we will, when what we will may be quite contrary, should give us pause. What strikes one most about Wordsworth's pictorialism is, first, simply its heterogeneity and, second, the uncommon fascination with visual set-pieces as such.

Even the casual reader is aware of passages in which Wordsworth writes of inability to "paint" some picture that he would convey to his reader. In *Tintern Abbey*, for example, "For nature then / . . . To me was all in all.—I cannot paint / What then I was" (ll. 72–76). Wordsworth is not merely bowing toward the old notion that the poet gives us "speaking pictures." In fact, he is leaning rather in the opposite direction. In pointing up the poet's struggle, even his inability, to successfully paint his pictures upon poetic canvas, he posits a primacy of images in the poet's mind, images which cannot in fact readily be made to speak. In the mind, the image stands independent of the word. This is a recurring notion in Wordsworth's poetry. One thinks of the lines which introduce the "prospectus" to *The Recluse:* "On Man, on Nature, and on Human Life, / Musing in solitude, I oft perceive / Fair trains of imagery before me rise." When the Wordsworthian recluse sits down to reflect in his solitude, what first rises up before him is not the word. Instead, he is haunted by "fair trains of imagery." He sees, first of all, pictures of things. So does the poet of *The Waggoner:*

Darbishire edition of Wordsworth's *Poetical Works* (Oxford, 1940–49; vol. 2 reissued by Helen Darbishire in 1952). For *Prelude* quotations, I have used the de Selincourt edition, revised by Helen Darbishire (Oxford, 1959); references are to the 1850 version of that poem.

3. *Resolution and Independence*, ll. 129–31.

What shifting pictures—clad in gleams
Of colour bright as feverish dreams!
Earth, spangled sky, and lake serene,
Involved and restless all—a scene
Pregnant with mutual exaltation,
Rich change, and multiplied creation!
This sight to me the Muse imparts.
[Canto 3, ll. 36–42]

This is interesting, but still more so is the fact that the poet is by no means distinctive in his experience of such pictorial hauntings. The dramatic characters of his poems are similarly affected. Some of these characters, to be sure, are in part types of Wordsworth himself and hence are perhaps mute poets. Such, for example, is the Wanderer in *The Excursion*, of whose intellectual development Wordsworth writes:

he thence attained
An active power to fasten images
Upon his brain; and on their pictured lines
Intensely brooded, even till they acquired
The liveliness of dreams.
[book 1, ll. 144–48]

So too perhaps is the Solitary of the same poem, to whom the Wanderer says, "You dwell alone; / You walk, you live, you speculate alone; / Yet doth remembrance, like a sovereign prince, / For you a stately gallery maintain / Of gay or tragic pictures" (book 4, ll. 558–62). But other of Wordsworth's dramatic characters, who are by no means obviously poetic, also create and maintain picture galleries in their minds. Thus, old Adam in *The Farmer of Tilsbury Vale:* " 'Mid coaches and chariots, a waggon of straw, / Like a magnet, the heart of old Adam can draw; / With a thousand soft pictures his memory will teem, / And his hearing is touched with the sounds of a dream" (ll. 77–80).

That the old farmer in this last quotation should be named Adam is, as often with Wordsworth's namings, significant. We are invited to consider this Adam, drifting away from the coach-and-chariot world of his present, "real" sensory experience into the picture-world of his own mind, as the father of us all. In our experience, his is reproduced: we are all Adams, shapers of pictures which stock the mind; and we tend to drift inward, wandering through our mental gallery. One recalls Wordsworth

addressing his sister Dorothy near the conclusion of *Tintern Abbey:* "and, in after years, / When these wild ecstasies shall be matured / Into a sober pleasure; when thy mind / Shall be a mansion for all lovely forms . . ." (ll. 137–40). The difference between the ordinary man and the poet in this matter is not a profound one. The poet, we remember from the preface, is a *man* speaking to men. Those "fair trains of imagery" Wordsworth mentions in his "prospectus" rise up in all of us. The poet is simply that man among us who, instead of "Husbanding that which they possess within" and so going "to the grave, unthought of" (*Excursion* 1, ll. 90–91), seeks to draw what is within out. The poet struggles to make the mind's pictures speak.

To Wordsworth, man is a picture-shaping animal. Hence Wordsworth's tendency in his many passages descriptive of encounter[4] to emphasize form or shape more than linguistic impression. Consider the encounter with a blind beggar in book 7 of *The Prelude*, for example: the beggar stands "propped against a wall, upon his chest / Wearing a written paper, to explain / His story, whence he came, and who he was"; and Wordsworth's mind is "Caught by that spectacle." But what arrests the mind has nothing to do with what is written on the beggar's paper; rather, it is "*on the shape* of that unmoving man, / His steadfast face and sightless eyes" that "I gazed, / As if admonished from another world" (ll. 639–49; italics mine). Or again, the encounter with the leech-gatherer in *Resolution and Independence:* "While he was talking thus the lonely place, / The old Man's shape, and speech—all troubled me." What first impresses the mind is shape; and second, with a comma and almost as an afterthought, speech. But then in the next two lines, and even as the leech-gatherer continues talking, speech dwindles into insignificance as the mind shapes its image: "In my mind's eye I seemed to see him pace / About the weary moors continually" (ll. 127–30).

The mind takes its cue from substantial hints in the world of outer sensory experience; but then, shaping these on its own terms, it begins withdrawing (as does old Adam) into the interior world of self-created pictures. So Margaret in book 1 of *The Excursion*, withdraws into dreams of her husband's return: "On this old bench / For hours she sate; and evermore her eye / Was busy in the distance, shaping things / That made her heart beat quick" (ll. 879–82). So too Wordsworth, as a child, with-

4. For the encounter pattern in Wordsworth, see Frederick Garber, *Wordsworth and the Poetry of Encounter* (Urbana, 1971).

drew into his own picture of far-off London: "Would that I could now / Recall what then I pictured to myself, / Of mitred Prelates, Lords in ermine clad . . . Dreams . . ." (*Prelude* 7, ll. 106–11). The mind composes for itself its own pictures, shaping "dreams."

The metaphysics underlying such picturing emerges, I think, in that famous image of "the Child among his new-born blisses" in the Immortality Ode:

> See, at his feet, some little plan or chart,
> Some fragment from his dream of human life,
> Shaped by himself with newly-learned art.
>
> [ll. 90–92]

The Child ("father of the Man," Wordsworth reminds us in the poem's epigraph) is, first of all, a *shaper* of things. He relates to the things of the outer world by shaping them into little plans or charts which correspond to "his dream of human life." What Wordsworth is pointing to here, of course, is simply the fact that small children play; but he is pressing us to recognize that this fact is not really so simple. Instead of conforming themselves to the earthly nature of things, children play games with that nature. They ignore the "laws" of nature and create their own rules of the game. A child, as we say, "makes things up"; and Wordsworth would have us attend to the implications of our language: this child is a "maker," and he raises things "up." The child's play, that is, is like the play of God: he shapes what for him is brute matter into the stuff of his dream. Hence the famous "trailing clouds of glory do we come / From God, who is our home" (ll. 64–65). And hence Wordsworth's assertion that the child's "newly-learned art" is attended by "light upon him from his father's eyes!" Art or child's-play manifests the activity of the fallen god, bringing the Father's light into darkness.

With time, of course, this light fades—first, to the "gleam," and then, finally, into embers. Yet there are still live coals in these embers, as the Immortality Ode goes on to argue: "O joy! that in our embers / Is something that doth live" (ll. 129–30). We are able to remember the earlier gleam, and, through that, the light which once was. Which brings us back to those mental galleries of pictures through which Dorothy and Wordsworth's Solitary are urged to walk. Wordsworth's "gleam" is associated most obviously with the process of what we ordinarily think of as artistic creation. But that gleam is equally and still more interestingly

associated simply with the primal impulse, which attends mental activity in general, to shape pictures from life's experiences. There is, for example, Wordsworth's tribute to his wife Mary: "She was a *Phantom* of delight / When first she *gleamed* upon my sight; / . . . A dancing *Shape*, an *Image* gay, / To haunt, to startle, and way-lay" ("She Was a Phantom," ll. 1–10; italics mine). Whether through that conscious activity we call art or simply through that unconscious picture-making which characterizes the art of human perception, the growing adult continues, though less obviously, to play a child's game with the world around him.

But, ultimately, that child's game is God's game. Man's mental picture-making is a manifestation of his otherwise forgotten divinity ("Our birth is but a sleep and a forgetting"). This is of primary importance to Wordsworth, and it loads the pictures which appear in his poetry with a weight of significance and implication which, to the casual reader, may not be immediately obvious.

Let us go back to those introductory lines from *Tintern Abbey* and consider the passage in full and with attention to poetic context.

> *—Once again*
> *Do I behold* these steep and lofty cliffs,
> That on a wild secluded scene impress
> Thoughts of a more deep seclusion; and connect
> The landscape with the quiet of the sky.
> The day is come *when I again repose*
> Here, under this dark sycamore, and view
> These plots of cottage-ground, these orchard-tufts,
> *Which at this season*, with their unripe fruits,
> Are clad in one green hue, and lose themselves
> 'Mid groves and copses. *Once again I see*
> *These hedge-rows, hardly hedge-rows, little lines*
> *Of sportive wood run wild*: these pastoral farms,
> Green to the very door; and wreaths of smoke
> Sent up, in silence, from among the trees!
> *With some uncertain notice*, as might seem
> Of *vagrant dwellers in the houseless woods*,
> Or of some Hermit's cave, where *by his fire*
> *The Hermit sits alone.*

> [ll. 4–22; italics mine]

The lines I have italicized indicate the dramatic quality of the passage.

We have here not simply description of a scene, but rather a mind shaping a picture of the scene. And there is tension in the activity. The mind repeatedly insists that it is here *again*, in "repose" at this *same* place, beholding this *same* scene it beheld once before. But Wordsworth makes us aware that the things being seen exist in a dimension of time and change: "these orchard-tufts" change and grow in tune with changing "seasons," fruits ripening and falling, new unripe fruits appearing. And he makes us aware that the mind is having some trouble capturing this growing, changing nature in permanent mental categories: the mind makes a wrong move and its picture slips for a moment ("Once again I see / These hedge-rows, hardly hedge-rows"); but it then recovers ("little lines / Of sportive wood run wild"). Both a literal and a symbolic touch here: what were once hedge-rows are no longer quite that; and the mind's attempt to render sportive wildness into "rows" fails. Hence "uncertain notice," the drama of indecision, at the passage's climax: its suggestion either of human presence struggling to dwell where there is no dwelling or of some hermit, "alone" and cave-enclosed, linked not to the outer world but only to "his" fire. The passage invites us to experience the mind forming a picture to which the sportive wildness of things will not quite conform.

Hence the richness of the word *forms* in the passage that follows:

> These beauteous forms,
> Through a long absence, have not been to me
> As is a landscape to a blind man's eye:
> But oft, in lonely rooms, and 'mid the din
> Of towns and cities, I have owed to them
> In hours of weariness, sensations sweet.
>
> [ll. 11–17]

Five years earlier, the mind had formed a picture, carried forms away with it; and now, returning, it has sought to fit those forms to the scene again. The question of the poem becomes whether it can do so; or, more precisely, the question becomes whether it can persuade itself to cling to its picture of nature:

> And now, with gleams of half-extinguished thought
> With many recognitions dim and faint,
> And somewhat of a sad perplexity,
> The picture of the mind revives again.
>
> [ll. 58–61]

The "gleams of half-extinguished thought" are most important. Within the poem, this phrase of course looks back to the hermit's "fire" and thus reminds us that the picture of a calm, beauteous nature wherein man can find "repose" under the "dark" sycamore is a picture not of nature itself but "of the mind." But these "gleams" also transcend the poem, ushering our reader's mind into the mythology which weaves its thread through other Wordsworth poems. We find ourselves halfway down that road between the Child, playing games upon the world's matter with "light upon him from his father's eyes," and the aging Adult, stirring only the "embers" of the celestial light. The question of *Tintern Abbey* is thus, more profoundly, whether the mind will revive its own spark of divine activity. And the answer in *Tintern Abbey* is of course yes. The mind's picture does revive: what the mind "would" believe ("other gifts / Have followed; for such loss, I would believe, / Abundant recompense" [ll. 86–88]) becomes what it *does* believe, as the poem presses toward expression of "cheerful faith" (l. 113), and that significantly *mental* mansion "for all *lovely forms*" (ll. 139–40; italics mine) which I discussed above.

The weight of significance attendant upon the "picture of the mind" in *Tintern Abbey* is generally present in Wordsworth's pictorial passages. Without too much distortion, we can isolate two main, complementary aspects of this significance. First, it is sometimes most important that a Wordsworth picture is *of the mind*. The characteristics of the picture suggest something about the nature of the mind. This in turn points back to the nature of that divinity of which the mind retains a spark. Thus, for example, those images of fusion in Wordsworth ("connect / The landscape with the quiet of the sky") tell us not about the world of nature, but rather about how the mind *would* see that world of nature; and this leads us toward the world of spirit, how a God sees. What in some cases may be most significant, however, is not the particular imagery that goes into the picture but rather the nature of the distinction between the picture qua picture and the qualities of the sensory, experiential world from which the picture takes its cue.

In Wordsworth's *Elegiac Stanzas* what is fundamentally important is not the particular character of the picture Beaumont has painted of Peele Castle (hemmed in by "This sea in anger, and that dismal shore"), nor is it the character of the picture Wordsworth affirms that he himself would have painted in his unknowing youth ("A Picture had it been of lasting ease, / Elysian quiet, without toil or strife"). The significance is

instead that both these pictures are static extremes, abstractions from the shifting nature of the world they pretend to portray. Here, as in *Tintern Abbey*, Wordsworth makes us recall that the "real" world is one of changing seasons: "How perfect was the calm! it *seemed* no sleep; / No mood, which season takes away, or brings" (ll. 9–10; italics mine). Beyond the mind's *seemed*, we are so reminded, lies the shifting world of calm *and* storm. But the poem now draws us away from this world into the realm of the mind's picturings:

> Ah! if mine had been the Painter's hand,
> To express what then I saw; and *add the gleam,*
> *The light that never was, on sea or land,*
> The consecration, and the Poet's *dream.*
>
> > [ll. 13–16; italics mine]

Now we find ourselves involved in a question about which is the truer *picture* of the world, Wordsworth's youthful picture of endless calm or Beaumont's picture of endless strife. The fact, of course, is that both pictures are unnatural; but Wordsworth's dramatic point is that the mind does not think about this. The mind's "real" world is one of permanencies; and the mind's only question, therefore, is which vision of permanence is the more "wise and well" (l. 45). This imposition of permanence in both pictures, to which the mind adapts itself so cheerfully, is that "gleam" introduced earlier. It is the "light that never was, on sea or land." This "light" was never "on sea or land"—but then where was it? It comes from the mind—but, if not to be found anywhere in the world, then from what did the mind derive such an unnatural notion? Wordsworth is teasing us back toward clouds of glory, those fragmentary memories of eternity that emerge in human thought as attraction to permanence.

The characteristics of a given picture, then, or sometimes simply the properties of picture qua picture, open windows upon the nature of the mind. Sometimes, however, it is the pictorial activity more than the picture itself that receives special emphasis. Thus in the final stanza of *The Two April Mornings*:

> Matthew is in his grave, yet now,
> Methinks, I see him stand,
> As at that moment, with a bough
> Of wilding in his hand.

Of primary importance here is the young speaker's *act* of picturing. The poem sets up a drama of choice. We humans live in a natural world characterized by cyclic revolutions. Particular identities like Matthew and his daughter Emma live and die, but their generic forms reappear. Matthew, turning from his daughter's grave, confronts, "Beside the churchyard yew, / A blooming Girl, whose hair was wet / With points of morning dew" (ll. 42–44). While in one sense she is not Emma, in another sense she is. The problem is whether to accept this recompense—and Matthew rejects it. At the poem's conclusion, we find the young speaker making the same choice: he turns back in his mind to what has disappeared, reviving his picture of Matthew. By setting this pictorial action in a context of "April Mornings," Wordsworth colors it with a pun yielding religious significance. We are reminded that nature's cycles are, in their own natural kind, resurrections: all things are reborn in the return of April morning; and they rise up glistening, offering to replace our tears with "morning dew." But the speaker, like Matthew before him, turns from this consolation. He gives himself, instead, to an unnatural resurrection.[5] For him, morning becomes mourning (and morning dew, mourning *due*); and he raises Matthew from his grave through the pictorial impulse of his own mind. It is the act of picturing which, in this poem, Wordsworth would have us find awesome. The human mind is reacting against nature. It plays God. In picturing, the mind reveals it is not of this world.

Wordsworth's pictures, then, mean beyond themselves. One only begins to learn what they mean by pressing deep, seeking out those principles of pictorial significance which lie behind the pictures in the poet's work. We must ask not only what, but also why. Unless we ask this latter question, we may not know what we are looking at.

5. See Karl Kroeber, *The Artifice of Reality* (Madison, 1964): For Wordsworth, he argues, "remembering is a creative, not a mechanical process, a human form of resurrection" (p. xix).

CARL WOODRING

What Coleridge Thought
of Pictures

Henry Nelson Coleridge, nephew and son-in-law of the poet, praised his uncle as "an unerring judge of the merits of any serious effort in the fine arts."[1] The present brief exploration will touch on some of the ways Coleridge came to judge pictures on a wall before him.

The graphic arts came into full existence for Coleridge, as for Wordsworth,[2] from acquaintance with Sir George Beaumont in 1803. After a week with the Beaumonts at Dunmow, Essex, in February 1804, he wrote to John Rickman:

> . . . I have learnt as much fr[om] Sir George respecting Pictures & Painting and Painte[rs as] I ever learnt on any subject from any man in the same Space of Time. A man may employ time far worse than in learning how to look at a picture judiciously. [*CL*, 2:1063]

Pompous though his second sentence might seem, it may have sounded eminently debatable to the statistical assistant to Parliament who received it; more to the point, it is replete with self-discovery. The "divine" paintings owned by Sir George made Coleridge "almost an apostate to Music" (1066). Although Beaumont's Coleorton Hall was not yet completed, many of the famous paintings later to enter the National Gallery hung at Dunmow or in the Beaumont's house in Grosvenor Square, where Coleridge stayed before leaving for Malta in March. From the Beaumont collection, we can identify among Coleridge's favorites a large, detail-packed Rubens, *Autumn, Chateau de Steen*—which made

1. *TT*, 2:219 n. See the list of abbreviations at the end of this chapter.
2. Martha Hale Shackford, *Wordsworth's Interest in Painters and Painting* (Wellesley, 1945), pp. 10–18.

identifiable contributions to Constable, Crome, and Turner[3]—and a
landscape by Richard Wilson, Claude-descended but throbbing with
human activity, *The Destruction of the Children of Niobe*.[4] In coloring,
Coleridge preferred Sir George's own landscapes to the Wilson—but
then Wilson was neither his tutor nor his host. For the moment, and I
think only for the moment, he was impressed by Nicolas Poussin's
Landscape, "Phocion" (National Gallery 40) and two Claude Lorraines
(*CL*, 2:1110). Given English taste for the previous hundred years, we can
understand why he found it worth three exclamation marks that any-
body less than a duke should own a Poussin, whether Nicolas or Gaspar.

Coleridge visited James Northcote, admired on his wall a work attrib-
uted to Bronzino, and was sketched by Northcote for a portrait, but
they did not take to each other. Beaumont made possible, however,
Coleridge's inspection in 1804 of several larger collections, notably that
later purchased from J. J. Angerstein to form the nucleus of the Na-
tional Gallery—Titian, Correggio, Sebastian del Piombo (*The Raising of
Lazarus*, the first work catalogued in the national collection), both Pous-
sins, Claude, Rubens (*The Rape of the Sabines*, NG 38), Rembrandt, Van
Dyck, Aelbert Cuyp, and works attributed to Domenichino and the
Carracci. Writing to Southey, Coleridge gave priority, perhaps by
chance, to the collection of Lord Ashburnham, which included a Cuyp
and a festival scene by Teniers. With a note from Beaumont, he visited a
prominent picture-cleaner to see a Salvator Rosa and "above all the
picture of St. Helena dreaming the vision of the Cross, designed by
Raphael & painted by Paul Veronese." This *Saint Helena* (NG 1041) has
been variously ascribed, but its diamonded pattern of diagonals has given
the majority vote to Veronese and has led more professional critics than
Coleridge to echo the spirit of his final remark, "That is a POEM
indeed!" (*CL*, 2:1110).

The weeks with Beaumont made Coleridge alert to the sunlight and
antiquities of Malta and appropriately poised for the conjunction of
Rome and Washington Allston in 1806. Allston, who gave him his best
chance to understand painters and Americans, also opened for him the
glories of Italian churches, frescoes, and galleries. He saw for himself the

3. Sir Charles Holmes, *The National Gallery*, 3 vols. (London, 1935), 2:59–60.
4. The Wilson was destroyed by enemy action in 1944. Other versions survive in the
Mellon Collection (Yale Center for British Art) and in the collection of the Earl of
Ellesmere.

supremacy of Raphael and Michelangelo. He had the two greatest visual orgies of his life—and, as we shall see, something more than visual orgies—in the Sistine Chapel, with Allston as guide, and at the Campo Santo in Pisa.

In the one note that has survived from his visit to the Uffizi in the spring of 1806 he remarks of *The Holy Family* of Parmigianino there that it was reworked (*"umarbeitet,"* for *umgearbeitet*) into the *Puck* (or *Robin Goodfellow*) and *Muscipula* (or *Mouse-Trap Girl*) of Sir Joshua Reynolds. He refers, one feels confident, to parallels between the somewhat coy solemnity of the Holy Mother, similarly repeated in the face of her child, and the respectively mischievous and knowing smirks of the Reynolds Puck and Muscipula. The almost identical curls of the holy child and of Puck extend down the center of the foreheads. This line of curls, double in the Parmigianino and single in the *Puck,* has its counterpart in one straight and one curved forelock extending to the sideward glance of the *Muscipula.*[5] As the facial form and expression of the two Reynolds paintings were available in widely circulated engravings, it is impossible to tell how long Coleridge's recollection of them had persisted. He could have seen the *Puck* at Samuel Rogers's in March. He was certainly not a regular visitor at Holland House, where the *Muscipula* hung, but he could have been there at several widely separated dates. Whatever the interval, his notation shows that he did carry from painting to painting a memory of expressive design that gave him a connoisseur's recognition of Reynold's reminiscence.

On his return to England with reproductions of the Italian masters, he planned at once a series of lectures at the Royal Institution on "the Principles common to the Fine Arts." For these he needed first his "collection of Prints from the Fresco Works of Raphael" (*CL*, 2:1190–91). Thereafter, he often visited collections of art along his way; in 1808, Angerstein's again; in 1810, Burleigh House, seat of Brownlow Cecil, the Marquis of Exeter, with a rich confusion of major and minor works in 145 rooms; in 1814, various collections in Bristol, the pictures of the Marquis of Lansdowne at Bowood, and the celebrated collection of Paul Cobb Methuen at Corsham House, representative of English interest in Italian painting of the Renaissance and the seventeenth century, landscape from the Poussins and after, and the later Flemish and Dutch

5. *CN*, 2:2853. The three paintings are reproduced in *CN* immediately following this entry, as plates 6–7.

painters. At Burleigh, Coleridge made note (surviving to us) only of *The Marriage of Boaz and Ruth* by Ciro Ferri (1637–89); at Corsham, among some 500 catalogued paintings he noted a Ferri and fifteen other works, including two large Rubens canvases and a Parmigianino, *Madonna and Child with Saint Jerome, Saint Mary Magdalen, and the Infant Saint John* (original in the Uffizi, identified descriptively by Coleridge as "Glass Painting looked at thro' colored Glass"[6]). The *Boaz and Ruth* stacks ingeniously one above another a delightful series of horizontals connecting triangles within diamonds; but perhaps Kathleen Coburn correctly identifies Coleridge's interest in the second Ferri as resulting from interest in the first, and his interest in the first as a resemblance between Ferri's Ruth and Sara Hutchinson (*CN*, 3:3995 n.). In any event, to exhaust the remaining evidence of Coleridge's visits to collections of art would be to mislead; the safe summary is that he visited unsystematically whatever collections opened along his irregular path.

A list of English artists that Coleridge knew but disliked or pointedly ignored (for example, Benjamin Robert Haydon) included most of those who painted portraits of him. In 1808, when John Landseer the engraver presumed upon their common ground as lecturers at the Royal Institution, Coleridge was too ill to see him and was unperturbed at the loss (*CL*, 3:50–51). He apparently gave little thought or attention to Constable or Turner. He disliked Fuseli's "horrors." He was not unique in disliking the poet Samuel Rogers but learning from Rogers's collection of paintings and drawings.[7]

He thought of Charles Robert Leslie and Samuel F. B. Morse largely as cooperative friends of the great Allston, even though Leslie "contrived to take a head of me which appears to be the most striking Likeness ever taken—perhaps, because I did not *sit* for it" (*CL*, 4:879). The remark was occasioned because Coleridge, who had not seen his daughter for five years, was confused by a picture of her—brought by Leslie for Coleridge to admire but actually by William Collins—and thought it

6. *BL*, 2:222–23; *CL*, 3:536; *CN*, 3:3995, 4227. Coleridge ascribed to John Martin the same sort of excessive accentuation: ". . . Martin never looks at nature except through bits of stained glass" (*TT*, 1:159). As early as 1799 he had made a notation to send Greenough a "Claude Lorraine [mirror] & the coloured glasses" (*CN*, 1:452). In 1803 he recorded experiments of his own, putting "the colored Glasses to my eyes as a pair of Spectacles, the red to the left, the yellow Glass to the right eye," etc. (*CN*, 1:1412).

7. G. F. Waagen, *Treasures of Art in Great Britain*, trans. Elizabeth Rigby, Lady Eastlake, 3 vols. (London, 1854), 2:73–82. Rogers spoke spitefully of the Beaumonts—as of almost everybody—to Coleridge's annoyance (*CL*, 2:964–65, 1093, 1098).

"the most beautiful Fancy-figure, I ever saw" (*CL,* 4:878, 892). The epithet "Fancy" here does not derogate, although it distinguishes a kind which is not portrait, not history, not genre. Assuming the picture to be by Leslie, Coleridge thought his daughter *might resemble it.* The composition, a figure seated with hands in lap, legs extended under a long dress diagonally, and feet crossed, resembles iconographically Gainsborough's portrait of Mrs. Richard Brinsley Sheridan,[8] with softening linear touches of Miss Muffett, Undine, and dreaming adolescence. After praising Collins's work for *"Natural fineness,"* as distinct from superimposed refinement, Coleridge went on: "Your landscape, too, is as exquisite in its correspondence with the figure as it is delightful to the eye, in itself" (892). Primarily, although contour would be subsumed, Coleridge's perception must rest on the interaction of tonal and color values that the eighteenth century had known as "keeping." Of such technical matters he had haphazard knowledge, but more than his untechnical language might convey.[9] He had learned especially from friends, Beaumont the earliest and Allston the most. The personal story boils down to these two. Coleridge writes to Leslie of Allston's genius, not of Leslie's talents. He seems to have regarded Benjamin West as a chilly painter and colder man, except in West's moments of championing Allston (*CL,* 3:352, 534).

Had Coleridge known no painters and seen few paintings, his theories of art might have been scarcely different. He begins at bedrock by distinguishing between imitation and copy. A copy has sameness; an imitation has sameness with difference. One of Coleridge's favorite examples, with a representative application of the distinction, appears in his statement of the principle in 1814 to the actor Charles Mathews:

> Now an *Imitation* differs from a Copy in this, that it of necessity implies & demands *difference*—whereas a Copy aims at *identity.* What a marble peach on a mantle-piece, that you take up deluded, & put down with pettish disgust, is compared with a fruit-piece of Vanhuysen's, even such is a mere *Copy* of nature compared with a true histrionic *Imitation.* A good actor is Pygmalion's Statue, a work of

8. Andrew Mellon Collection, National Gallery, Washington, D. C.

9. In "Satyrane's Letters" of 1809, revising letters of 1798–99 from Germany, he described Ratzeburg at evening, "the whole softened down into *complete keeping,* if I may borrow a term from the Painters." *The Friend,* ed. Barbara Rooke, 2 vols. (Princeton, 1969), 2:238.

exquisite *art, animated* & gifted with *motion;* but still *art,* still a species of *Poetry.*[10]

The basic distinction, noted by Petrarch, apparent in the argument of Joseph Warton and Edward Young against Richard Hurd, and explored by Adam Smith (cited by Coleridge) was carried further with the help of Schelling. It is perceptible in Aristotle, where I take it to oppose Plato's charge that imitation, in the form of impersonation in the speeches of epic and tragic poetry, conveys evil motives in persuasive form.

The distinction in itself leaves little room for the imagination to maneuver. But Coleridge has a further point to make: "Imitation is the mesothesis of Likeness and Difference," more or less as "Painting is the intermediate somewhat between a thought and a thing" *TT,* 1:91; 2:215). The difference enters with thought. The artist thus produces "the intermediate somewhat" instead of an imitative thing. In the fine arts, Coleridge argued in his essay on method, the initiative must proceed from within (*The Friend,* 1:448–524). And notice the implication: a poem is neither an object, a thing, nor an "immediate somewhat." A poem is mental; a picture is somewhat.

When we look into Coleridge's encounters with the picturesque, we find both convention and the unique Coleridge. In 1810 every educated Englishman, and many who were uneducated, approached the visual carrying the terms *beautiful, sublime,* and *picturesque* like buckets, each filled to the sloshing point with accumulated meanings.[11] For Coleridge as for most, sublimity in painting starts with Salvator Rosa. If John Martin embodied the material sublime, and Fuseli debased it with "Diableries,"[12] Salvator married material and psychic sublimity. Salvator's pictures of battles, banditti, and blasted trees possessed also the quality that Coleridge regarded as more essential than all others to the

10. *CL,* 3:501. Similar statements occur in *TT,* 2:218–19; *BL,* 2:6, 30, 56, 185, 255–61; *CL,* 6:1038; *PL,* pp. 291–92; *ShC,* 1:115, 117, 177–78; in other lectures and marginalia, and elsewhere. A later age might say that *even* flower paintings by the Huysum family possessed some difference from a copy, but in Coleridge's day the paintings of Jan van Huysum (1682–1749) were said to "excite as much surprise by their finishing, as they excite admiration by their strict imitation of nature." John Gould, *Biographical Dictionary of Painters, Sculptors, Engravers, and Architects,* "New Edition." 2 vols. (London, 1838).

11. For a convenient bibliography, see Walter John Hipple, Jr., *The Beautiful, The Sublime, and The Picturesque in Eighteenth-Century Aesthetic Theory* (Carbondale, 1957), pp. 377–84.

12. On Martin, *CN,* 3:4227; *TT,* 1:159; on Fuseli, *CL,* 1:135; *CN,* 1:742, 954 ("a Brusher up of Convulsia & Tetanus upon innocent Canvas").

sublime: obscurity, "the half perceived, yet not fixable, resemblance of a form to some particular object of a diverse class, which resemblance we need only increase but a little, to destroy, or at least injure, its beauty-enhancing effect, and to make it a fantastic intrusion of the accidental and the arbitrary, and consequently a disturbance of the beautiful." This description of half-conscious perceptions introduces a fragmentary essay on the essence of beauty, but the process, Coleridge concludes, "might be abundantly exemplified and illustrated from the paintings of Salvator Rosa."[13] Coleridge partook, inevitably, of the growing conception of sublimity as a power of the human mind ready to dissolve the restrictive limits of any external stimulus; yet his canon of the sublime remained incongruously physical.

Nowhere does he show much interest in the two Poussins or Claude. He does not bring the rules of picturesque asymmetry to the description of landscape paintings. He takes the word *picturesque* logically, not only in William Gilpin's sense of applying principles extracted from Nicolas Poussin for the determination of actual vistas outdoors, but in the negative sense that whatever is like a picture cannot be a picture. Coleridge, in more intense observation of actual landscape than Gilpin's, incorporates the discipline of the picturesque within his own kinesthetic responses. In November 1803, reading and meditating an essay by Christian Garve, "Über einige Schönheiten der Gebirgsgegenden," he noted:

> The effect ought not to be forgotten, that from the distance in mountain Countries being so distinct, you have a continual Inducement to look forward to the distance—whereas in flat Countries you look just before you, or on each side of you, at the turn in the Road, or the Flowers in the Hedge. Now there certainly is an intellectual movement connected with looking forward / a feeling of Hope, a stirring & inquietude of Fancy—. To look down upon, to comprehend, to be above, to look forward to, are all metaphors that shew in the original feeling a resemblance to the moral meaning christened thereafter. [*CN*, 1:1675.4]

He finds in his responses to landscape the original moral meanings that he expects the painter to transfer, along with the muscular dimension of composition, into oil on canvas.

13. *BL*, 2:250. On Salvator Rosa, see also *CN*, 1:1495 f67ᵛ, 2:1899.23. On the sublime, see also *BL*, 2:309 n.; *ShC*, 1:162, 220; 2:37, 104, 199.

A few months later, planning a series of poems on drawings and oil sketches by Beaumont, he conflated his sense of Beaumont's compositions with his own kinesthetic and emotional responses to the scenes invoked by Beaumont. On the left side of the second drawing, "a noble old Stump of a Tree with its picture-ward Horn not unantlered—: in the Center *A solitary Church* on a Hillock, unenclosed, unrailed, wild—!! behind it you see *down into* [the *to* of *into* cancelled] *upon* a flat vale /: the whole back of the Picture filled by Mountains in the Two Ridges—clouds upon them" (*CN*, 2:1899.2). His abbreviations and symbols for transliteration of spatial elements make quotation difficult, but part of his mnemonic description of the twenty-eighth drawing can illustrate further the way his practice on landscape of disciplined observation redounds on his responses to pictures: from the left edge, one-fifth of the horizontal foreground is occupied by a clear moat, "then commences the point of the beautifully hillocked & serrated Bay, whose other point reaches more than one third into the picture / near that point comes out a lingula of Land, one half as long as the lingula which forms that inner point of the bay, & so forms a bay within the bay, exactly a semi-oval, only that its inner line is longer by the half than the line" toward the lower frame. For Coleridge, writers on the picturesque had not deadened nature with the "mimic rules" against which Wordsworth complained, but had awakened a layman's mind to the interchanges between seeing and painting. The notebooks contain remarkable explorations of sublimity and unity in scenes of nature and civilization; several in 1804 show that Coleridge was to learn from Schelling only terminology and a dubious analogy between art and organic life.

With Lessing's *Laokoön* as his starting point, Coleridge developed a deep distrust of the Horatian adage *ut pictura poesis est*. Walter Scott had a "Rubens-like power of painting motion," but Spenser's descriptions are all medleys that "disregard time and space." [14] Although Coleridge could play at assigning stanzas of Milton's "Ode on the Morning of Christ's Nativity" to particular painters—stanza 15 "for the ceiling of a princely banquet-room, in the style of a Parmeggiano or Allston," stanza 23 "I think I have seen—possibly, by Fuseli"—Milton's poems and his own he took to be musical even where common error regarded them as picto-

14. Cited by Sara Coleridge, "Appendix on the Poetical Picturesque," in her edition of *Biographia Literaria*, 2 vols. (London, 1847), 2:442, 447. Cf. *ShC*, 2:85.

rial.[15] The corollary is equally true: the spider web on the poor box in the *Rake's Progress* series is "one proof of a hundred that every thing in Hogarth is to be translated into *Language*—words—& to act as words, not as Images" (*CN*, 3:4096).

One can predict certain deductions from Coleridge's theory that visual art is a collection of objects. After meeting Beaumont he had begun to wonder if knowledge, feeling, and taste could not be produced naturally, independent of wealth or other opportunity to study Raphael and Rembrandt, and he was to maintain thereafter the disinterestedness of all taste; but add it any way you liked, it clearly took wealth to live among great exemplars of the visual arts (*CN*, 1:1755; 3:3584; *TT*, 2:280). Painting had therefore, and for other reasons, not been as universal as poetry.

Painting is intermediate between a thought and a thing, but the *thing* that makes it possible is eminently and imminently perishable (*CN*, 2:2813). The sphere of "action," of influence, is incomparably less for painting than for poetry, and the chance of physical annihilation is far greater. Even in the Sistine Chapel, Coleridge says, he felt the pain of physical risk at all times to Michelangelo's conception (*CN*, 3:3286). A poem can exist without a page, but the visual arts are unalterably physical in their dress.

So much for the work of art. What of the worker: What kind of youth turns into a painter? Coleridge's high praise of Allston as a person comes often by way of contrast with other painters (*CL*, 3:352, 510). Allston grew into manhood with the conception before him of ideal beauty rather than of copying or imitation of *natura naturata*. Of Coleridge's acquaintance, Allston and Wordsworth so concentrated on ideal wholeness that they could work in a room of "broken gallipots" or a "dusty Paper-wilderness"; whereas Southey and—Coleridge adds—S.T.C. needed a "Lady-like Wholeness" in their physical surroundings (*CN*, 3:4250). Most young painters, lacking "the Love of *Beauty*," grow into selfish, greedy, envious scoundrels who go into a neat room and paint for money. Thank God for Allston.

Intimacy over several periods, in Rome, London, and Bristol, led Coleridge to find increasingly in Allston's paintings the painter's own

15. *Miscellaneous Criticism*, ed. T. M. Raysor (Cambridge, Mass., 1936), p. 184; *BL*, 2:14, 103.

aspirations. Of Allston's "large Scripture Piece" of three years' labor, *The Dead Man Revived by Touching the Bones of the Prophet Elisha* (fig. 41), Coleridge wrote to a friend when it was exhibited in Bristol, July 1814:

> ... I was more than gratified by the wonderful Improvement of the Picture, since he has restored it to his original Conception. I cannot by words convey to you, how much he has improved it within the last Fortnight. Were it not, that I still think (tho' ages *might* pass without the world at large noticing it) that in the figure of the Soldier there is too much motion for the distinct Expression, or rather too little expression for the quantity & vehemence of Motion, I should scarcely hesitate to declare it in it's present state a *perfect* work of art. Such Richness with such variety of Colors, all harmonizing, and while they vivify, yet deepen not counteract, the total effect of a grand Solemnity of Tint, I never before contemplated. [*CL*, 3:517]

A century and a half later, nearly every reviewer in the *Times Literary Supplement* had learned how to complain of "our society's continuing commitment to content at the expense of form in all the arts."[16] Coleridge conceives the harmony of colors as subservient to the harmony of subject, but his commitment to *idea* enables him to require a harmonizing of the several harmonies in "the *perfect* work of art." On this ground he had been a teacher to Allston—and in other fields than painting, to greater minds than Allston's.

After following the eye of the observer from figure to figure in *The Dead Man Revived*, in his third essay "On the Principles concerning the Fine Arts" (a series undertaken partly to promote Allston and this painting), Coleridge concluded with a generalization similarly applicable, he thought, to Raphael's *Galatea*:

> You will find, what you had not suspected, that you have here before you a circular group. But by what variety of life, motion, and passion is all the stiffness, that would result from an obvious regular figure, swallowed up, and the figure of the group as much concealed by the action and passion, as the skeleton, which gives the form of the human body, is hidden by the flesh and its endless outlines![17]

16. Terence Hawkes, *TLS*, 26 November 1976, p. 1480.
17. *BL*, 2:234. Shawcross found in this passage and that following it on Raphael's *Galatea* a separation of form and content, but the separation of perceived form and felt subject exists chiefly in the polarity of objects to be reconciled through the psychological process of

Attracted though he is by line and contour, he has learned under tutelage to praise the submersion of contour beneath a communicated sense of motion and passion.

He had something less definite to learn. Acquaintance with Beaumont and soon after with Allston had opened Coleridge's perceptions like two sudden descents of Zeus. Coming to know Charles and Eliza Aders, at the end of 1812 or early 1813, had a more gradual effect, with consequences that are not easy to demonstrate. Aders introduced a taste for northern, "Gothic," early Flemish and German (and later Nazarene), pre-Raphaelite, unclassical work soon to overspread Victorian England.[18] In the notable collection Aders began to assemble about 1817, Coleridge would have seen, and often, paintings attributed to the van Eycks, Petrus Christus, Lucas van Leyden, Martin Schöngauer, Hendrik Bles, and Cornelius Engelbrechsten, as well as a few noteworthy Italian paintings and work by current artists later to be more prized than in their own time. Knowing that Coleridge admired the early Flemish and German works, and would have thought about them, does not tell us what he thought. Of Catharine de Predl, a protegee of Mr. and Mrs. Aders who did "a very fine Likeness in Chalk" of Coleridge, he remarks on a firm line typical of the early northern painters, but his examples for comparison are Italian:

> Her painting is more like the best specimens of Andrea del Sarto and Fra Bartholomeo, than I have ever seen—and as to Drawing, I question whether any of our English Artists, unless it be Lawrence, . . . could approach to the perfect science & yet delicate stroke of her pencil. [*CL*, 6:588]

Confirmation of Coleridge's preference for line over color lies not in Dutch realism—with a Christ child or other children "just like the little rabbits we fathers have all seen with some dismay at first burst"—but in the firm linear manner of successive early paintings that he comes upon

creation (*BL*, 1:197–98, 202; 2:12). The philosophic critic analyzes the whole into its reconciled opposites. The polarity of subject and opposite constitute two ways of viewing the same whole. For Coleridge's remarkably topographical and kinesthetic response to Allston's *Diana and Her Nymphs in the Chase*, in 1806, see *CN*, 2:2831.

18. M. K. Joseph, *Charles Aders . . .*, Auckland University Bulletin No. 43, English Series No. 6 (Auckland, 1953); John Steegman, *Victorian Taste: A Study of the Arts and Architecture from 1830 to 1870* (London, 1970), pp. 10–48. In Frank Davis, *Victorian Patrons of the Arts: Twelve Famous Collections and Their Owners* (London, 1963), the taste for northern art is reflected only in the collecting of the Prince Consort.

for the first time surprised by joy. For the exception, his favorite colorist, Rubens, he appeals to an aesthetics of infinity: "In other landscape painters the scene is confined and as it were imprisoned;—in Rubens the landscape dies a natural death; it fades away into the apparent infinity of space" (*TT*, 1:237, 238). One could, of course, point to paintings with firmly outlined figures arranged in open form, but Coleridge's Rubens substitutes openness for line in every portion of the work.

If Coleridge's delight in Rubens does not directly challenge the nephew's dictum that his eye was "almost exclusively, for the idea or universal," it leads us toward a challenge. The fullest account we have of Coleridge's responses to paintings came about when the nephew and his wife, Coleridge's daughter, encountered him amidst the annual loan exhibition of the British Institution in 1831. Each recorded a few of his remarks. The paintings exhibited, representative of English collectors' taste during the first third of the century, made it inevitable that viewers would particularly notice later Flemish and Dutch painting, but Coleridge's comments as he stood before *Archers Shooting at a Target*, by David Teniers (1610–90), typify certain of his preferences:

> Observe the remarkable difference between Claude and Teniers in their power of painting vacant space. Claude makes his whole landscape a *plenum*: the air is quite as substantial as any other part of the scene. Hence there are no true distances, and every thing presses at once and equally upon the eye. There is something close and almost suffocating in the atmosphere of some of Claude's sunsets. Never did any one paint air, the thin air, the absolutely apparent vacancy between object and object, so admirably as Teniers. . . . See the distances between those ugly louts! how perfectly true to the fact! [*TT*, 1:232–35]

In his own art, the romantic seeks the universal in the dynamic particular, but concentration on the particular enables the romantic to respect and enjoy an effort to achieve surface realism of fact—on occasions when no principle of hierarchy is involved. A Crabbe and a Teniers can be admired, so long as they are not put in competition with a Milton or a Raphael.

The possibilities of stylization learned from Aders's early northern pictures could not be tested in the exhibition of 1831, where Coleridge's favorite was Rubens. The seven paintings by Rubens in the exhibition

included *The Triumph of Silenus*, which Coleridge found wonderfully libidinous. (Sir Robert Peel, the owner, had employed a breeches painter to cover the ultimate indecencies.) The poet stood before *Landscape, Sunset* (NG 167) and thought also of the Rubens landscape owned by Beaumont, *Autumn, Chateau de Steen* (NG 66): Rubens extracts "latent poetry" out of "common objects," though his beastly goddesses and heroes show that he has no comprehension of the spiritual (*TT*, 1:237). With or against his will, Coleridge was clearly drawn to the *thingness* of northern art.

Parties at the Aders's included Francis Danby, John Linnell, Samuel Palmer, and William Blake, all at this period in their several ways visionary. In 1818 the Swedenborgian C. A. Tulk elicited from Coleridge comments on *Songs of Innocence and of Experience* as experiences of the eye. Coleridge reported first to H. F. Cary on these "Poems with very wild and interesting pictures, as the swathing," by "a man of Genius," a "mystic *emphatically*" (*CL*, 4:833–34). Blake afforded him the pleasure of proclaiming himself sane and ordinary by comparison. He comments on poems and illuminations separately, in disjunction. Blake has weighted the illuminations with two disadvantages, poor anatomy and "despotism in symbols." Specifically, concerning the general title page and plate 2 (the piper with celestial child and sheep—"such as only a Master learned in his art could produce"), Coleridge complains of bad draftsmanship:

> . . . occasionally, irregular unmodified Lines of the Inanimate, sometimes as the effect of rigidity and sometimes of exossation— like a wet tendon. So likewise the ambiguity of the Drapery. Is it a garment—or the body incised and scored out? The *Limpness* (= the effect of Vinegar on an egg) in the upper one of the two prostate figures in the Title page, and the *eye*-likeness of the twig posteriorly on the second—and the strait line down the waist-coat of pinky gold-beater's skin in the next drawing, with the I don't know whatness of the countenance, as if the mouth had been formed by the habit of placing the tongue, not contemptuously, but stupidly, between the lower gums and the lower jaw—these are the only *repulsive* faults I have noticed.[19]

19. *CL*, 4:836–37. Coleridge saw the copy later available to Garth Wilkinson for the first reprint (1839). For a fuller discussion of Coleridge's comments see B. R. McElderry, Jr., "Coleridge on Blake's Songs," *Modern Language Quarterly* 9 (1948): 298–302.

The tone, as well as Coleridge's high praise for most of the poems he specifies, makes the point clear: it is not inability he is trying to describe for Tulk, but perversity.

Unsatisfied with surface realism and suspicious of the visionary in art, Coleridge prized above all the ideal. In the symbols of the ideal there would be no despotism, but full harmony with the medium employed to reveal the translucent particular. Acquaintance with early northern art would have reinforced the experiences in Italy to bring about his insistence that the arts might improve steadily in technique and dexterity but not, to go by the record, in substance:

> Painting went on in power till, in Raffael, it attained the zenith, and in him too it showed signs of a tendency downwards by another path. The painter began to think of overcoming difficulties. After this the descent was rapid, till sculptors began to work inveterate likenesses of perriwigs in marble,—as see Algarotti's tomb in the cemetery at Pisa,—and painters did nothing but copy, as well as they could, the external face of nature. Now, in this age, we have a sort of reviviscence,—not, I fear, of the power, but of a taste for the power, of the early times. [*TT*, 1:181]

To interpret these remarks according to Coleridge's basic aesthetics, substance and technique were as one at the height of painting, before dexterity began to outpace substance. Some such discovery Coleridge made in Italy in 1806. Although he declared in 1815 that ideally he would summer in Zurich, for "German depth, Swiss ingenuity," and spend the rest of the year "alternately at Rome and in Florence," his discovery of ideal fusion can be traced to the Sistine Chapel and the Campo Santo at Pisa (*CL*, 4:569).

In the philosophical lectures of 1819 he described the Pisan mural *Il Trionfo della morte* as an idea, a Platonic idea of death, the scattering of all except miserable beggars from the approach of the dreadful goddess, an example of Platonism as the possibility of search for the essential powers of things "as they exist in the Supreme Mind": "There, from all the laws of drawing, all the absence of color (for you saw no color—if there were any you could not see it, it was gone) it was one mighty idea that spoke to you everywhere the same."[20] Coleridge returned to the coincidence of

20. *PL*, p. 168. The mural, by an unknown artist, was ascribed by Vasari to Andrea

Platonism in the Pisan muralists, Michelangelo, Dante, and the post-Aquinian philosophers again and again.[21]

Confronting the masterpieces of Michelangelo, Coleridge's gothic romanticism moves in stark divergence from Shelley's romantic hellenism. Shelley reported to Peacock on the Sistine Chapel:

> I cannot but think the genius of this artist highly overrated. He has not only no temperance no modesty no feeling for the just boundaries of art, (and in these respects an admirable genius may err) but he has no sense of beauty, and to want this is to want the essence of the creative power of mind. . . . What a thing his Moses is, how distorted from all that is natural & majestic only less monstrous & detestable than its historical prototype.[22]

The difference comes down at bottom to those detestable biblical prototypes. Coleridge's Plotinized Platonism receives the sanction of his belief in the Holy Trinity of three in one. Here rises still another significance of Aders's northern primitives. Coleridge wishes evermore to see a painting of the Holy Family, with no smirk on the face of the child and a kinesthetically convincing projection of the Holy Ghost.

From 1803 Coleridge looked at pictures and landscapes with eyes enriched by the words of books and friends concerning the picturesque and the sublime. Told how to follow the hand of Beaumont and the longer reach of Allston, he practiced not only on engravings—print shops and portfolios were the Time-Life (including television) of his day—but more keenly in the midst of natural scenery offering opportunity for sharpened and imaginatively unified perception. Frequently if unsystematically he stood before walls filled with the available masterpieces. Almost everything within him, the customs and manner of almost every painter he met, almost all his belief in imagination, told him that

Orcagna but usually by Coleridge, for convenience and impact, to Giotto. For a reproduction (from an engraving) and a description see Robert Gittings, *John Keats* (Boston, 1968), p. 280, pl. 39. Leigh Hunt, without any of Coleridge's Plotinian Christianity, concurred on arrival at Pisa that the muralists there (rather than "the Massaccios and Peruginos") were the real inspirers of Raphael and Michelangelo. The tomb of Algarotti that Coleridge marks as periwigged proof of artistic decline in substance receives Hunt's disinterested praise. "Letters from Abroad, Letter I.—Pisa," *The Liberal*, No. 1 (1822): 109–15.

21. See *CN*, 2:2856–57; *PL*, pp. 167–68, 193; *TT*, 1:179–80; *Miscellaneous Criticism*, pp. 7, 10; *CL*, 4:569.

22. *The Letters of Percy Bysshe Shelley*, ed. Frederick L. Jones, 2 vols. (Oxford, 1964), 2:80. Coleridge is specific about the role of Greek genius in Christian idealism in *PL*, p. 257.

no adornment of walls could compare with Beethoven or the greater heights of poetry. Like Wordsworth's leech-gatherer, he persevered. He learned progressively about design and technique, especially in landscape painting. More than one would expect, he came to admire realistic imitation of nature. With a uniform theory of the arts to mount upon, he could in several great moments pay his highest tribute to a picture: it was true poetry. Even so, he could risk only Dante and Milton, not Shakespeare, for comparison.

Abbreviations Used in Citing Works by Coleridge

BL *Biographia Literaria*, ed. J. Shawcross (2 vols., London, 1907).
CL *Collected Letters of Samuel Taylor Coleridge*, ed. Earl Leslie Griggs (6 vols., Oxford, 1956–71).
CN *The Notebooks of Samuel Taylor Coleridge*, ed. Kathleen Coburn (vol. 1, London, 1957; 2, New York, 1961; 3, Princeton, 1973).
PL *The Philosophical Lectures*, ed. Kathleen Coburn (New York, 1949).
ShC *Shakespearean Criticism*, ed. T. M. Raysor (2 vols., London, 1960).
TT *Specimens of the Table Talk of the Late Samuel Taylor Coleridge*, ed. H. N. Coleridge (2 vols., London, 1835).

WILLIAM WALLING

More Than Sufficient Room:
Sir David Wilkie and the
Scottish Literary Tradition

I

The midnight torch gleamed o'er the steamer's side,
And Merit's corse was yielded to the tide.

J. M. W. Turner, "The Fallacies of Hope"[1]

Perhaps no artist has been accorded a more successful—and ambiguous—memorial than the one Turner painted for Sir David Wilkie in 1841–42, shortly after the latter's death on the homeward leg of a visit to the Holy Land. From a sufficiently jaundiced point of view, in fact, Turner's remarkable *Peace—Burial at Sea* (fig. 42) may be said to have eclipsed Sir David Wilkie himself, inflicting upon his memory the exact inversion of what Mark Antony was able to accomplish so effectively for Caesar. In a word (to keep to the jaundiced Antonian view), Turner came to the Royal Academy Exhibition of 1842, not to praise his long-time rival with a speech, but to bury him with a painting.

The provocative use of black (most particularly for the sails of the vessel from which Wilkie's body was being so obscurely lowered into the water), the quite deliberate decision to paint the scene as if viewed from the Spanish mainland, somewhere in the vicinity of Gibraltar (because of quarantine regulations the steamship *Oriental* had been compelled to sail from Gibraltar into the Atlantic, where, at latitude 36.20, longitude

1. Printed by Turner in the catalogue of the Royal Academy Exhibition of 1842 to accompany *Peace—Burial at Sea* (no. 338).

6.42, Wilkie's body had been consigned to the sea), the composition by Turner of a couplet for the ever-convenient "Fallacies of Hope" in order to suggest that the burial had occurred at "midnight" (in reality Wilkie had been buried 1 June 1841 at 8:30 P.M., still twilight at that hour in that latitude and longitude)—all these together could easily support a judgment that *Peace—Burial at Sea* is the almost stunning concentration of Turner's genius upon the utter (and utterly final) waste of Wilkie's artistic potential.

"Renown in vain taps at the door," Turner had written of Wilkie thirty years before his death, lamenting the younger man's willingness at that time (1810 or 1811) to remain within the tradition of Dutch and Flemish genre painting which had brought him so enviable a fame at so early an age. "I only wish I had any colour to make them blacker," Turner remarked thirty years later of the sails that brooded over Wilkie's scarcely distinguishable body in *Peace—Burial at Sea*. But with this remark he left the possibility forever open that he had in truth intended a devastating verdict in his memorial painting upon the "second" style Wilkie eventually developed. For the dispute over the merits of that "second" style was a commonplace in Wilkie criticism during the later years of his career. Indeed, Wilkie's deliberate pursuit of a style grander and more sweepingly dramatic than the laboriously composed genre pictures of his early fame had led him finally to Spain in 1827–28, where, beginning with pictures like *The Spanish Posada* and *The Maid of Saragossa*, he had made a conscious attempt to emulate the darker tones (that is, the "blackness," as many of Wilkie's contemporary critics perceived it) and the bolder compositions (though surely none are bolder than Turner's own in *Peace—Burial at Sea*) of Velasquez and Murillo. And Velasquez and Murillo, of course, were masters of that same Spain from which Turner, by the retention of the outline of the Rock of Gibraltar in his composition, had compelled the informed viewer of *Peace—Burial at Sea* to contemplate the spectacle of Wilkie's extinction.[2]

2. Although B. R. Haydon, for one, thought that Italy rather than Spain had been Wilkie's "ruin," my own simplifications are hardly extreme, especially in terms of the radically simple drama Turner gives us. See Allan Cunningham, *The Life of Sir David Wilkie*, 3 vols. (London, 1843), 2:417, 459, 507; 3:6, 16, 474; Frederick Brill, "On Turner's 'Peace—Burial at Sea,' " *Painters on Painting*, ed. Carel Weight (London, 1969), pp. 25–27; A. J. Finberg, *The Life of J.M.W. Turner*, 2d ed. (Oxford, 1961), pp. 314, 390–91, 507; and Lawrence Gowing, *Turner: Imagination and Reality* (New York, 1966), pp. 28–31.

II

His death [is] yet more remembered than his life, through the great
picture which tells us of the passionate affection of Turner.

<div align="right">Sir Frederick Wedmore, 1880[3]</div>

But whatever the ambiguities we choose to find in Turner's memorial
tribute, they surely dwindle into insignificance beside the larger drama
of the revolution in taste which was soon to overtake Wilkie's name.
Indeed, it was a revolution in taste so extreme that by 1880, as the
epigraph of this section indicates, Wilkie was already beginning to find
no surer basis for immortality than in the gloss his name provided upon
Peace—Burial at Sea. As for Turner, none of us will have to be reminded
of the quite different direction his reputation has taken. The first great
painter of "modern" art (as we have all had to learn to the level of cliché),
Turner looms for us today even larger than for his contemporaries, the
extraordinary figure whom, earlier than any other of the nineteenth
century, "we meet . . . with a sense of recognition."[4] In short, the
"revolution in taste" to which I have alluded can be conveniently—if
evasively—described as one aspect of a very broad prelude to what we
now call by the slippery name of "modernism."

No doubt the revolution in Wilkie's and Turner's particular case offers
a contrast too extreme to permit even the illusion of a simple answer.
Nonetheless, it may be useful to invoke a modest point of reference in
connection with the area of Wilkie's achievement which had seemed
most secure to his contemporaries—those earlier triumphs of genre art
beginning with *Pitlessie Fair* (1804) (fig. 43), and continuing through *The
Blind Fiddler* (1806) (fig. 44) *Blind Man's Buff* (1813) (fig. 45), and *The
Letter of Introduction* (1814) (fig. 46). Exactly one quarter-century after
Wilkie's death the remarkably belated "discovery" of Vermeer's great-
ness had begun, with all its concomitant effect upon our understanding
of the nature of successful genre painting. It was the beginning of a
transformation in our critical understanding we perhaps have yet to
fully comprehend. But we can at least gauge something of its long-term
consequence through the readily available evidence of the treatment of

3. *The Masters of Genre Painting* (London, 1880), p. 231.
4. Gowing, *Turner*, p. 56.

"Genre" in one of the standard reference works of our own time, *The Encyclopedia of World Art* (1962). For there we find Vermeer praised for the dreamlike "immobility" and "formal integration" of his best work, painterly achievements in pure construction which lie far beyond "story, anecdote, or argument"—and which are therefore seen to carry his art to the highest level yet attained in the history of Western genre painting.[5] Consequently, T. S. R. Boase is right to point to the striking prominence Wilkie held in British art during the first part of his career:

> Any connoisseur, either English or continental, looking back at this Academy [of 1813] from any point in the next thirty years would probably have selected as the most important picture Wilkie's *Blind Man's Buff*. . . . A new bias had been given to English art by this young, lanky Scot from the Fifeshire manse of Cults.[6]

But what is needed in addition to this helpful reminder is a clearer sense of the dynamics involved in the subsequent decline of Wilkie's fame.

My aim in the following pages, then, will be to define a more appropriate context for the discussion of Sir David Wilkie than we are likely to get through the resources of a conventional historical scholarship—or even through the general invocation of that long revolution in taste to which we are all, in any case, only partially conscious heirs. Thus, by attending to Wilkie's art in relationship to what is rather loosely known as "the Scottish literary tradition," I hope to arrive at a criticism responsible enough to illuminate certain neglected aspects not only of Wilkie's achievement but of that complex literary tradition as well.[7] And since the

5. Gordon Bailey Washburn, *Encyclopedia of World Art*, 6 (New York, 1962), pp. 94–96. For the "discovery" of Vermeer in 1866, along with the argument that it represented a milestone in modern formalism, see André Blum, *Vermeer et Thoré-Burger* (Geneva, 1945).

6. *English Art: 1800–1870*, Oxford History of English Art, vol. 10 (Oxford, 1959), pp. 153–54.

7. For Wilkie's relationship to the art of Scotland I have found most useful three older books: Lord Ronald Charles Sutherland Gower, *Sir David Wilkie* (London, 1902); Edward Pinnington, *Sir David Wilkie and the Scots School of Painters* (Edinburgh and London, n.d.); James L. Caw, *Scottish Painting: Past and Present 1620–1908* (Edinburgh, 1908). Two more recent studies—Ian Finlay, *Art in Scotland* (New York, 1948) and William Buchanan, "Nineteenth-century Scottish Painting," *Antiques* 98 (July-Dec. 1970): 394–99—have not been as useful as I had hoped. For my general understanding of the Scottish literary tradition I have found the following two books most helpful: Kurt Wittig, *The Scottish Tradition in Literature* (Edinburgh and London, 1958); John Speirs, *The Scots Literary Tradition* (London, 1940). A good brief account of this tradition can also be found in the introductory chapter to David Daiches's *Robert Burns* (New York, 1950).

notion of a useful relationship between different arts inevitably suggests an extremely large generalization, let me indicate at once that my major concern will be directed towards four particular paintings in conjunction with four particular literary works. Other paintings and other works of literature will be mentioned in the course of my discussion, but these four pairings are meant to retain as much of the critical virtue of particularity as I can conceive, within the admittedly problematic context I am trying to establish: Wilkie's *Pitlessie Fair* (1804) and Robert Fergusson's "Hallow-fair" (1772); Wilkie's *The Letter of Introduction* (1814) and John Galt's *Sir Andrew Wylie* (1822); Wilkie's *The Refusal* (1814) (fig. 47) and Robert Burns's "Duncan Gray" (1792); Wilkie's *The Blind Fiddler* (1806) and Sir Walter Scott's *The Antiquary* (1816).

III

The Earl of Mansfield no sooner saw *Pitlessie Fair* [in 1806] than he felt its beauty as a composition, and had enough of old Scotland in him to perceive that it was as true to the people as the sun is to summer.

Allan Cunningham (*Wilkie*, 1:95)

"Its beauty as a composition" is hardly the point likely to strike a critic of *Pitlessie Fair* today. Encountering the 140 or so figures crowded onto Wilkie's canvas, the critical eye hesitates, and it hesitates not only in uncertainty at the appropriate place to begin but also with the sense of some conflict in the demands being made upon its attention. (Leonardo's famous dictum concerning the unique potential of the painterly medium—that "in an instant" a painting will show what a poem is able only to suggest, "bit by bit"[8]—comes into the memory with more than a hint of ironic inappropriateness.) Impelled by custom at least as much as by common sense, the eye looks once more towards the center of the crowded canvas. But even here, at what seems the heart of the milling figures, we can find no secure moment of rest. To be sure, an open space is provided for us in the foreground, leading us on and inward to the dwarflike figure whose curved back and extended arms begin the near-circle which the barking dog and the curious ox help to almost complete. Yet radiating out from either side are conflicting calls upon our atten-

8. *The Literary Works of Leonardo da Vinci*, trans. Mrs. R. C. Bell, ed. Jean Paul Richter, 1 (London, 1970), pp. 60–61.

tion. To the left we are drawn into the little comic drama of recruitment: a rustic youth with a credulous expression on his face gazes in obvious absorption at the ramrod-straight recruiting officer, whose back alone is presented to us. To the right, however, another comic drama is in process: a dwarflike couple are squabbling in the foreground, and as we glance back from them to the center, to the dwarfish figure *there,* we can scarcely avoid perceiving that his extended right finger, which points so clearly to the head of the ox while he eggs the barking dog on, is also directing our gaze past the two animals to the queer quarreling couple. And even as we absorb *this* fact, we realize that the stout matron standing above the dwarfish pair is egging *them* on, while she holds an oblivious thumb-sucking infant in her arms.

At this point we may be tempted to look back to the little recruitment drama. And this time the two gray-haired men who flank it make a larger claim upon our attention. The one to the right of the credulous youth is clearly beating a drum. As such, then, he is a significant part of the almost hypnotic process which is drawing the youth into committing himself to long years of service: the impressively erect recruiting officer with the sword at his left hip, the flashy uniform displayed so prominently between officer and drummer, the sound of the drum itself. Yet to the left of the recruiting officer another gray-haired man appears to be —is it possible?—openly mocking the entire procedure by thumbing his nose at it. It is, in fact, a comic act of subversion that Wilkie presents—one, moreover, that he apparently intended us to understand as the reaction of a discharged veteran to the same sort of display that, years ago, had once seduced *him* into military service.[9] But even here the critical eye is impelled in conflicting directions: the drum, we suddenly realize, presents in its surface that complete circle which the dwarf and the dog and the ox on the immediate right are already suggesting in more open form, while the raised drumstick finds its sharply contrary continuation in the walking stick on the left which is being held so tightly under the left arm of the man who has just purchased an apple for his female companion. Nor does it seem entirely fanciful to discern in the walking stick—the tip of which, on the flat surface of the canvas, is pointed directly at the head of the credulous, about-to-enlist youth—the suggestion of a rifle.

9. See the anonymous verse description of *Pitlessie Fair* reprinted in Cunningham, *Wilkie*, 1:63.

We might continue this sort of response to *Pitlessie Fair* for a good deal longer, but certain critical conclusions should already be clear. Most obvious is the demand Wilkie's painting makes on us for a "reading." As Lindsay Errington remarks, "*Pitlessie* must be read as a series of verses, not swallowed down in a single gulp like an Impressionist scene."[10] Perhaps not quite so obvious, however, are two further conclusions which I have already tried to suggest and which serve to refine the kind of "reading" we are invited to make. First, unlike "a series of verses," *Pitlessie Fair* gives us no certain place to begin; and second, the various "readings" *Pitlessie Fair* does propose offer us no secure moral direction by which we can organize our response.

It is this last point, I suspect, which best helped the nineteenth-century critic to distinguish Wilkie from another British artist whose work demanded a patient "reading": William Hogarth. To quote the ever-shrewd Hazlitt, writing in 1815: "Hogarth never looks at any object but to find out a moral or a ludicrous effect. Wilkie never looks at any object but to see that it is there."[11] We may be inclined to resist the overly neat antithesis of this. Indeed, for at least some of us, the absence of Hogarth's moral concentration is what most leads Wilkie into the sentimentalities of his weaker pictures. But although it would be useful to pursue still further the contrasting ideas of order we find in Wilkie and Hogarth, it seems potentially even more illuminating to first consider *Pitlessie Fair* in connection with one of the earliest poetic successes in the Scottish literary renaissance of the eighteenth century, Robert Fergusson's "Hallow-fair."[12]

It is, in fact, Fergusson's "Hallow-fair" which Errington cites as an apt illustration of the "series of verses" he believes *Pitlessie Fair* resembles. "*Pitlessie* could . . . well be described as a picture with a narrative ballad form," he writes. "Its composition, like that of the poem *Hallow Fair*,

10. *Sir David Wilkie: Drawings into Paintings* (Edinburgh, 1975), p. 7.

11. "On Mr. Wilkie's Pictures," *The Champion* (5 March 1815), reprinted in *The Collected Works of William Hazlitt*, eds. A. R. Waller and A. Glover, 11 (London, 1904), p. 249.

12. "With 'Hallow-fair' Fergusson reached his full stature as a poet," Allan H. MacLaine, *Robert Fergusson* (New York, 1965), p. 70. In writing about this remarkable poet, whose creative life ended in madness at the age of twenty-three, I have drawn especially upon *Robert Fergusson: Essays by Various Hands*, ed. Sydney Goodsir Smith (Edinburgh, 1952). "Hallow-fair" can be found in the *Penguin Book of Scottish Verse*, ed. Tom Scott (1970), as well as in the standard edition, *The Poems of Robert Fergusson*, ed. Matthew P. McDiarmid (Edinburgh and London, 1956), 2:89–93. It is the latter text which provides the basis for my quotations.

resembles a string of beads in that it appears, on close inspection, to break down into a number of very disconnected episodes whose only real link with each other is that they occur at a fair."[13] Yet we have already seen how this apparent similarity must be qualified in at least one important sense. Unlike a painting, "Hallow-fair" presents us with a quite different order of seriality:

> At *Hallowmas*, whan nights grow lang,
> And starnies shine fu' clear, ∠stars
> Whan fock, the nippin cald to bang, ∠folk, beat
> Their winter *hap-warms* wear, ∠wrappings
> Near Edinbrough a fair there hads, ∠holds
> I wat there's nane whase name is,
> For strappin dames and sturdy lads,
> And cap and stoup, mair famous ∠cup, cask
> Than it that day.

This is the first stanza of thirteen, and it clearly functions as a prelude to the twelve stanzas of narrative which follow it and which succeed one another with the fixed consecutivity of the verbal medium on a conventionally printed page.

Nevertheless, this relative lack of flexibility in the verbal medium finds its appropriate antithesis in Fergusson's much greater freedom to suggest the passage of time. Consider the justly admired opening of the narrative proper, the first four lines of stanza 2:

> Upo' the tap o' ilka lum ∠chimney
> The sun began to keek
> And bad the trig made maidens come
> A sightly joe to seek.

What we have, of course, is a vigorously presented sunrise, displayed to us in an intensely social fashion. And from this noticeably un-Wordsworthian "common dawn," Fergusson proceeds to an account of a full day of activities at the fair itself (stanzas 2–8), back to Edinburgh for a night of carousing (stanzas 9–11), and from there to a description of the ensuing consequences of being arrested by the City Guard while publicly drunk—a fine of a "groat" the "neist day," along with an ap-

13. *Wilkie: Drawings into Paintings*, p. 6.

pearance in "the Council-chawmir,/Wi' shame" (stanzas 11–13). In short, "Hallow-fair" carries us across an entire day and into the next; *Pitlessie Fair*, on the other hand, is constrained by its own medium to suggest to us the sweep and variety of a fair through the illusion of a wonderfully concentrated moment.

There are, to be sure, significant similarities between painting and poem. Most apparent, perhaps, is Fergusson's choice of a recruitment scene for *his* presumed center (the seventh stanza of "Hallow-fair," the precise midpoint of the poem's thirteen stanzas):

> The dinlin drums alarm our ears,
> The serjeant screechs fu' loud,
> "A' gentlemen and volunteers
> "That wish your country gude,
> "Come here to me, and I sall gie
> "Twa guineas and a crown."

But if we do pursue this sort of comparison for any length we can hardly avoid perceiving the different potentials of the two media: *Pitlessie Fair* can only suggest the "dinlin drums" through Wilkie's representation of a raised drumstick above the flat circle of a drum, "Hallow-fair" contrarily, gives us a pretty good approximation of the range and even *kind* of sounds we might expect to be associated with a recruitment scene, as the just-quoted lines make clear. And the distinction even deepens when we allow proper weight to the verbal specificity of the sergeant's recruitment speech as opposed to Wilkie's necessary reliance in *Pitlessie Fair* upon a straight red back with a sword on its left hip, a credulous youthful face below a rustic's cap, and an empty dress uniform.

A much more interesting similarity, however, resides in an issue that transcends both local detail and the varying potentials of different artistic media—the denial in painting and poem of any secure formal center. We have already seen how this denial functions in *Pitlessie Fair*: our eye is led across an empty foreground into the midst of more than a hundred milling figures, and there we encounter what would seem to be the hub of all this swarming activity—the circular surface of a drum and the parodic near-circle formed by a dwarf, a barking dog, and a curious ox. Yet we quickly realize that this particular center (like another, rather more famous one) cannot hold. Indeed, in what I hope might be a suggestive contrast for admirers of a painter like Vermeer or Cezanne,

the larger formal drama of *Pitlessie Fair* would seem to resolve itself into a tension between rounded natural forms (treetops, clouds) and angular manmade objects (chimneys, rooftops, tent- and flagpoles), were it not for the insistent human and animal activity which fills so much of the canvas. For, as I have already suggested, the drum and drumstick are hardly an adequate formal condensation of this larger tension, even if we allow the condensation its full human content. Quite simply, there are too many other kinds of activity going on in *Pitlessie Fair*—I think almost randomly of the dog urinating in the lower righthand corner of the canvas, below a rope stretched taut by a recalcitrant heifer—to be encompassed within any coherent formal pattern.

And this same denial of a secure center occurs in "Hallow-fair" as well, with much the same consequence for any formal criticism of the poem. Thus, on its most obvious level, we encounter Fergusson's so-called episodic presentation: almost half the stanzas are concerned not with the fair itself but with its aftermath.[14] A good deal less obvious, however, is the general effect of divided emphasis created by a narrative that opens by leading us to expect "trig maidens" and "sightly joes," and then proceeds to involve us, in the poem's most sustained dramatic event, with a drunken rowdy named *"Jock Bell"* who is brutally mauled by the City Guard (stanzas 9–11).

But it is in Fergusson's specific manipulation of language that we appropriately find the most nearly exact correspondence to Wilkie's use of *his* medium to deny the imposition of any formal coherence. Consider, for example, the eighth stanza of "Hallow-fair," perhaps the most successful in the entire poem:

Without the cuissers prance and nicker	∠lancers
An' our the ley-rig scud;	∠over, grass-field
In tents the carles bend the bicker,	∠old men, wooden mug
An' rant an' roar like wud.	∠mad
Then there's sic yellowchin and din,	∠yelling
Wi' wives and wee-anes gablin,	
That ane might true they were a-kin	∠believe
To a' the tongues at Babylon,	
Confus'd that day.	

14. In these general terms, Wittig's comment on Fergusson within the larger context of the Scottish literary tradition seems appropriate here: "Scots poetry is usually more interested in the details of a mosaic than in the total conception or structure" (*The Scottish Tradition*, p. 181).

It is the last time we encounter the fair itself in Fergusson's poem, and the confusion of "tongues" is surely his verbal equivalent to Wilkie's kaleidoscopic visual representation of the fair's activities. For not only does Fergusson begin his next stanza with a delightfully droll disjunction of styles to indicate the coming of night and the removal of many of the fair's now-drunken participants to Edinburgh—"Whan *Phoebus* ligs in *Thetis* lap, / Auld Reikie gies them shelter"—he is also clearly taking pains throughout "Hallow-fair" to represent a broad range of contemporary Scots dialects. Thus, in stanza 5, "Sawny" speaks an Aberdeen version of Scots, reproduced by Fergusson with almost the exactitude of a philologist;[15] while in stanza 11 Fergusson is evidently delighted at his chance to represent the Highlander's difficulty with certain consonants:

> A Highland aith the serjeant gae ∠oath
> "She maun pe see our guard."
> Out spak the weirlike corporal,
> "Pring in ta drunken sot."

Often praised, this aspect of Fergusson's art has usually been misunderstood. Edwin Muir's comment is perhaps the best known:[16]

> Fergusson's use of dialect Scots was infinitely more close and workmanlike than Burns's; one feels, indeed, that had he lived he might have continued, with his genius for words, to turn dialect Scots into a literary language, for it is evident from his poetry, as from no other Scottish dialect poetry, except the Ballads, that he is thinking in terms of the language he uses.

My own sense, however, is that it is precisely Fergusson's *resistance* to turning Scots "into a literary language" which provides so much of the ultimate verbal energy in "Hallow-fair." Hence the broad range of styles—the classical allusions rubbing shoulders with the vernacular of "Auld Reikie," the variations played upon the same Edinburgh vernacular by the portrayal of characters from Aberdeen and the Highlands, the climactic lines describing the fair itself, with their reference to "a' the tongues at Babylon, / Confus'd that day"—all this together suggests Fer-

15. See Albert D. Mackie, "Fergusson's Language," in *Robert Fergusson*, ed. Smith, pp. 139–41, and Matthew McDiarmid's notes in the standard edition, 2:271–72.

16. "Best known," that is, because of Muir's challenge to singleminded admirers of Burns. The passage is cited, with his own approval, by Hugh MacDiarmid, in "Direct Poetry and the Scottish Genius," in *Robert Fergusson*, ed. Smith, p. 61.

gusson's implicit challenge (however unconscious he may have been of casting one) to the adequacy of his own language to encompass the experience being presented. In brief, like *Pitlessie Fair*, Fergusson's poem conveys most surely the sense of a powerfully felt social life which, because of the nature of its representation, seems to suggest the inadequacy of any formal design to contain it.

Moreover, this seeming resistance to imposing a coherent pattern on social experience has the obvious consequence we have already glanced at in considering Wilkie's relationship to Hogarth—the absence of any secure moral direction for our response to *Pitlessie Fair*. Yet the same observation might be made about Fergusson's "Hallow-fair." David Craig, for example, has complained of the moral insensitivity he finds in a poet like Fergusson, eighteenth-century renaissance in Scotland or not:

> Much of the action in . . . "Hallow-fair" is horseplay, gross and dirty, and the poet's attitude is to revel in the discomfiture of the butt who falls down in the gutter. . . . The real destructiveness and brutality of such a life is . . . lost sight of in Fergusson's . . . kind of rollicking comedy.[17]

Clearly, this is a dangerous opinion to disagree with, for to challenge it runs one into the risk of seeming callous. Nevertheless, the question ought still to be asked whether an overt moral concern like Craig's wouldn't have resulted in a significant loss of vitality for Fergusson in the practice of his art. It is the same kind of question we will have to return to more than once in considering the course of Wilkie's later career— although there, in Wilkie's extended confrontation with a culture other than his own (Fergusson by contrast died at twenty-four, in a Scottish asylum), we may decide that the real issue is a good deal more complicated than the rather simple moral antithesis nineteenth-century critics repeatedly invoked in contrasting Hogarth to Wilkie.

IV

> When I was in Scotland I considered that every thing depended on my success in London; for this is the place of encouragement for people of our profession, and if we fail here we can never be great anywhere.
>
> Wilkie to his father, 1806 (Cunningham, 1:102)

17. *Scottish Literature and the Scottish People, 1680–1830* (London, 1961), p. 37.

An observation by Delacroix from the late 1820s can serve today to remind us of one of the most problematic issues we are likely to face in the attempt to understand the overall shape of Wilkie's career. "He seemed to me," Delacroix wrote upon seeing Wilkie in Paris in 1828, "to have been brought utterly out of his depth by the pictures he had seen. How is it that a man of his age can be so influenced by works which are radically opposed to his own?"[18] Coming as it does in response to Wilkie's radical change of style in Spain, Delacroix's comment also raises for us a larger question, that of Wilkie's vulnerability in the face of any art grander and more fully sanctioned by tradition than those works (Teniers's and Ostade's especially) he had first taken as his models under Sir George Beaumont's guidance shortly after his arrival in London in 1805 with the completed *Pitlessie Fair*. Doubtless it is a question much too unwieldy to be answered in any brief space. But even to consider the futility of trying to answer it here does lead us in turn to the more modest—and manageable—issue of a localized, discernible confrontation between different cultural styles. And it is with the dynamics of this confrontation that I want to concern myself in considering Wilkie's *Letter of Introduction* (fig. 46) and John Galt's novel of 1822, *Sir Andrew Wylie*.

Surely one of Wilkie's finest paintings, *The Letter of Introduction* was first exhibited in 1814, a conveniently exact midpoint between Wilkie's arrival in London nine years earlier and the painting generally regarded as the close of his "first" style, *The Parish Beadle* of 1823. For it was soon after the completion of *The Parish Beadle* that Wilkie's health began to break down badly, leading eventually to his extended tour of the Continent (begun in 1825), with the visits to Italy and especially Spain resulting in the "new" style that dismayed so many of his contemporary admirers. Moreover, 1814 was also the year in which Wilkie experienced his first direct encounter with Continental art, journeying to Paris and the Louvre in the late spring, after first consigning *The Letter of Introduction* to the Royal Academy Exhibition. Accordingly, there is something unusually appropriate about the wonderful equilibrium of tension we find in *The Letter of Introduction* between the provincial and the established, the youthful and the more than middle-aged, the would-be entrant into a richer world and the not entirely secure inhabitant of that same world who himself has so obviously arrived there so many years

18. Cited in Richard Muther, *The History of Modern Painting*, 2 (London, 1896), p. 112.

earlier. Thus the sword on the wall above the desk is not only a reminder of the older man's self-conscious awareness of his "gentle" descent (and hence of his ostensibly secure place in the established order), it also serves as a witty commentary on the nature of "heroism" in modern society, a heroism which the anxious young man is exemplifying so perfectly in his attempt to rise above his provincial origins.

Nor would it be at all difficult to continue the same sort of analysis of other details in *The Letter of Introduction*. The massed array of books in the background, the bust on the wall in the upper right-hand corner, the not quite so distinct vases on top of the bookcase, the prominent Chinese jar in the lower right-hand corner, the elaborate design on the covering of the old-fashioned chair, the thick heavy volumes on the desk—each of these suggests in its different fashion the achieved finality of an attained objective; and they therefore operate together, with splendid antithetical wit, against the painfully tense expression of the young man just begin-ning the effort to make a place for himself in the world (or, as the fashion of a few years ago had it, to achieve his own "identity").

Perhaps the most remarkable feature of *The Letter of Introduction*, however, is the impression it gives of Wilkie's refinement of one of the striking qualities we examined earlier in *Pitlessie Fair*—the denial of any dominant center of interest. For if the objects I have mentioned suggest an achieved finality, the oldish man seated in the chair is clearly on the far side of that implicit self-containment. And although *The Letter of Introduction* must be classified as an example of "anecdotal painting," it seems worth mentioning that there are anecdotes and then there are anecdotes. In *The Letter of Introduction*, in the conflicting demands made upon our attention by tense suppliant and uneasy recipient, we en-counter something very close to the inexhaustible energy of a symbolic equipoise between two different yet equally authentic kinds of "culture."

Unfortunately, in *Sir Andrew Wylie* it is precisely the thinness of the "anecdote" which makes Galt's long novel such a disappointment for even his admirers. Galt himself has told us that his original idea was to give "a view of the rise and progress of a Scotchman in London."[19] Yet one of his most sympathetic critics has nearly said it all when he observes that Galt's conception of Andrew is the actual literary "original of the Scot of low comedy and popular jest," the prototype, in short, of that

19. *The Autobiography of John Galt*, 2 vols. (London, 1833), 2:239.

now all-too-familiar figure of absurd stinginess and shrewd self-advancement we have all met in any number of jokes.[20] Thus the usual explanation for the weakness of *Sir Andrew Wylie*—that in it Galt's deepest creative energies were thwarted by the "galling harness" of a formal plot[21]—is somewhat wide of the mark.

Admittedly Galt does reflect in his best work something of the same tendency we saw earlier in Fergusson—a resistance to imposing any formal pattern on experience. And no one would deny that the leisurely, episodic *Annals of the Parish* (1821), with its time-span of fifty-one years and its corresponding fifty-one chapters of diverse social chronicle, is somehow a far more satisfying artistic entity than *Sir Andrew Wylie* with its "beginning, middle, and an end."[22] But the real failure of the later novel is attributable not so much to the artificial formality of its pattern as to the inadequacy of Galt's imagination in confronting the even more fundamental social dynamics of his original theme, "the rise and progress of a Scotchman in London."

Let us take but one of the distracting examples of this inadequacy. In chapter 12 Galt's hero encounters London for the first time. Quickly finding himself lost among unfamiliar surroundings, he wanders aimlessly for hours, unable to make any progress towards his destination, the law office where he is to begin his apprenticeship. Finally, by a stroke of pure luck, he meets with one of his old schoolfellows from Scotland, the latter now transformed into a sophisticated young man about London. Asked by this old friend why, as a means of solving his difficulty, he did not call a coach, Andrew replies, "in the utmost astonishment":

> "Me hire a coach! . . . Na, na, demented as I hae been, I was nae so
> far left to myself, to be guilty of ony sic extravagance. Me hire a
> whole coach! Ah! Charlie, Charlie, I maun ca' mair canny; and ye
> ken I never had ony turn for gentility like you."

The old friend himself then proceeds to hire a coach for the two of them. But, before stepping in, Andrew says: "Now, mind, Charlie, ye're

20. S. R. Crockett, "Introduction," *The Works of John Galt: Sir Andrew Wylie*, ed. D. S. Meldrum III (1895) (rpt. New York, 1968), p. xiii. This is the edition I have used for my quotations.

21. See Keith M. Costain, "Theoretical History and the Novel: The Scottish Fiction of John Galt," *ELH* 43 (1976): 342–43; Frank Hallam Lyell, *A Study of the Novels of John Galt* (Princeton, 1942), p. 96; Ian A. Gordon, *John Galt* (Edinburgh, 1972), pp. 44–48.

22. Galt, *Autobiography*, 2:239.

to pay for't a'; I'l no be a single bawbee; for I hae laid it down as a rule no
to waste a plack on ony sort of pleasure." There is a good deal more of
this sort of thing, but the general dynamics of what Galt is about in
portraying Andrew's first encounter with London should be clear: the
young, ambitious invader from the north is revealed to be a comical
eccentric with some laughably harmless foibles about spending money
and about being duped. It is a set of dynamics, in short, not so very
different from what black Americans sometimes describe as the
"Step'n'-fetchit syndrome," and there may be something more than
mere literary chance in the success *Sir Andrew Wylie* enjoyed in England,
where it proved to be Galt's most popular novel.

Yet as the title *Sir Andrew Wylie* leads us to expect, Andrew's eventual
success in English society is so great that he achieves the rank of baronet.
Indeed, before the novel is finished we find Andrew on familiar terms
with George III, charming the king completely, while remaining comi-
cally true to his own Scottish heritage. The degree of wish-fulfillment in
this is manifest, I think.[23] Nevertheless, as I have already suggested, the
wish-fulfillment Galt gives us is not really bold enough. Hence the
Scotsman who succeeds so spectacularly in the wealthier, more powerful
south is never endowed with qualities which might make him a truly
threatening intruder into English society. And, in fact, it is only through
the largesse of an English earl and his lady that Andrew finally gains his
title.

We could, from this, go on to construct a reasonably persuasive bio-
graphical explanation for the contrast between the splendid equipoise of
The Letter of Introduction and the distracting contradictions we enounter
in *Sir Andrew Wylie*. Wilkie, after all, had actually achieved great success
in England (and beyond) by 1814; Galt could only hunger after it for
much of his life. But it seems more useful to conclude with a reminder
that the theme we have been considering bears a significant relationship
to the overall direction of this study. For Wilkie, as for each of the writers
we are concerned with, the existence of a potential English and even
European audience, with the promise of all the recognition and reward
that such an audience might grant, exerted a continual pressure on the
shape of their art. Yet clearly theirs was an art which had had its origins

23. Some years after the publication of *Sir Andrew Wylie* Galt did indeed appear at the
court of George IV, but without the spectacular success of his hero; see Jennie W.
Aberdeen, *John Galt* (London, 1936), p. 115.

and still found its deepest roots in a culture no longer in the mainstream of modern European society, neither in terms of its traditions, its language, nor its economy.

V

It may be observed, that success only follows intense devotion and unwearied study . . . yet all this is like water spilt in a desert, unless the mind moulds and forms its speculation to the circumstances of its situation and the ruling desires of the times. . . . To know, then, the taste of the public—to learn what will best please the employer—is to an artist the most valuable of all knowledge.

Wilkie, 1836 (Cunningham, 3:143–44, 148)

With Wilkie's *The Refusal* (fig. 47) we come unavoidably for the first time in considering his work to the issue of "sentimentality." Based on an incident in Burns's "Duncan Gray" and completed early in 1814, *The Refusal* was exhibited at the Royal Academy that same year, along with *The Letter of Introduction*. Yet in no way can *The Refusal* be considered the equal of its companion piece as a work of art, however genial and technically accomplished *The Refusal* surely is. It may be of some interest to consider why.

Part of the problem, as I have already suggested, is one of sentimentality. But sentimentality resembles "obscenity" in at least one exasperating way: its surest place is in the eye of the beholder. A preliminary word of definition is probably in order, then. We are likely to judge a work of art as sentimental at the point when we become conscious that an overt appeal is being made to us for emotional responses stronger than the subject itself would seem to warrant.

Such a definition, whatever its other shortcomings, is at least useful for a closer consideration of the incomplete success of *The Refusal*. The subject matter is simple enough. As we know from Burns's poem, the moment before us in the painting is one soon after Meg's adamant rejection of Duncan's proposal of marriage. Yet Wilkie in his treatment has so overburdened Burns's simple comic song with palpable designs upon our emotions that the closer we look at the canvas, the more disturbing becomes our sense of Wilkie's unnatural straining. And eventually, with near-fatal application, Burns's own comment on his song comes into mind: "Duncan Gray is that kind of light-horse gallop of an

air which precludes sentiment."[24] For in the painting we can perceive all
of this—the faces of two giggling eavesdroppers through the partly open
doorway; Meg's mother to their right, looking at her daughter with the
tender concern of one woman consciously sharing with another a realm
of experience closed to men; Meg's father, his hand on his daughter's
shoulder, gazing down at her with what appears to be speechless love;
and Meg herself sitting with tautly folded hands, carefully avoiding
everyone else's glance. As for Duncan, the little finger of *his* hand
dimples his cheek in vexation, his other hand clutches his hat, and his
entire posture of comic dejection is parodied by the dog beneath his
chair. Once more, in short, we are confronted by the obvious fact that
there are anecdotes and then there are anecdotes. But unlike the admi-
rable aesthetic balance of *The Letter of Introduction, The Refusal* offers a
composition which, sooner or later, seems certain to strike us as being
much too affectively anxious. Indeed, because of this elaborate attention
to emotional states, *The Refusal* finally suggests a paradoxical gentility, in
spite of the great skill with which the rustic kitchen is evoked.

Yet Burns, we know, had his own problems with "Duncan Gray." For
one thing, the strongest complaint he ever made on the difficulty of
composing in English rather than in Scots occurs in connection with his
attempt to turn the galloping tune of "Duncan Gray" into a fashionable
English song:

> These English Songs gravel me to death.—I have not that command
> of the Language that I have in my native tongue. . . . I have been at
> "Duncan Gray," to dress it in English, but all that I can do is
> deplorably stupid. [3:1458–59]

As a result, the English song he did produce—"Let not Woman e'er
complain / Of inconstancy in love" (2:743)—is strikingly vapid and even
"sentimental" in comparison to the jaunty Scots version Wilkie chose as
his starting point for *The Refusal* ("Duncan Gray came here to woo, / Ha,
ha, the wooing o't," 2:667).

Even here, however, in the version Wilkie chose, there is a further
complication. For Burns published *two* Scots versions of "Duncan Gray,"
the earlier one ("Weary fa' you, Duncan Gray, / Ha, ha, the girdin o't,"

24. To George Thomson, 19 Oct. 1794, cited in *The Poems and Songs of Robert Burns*, ed.
James Kinsley, 3 vols. (Oxford, 1968), 3:1458–59. Parenthetical references in my text to
subsequent citations of Burns will be from this edition.

1:393) being a good deal earthier than the text underlying *The Refusal*. And if we go still further and consider the version of "Duncan Gray" we find in *The Merry Muses of Caledonia* as the closest of all in spirit to the bawdy folk original (as I think we must), then we encounter an additional *lack* of refinement as the root source of Wilkie's work. For in *The Merry Muses*, the "girdin" of Burns's earliest published version of "Duncan Gray" ("Weary fa' you") is here allowed its fully sexual, folk connotation of "grinding," in the act of love:

> He kiss'd her butt, he kiss'd her ben,
> He bang'd a thing against her wame;
> But, troth, I now forget its name;
> > But, I trow, she gat the girdin' o't.
> > > [3:1266]

The range from "Let no Woman e'er complain" to this "Duncan Gray" from *The Merry Muses* is, to put it mildly, a rather wide one. Nor would much more than a quarter of it be encompassed under the rubric of "sentimentality" with which I began. Yet a combined rubric of "sentimentality" *and* "obscenity" might be of help—at least so far as a reminder of the ever-present tension between an artist's desire to satisfy an audience and his need to satisfy himself. But for Wilkie, as for Burns, there were particular problems involved in the sense of what a "cultivated" audience demanded; and if we turn from the various versions of "Duncan Gray" to "The Cotter's Saturday Night," it is there that we will probably find a truer analogue in Burns's poetry to the mixed success and failure Wilkie had with *The Refusal*.

VI

My ambition is got beyond all bounds, and I have the vanity to boast
that Scotland will one day be proud to boast of David Wilkie.

Wilkie to his father, 1806 (Cunningham, 1:110)

Although it was a common pastime in the first half of the nineteenth century to discover parallels of creative accomplishment between Wilkie and Scott,[25] we seem far more likely today to find interest in parallels of a

25. See, for example, Catherine Gordon, "The Illustration of Sir Walter Scott: Nineteenth-Century Enthusiasm and Adaptation," *Journal of the Warburg and Courtauld Institute* 34 (1971): 297 ff.

rather different sort. The parallel I have in mind in particular for Wilkie and Scott is the melancholy one suggested by the similarity of their critical fates as the nineteenth century began to wane. Indeed, it would probably require a nice discrimination of judgment to decide which of these two figures, each so honored and world-famous in his own lifetime, has suffered a greater loss of prestige dówn to the present: the now but obscurely remembered Wilkie or the now relatively little read Wizard of the North. In this section, then, through the juxtaposition of Wilkie's genre picture of 1806, *The Blind Fiddler* (fig. 44) with the novel Scott himself declared to be his own favorite, *The Antiquary* (1816), I want to make a modest attempt at understanding a little better something of the dynamics involved in that critical decline.

Of *The Blind Fiddler* Hazlitt declared in 1815 that it contained the only overt "joke" he could remember in all of Wilkie's work—the boy at the other end of the fiddler's audience who is sawing away at the bellows in clownish mimicry.[26] We see what Hazlitt means, of course, although I suspect we would prefer his using another word than *joke*. And, in fact, the boy's mimicry might even serve for some of us as an emphatic formal device, effectively creating, beneath the seeming diversity of reaction in the figures between fiddler and mimic, the more than suggestion of a closed circle (a suggestion further reinforced by the pointing fingers, in exact opposition to one another, of the man playing with the child). This, at any rate, seems to have been the impact the composition of *The Blind Fiddler* made on Cunningham, who declared it to be, "in unity of purpose . . . probably the finest work of Wilkie" (1:144).

But the superior "unity of purpose" which Cunningham finds in *The Blind Fiddler* leads in turn to some suggestive reflections upon the distance Wilkie had traveled in the two years since he had painted *Pitlessie Fair* in Scotland, using a chest of drawers for his easel. We know, for example, that *The Blind Fiddler* was the first painting commissioned from Wilkie by Beaumont. We know further that some years later Wilkie wrote to his advisor and friend to indicate his ever-increasing awareness of the need, even in crowd-scenes, "to concentrate the interest to one point, and to improve the composition by making it more of a whole" (Cunningham, 2:48). And we also know that, while working on *The Blind Fiddler*, Wilkie had one of Beaumont's old masters—a Teniers—at his

26. *Collected Works*, 11:251.

disposal as a model, his first sustained and direct contact with the more formalized structures of European painting. (In later life, on the fateful trip to Spain, Wilkie described Velasquez in his journal as "Teniers on a large scale.") Yet despite Cunningham's judgment of the superior unity of *The Blind Fiddler*, we can still perceive the painter's resistance to the imposition of a wholly formalized pattern.

The resistance is one nowhere near so pronounced or instinctive as that in *Pitlessie Fair*. But in the eleven figures (I include, of course, the dog) which come between the fiddler and his mimic, we again encounter something of that strongly felt sense in the earlier painting of the unmanageable energy and diversity of social life. The child (presumably the fiddler's) warming her hands at the fire and oblivious to the music, the standing gray-haired man with a look of revery on his face, the two children in front of him who are gazing in thorough absorption at the spectacle of the fiddling, the seated woman to their right who is entirely intent on the face of her own infant. And so on. Indeed, in a really charming touch, Wilkie allows two childish sketches (said to be based on his own early efforts) into the right-hand side of the painting, directly above the head of the mimic, as if to indicate his own quiet skepticism about the adequacy of any form of "imitation"—including his own. Hence Hazlitt's designation of the boy with the bellows as an overly transparent "joke" may be one more example of his critical shrewdness: for with an ambivalence perhaps not entirely clear to himself, Wilkie seems to have both been tempted by the attraction of a formal pattern (no doubt owing in part to Beaumont) and been drawn to repeating the kind of swarming and unpatterned diversity he had first depicted in *Pitlessie Fair*. In short, then, the boy with the bellows must finally be judged as only a gesture toward a formal device instead of being the successful embodiment of one.

Yet much the same thing might be said about Lovel, the ostensible "hero" of *The Antiquary*. We all know, of course, how easy it is to ridicule Scott for his "plotting" of *The Antiquary*. E. M. Forster provides in his *Aspects of the Novel* a classic case of comic deflation, demonstrating almost luxuriantly the inadequacies of Scott's formal organization. Nor would it be difficult to construct a damning criticism of the novel in terms much more responsible than Forster's. For the theme of *The Antiquary* seems clear enough. As its title suggests, Scott's novel comes back again and again to a consideration of the interrelationship between present and

past. Unfortunately, novels (unlike themes) must come to an end. And Scott, no doubt wanting to give his long story the appropriately dramatic illusion of closure he felt his public wanted, brings the good fortune of his "hero" Lovel emphatically forward in the final chapter. But it is precisely here, in the emblematic weight Lovel is meant to carry in *The Antiquary*, that a serious critical problem resides.

Even Scott's most passionate adherents are compelled to admit this. Thus Edgar Johnson, who finds "the clearest thematic unity" in *The Antiquary*, yet must concede that Lovel is in fact "much more nearly the conventional pasteboard hero that conventional criticism has dismissed all Scott's heroes as being"—and, as such, "he is consequently a rather unsatisfactory focus . . . and . . . a somewhat inadequate symbol."[27] In simple fact, however, Lovel is, as a sympathetic but less anxious critic of Scott has remarked, "the extreme among Waverley heroes in the discrepancy between the significance of his role and the insignificance of his character."[28] He drops completely out of the novel before it is half through, reappears only for the final chapter under an entirely different name, and is given still another identity during the course of *that* chapter when he is revealed to be, in a huddled dramatic exposition, the true son and heir of the Earl of Glenallan. To describe him as "a somewhat inadequate symbol" for the mutual redemption of past and present, then, is surely to be generous to a fault.

For the real critical issue in *The Antiquary*, of which Lovel's inadequacy is only symptomatic, is the uneasy marriage between two different modes of creative response to experience. On the one hand, we have Scott almost reveling in the variety and comedy of social relationships (it is easy to see why this was his own favorite among all his novels); on the other hand, his sense of an audience and his own unwillingness to pursue seriously any aesthetic alternative led him into the negligent gesture towards a formal pattern that the "hero" of *The Antiquary* suggests. The same uneasy marriage operates in most of Scott's other novels as well, of course, and the unsatisfying quality of his "heroes" has become a critical cliché. But it is in *The Antiquary*, I think, that we come closest by analogy to the weak "joke" Hazlitt discerned in the inadequate echo of a youthful mimic within the composition of *The Blind Fiddler*.

27. *Sir Walter Scott* (New York, 1970), 1:538. For my own reading of *The Antiquary* I have used the two-volume edition in the Edinburgh *Waverley* (1901).
28. Francis R. Hart, *Scott's Novels* (Charlottesville, 1966), p. 255.

Furthermore, an uncanny coincidence deserves to be noted in any discussion of Wilkie's and Scott's shared confrontation with the problems of a formal patterning. In *The Antiquary* we encounter a broad range of social types, most of them deriving a particular kind of vitality from their own recognizable place in the traditional life of Scotland at the close of the eighteenth century. Compared to Lovel, in fact, each of these figures reflects a much richer particularization of character, rooted as each one is in a set of ongoing social relationships entirely denied to the novel's "hero." And it is here, in the most memorable of these figures, the beggar Edie Ochiltree (who, in the words of at least one modern critic, "steals the book"[29]), that the uncanny coincidence resides. For we know that Scott based the character of Edie Ochiltree on an actual beggar who was famous around Edinburgh during the period in which *The Antiquary* is set—one Andrew Gemmells (see Scott's own preface to the novel). Yet this same Andrew Gemmells also supplied Wilkie with the prototype for one of the most striking figures in his first significant painting, *Pitlessie Fair*—the gray-haired man who, to the left of the recruiting officer, is seemingly thumbing his nose at the entire military charade (Cunningham, 1:63). And from this striking identity of source it seems possible to proceed to an even greater clarification of the discrepancy of tension Hazlitt first perceived in *The Blind Fiddler*. Like the childish sketches above the head of the youthful mimic in the later painting, the mockery of the gray-haired man in *Pitlessie Fair* can be seen to be nothing less than an instinctive, perhaps entirely unconscious, subversion of whatever formal implications the center of Wilkie's canvas might otherwise suggest (the rounded surface of the drum, for example, and the parodic near-circle beside it). Nor is the relationship of Ochiltree to the "hero" of *The Antiquary* essentially different, for the beggar ranges across the entire social spectrum of the novel, is recognized and welcomed everywhere, possesses the soundest knowledge of historical tradition of any character, and in all respects serves as the most effectively vital foil to the formal design suggested by the rootless and history-less Lovel who exists wholly within, even as he abstractly forwards, the melodramatic "plot."

For precisely this reason, then, it may be that the usual criticism of Scott as "negligent" and "careless" about his art (I make the same charge

29. Ian Jack, *English Literature 1815–1832*, The Oxford History of English Literature, vol. 10 (Oxford, 1963), p. 193.

myself, a few paragraphs back) is something of an injustice. Wilkie was neither "negligent" nor "careless." All the same, we find him in his later career reflecting a similar tendency to Scott's: again and again the effort to enhance the formal properties of a work of art results in a hollow theatricality. No doubt there are other reasons for this disjunction than the ones I have suggested. But the consequences of the disjunction itself are evident. To it, as much as to any single cause, we can ascribe the precipitous decline in critical reputation both men endured as the nineteenth century waned into the twentieth.

VII

The Waters were his Winding sheet, the Sea was made his Toome;
Yet for his fame the Ocean Sea, was not sufficient roome.

Richard Barnfield, *The Ecomion of Lady Pecunia* (1598)

We have seen, during the past hundred years, a steady growth in the formal conception of the arts. For the critic, much of this has been a good thing, and I have no wish to quarrel with it. Yet a formal conception of art for the criticism of Wilkie, a formal conception of the novel for a writer like Galt or Scott, even a formal conception of poetry for a poet like Fergusson[30]—somehow the critical tools seem overly precise and ultimately far too negative in their effect. At the same time, my own experience in this paper suggests to me that the sort of sympathetic assessment I have been attempting here is likely to result in nothing more certain than a sense of the unavoidable loss we have experienced in return for the greater precision of our formal understanding of art. Let me conclude, then, by trying to suggest something of the dimensions of the intellectual tradition I have felt shadowing me (the figure is a deliberate one) throughout this study.

Effectively in Vermeer, quite spectacularly in Turner, two of the most astonishingly original sensibilities ever to participate in the artistic tradition of the West first revealed to us the final, radical implications of light. For the one, this "poetry of light" (I quote André Blum) permitted the

30. Consider Raymond Bentman's comment: "Fergusson showed considerable promise as a poet but he did not express, in either themes or diction, the idea, which Burns developed so successfully, that distinction must be subordinated to connection." "Burns's Use of Scottish Diction," in *From Sensibility to Romanticism*, eds. Frederick Hilles and Harold Bloom (New York, 1965), p. 251.

portrayal of an order in which the potential activity of life was stilled to the timeless duration of eternal form; for the other, form itself was shown to be entirely at the mercy of the eternally ravenous power of light. Few of us will want to proceed from this to an acceptance of the suggestion originally made by Ruskin that Turner's truest subject is death—particularly since Ruskin himself had no chance to see those works in which Turner's own "poetry of light" is most triumphant. But we may want to consider further that in England, within a very short period of the dramatic transformation of Turner's art in 1818–19,[31] Keats was vainly trying to give form to a new conception of light (in the final creative struggle with *The Fall of Hyperion*), while Shelley, apparently an eternity beyond the earlier hope he had held for an increase of Promethean illumination, wrote in his own final days of a terrible chariot whose

> cold glare intenser than the noon,
> But icy cold, obscured with blinding light
> The sun, as he the stars.
>
> [*The Triumph of Life,* ll. 77–79]

The figure of Wilkie (or even of Scott) will surely seem a frail counter to the kind of critical tendency I have been suggesting. For we now know all too well where the roots of this critical tendency lie: in an intellectual tradition whose formidable origins we still call by the more than appropriately ironic name of "Enlightenment." But that Wilkie (or Scott) *will* seem frail as a counter in this context may be sufficient cause for a reaction at least as strong as regret—or so I would hope—in any sensitive critic writing today. That, at any rate, has been perhaps the most fundamental part of the argument underlying this study.

31. See n. 7 to Karl Kroeber's essay (chapter 9) in this volume. Ronald Paulson's discussion of Turner's use of light (chapter 10) also bears upon the argument of my final paragraphs.

JAMES A. W. HEFFERNAN

The English Romantic
Perception of Color

Some years ago, a distinguished literary critic said to me flatly that "Wordsworth does not see color." There is at least a grain of truth in this startling observation, for color is something that Wordsworth does not always *wish* to see. In a well-known passage of *The Prelude*, in fact, he chides himself for his onetime habit of judging natural scenes "by rules of mimic art," and he specifically recalls his infatuation with "meagre novelties / Of colour or proportion" (book 11.154, 160–61).[1] This tempts us to infer that Wordsworth's interest in color went the way of his youthful enthusiasm for the fashionable art of "picturesque" description. Guided by his own language, we may easily conclude that after the bright but superficial hues of "An Evening Walk" and "Descriptive Sketches," which he published in 1793, he turned from a poetry of picture to a poetry of feeling, from colors and proportions to "the moods / Of time or season" and "the spirit of the place" (*Prelude* 11.161–63). Wordsworth's presumed aversion to color thus becomes a part of his rebellion against what he calls the "tyranny" of the eye (*Prelude* 11.180).

But the passage from *Prelude* 11 is in fact a little misleading. He wrote it in 1804. Six years later, in the first published version of what later became his *Guide through the District of the Lakes*, he speaks of the seasons in plainly chromatic terms. In autumn, he says, the "rich green" of summer gives way to bright yellow, orange, and dark russet brown; and winter, he adds, brings an interplay of brown with olive and tawny

1. I quote from the text of 1805–06 in *The Prelude*, ed. Ernest de Selincourt, 2d ed. rev. by Helen Darbishire (Oxford, 1959).

green.[2] Wordsworth clearly *does* see color here. Indeed, his sensitivity to color was one of the very first things that Hazlitt noticed when he met the poet at Nether Stowey in 1798. Looking out the window of Coleridge's cottage, Wordsworth said, "How beautifully the sun sets on that yellow bank!" and Hazlitt thought to himself, "With what eyes these poets see nature!"[3] Wordsworth's "discovery," as Hazlitt calls it, was evidently the fact that in the light of the setting sun, the color of grass changes from green to yellow. In any case, shortly after their first meeting, it was a conversation with Hazlitt which prompted Wordsworth to write "Expostulation and Reply" and "The Tables Turned," where he invites his bookish friend to see that the setting sun "through all the long green fields has spread, / His first sweet evening yellow" (ll. 7–8).

I quote these lines not simply to show that Wordsworth actually did see color in some of his most characteristic poetry, but also to illustrate his way of seeing it. In 1815 he wrote that "in nature everything is distinct, yet nothing defined into absolute independent singleness" (*PrW*, 3:77). "Everything" includes color, and as Wordsworth represents them, colors are at once a means of individuation and a source of interaction, modifying each other in ways that are sometimes strikingly close to those we find in the landscape paintings of Constable and Turner. The yellowing of green turf in the light of the sun, for instance, is an effect superbly rendered in Constable's *Flatford Mill* of 1817.[4] What poem and picture jointly illustrate, I think, is the English Romantic perception of color.

I use this phrase with some degree of tentativeness. Quite aside from the discrepancy between the colors of a poem and the colors of a painting, Turner and Constable scarcely see the world through the same pair of eyes, and the golden radiance with which Turner characteristically fills his canvases is certainly not the same as the blue-green vibrancy that we so often get from Constable. But certain ways of looking at color are nonetheless common to both. What they share with each other and with Wordsworth and Coleridge is a perception of color fundamentally different from that of their Augustan predecessors.

The Augustan attitude toward color in art is representatively expressed in the fourth Discourse of Joshua Reynolds, who delivered it at

2. *The Prose Works of William Wordsworth*, ed. W. J. B. Owen and Jane Worthington Smyser, 3 vols. (Oxford, 1974), 2:176–77. Hereafter cited as *PrW*.
3. *Complete Works*, ed. P. P. Howe (London and Toronto, 1933), 17:118.
4. Reproduced in Leslie Parris et al, *Constable: Paintings, Watercolours & Drawings* (London, 1976), opp. p. 81.

the Royal Academy in 1771. In the previous discourse, Reynolds had said that "a firm and determined outline" was indispensable to the great style of painting.[5] Now he develops the point that color and chiaroscuro alike should be ruled by a principle of linear simplicity. "To give a general air of grandeur at first view," he says,

> all trifling or artful play of little lights, or an attention to a variety of tints is to be avoided; a quietness and simplicity must reign over the whole work; to which a breadth of uniform, and simple colour, will very much contribute. Grandeur of effect is produced by two different ways, which seem entirely opposed to each other. One is, by reducing the colours to little more than chiaro oscuro, which was often the practice of the Bolognian schools; and the other, by making the colours very distinct and forcible, such as we see in those of Rome and Florence; but still, the presiding principle of both those manners is simplicity. Certainly, nothing can be more simple than monotony; and the distinct blue, red, and yellow colours which are seen in the draperies of the Roman and Florentine schools, though they have not that kind of harmony which is produced by a variety of broken and transparent colours, have that effect of grandeur which was intended. [*D*, p. 61]

Reynolds thus defines two kinds of "simplicity" in the coloring of a picture. One of them reduces all colors to the light and dark of chiaroscuro, and in fact Reynolds says elsewhere that "however distinguished in their light, [colours] should be nearly the same in their shadows."[6] The other kind of "simplicity" epitomizes the Augustan belief that color was something to be kept in line. Newton, in his celebrated and highly influential *Opticks* (published 1704), divided light into the seven colors of the spectrum and thus endeavored to fix a place for each of them within established borders. Yet even after the *Opticks* appeared, color remained an agent of potential confusion, an enemy to order, structure, and line. In Pope's *Essay on Criticism* (1711), judgment and good sense correspond to "*Lines . . . drawn right*"; threatened by "*false Learning*," they are like a "justly trac'd" sketch which is disgraced by "ill *Colouring*." Similarly, Pope compares the impermanence of language to the fading of "*treach'rous*

5. *Discourses on Art*, ed. Robert Wark (San Marino, Cal., 1959), p. 52. Hereafter cited as *D*.
6. *The Works of Sir Joshua Reynolds*, ed. Edmund Malone (London, 1798), 3:157.

Colours" in a painting.[7] Painters themselves believed that "treach'rous" colors needed firm control. Hogarth saw "fixed and permanent colours" in every object, and the function of colors in painting, he thought, was to distinguish the parts of a picture more clearly—not to obliterate its outlines.[8] Reynolds is therefore typically Augustan when in Discourse IV he calls for the "simplicity" of "distinct and forcible" coloring. And he is equally so in a later Discourse when he condemns the softening and blending of colors "to excess," and insists that "the true effect of representation . . . consists very much in preserving the same proportion of sharpness and bluntness that is found in natural objects" (*D*, p. 197).

If every object were indeed sharp or blunt, and had a fixed and permanent hue, as Hogarth assumed, then separate colors would indeed convey "the true effect of representation." But neither Reynolds nor Hogarth tells the artist how to represent the indeterminate hues of the landscape, where yellow sunlight may invade green fields, and where the setting sun may leave behind it the "peculiar tint of yellow green" that Coleridge observes in "Dejection: An Ode" (l. 29). The atomistic coloring recommended by Reynolds simply did not match what the Romantic poets and painters saw in nature; for in nature, wrote Turner, "colors mingle, features join, and may converge."[9]

Colors began to mingle in Turner's own work as early as 1797, when at age twenty-two he did a watercolor version of *Buttermere Lake*.[10] His effort here to catch the subtle convergence of pink, blue, green, and white in a brightening sky of misted mountaintops was the start of a lifelong effort to represent color in action: to catch on paper or canvas the interfusion of colors which he found in nature itself. Sometimes he catches this phenomenon verbally. In a sketchbook used from about 1806 to 1808, he repeatedly tries to set down in words the running colors of the sky, which is "Greenish Blue" on one page, and on another "Greenish Gray yet yellowish."[11] A few years later, he notes "orange green" on a hillside and "purple shadow" on the sea (TSB 127, f. 32).

7. Ll. 19–25, 484–93.
8. *The Analysis of Beauty*, ed. J. Burke (Oxford, 1955), pp. 120, 133.
9. Turner Manuscripts in the British Museum: Add. MS 46151 (hereafter cited as TMS), N, f. 7.
10. Reproduced in Gerald Wilkinson, *Turner's Early Sketchbooks* (New York and London, 1972), pp. 48–49.
11. Turner Sketchbooks in the British Museum Print Room (hereafter cited as TSB), 101, f. 4., f. 10.

And in 1819, during his first visit to Italy, he describes a landscape in which almost every color seems in motion:

> the olives the light [of sky?] when the sun shone grey green, the ground redish green grey and apt to Purple, the Sea quite Blue.
> . . . Beautiful dark green yet warm the middle Trees, yet Bluish in parts, [in] the distance the aqueduct reddish, the foreground light grey in shadow. [TSB 177, inside cover]

It is instructive to compare these descriptions with one made by Coleridge in 1800: "Eastdale—the dusky orange upon the yellowing green under the tender gloom of black [? Purple/Poplar]."[12] Coleridge's eye here is Turnerian. No color in this description is caught in the "firm and determined outline" prescribed by Reynolds, and, conversely, none is swallowed up by the "simplicity" of Reynolds's monochromatic shade. Instead, orange, yellow, green, and possibly purple all interact with each other and with the "tender gloom" of a shade that is thereby richly colored. Coleridge habitually perceived the colors of landscape in this way. In notebook entries dating from 1800 to 1804, he repeatedly records the interaction of yellow and green.[13] He found "yellow-red" in one landscape, reddish brown in several others, and during his voyage to Malta in the spring of 1804 he was fascinated by the interplay of green with various shades of blue and purple in the sea.[14] Colors for Coleridge were living things, continually in motion. He could observe the changing colors of a tree, of mountains, and of a sunrise, the subtle turning of a stream from white to blue, the flickering colors of pink rocks seen through white foam, and the silvering of black water beneath ice.[15] It was in these shifting forms that colors most appealed to him. In "Lewti" (1798) he speaks of a pale cloud brightening as it approaches the moon, "with floating colours not a few" (l. 18). And on a winter night two years later, he set down a similar effect in his notebook. The hazy light of the moon, he writes, filled up the sky "as if it had been painted & the colors had run" (*NC*, 1:875).

When Coleridge later came to formulate his concept of color in the

12. *The Notebooks of Samuel Taylor Coleridge*, ed. Kathleen Coburn; 3 vols. to date (London and Princeton, 1957–73), 1:823. Hereafter cited as *CN*.
13. *CN*, 1:789 f. 11, 798 f. 38v, 1319, 1413, 1812 f. 57.
14. *Collected Letters*, ed. Earl Leslie Griggs, 6 vols. (Oxford, 1956–71), 1:503; *CN*, 1:549 f. 27v, 1433 f. 6, 1487 f. 47v; 2:2015, 2070 f. 30v. Coleridge's *Letters* are hereafter cited as *CL*.
15. *CN*, 1:825 f. 60–60v, 833, 1503. Cf. *CN*, 1:836, 899.

"Fragment of an Essay on Beauty" (1818), phenomena such as these must have lingered in the back of his mind. Lines, he says, belong "to the shapely *(forma, formalis, formosus)*, and in this, to the law, and the reason; and [colors belong] to the lively, the free, the spontaneous, and the self-justifying."[16] Coleridge's concept of color is thus paradigmatically Romantic. Setting color against line, he calls to mind the opposition formulated by Pope, but even as he does so, he drastically revalues color itself. No longer a treacherous agent of confusion, it becomes instead the embodiment of freedom, spontaneity, and life itself.

As applied to painting, this new standard of chromatic energy challenged more than one law of linear form. Reynolds had taught not only that the colors of a painting should be "distinct and forcible" and that shadows should be almost monochromatic; he also taught that "warm" colors should be virtually separated from cold ones. In Discourse VIII he says:

> It ought, in my opinion, to be indispensably observed, that the masses of light in a picture be always of a warm mellow colour, yellow, red, or a yellowish white; and that the blue, the grey, or the green colours be kept almost entirely out these masses, and be used only to support and set off these warm colours; and for this purpose, a small proportion of cold colours will be sufficient. [*D*, p. 158]

Reynolds allows some blending of colors ("yellowish white") and a little relief from the predominantly mellow tone that he decrees. But the gist of Reynolds's theory was plainly caught by his devoted disciple George Beaumont, who came to be a mentor as well as a patron of his fellow artists, and who urged Constable to use "the colour of an old Cremona fiddle for the prevailing tone of everything."[17] If Reynolds stops short of this much dogma, he is nonetheless capable of criticizing Poussin for often making "a spot of blue drapery, when the general hue of the picture was inclinable to brown or yellow" (*D*, p. 158).

The man who liberated color from rules such as this was Turner. He was trained at the Royal Academy during the last two years of Reynolds's

16. *Biographia Literaria*, ed. J. Shawcross, 2 vols. (London, 1907), 2:251. Hereafter cited as *BL*.

17. C. R. Leslie, *Memoirs of the Life of John Constable*, ed. Jonathan Mayne (London, 1951), p. 114.

presidency (1788–90), and in the Academy lectures which he himself began to give in 1811 he warmly acknowledged the value of Reynolds's teachings. But Turner was a pupil with a mind of his own. When a lady once asked him why touches of red, blue, and yellow permeated one of his pictures, he replied: "Well, don't you see that in Nature? Because, if you don't, Heaven help you!"[18] Unlike Reynolds, who thought that paintings should be golden, warm, and undisturbed by spots of blue, Turner liked to see all parts of the spectrum collaborate in a work of art. During his visit to the Louvre in 1802, he set down this comment on Titian's *La Mise au Tombeau:*

> Mary is in Blue which partakes of crimson tone, and by it unites with the Bluer sky. Martha is in striped yellow and some [s]treaks of Red, which thus unites with the warm streak of light in the sky. Thus the Breadth is made by the 3 primitive colours breaking each other, and are connected by the figure in vermilion to the one in crimson'd striped drapery which balances all the breadth of the left of the picture by its Brilliancy. [TSB 72, f. 31]

Turner's comment is striking. His statement "Breadth is made by the 3 primitive colours breaking each other" directly contradicts the teaching of Reynolds, who thought broken color antithetical to breadth (*D*, p. 61). Furthermore, the "breadth of uniform, and simple colour" recommended by Reynolds struck Turner as "monotonous" when he saw it in Domenichino's *Combat d'Hercule et d'Achelous*; the figures in this picture, he noted, "are not sufficiently diversify'd as to colour as to create any interest" (TSB 72, f. 76). In Turner's eyes, breadth was something made by the interpenetration of "diversify'd" colors, and in the year after his trip to Paris he exhibited a picture of his own which demonstrates the point: *Calais Pier*.[19] Representing a wind-whipped sea on a cloudy, stormy day, this picture gives far more space to green, blue, and gray than Reynolds's formula for mellowness would allow. But the touches of red on various figures run all the way from left to right; the conspicuous pier is a yellow-reddish brown; and in the prominent sails of the boats as well as in the clouds directly over them, Turner has subtly used both yellow and pink. All of these colors are integrated by means of the

18. Quoted in John Gage, *Color in Turner: Poetry and Truth* (New York, 1969), p. 40.
19. Reproduced in Diana Hirsch, et al, *The World of Turner: 1775–1851* (New York, 1969), pp. 66–67.

pinkish yellow-white sail in the very center of the picture. With white surf spreading out below it and yellow-white clouds spreading out above, the sail forms the neck of an hourglass, and through it pass the colors that permeate the picture. Below it, white surf invades the blue, gray, and green of the sea, and white clothing mingles with the bits of red on the figures; above it, yellow stripes appear in the flag, and just above the flag, yellow and pink soften the white of the clouds, which are also shadowed heavily with bluish gray, touched with green, and broken by patches of blue. At lower right, the pier is yellow-brown; at lower left, the waves are flecked with yellow-green. Turner thus uses yellow, pink, and white to make both ends of the spectrum interpenetrate: to recreate the kind of "breadth" he found in the complex coloring of nature itself.

From poems such as Wordsworth's "Tables Turned" and Coleridge's "Dejection," from Coleridge's descriptions of landscape in his notebooks, and from pictures such as Constable's *Flatford Mill* and Turner's *Calais Pier* it is clear that the English Romantic perception of color was fundamentally different from what prevailed among the Augustans. Inheriting from Newton a universe newly reduced to the sum of its particular parts, inheriting a rainbow newly deconstructed and divided into seven separate hues, the Augustans saw and wished to represent colors as things "distinct and forcible," firmly regulated by the decisiveness and divisiveness of line. In Romantic poetry and painting the lines that were arbitrarily drawn between one color and another become what Wordsworth calls "puny boundaries" (*Prelude* 2. 223). They cannot circumscribe the vitality and spontaneity of colors that overflow into each other, that subtly permeate shadows, and that transcend the opposition between "cold" and "warm." The "breadth" of complex interaction which Turner achieves in the coloring of *Calais Pier* is a world away, therefore, from the "breadth of uniform, and simple color" recommended by Reynolds.

Some years after the exhibition of *Calais Pier*. Turner's desire to perfect this new and complex kind of "breadth" in painting led him to develop his theory of optical fusion.[20] This theory might be seen as a way

20. My account of this theory will be much abbreviated. For a more comprehensive account of it and its antecedents, see Gage, *Color in Turner*, pp. 110–17, and Gerald Finley, "Turner: An Early Experiment with Colour Theory," *Journal of the Warburg and Courtauld Institute* 30 (1967): 357–66.

of resolving an apparent contradiction raised by the Romantic attitude toward color. On the one hand, the poets and painters we have been examining implicitly rejected the principle that colors should be "distinct and forcible," for experience taught them that the colors of landscape mingled and ran. On the other hand, they sought to perceive and preserve in their representations of landscape a sense of its variety, a consciousness of the distinct and different forms of which its unity was composed. Wordsworth believed that nothing in nature is "defined into absolute independent singleness," yet he also believed that in nature, "every thing is distinct." It is far too easy for us to ignore this paradox in the English Romantic perception of landscape. Wordsworth's "original gift," as Coleridge called it, of spreading "the *atmosphere* . . . of the ideal world" around natural objects (*BL*, 1:59) can lead to the mistaken notion that in Wordsworth's poetry everything is blurred; and Turner's obsession with atmospheric effects has prompted the conclusion that in his paintings—especially in his later work—objects are blurred beyond recognition.[21] But in fact they are not. Careful scrutiny reveals that even Turner's later work conforms to a principle he himself articulated some time after 1812: that the artist must represent natural forms "in such a manner as . . . to express and particularize each object by its angles or characteristics."[22] Its characteristics of course include color, and for Turner color became at once an agent of particularization and of integration. His theory of optical fusion thus provides one way of realizing for the eye the paradox formulated by Wordsworth.

The theory was based on Turner's perception that the interaction of colors in nature could not be represented in painting by a simple mixture of pigments. In the first Academy lecture of the 1818 series, which—says John Gage—embodies Turner's "first treatment of chromatics per se,"[23] Turner contends that color is inseparable from light, that aerial color alone preserves this light, and that mixtures of material colors (or pigments) bring nothing but monotony and darkness. Speaking of pigments, he says, "if we mix two we reduce the purity of the first a

21. E. H. Gombrich, for instance, says that in Turner's late work, "the structure of objects is often quite swallowed up by the modifications of the moment—mist, light, and dazzle." *Art and Illusion* (Princeton, 1969), p. 296.

22. TMS BB, f. 45. It is worth noting that in *Approach to Venice* (1843), which Gombrich reproduces as a sample of Turner's late work (*Art and Illusion*, p. 295), the structures of at least four gondolas and one small barge are readily discernible.

23. *Color in Turner*, p. 111.

third impairs that purity still more and all beyond is minotony [sic], discord, and mud. . . ." (TMS H f. 25ᵛ). What Turner saw is the fundamental difference between pigments and rays. "White in Prismatic order as Daylight," he says,

> is the union or compound [of] Light while the Commixture of our material *colours* becomes the opposite that [is] the destruction of all or in other words—Darkness. Light is therefore colour, and shadow the privation of it by the Removal of these rays of color or subduction of power and throughout nature these [i.e., rays] are to be found in the ruling principles of diurnal variations; the grey dawn, the yellow morning
> golden sun rise and red departing ray, in ever changing combination; these are the pure combinations [of] Aerial Colours." [TMS H f. 34–35]

Turner's problem was to find a way of representing these pure combinations of aerial color with material pigments. Anticipating the theory and practice of the Impressionists, his solution was to preserve on canvas the purity and distinctiveness of separate pigments, but to juxtapose them in such a way that their separate colors formed an aerial mixture for the eye: an optical fusion. Very late in his career he demonstrated the method in two pictures ostensibly prompted by Goethe's *Theory of Color (Die Forbenlehre)*, which had been translated by Charles Eastlake and published in 1840. Both exhibited in 1843, the pictures were *Shade and Darkness—the Evening of the Deluge* and *Light and Colour (Goethe's Theory)—the Morning after the Deluge.*[24] According to Goethe, colors are either "plus" or "minus." The minus colors of blue-green, blue, and purple—hitherto called "cold"—produce "a restless, susceptible, anxious impression," like music in a minor key; the plus colors of red, yellow, and orange—hitherto called "warm"—excite feelings that are "quick, lively, aspiring," like music in a major key.[25] Turner's *Evening* and *Morning* embody respectively the minus and the plus colors. But as Lawrence Gowing implies, the pictures seem to illustrate not so much the difference between plus and minus colors as the difference between mate-

24. Reproduced in Lawrence Gowing, *Turner: Imagination and Reality* (New York, 1966), pp. 40–41.
25. I quote Goethe's definitions from Gowing, *Turner*, p. 51; the musical analogies are my own.

rial and aerial, darkness and light.[26] Turner actually uses some of the plus colors in the minus-colored *Evening*, but in the center of the foreground, they are swallowed up in a mixture of pigments—corresponding to the mass of darkness at the top. On the other hand, the predominantly "plus"-colored *Morning* contains the "minus" greens and blues, and these two converge in dark 'masses at lower left and just beneath the center. Both pictures therefore demonstrate the Turnerian principle that a mixture of material colors brings darkness; yet both also show that aerial color is the embodiment of light. In *Evening* aerial colors emanate from a circle of white. Delicate strands of blue, green, and yellow are juxtaposed on either side of the circle so as to represent "the pure combinations [of] Aerial Colours." Unmixed on canvas, the colors are optically fused by the eye, which sees them reintegrating into the white from which they have separately emerged. In *Morning* strands of red, yellow, and orange emanate from a massive sun of light, but here also they are juxtaposed for the eye to fuse them. Though nominally inspired by Goethe's theory, then, the *Deluge* paintings actually express Turner's reaction to that theory. As Jack Lindsay observes, he "could not agree with Goethe's proposition that colours arise from the meeting of light and darkness. Turner held that they come wholly out of light."[27]

Turner's belief in this principle partly derives from his frequent experiments with the painting of rainbows. So far as I know, the first one he painted appears in the oil version of *Buttermere Lake*, which he exhibited in 1798. A good deal has been written about this picture, but I do not think anyone has noted plainly that its treatment of the rainbow constitutes a radical departure from the Newtonian model—on which it is ostensibly based. In a passage from *The Seasons* (1730) which Turner himself associated with *Buttermere*, James Thomson had long since enshrined the Newtonian rainbow: a "showery Prism" unfolding "every hue" in the Newtonian spectrum, it runs "in fair proportion" from red to violet.[28] But the rainbow of Turner's *Buttermere* does nothing of the kind. Unlike early illustrations of Thomson's poem, which neatly divide the rainbow into seven channels,[29] Turner's picture gives us an arc of undi-

26. Gowing, *Turner*, p. 51.
27. J. M. W. *Turner: His Life and Work* (London and Greenwich, Conn., 1966), p. 211.
28. "Spring," ll. 205–07. Turner quoted this description under the title of *Buttermere* in the exhibition catalogue of 1798; see Gowing, *Turner*, p. 59.
29. See Ralph Cohen, *The Art of Discrimination* (Berkeley and Los Angeles, 1964), fig. 5, 8, and 28.

vided light. His effort to catch a subtle convergence of hues in the entire sky of the watercolor version of *Buttermere* led him to a more concentrated effort in the oil version, where the rainbow assimilates all hues into its narrow, borderless band of faintly yellowish white.

Though the *Buttermere* rainbow is not itself a specimen of optical fusion, it points the way toward that effect. The fine strands of stippled yellow which Turner weaves into its whiteness indicate the technique by which he would later get other hues into his rainbows—and *into* is the crucial word. In a watercolor of about 1817, for instance, the rainbow is predominantly white, and on its upper edge are strands of pink and yellow pigment (TSB 197-G). By optically fusing these, the eye makes orange. Consequently, even as we distinguish separate colors in this rainbow, they seem to be in the very act of returning to their source: of reuniting and hence reconstituting the light of which they are the component parts.

The theory and practice of optical fusion thus provides a means by which separate colors may be made distinct, yet none defined into absolute independent singleness. It also confirms one of the most fundamental beliefs of both Wordsworth and Coleridge: that perception is a creative, coadunating act. Coleridge defines imagination as both a *"co-adunating* Faculty" (*CL*, 2:866) and as "the prime Agent of all human Perception" (*BL*, 1:202). Wordsworth says that when awakened by a mother's love, the mind of an infant is "eager to combine / In one appearance, all the elements / And parts of the same object" (*Prelude* 2. 247–49). But for Wordsworth the act of unification begins with the senses. In 1798–99, about the time he wrote his description of the infant's mind, he also wrote:

> There is creation in the eye,
> Nor less in all the other senses; powers
> They are that colour, model, and combine
> The things perceived with such an absolute
> Essential energy that we may say
> That those most godlike faculties of ours
> At one and the same moment are the mind
> And the mind's minister[30]

30. *The Poetical Works* ed. E. de Selincourt and Helen Darbishire, vol. 5 (Oxford, 1949), p. 343.

Since poets work with words rather than pigments, no precise counterpart of optical fusion can be found in Romantic poetry. But Wordsworth's account of perception here is quite consistent with Turner's treatment of color. When the carefully juxtaposed strands of pink and yellow in a rainbow invite the eye to see the two as orange, they plainly elicit the power of the eye to "colour, model, and combine" the things it sees. And just as Wordsworth recognized the optical power that makes optical fusion of colors possible, so also did Coleridge, who studied theories of color and sometimes wrote about them. In 1807, apparently commenting on an abridged version of Newton's theories which had appeared in the *Philosophical Transactions*, he set down in his notebook an extensive analysis of the way certain colors combine to produce others, or to make white (*CN*, 2:3116 and note). In 1812, just two years after the German original of Goethe's *Theory of Color* was published, he expressed a keen desire to see it (*CL*, 3:422), and several years later he commended the book for attacking the Newtonian position that light was a physical compound mechanically divisible into "7 specific individua."[31] The habit of Coleridge's eye and mind was to see colors not as isolated "individua" but as mutually modifying parts of a unified whole. "White," he noted in 1804, "is the very emblem of one in being the confusion of all" (*CN*, 2:2357). Many years later, he reportedly described a formula for color in which yellow is a thesis, blue an antithesis, and green a synthesis.[32] This, of course, is a formula for optical fusion. And apropos of this particular formula, it is striking to note that in *View in the Park, Canbury House*, a late watercolor by Constable, the pale blue of the sky in the background and the brilliant yellow of the field in the foreground are both drawn into the trees of the middle distance, which by this means become a rich and sunlit green.[33]

Suggestively, the instance of optical fusion given by Coleridge and illustrated by Constable once again involves the convergence of a "warm" color with a "cold" one, a crossing of the line that Reynolds draws between the two. But the line may be crossed in other ways, as we have seen, and an extraordinary picture from Turner's final decade provides

31. *CL*, 4:750. Cf. *CL* 4:698.
32. *The Table Talk and Omniana of Samuel Taylor Coleridge*, ed. T. Ashe (London, 1888), p. 159.
33. Graham Reynolds, *Catalogue of the Constable Collection*, 2d ed. (London, 1973), #382, p. 48. Unfortunately, the picture is not reproduced here in color.

one more example of how *he* crossed it. *Slavers throwing overboard the Dead and Dying*, exhibited in 1840, is a cruelly ironic comment on Reynolds's dictum "that the masses of light in a picture be always of a warm mellow colour, yellow, red, or yellowish white."[34] Unlike *Calais Pier*, which defies the dictum by its emphasis on blue, green, and gray, *Slavers* superficially respects it—by emphasizing red and yellow. But because of the way these colors interact with others, the mellow warmth which they might project becomes instead a searing brilliance. *Slavers* uses every color in the spectrum—plus black and white. There is white in the foam at left, in the seagulls fluttering low over the drowning slaves, in the short streak of sun at the center of the picture, and in the ravenous fish at lower right. The conspicuous chains in the foreground are a glossy black; the waves at far left are green; the misty spume just above them is turning to violet; the sky in the upper right corner is a barely visible blue; and through much of the sea and the sky we find patches of yellow and orange. Nevertheless, all of these colors are subtly dominated by red. Positive red appears only in a few flecks below the ship at left, but the spiky masts of the ship are a reddish orange, the mist at upper left is a very pink purple, and red inflames the molten layers of yellow and orange that lie just under the setting sun. From this burning center, it sends its influence to every part of the picture, and though the bleeding of the slaves is more implicit than explicit, the colors are essentially those of fire and blood.[35]

Forty-two years earlier, Coleridge had used the same kind of coloring in *The Rime of the Ancient Mariner*, where the seascape is likewise made up of many colors but permeated by red. The *Rime* is a richly chromatic poem: its albatross is eponymically white; there are green, blue, and white in the sea (ll. 129–30); yellow in the locks of LIFE-IN-DEATH (l. 191); white in the moonbeams (ll. 267–68); and in the water snakes, blue, glossy green, and velvet black (l. 279). Yet the dominant hue in this poem is red. On the morning after the shooting of the albatross, the rising sun is glorious at first, "nor dim nor red" (l. 97); by noon, it has turned "bloody" in a hot and copper sky (ll. 111–12). The bloodying of the glorious (and presumably white) sun displaces the sight of the murdered albatross, whose bloodied white form is never shown to us as such. At the

34. For a color reproduction of *Slavers* (fig. 53 in the black-and-white illustration section below) see Luke Herrmann, *Turner: Paintings, Watercolors, Prints & Drawings* (Boston, 1975), pl. 148.

35. Above the setting sun in a sketch of about 1807, Turner actually wrote the words "Fire and Blood" (TSB 101, f. 9).

end of part 6, the mariner expects the Hermit to "wash away / The Albatross's blood" (ll. 512–13), but until that time the color of blood is diffused through the sea and the sky—as if the entire seascape had been bloodied by the mariner's deed. In part 2 the color of blood touches not only the sun, but also—implicitly—the dancing death-fires of the night (ll. 127–28). In part 3, after sucking the blood from his own arm in order to hail the spectre-bark, the mariner sees the bark against a western wave aflame with the setting sun. Here again, red is implicit, and its presence becomes explicit in the face of LIFE-IN-DEATH, who "thicks man's blood with cold," and whose red lips against a leprous white skin make her a ghastly travesty of the rose-red blushing bride we left behind us in part 1. Above all, the doomed ship itself is a vessel of blood, reddening the sea wherever it goes. In part 4, its shadow turns the water to "a still and awful red" (l. 271), and even in part 6, when the ship is at last returning to port, the angelic spirits rising from the bodies of the mariner's shipmates cast upon a bay of moonlit white shadows that are "crimson" (l. 485). Like Turner's *Slavers*, then, the seascape of *The Rime* is dominated by the color of fire and blood. Mirroring at once the guilt of the mariner and his purgatorial suffering, the pervasive redness in this poem also unifies the many-colored elements of his world.

From the above we can hardly conclude that Wordsworth, Coleridge, Constable, and Turner were at one in their treatment of color, which was far more important for the painters than it was for the poets. Yet I think we have seen that the ways in which these four men perceive the colors of nature are both fundamentally coherent and fundamentally Romantic. Rejecting the Augustan principle that colors must be absolutely distinct, that a firm and determined outline must divide the "7 specific individua" of the Newtonian spectrum, they likewise rejected the Reynoldsian principle that colors must be uniformly warm. Both of these principles were falsified by their experience of landscape, where they simultaneously perceived the distinctiveness and the interaction of colors both "warm" and "cool." Crossing—but not erasing—the line between such colors, each of them represented the interaction of yellow and green; and in Coleridge's *Rime* as in Turner's *Slavers* the interaction of various colors reaches out to both ends of the spectrum.

In different ways, what Turner, Constable, Wordsworth, and Coleridge saw and sought to represent was the paradox that every color in

nature is distinct, yet none defined into absolute independent singleness. By inviting the eye to fuse them or by modifying each other while remaining separate for the eye, the colors of their landscapes represent at once the individuality and the interdependence of particular things. Even when they seem detached from particular things, the colors represent their own distinctiveness—and their own interdependence. From his tireless experiments with structures of pure color Turner understood this final point better than anyone else, but it is nonetheless strikingly illustrated by what Coleridge wrote in his notebook one autumn day in 1803—when he saw the colors of Borrowdale as Monet and Renoir would later see the colors of Argenteuil:

> The woody Castle Crag between me & Lowdore is a rich Flower-Garden of Colours, the brightest yellows with the deepest Crimsons, and the infinite Shades of Brown & Green, the *infinite* diversity of which blends the whole—so that the brighter colours seem as *colors* upon a ground, not colored Things. [*CN*, 1:1603]

KARL KROEBER

Romantic Historicism:
The Temporal Sublime

Despite critical clichés of the 1960s and 1970s, the primary thrust of Romantic art was toward neither apocalypse nor transcendence but toward the representation of reality as historical process. This "isolating historicity," as Foucault calls it, is probably best studied (as he does) by treating it like one feature of an archaeological site, where coin and costume, book and picture, pot, weapon, and building stone appear as a coherence of contiguities rather than as part of a reductively rationalized sequence. [1] The archaeological model is certainly helpful if one juxtaposes historical writings and historical paintings, not to compare the obviously incomparable but to articulate complementarities so as to extend one's understanding of Romanticism beyond the realm of the purely aesthetic.

In a recent essay I identified the principal tradition of history painting radicalized by J. M. W. Turner as that initiated by Benjamin West's *Death of General Wolfe* (fig. 48), exhibited in 1771, in which an alien force, the near-naked Indian, disturbs a neoclassic "circle of response."[2] The Indian is important because genuine historical consciousness, as distinct from the awareness expressed in chronicle or legend or myth, derives from recognition of alternatives, of different social possibilities. Authentic history never simply records what happened, but what happened in a world where other things might have happened. Diversification of cultural perspective is a feature of Romanticism's breakup through enrichment of the Enlightenment's uncommon faith in common humanity.

1. Michel Foucault, *The Order of Things* (New York, 1973), p. xxiii.
2. "Experience as History: Shelley's Venice, Turner's Carthage," *ELH* 41 (1974): 321–39.

Modern history furnishes us with an example of what happened at this time in Rome. . . . Great occasions which produce great changes are different, but, since men have had the same passions at all times, the causes are always the same.[3]

The effect of this observation of Montesquieu is to reduce potential grandeur and awesomeness. Romantic historicism, in contrast, restores sublimity to the story of the past. David Hume, like Montesquieu, is lucid, not thrilling:

Would you know the sentiments, inclinations, course of life of the Greeks and Romans? Study well the temper and actions of the French and English: you cannot be much mistaken in transferring to the former most of the observations you have made in regard to the latter. Mankind are so much the same, in all times and places, that history informs us of nothing new or strange. . . .[4]

Neoclassical history can be beautifully rational—it is, for example, hospitable to lovely cyclical interpretations—but it cannot excite with the novel and surprising. Not irregular, it cannot be awe-inspiring; it cannot be sublime. Neoclassicism has no historical equivalent for the physical, topographical, material sublimity in which it delighted: its art and history remain distinct.

The French Revolution encouraged upheavals as violent historiographically as politically. By the beginning of the nineteenth century Hume's human nature had been renewed and estranged—witness Barthold Niebuhr:

The state of the law concerning landed property and the public domains of ancient Rome differed in such a degree in its peculiarities from the rights and institutions we are used to, that the confounding of our ordinary notions of property with those of the ancients . . . gives rise to the most grossly erroneous opinions on the most important questions of Roman legislation; opinions under which the voice of justice must pronounce condemnations against actions and measures perfectly blameless; . . .[5]

3. *Considerations on the Causes of the Greatness of the Romans and Their Decline*, trans. David Lowenthal (New York, 1965), p. 23 (from edition of 1848).
4. From the *Enquiry Concerning Human Understanding*, quoted by Emery Neff, *The Poetry of History* (New York, 1947), p. 230.
5. Barthold Niebuhr, *The History of Rome*, trans. Julius Hare and Connop Thirlwall (London, 1851), vol. 1, p. 1.

This awareness of profound difference between the historian and those whose lives he recounts involved an inversion of the concept of "heroic" events. History began to take on a complex texture. Thomas Carlyle, dismissing those who clung to uniformitarianism by appeals to inner, psychological consistency, quickly reextends his critique to externalities:

> Neither will it adequately avail us to assert that the general inward condition of Life is the same in all ages. . . . The inward condition of Life . . . is the same in no two ages; neither are the more important outward variations easy to fix on, or always well capable of representation.

Implicated in these complexities of fact and representation is the Romantic sublimity of the unspectacular, central in Wordsworth's poetry, Scott's fiction, and, as I shall try to show, even present in Turner's reworkings of his classical prototypes in history painting. History is used by the Romantics to challenge historical hierarchies. As Carlyle observes:

> Which was the greatest innovator, which was the more important personage in man's history, he who first led armies over the Alps, and gained the victories of Cannae and Thrasymene; or the nameless boor who first hammered out for himself an iron spade? When the oak-tree is felled, the whole forest echoes with it; but a hundred acorns are planted silently by some unnoticed breeze.[6]

To understand this sublime inversion, it may be useful to retreat to the relative simplicities of historical painting. The Indian in West's *Death of Wolfe* impresses a viewer with the possibility of another cultural attitude because his pose derives from, and is meant to recall, Poussin, and because he is located within so familiar a scheme of order, the circle of response created by the conventionalized gestures and facial expressions of the general's sorrowing subordinates. The Indian is outside their hierarchy though within their grouping, just as his nakedness, sensory evidence of a common humanity concealed by the Europeans, sets off their elaborate dress. Discrepancies compel one to doubt what the Indian feels watching Wolfe die. As is indicated by some dismayed reactions among the original viewers, West had introduced equivocation into conventionally heroic pathos. But equivocal scenes had been increasingly

6. Thomas Carlyle, "On History" (1830), *English and Other Critical Essays* (London, 1964, originally 1915), pp. 82–83.

popular throughout the eighteenth century, most obviously in the genre
of "ruins." The intrinsic dubiety of a ruined monument, what is opposed
to what was, what might have been against what could not be, needs no
rehearsing here. Nor is it necessary to show again how the art of ruins is
a symptom of a spreading belief in the efficacy of creative uncertainty in
art. The belief progressively infected all neoclassic orders and sequences,
as is suggested by Piranesi's *Carceri* (see figs. 12–14), which in part
disturb by seeming not to be ruins.

Such equivocations Turner develops in Claude-challenging pictures
such as *Dido building Carthage* (fig. 49) and *The Decline of the Carthaginian
Empire* (fig. 50). In the former there are unfinished buildings. An in-
complete edifice, whether a ruin, a Piranesi "fantasy," or Turner's not-
yet-built Carthage, is discernible *as* incomplete so far as it implies an
invisible totality, an unseen whole, from which "pieces" once derived
their function or meaning. The ruin picture is meant to be imaginatively
stimulating, not just appealing to the senses, to evoke what is not there,
as well as what is, because a ruin is a provocation to the viewer mentally
to reconstruct an architectural whole from a remnant. Turner's *Dido* is
more complex: not only was it notorious that the not-yet-constructed
buildings we see had been obliterated by the Romans, but also Turner
wished his picture hung between paintings by Claude of different "clas-
sical" subjects. So seen, *Dido building Carthage* becomes a dramatic part of
art/cultural history, the history of imaginative reconstructions. This
self-reflexive historicity was reinforced when Turner added *The Decline
of the Carthaginian Empire*, which portrays the city in apparently secure
luxury. Its invisible fate is spelled out in the catalogue description.

> The decline of the Carthaginian Empire—Rome being determined
> on the overthrow of her hated rival, demanded from her such terms
> as might either force her into war, or ruin her by compliance: the
> ennervated Carthaginians, in their anxiety for peace, consented to
> give up even their arms and their children.
>
> ". . . At Hope's delusive smile,
> The Chieftain's safety and the mother's pride,
> Were to th'insidious conqu'rors' grasp resign'd;
> While o'er the western wave th'ensanguin'd sun,
> In gathering haze a stormy signal spread,
> And set portentous."[7]

7. Quoted by A. J. Finberg, *The Life of J. M. W. Turner, R. A.*, 2d ed. (London, 1961), pp.

As important as what is depicted is what is not visible—even to a contrast of Turner's sequential pairing against Claude's structural, topical, but never historical pairings.[8] The presence of Claude (and with him an entire classical tradition of history painting) is deliberately evoked to be transformed. The transformation is possible because Turner works not toward abstraction but toward a self-reflexive historicity.

A key to his intention is his organizing through color. Were the Carthaginian pictures better preserved it would be easier to discern the details of how Turner changes Claude primarily by filling Claudean shapes and shape-arrangements with intricate tonalities. One must fall back on the evidence of critical response. In objecting to the original exhibition of *The Decline of the Carthaginian Empire,* Robert Hunt saw (but missed the meaning of) a "false splendour" in Turner's tones, complaining that they portray "a beautiful and noble personage, flushed with a burning fever, and arrayed in a profusion of shewy habilaments," presumably the impression Turner desired, as the catalogue description makes clear. That colors Hunt saw are no longer present is suggested by the fact that Hazlitt's famous critique applied to the paintings of these years, before Turner's first trip to Italy.

They are pictures of the elements of air, earth, and water. The artist delights to go back to the first chaos of the world, or to that state of things when the waters were separated from the dry land, and light from darkness, but as yet no living thing nor tree bearing fruit was seen upon the face of the earth. All is without form and void. Some one said of his landscapes that they were *pictures of nothing, and very like.*[9]

247–48. Fully to understand how *Dido* revises Claude's *Seaport,* one needs to study the pictures in relation to Turner's *Apullia in Search of Appulus* of the previous year, derived from Claude's *Transformation of the Apulian Shepherd,* probably a deliberate provocation of Sir George Beaumont. Gerald Wilkinson, *Turner's Colour Sketches, 1820–1834* (London, 1975), argues persuasively that Turner's Italian journey of 1819 *followed* a decisive advance in his techniques, and is supported by John Gage, *Color in Turner: Poetry and Truth* (New York, 1969). Philip Fehl, "Turner's Classicism and the Problem of Periodization in the History of Art," *Critical Inquiry* 3 (1976): 93–129, intelligently delineates the positive aspects of Turnerian "regressions." On a parallel reworking of Claude by Constable, see my *Romantic Landscape Vision: Constable and Wordsworth* (Madison, 1974), pp. 73–74.

8. Claude was also challenged by Turner in his original exhibition at the Royal Academy of *Dido* with the "paired" *Crossing the Brook,* "contemporary" with ancient, landscape with history. On Claude's formalized pairings see Marcel Röthlisberger, *Claude Lorrain,* 2 vols. (New Haven, 1961), 1:77.

9. Cited by Finberg, *Life of Turner,* p. 241; quotations from Hunt and Beaumont, p. 240.

That Hazlitt could see what for us appears only in Turner's later can-
vases will seem less surprising when we remember that the climax of Sir
George Beaumont's antagonism to Turner was focused by *Dido* and *The
Decline*. Beaumont perceived a hateful "colouring discordant, out of
harmony . . . violent mannered oppositions of Brown and hot colours to
cold tints, blues and greys. . . ." One may properly speak of *a* tonality to a
Claudean picture, but Turner's paintings are (or were) composed of a
bright complexity of contrarily interacting lights which might well pro-
voke an uneasy suspicion that the painter was less interested in objects
than in forces, though primal forces may strike us as more than "noth-
ing."

Complicating of color gradients is inseparable from Turner's inver-
sion of the tonal spectrum so as to work "down" from white instead of
"up" from dark. His "obscurity" increasingly comes from too much light,
not too little. Claude's centered suns illuminate, but Turner's blind.
Equivocation and confusion arise in the later Turner from much life,
not, as in traditional ruins paintings, from little. In any moment, Turner
shows us, there are multitudinous possibilities, so every perspective is
provisional. Even ancient history and traditional art are not in-
evitabilities, beyond time. Classical art can be re-viewed; past visions can
be re-seen; the shaping colors of life-forces can be restored to what had
become frozen, broken, even obliterated monuments. Unlike tra-
ditionalist critics such as Beaumont, Turner conceives of art as inextrica-
bly in and of time, only vital when engaged in the vortex of its own
history.

Given paint deteriorations and problems of accurate color reproduc-
tion, it is easier to show Turner's transformations of his classical models
through his shifts in organization of figures among architectural struc-
tures. Turner uses more figures than Claude and makes their interrela-
tions more ambiguously intricate. Turner's figures are of "normal" size
and occupied with ordinary affairs. But their ordinariness, like that of
characters in historical fiction, results in significant incongruities. What
the figures do sometimes appears contradictory to the painting's central
event, which is culturally important, not anecdotal—the rise or decline of
an empire. Turner's figures make problematic the relation of title to
scene, thereby pointing up complexities in relation of form to content
more stylized in his models. Thus the traditional title of Claude's *Mill*
derived from the detail in the middle distance, a derivation understand-

able, as commentators have observed, because the title, *Landscape: The Marriage of Isaac and Rebekah,* is formal—the painting doesn't strive to illustrate the biblical reference. Analogously, the structure of *The Mill* is mathematically ordered, the horizon at forty percent of the picture's height, the lake at twenty-five, and so forth.

Turner's figures aid what I have called unspectacular sublimity. They are not obscure in the fashion of Piranesi, nor dwarfed by monumental buildings, as John Martin's antlike, rigorously marshalled crowds tend to be, but they trouble us by indistinctness in their actions as well as vagueness of their shapes. They are neither Italianate nor Brueghelian. They are not badly drawn but conceived as painted rather than drawn, that is, fluidly mobile in contrast to a fixed architectural ambiance. The primary indistinctness for Turner is the human form.

The second indistinctness appears in human activities. In one picture few seem to be working to build Carthage, and in the other there is little overt decadence.[10] In both, too many people are doing too many different things to be ignored, but the significance of their actions appears neither in direct representation nor readily accessible allegory. Contrast Claude—the mathematically centered figures of slaves loading a chest into a boat literally represent the embarcation of a queen who is not prominent in the painting (fig. 51). Turner's Dido is the principal person in his painting. But she is focused by light rather than position, since she is shown walking on one side, curiously isolated. Her head turns toward the girls sailing toy boats and away from older men presumably discussing plans set forth in the scroll held by one. Across the water, which runs to the picture's lower edge, carrying reflected sunlight directly into the viewer's eyes, is a completed temple dedicated, the inscription tells us, to Dido's murdered husband Sychaeus. Dido's love for him has brought her to where Aeneas's betrayal will lead to her suicide. Turner's arrangement of details, including the morning sunlight dividing Dido's past and present while it links our "now" to her "then," is best understood. I think, as showing that Dido and the Carthaginians do not live as we live and cannot see as we see. In the disjunction lies the isolating historicity of which Foucault speaks. To grasp its nature, however, we need to see its relation to the transformation in historical writing itself,

10. The catalogue material clarifies the meaning of many details, such as the scatter of items of luxurious idleness, the nursing mother, etc., but increases the moral complexities of the Rome-Carthage/Britain-France parallel.

which deserves the kind of critical analysis we too often reserve for art alone.

> In the second century of the Christian era, the Empire of Rome comprehended the fairest part of the earth, and the most civilized portion of mankind. The frontiers of that extensive monarchy were guarded by ancient renown and disciplined valour. The gentle but powerful influence of laws and manners had gradually cemented the union of the provinces. Their peaceful inhabitants enjoyed and abused the advantages of wealth and luxury. The image of a free constitution was preserved with decent reverence: the Roman senate appeared to possess the sovereign authority, and developed on the emperors all the executive powers of government. During a happy period (AD. 98–180) of more than fourscore years, the public administration was conducted by the virtue and abilities of Nerva, Trajan, Hadrian, and the two Antonines. It is the design of this, and of the two succeeding chapters, to describe the prosperous condition of their empire: and afterwards from the death of Marcus Antoninus, to deduce the most important circumstances of its decline and fall; a revolution which will ever be remembered, and is still felt by the nations of the earth.[11]

Edward Gibbon's first phrase in this opening paragraph of *The Decline and Fall*, like the antique garb in neoclassic history painting, establishes a distant perspective: we, the now-living, look back on the long-dead. The clear hierarchism of the relation permits Gibbon's magisterially defining language which renders superfluous geographic or sociological detail: "fairest part of the earth," "most civilized portion of mankind." The second sentence reinforces this superlative comprehensiveness by its unhesitating reliance on heroic personifications, "ancient renown" and "disciplined valour": the doubtful and dark lie outside the "frontiers" of enlightened civilization, frontiers that are barriers, not leading edges. And Gibbon's diction and tropes regularly confirm the continuing solidarity of the civilized as a timeless condition of being that links distant "then" to "now": it is the "nations" not "people" that still remember and feel the fall of Rome.

The opening sentences are built on syntactic/semantic parallelisms,

11. I cite from the Modern Library three-volume edition (New York, n.d.).

"Fairest part . . . most civilized portion," "ancient renown . . . disciplined valour." The linking-paralleling "and" is Gibbon's favored conjunction, because he creates strongly balanced, stable compositional units. This overt architectural ordering subdues rhetorical figures as strong as oxymoron to unobtrusiveness: the third sentence's "gentle but powerful influence" shades off into all-too-reasonable contradictions, "inhabitants enjoyed and abused." Paradoxes and even ironies must be controlled rationally because Gibbon does not want his reader's mind sliding from visible behavior to invisible experience. What the "peaceful . . . enjoyed and abused" was not even "wealth" and "luxury," vocabulary relatively abstract (viz., "gold" and "silks"), but "the advantages of wealth and luxury." No construction is more characteristic of Gibbon than this of plural abstract noun plus "of," which enables him to delineate that kind of social behavior we see pictured by the conventionalized European figures in *The Death of General Wolfe.* Thus when Gibbon says that the "image of a free constitution was preserved with decent reverence," he exposes a reality of behavior according to recognizedly delusive appearances. What freedom individuals may or may not have experienced is irrelevant, because Gibbon's concern is that "which will ever be remembered" because always the same event. The fixed event, timeless because it *has* happened, demands formalized, linear representation.

Gibbon's subject is the falling of a definitively fallen object, a felicitous reflection of his Newtonian classicism. Gibbon's method is sequential presentation of chronological certainties, so he can inform us at the end of his first paragraph how he will proceed. Such orderliness of conception and perception Thomas Carlyle in *The French Revolution,* the most efficaciously sublime of Romantic histories, disrupts and complicates by resurrecting experiences from obscurity into the violence of chiaroscuro representations. And Carlyle is fascinated by how much has been forgotten—in just forty years—of what never was entirely clear. Against Gibbon's decisive definitions, Carlyle opens with clouded revelations:

President Hénault, remarking on royal surnames of honour how difficult it often is to ascertain not only why, but even when, they were conferred, takes occasion, in his sleek official way, to make a philosophical reflection. "The surname of Bien-aimé (Well-beloved)," says he, "which Louis XV bears, will not leave posterity in the same doubt. This prince, in the year 1744, while hastening from

Karl Kroeber

one end of his kingdom to the other, and suspending his conquests in Flanders that he might fly to the assistance of Alsace, was arrested at Metz by a malady which threatened to cut short his days. At the news of this, Paris, all in terror, seemed a city taken by storm; the churches resounded with supplications and groans; the prayers of priests and people were every moment interrupted by their sobs; and it was from an interest so dear and tender that this surname of Bien-aimé fashioned itself—a title higher still than all the rest which this great prince has earned."

So stands it written, in lasting memorial of that year 1744. Thirty other years have come and gone, and "this great prince" again lies sick; but in how altered circumstances now! Churches resound not with excessive groanings; Paris is stoically calm; sobs interrupt no prayers, for indeed none are offered, except priests' litanies, read or chanted at fixed money-rate per hour, which are not liable to interruption. The shepherd of the people has been carried home from Little Trianon, heavy of heart, and been put to bed in his own château of Versailles: the flock knows it, and heeds it not. At most, in the immeasurable tide of French speech (which ceases not day after day, and only ebbs toward the short hours of night), may this of the royal sickness emerge from time to time as an article of news. Bets are doubtless depending; nay, some people "express themselves loudly in the streets." But for the rest, on green field and steepled city, the May sun shines out, the May evening fades, and men ply their useful or useless business as if no Louis lay in danger.[12]

The first paragraph of *The French Revolution* is mostly quotation, from someone of whom probably few readers have heard. Carlyle, not citing Hénault out of admiration ("sleek official way"), immediately plunges us into doubts and difficulties of every kind—who is quoted in the second paragraph is as uncertain as the meaning of the quotation. Perhaps the chief organizational trait in Carlyle's structuring is suggested by questions aroused in the first sentence: what do royal names, let alone Hénault's speculations about them, have to do with the French Revolution? True, Louis XV was a king of France, but he died

12. I quote from the two-volume Everyman edition, now the only inexpensive one readily available (London, 1966).

fifteen years before the Revolution, and we are attending a passing illness thirty years earlier. If such questions are answered by the next paragraph, we have already left behind the *Decline and Fall*, in which paragraphs are self-sufficient: each of Gibbon's structural units is self-coherent. Gibbon, of course, begins before the decline, but makes it plain he is showing us what declined. Carlyle flings us into specific experiences and comments which puzzle us as to what is happening and why it is pictured in *this* way, rather as we feel before a Turner historical scene. Carlyle uses puzzles and illogical resonances to create something other than sequential coherency: he will treat of another king "arrested," a different "Paris all in terror," and diverse "supplications and groans" until the Bastille is "overturned by a miraculous *sound.*" Analogously, Carlyle transmutes Gibbon's enlightening irony of phrases such as "decent reverence" into the self-satirization of Hénault's particular sycophancy, which introduces us into a developing experience of uncertain events in which we, the readers, must learn to suspect all reporting, beginning with the very names reported, and from which suspicions Carlyle himself is not exempt.

It is a condition of Gibbon's irony that it never be applied to the historian himself. Carlyle is so conscious of the dubieties of his project that he first impresses us with how totally forgotten has been a "lasting memorial" of 1744, even as indifference overtook a "great prince" in thirty years. Gibbon's irony detaches us from the confusion of the moment (much of which he believes ought to be forgotten because trivial) to distinguish lines of rational chronology. Carlyle's irony engages us in the indefiniteness of specific experiences and the fuzziness of reports about them. Thus we encounter Louis's final illness through the fashion in which it was disregarded by ordinary citizens, and by the second paragraph have become involved with a tense unknown to Gibbon, the present. With Carlyle's history, as with Turner's, *we* are *in* the picture. Throughout *The French Revolution* Carlyle, so impressed has he been by the equivocations in all accounts of human affairs, denies us the advantages of simple retrospectiveness. The past of the first paragraph, Louis's illness in 1744, is forgotten in the second paragraph, the subject of which is this absence of positive act. Carlyle thus emphasizes the discrepancy between a historian writing of an event and the event itself. He must select from, thereby distorting, the wholeness of a total situation, whose totality is probably an artificial construct.

The Romantic historian perceives memorable events to be made up of what Wordsworth called "little, unremembered acts." And what to the historian seem important deeds or deaths (or what he makes to seem important) take place amongst those to whom they are but an opportunity for casual betting or *prix-fixe* litanies. The essence of history is its equivocal reconstructing of intrinsically doubtful experiences. At the height of the Terror, Carlyle will remind us, nearly a hundred theaters were crowded nightly. So he will follow home from public celebration a "Goddess of Liberty" who must prepare dinner in a modest flat for a pedantic husband. And so Carlyle seldom forgets what the neoclassic historian seldom mentions, the epitome of life's trivial incertitudes, the weather.

But one notices that the specificities of detail which characterize Carlyle's writing often call into doubt the validity of sensory evidence. Just as Turner paints a picture in which it is difficult to be sure what one may be seeing because he paints accurately how one sees in a storm or blazing sunshine, so Carlyle, however anxious he may be to make us see his scenes, never forgets how delusive and unreliable our perceptive powers are, how untrustworthy is the evidence of our senses, which, at best, give us one perspective out of many possible, and none of which, even the historian's, is privileged. So Carlyle's history resounds with confusing echoes, not only partial repetitions whose contexts shift (as with "this great prince"), but also inversions of situation, as in the two first paragraphs. Analogously, syntax and semantics are made to intersect violently, even counteracting one another upon occasion. Not just in the opening lines but throughout the book we encounter diversified negatives, abrupt tone changes, reversals of customary word order, and startling interrogatory and exclamatory interjections, while Carlyle maneuvers constantly from dramatization to narration to speculation—both retrospective and prospective.[13]

The significance of the French Revolution to *The French Revolution* is not simple, in part because the historian is involved in what is now called imaginative deconstructions—for example, his final evaluation of the

13. An excellent study of these shiftings is by H. M. Leicester, Jr., "The Dialectic of Romantic Historiography: Prospect and Retrospect in *The French Revolution*," *Victorian Studies* 15 (1971): 5–17. See also Philip Rosenberg, *The Seventh Hero* (Cambridge, Mass., 1974), as well as René Wellek's essay in *Confrontations* (Princeton, 1965) and Hedva Ben-Israel's chapter in her *English Historians on the French Revolution* (Cambridge, Mass., 1968).

Reign of Terror that it was no more what it is called than Louis XV was
Bien-aimé: "there is no period to be met with, in which the general
Twenty-five Millions of France suffered *less* than in this period which
they name Reign of Terror." That this judgment should often have been
lost sight of by subsequent commentators is in accord with Carlyle's
feelings about the unreliability of sources—intrinsically dubious, they
are less likely to be understood than misunderstood, since what makes
history possible is not mechanical recording but creative imagination.

Romantic historical vision is founded upon the impossibility of any
definitive, that is, rationally unchanging, representation of historical
phenomena. Of course the past no longer exists; but even when the past
was the present, its significant events were to a considerable degree not
perceivable and not comprehensible. For the Romantic, the central prob-
lem is not the pastness of the past but its former presence. One of the
great Romantic forms, the historical novel, is a specific response to that
problem. One can perhaps suggest the nature of the responses through
one more pictorial/literary juxtaposition, centering upon Turner's *Snow
Storm: Hannibal and his Army crossing the Alps* (Fig. 52), which represents
the immediate, sensory experience of an ancient event.

As I have observed elsewhere, the historical fact of Hannibal's crossing
the Alps was perceived in Britain of 1812 as an event of ambiguous
significance, and Turner exploited the doubtfulness.[14] Most important,
he looked at history from what in the neoclassic tradition would have
been its backside. The picture's foreground is the rear of Hannibal's
army, the hangers-on, the stragglers, the abandoned, the dying, and the
dead. To the left of the center foreground an African is being despoiled
of arms and clothing; above him are flung corpses, while to the right,
below a pyramidal rock, a man cooly ties on the footgear of a dead
soldier. Behind him, another soldier pressed against a boulder is
stripped of clothes and gear. The center of this foreground is a dramati-
cally puzzling group of four figures. Over a supine, nearly naked body a
man kneels with knife raised, his arm arrested by another man whose
left hand supports a woman, naked to the waist, her head lolling in
faintness or death. The meaning? Well, the heroic army has passed.
Storming vortices of cloud brighten over distant elephant and Italy,
leaving behind the forgotten of history, the sordid, personal, "meaning-

14. "Experience as History," p. 330.

less" violence of trivial anonymity. It is in keeping with Turner's presentation that commentators have disagreed as to whether we see Carthaginians robbing natives or mountaineers preying on army stragglers. Who cares? Turner's historical vision is through history's little, nameless, unremembered acts of violence and fear.

Romantic historical art, in other words, not only represented subjects from the past but also was about the difficulties of historical representation. The primary work in this tradition, of course, is *War and Peace*, which is founded on Tolstoy's recognition of the impossibility of historical representation, despite his conception of reality as in essence nothing but temporal processes. The trouble is that

> absolute continuity of motion is not comprehensible to the human mind. Laws of motion of any kind become comprehensible to man only when he examines arbitrarily selected elements of that motion; but, at the same time, a large proportion of human error comes from the arbitrary division of continuous motion into discontinuous elements. . . . to assume a beginning of any phenomenon . . . is in itself false.

This is the theory. Now for the dramatization of General Kutúzov, like Hannibal, "in the midst of a series of shifting events":

> it is suggested to him to cross the Kalúga road, but just then an adjutant gallops up from Milorádovich asking whether he is to engage the French or retire. An order must be given him at once, that instant. . . . after the adjutant comes the commissary general asking where the stores are to be taken, and the chief of the hospitals asks where the wounded are to go, and a courier from Petersburg brings a letter from the sovereign . . . the commander in chief's rival, the man who is undermining him . . . presents a new project . . . and the commander in chief himself needs sleep and refreshment . . . and a respectable general who has been overlooked in the distribution of rewards comes to complain, and the inhabitant of the district pray to be defended, and an officer sent to inspect the locality comes in and gives a report quite contrary to what was said by the officer previously sent; . . .[15]

15. I use the Maude translation in the Norton Critical Edition, ed. George Gibian (New York, 1966), pp. 917–18, 922.

Tolstoy's Kutúzov and Turner's Hannibal are caught up in continuities of motion for which the most appropriate form of representation is the vortex. The paragraph above illustrates the nature of vortical action. Unlike a circle, or even a spiral, a vortex is a complex of diverse movements, little movements, a coherence of contiguous, affiliated, similar, yet distinct, partly antagonistic, curvilinear forces. The vortex is the primary design produced by vital processes; all living things are shaped by the multi-dimensional swelling curves of growth forces. Turner's and Tolstoy's involuted reiterated rhythms reflect the fecund near-repetitions of minute actions which constitute vitality. In *Snow Storm: Hannibal* each vortical pattern is made up of reechoing, reinforcing yet diverse turnings, each whorl dependent on others so that one cannot define any beginning or end point to the storm—an exact analogue for the swirling of beginningless interactions and diverse contingent processes Tolstoy represents as historical experience. The involution of many "minor" conjoined contrarieties as temporal force is the key form in Romantic historical vision, demanding an imaginative, rather than a rational or perceptual, ordering of interdependent energies. In literature the impress of vortical form can be traced in such matters as the development of the novel with multiple plots. The linear formalism of neoclassic unitary plots, however fragmented or inverted, is unlike the multiple intersecting plots characteristic of nineteenth-century fiction. In painting what needs recognition is the association of vortices with the development of color-structuring as a revision of form-structuring.

Turner needed not just whirling configurations but swirling colors, for in color alone could he attain the minutely shifting interpenetrations necessary to what he perceived to be actuality. Color finally is the antagonist of fixed forms. To structure a painting by color, as Turner does, is to organize by dissolving, diffusing, and dissipating forms. It is to arrange according to the ever-changing dynamics of liquid or gaseous conditions, dynamics irreducible to the definite boundaries of geometric shapes. The obscurity, vagueness, indistinctness of Turner is accurate, even pedantic, rendering of the fluidly vital. And one should not expect a Romantic artist to be so inconsistent as to present an active universe for an inert audience. Color-perception and form-perception are different; the former is more directly violent, less intellectual, more evocative of affects. As Schachtel, who studied the psychology of color in Rorschach tests, puts it, "color seizes the eye," whereas "the eye grasps

form"; in Gombrich's terminology, form is more dependent than color on schemata. Schachtel notes how color frequently compels reaction without reference beyond itself. Color does not, he observes, require the memory necessary for the appreciation of form's meaning; often, he says, red *is* fire or *is* blood without symbolic mediation.[16] Color moves us, which is what the Romantic wants, because only if we are "in motion" can we imaginatively respond to the continuity of action which is reality.

Turner's appeal to imagination puts him in opposition to the rational formalism of many of his predecessors as well as to the abstraction of many of his successors. He portrays the full complexity of a specific perception of a particular event, but that means diffusively rendering curves of action, since both perception and what one perceives are live processes. Of course he was fascinated by physical exemplifications of continuous movement, by water, and by all atmospheric phenomena, in short, by rain, steam, and speed. And when he could conjoin fire and water he was delighted. His enjoyment of the burning of the Houses of Parliament is so unmistakable one wonders he wasn't imprisoned for treason. But these are surface manifestations of a deep-rooted instinct for regarding all actuality as working according to principles more like those of the shifting transformations we study in organic chemistry than the defined consistencies which were the focus of Newtonian physics. Actuality cannot be identified through arithmetic relations of fixed structures because it exists in a perpetual interflowing and interfusing of conditions fundamentally plastic, porous, equivocal. Reality is only truly perceived as we are meant to perceive it in *Snow Storm: Hannibal*—uncertainly, provisionally, imaginatively.

The main thrust of Romantic historicism is not toward apocalypse nor transcendence but, instead, toward a dialectical engagement with confusingly open-ended experiences, for experience to a Romantic is, by definition, transitional. So the Romantic with an historical subject is in the position of representing what he recognizes cannot be represented. Or, to use a term again becoming popular, he seeks the sublime, which even Schiller (whom Coleridge thought old-fashioned in his conception)

16. Ernest G. Schachtel, "On Color and Affect," *Psychiatry* 6 (1943): 393–407, p. 396. Wilkinson, *Turner's Colour Sketches*, p. 147, commenting on two sunset sketches, observes that Turner has "concentrated on what seems to be the struggle of the colours of fire and blood against the encroaching purple of night, or death. There are many indications in his notebooks that Turner thought of his colours in just such terms."

identified as incomprehensible to reason and inapprehensible to the senses, and, therefore, specially evocative of imaginative power.[17] The evidence shows Romantic historicism to be part of the aesthetics of such sublimity, specifically, the sublimity not of space but of time.

17. There is a useful translation of *On the Sublime* by Julius A. Elias (New York, 1966). The elaborate diction of Thomas Weiskel's *The Romantic Sublime* (Baltimore, 1976) obscures some excellent commentaries, which recognize that Romantic sublimity differs from Burke's, for instance, in emphasizing discordance between outer events and psychic powers. John Dixon Hunt argues cogently for Turner's deliberate, sustained exploration of a painterly vocabularly for the sublime in "Wondrous Deep and Dark: Turner and the Sublime," *Georgia Review* 30 (1976): 139–54.

RONALD PAULSON

Turner's Graffiti:
The Sun and Its Glosses

Turner's painting is an extreme case of the incompatibility of visual and verbal structures in a single object. The dichotomy is brought out by two seminal studies of Turner: Lawrence Gowing's Turner makes the discovery that painting is essentially pigment on canvas, the pure form, color, and texture which are the traces of an artist in action. John Gage's Turner is trying to reconstitute the iconography of history painting in the genre of landscape.[1] The paradox is that a Turner painting substantiates both claims. Gage chooses for analysis the painting that most cogently demonstrates the problem.[2] In *Rain, Steam, and Speed* (1844, London, National Gallery) Turner produces one of his most masterly expressions of pure paint in the forward thrust of blackness out of a hole of light—which becomes a train rushing at us along a high trestle. But then he adds (visible only upon close inspection), racing down the track ahead of the train, a tiny rabbit, something between emblem and pictograph, which verbalizes as "speed" and also perhaps "transience"; and in the distance a tiny ploughman, perhaps indicating the tag "Speed the plough."[3] To this he finally adds a title "Rain, Steam, and Speed: The Great Western Railway."

A less radical example to begin with is *Dido building Carthage* (fig. 49), a harbor scene with classical buildings. It hangs, by Turner's instructions, in the National Gallery next to Claude Lorrain's *Embarcation of the Queen of Sheba* (fig. 51), and it is Turner's version of a Claude, showing

1. Lawrence Gowing, *Turner: Imagination and Reality* (London, 1966), and John Gage, *Colour in Turner: Poetry and Truth* (London, 1969).
2. *Turner: Rain, Steam and Speed* (London, 1972).
3. G. D. Leslie, *Inner Life of the Royal Academy* (1914), pp. 144–45.

that he could equal the old master on his own ground but also indicating his roots in the great tradition. Only when you are close do you recognize the Turner style in the sketchy, always slightly caricatured (or overparticularized) figures, more from the Dutch tradition than the Italian. Moreover, he has omitted the horizontal shoreline that closes the bottom of Claude's picture and creates the "harbor": the reflection of the sun in the water cuts the base line of the picture in two and leads all the way up to the sun itxelf, which is the cynosure of the picture—to a degree quite unlike the Claude. The Claude is structured architecturally on a series of planes parallel to the picture plane connected by diagonals, with the sun serving as the ultimate plane at the horizon. In Turner's picture the buildings and the harbor banks curve, the encroaching foliage recoils, in the wake of the. sun's rays, making the composition a vortex shaped by the sun.

Turner paid similar homage to Watteau and Rembrandt and showed Canaletto painting Venice in the manner of Turner and Raphael displaying a landscape which looks suspiciously like a Turner. He even painted an English artist in his studio that is meant to recall Hogarth's *Distressed Poet* (or his lost *Distressed Painter*). In each case Turner fits himself into the role of the painter to whom he acknowledges a debt but transforms him into a Turner. Each reference is both homage and correction. The Claude *Embarcation* stands for the whole genre of classical landscape as Other, much as in Pope's Horatian imitations the Horatian text was printed on the page facing his modernization that brought out the true "genius of the place."

There is a slight story element in Turner's harbor scene: a queen, surrounded by courtiers, is pointing to some plans related to the construction that is going on around them. When the painting was shown at the Royal Academy in 1815 Turner entered a title in the catalogue: "Dido building Carthage; or the Rise of the Carthaginian Empire—1st Book of Virgil's *Aeneid*." But even before making the catalogue entry he had added to the picture, along the wall at the far left, these same words as an inscription carved in the stone (in English). (The Claude pendant also helps by showing a queen and an implied foreign rival; as Sheba leaves to meet King Solomon, Dido is soon to encounter Aeneas.) The presence of the *Aeneid* renders the word *Rise* an irony, projecting the destruction implicit in the building of Carthage and the setting of the sun implicit in its rising. In 1815 the informed viewer would also have

felt a reference to France/Carthage and England/Rome. Finally, in 1817 Turner materialized the sequel, *The Decline of Carthage*, in a separate painting with the sun setting.

In the foreground of *Dido building Carthage* there is a group of children symbolically launching a toy boat (Carthaginian trade)—a touch we associate with Hogarth rather than Claude. The name of Sychaeus, Dido's husband, whose murder led to her flight to North Africa and the founding of Carthage, is inscribed on a tomb at the right. In *The Decline of Carthage* a building at the far left is decorated with a statue of Mercury, whose caduceus is inscribed on a pediment at the right. This was the god who told Aeneas he must not tarry with Dido but proceed on his way to found Rome.

Peripheral details like these are meant to draw our attention to what Wittgenstein in *Philosophical Investigations* referred to as an "aspect" of a work of art—a feature to which our attention may be drawn by a critic, as to the duck in the famous duck-rabbit figure. Seeing aspects, or *seeing as*, is the interpretive aim of Turner's juxtaposition of his landscape with a significant detail, a title, a painting by Claude, another painting as sequel, and so forth. What we notice, consequently, is the artist's need to draw our attention to this aspect rather than another; and that the aspect to which he draws our attention is the moral one. The aspect he apparently lacked complete confidence in, but which we may now (with Gowing) see as primary, is the paint on canvas arranged in a certain graphic rhythm. This rhythm Turner wanted us to understand as a public statement about his world, but the interesting fact is the intransigence of his materials, for as he forces us to look at one aspect, we cannot help being aware of another which we may feel is more important.

Some of these details are likely to recall Brueghel's *Fall of Icarus*, which is *about* the Flemish peasant ploughing the field, but allows a sidelong glimpse of the tiny figure of Icarus plunging unnoticed into the sea. The detail dissociates or makes peripheral the mythical from the routine of everyday life. We might see Turner's details of the ploughman and rabbit (and the boating party far below the train) or of the boys sailing a boat as a reminder of the persistence of natural and human cycles in the presence of a sublime landscape. Certainly the figures in most Turner history paintings are details in relation to the large sweep of the composition. In some paintings the relationship can be read as a mock-heroic deflation, as when a majestic Gothic ruin is accompanied by details of

contemporary debris (chickens, coops, and farm implements). As in the title of the poem from which he took many of his epigraphs for his paintings, Turner is dramatizing "The Fallacies of Hope."

In the paintings of his maturity Turner emphasizes these human details as almost pure linguistic signs. It is only a step from the speeding rabbit to the greyhound pursuing a "hare" which refers, as the picture's title, *Battle Abbey: The Spot where Harold Fell*, indicates, to Harold Harefoot, the Battle of Hastings, and the fall of the Anglo-Saxons. The aspect of the hare as a tiny creature in relation to the ruins of the abbey is overlaid with the pun. The hare is an addition, gloss, *remarque*, or superscription, and not an integral part of the composition like either the Brueghel Icarus or the Hogarthian detail. Whereas in Hogarth word and image join (even sometimes in puns), in Turner they tend to diverge. The title and pictograph make the painting something other than its image by itself would mean. Spatially the linguistic structuring is literally on top of the image, and chronologically word follows visual image. I think of the Varnishing Days as paradigmatic: Turner adds representation, brings certain parts of the pure form and texture to a finish, and then continues to impose meaning in the details, title, epigraphs, and other attached documents, extending to the clauses and codicils of his will. The progression is indeed a linguistic one from pictograph to hieroglyph to alphabetically constructed words and sentences, with a result very like the evolution, and the visual effect, of an emblem.

Now if we return to the so-called purely graphic image with which we began, and seek the lowest level of denotation, we find what is essentially the shape of a vortex tunnelling into the far distance to a source of light. This is the most basic conformation of a great many Turner landscapes; so many that we must look for an explanation of it somewhere other than in the direct imitation of nature. Graphically the vortex may derive from the opening in the clouds in the far distance of some Richard Wilson landscapes,[4] but if we relate it to the titles, epigraphs, and details that indicate "aspects" of the painting, we have to agree with Lord Clark among others that it expresses Turner's pessimistic belief in the cyclic nature of history.[5] If we regard this as only a public "aspect" to which

4. For a possible explanation in terms of the influence of Richard Wilson, see my "Types of Demarcation: Townscape and Landscape Painting," *Eighteenth-Century Studies* 7 (1975): 348.

5. *The Romantic Rebellion* (New York, 1973), pp. 236–37.

Turner has chosen to draw our attention, however, we might entertain Jack Lindsay's speculation that it derives in fact from the representation of copulating bodies in Turner's sketches or from some equally primal scene.[6] On one side, considerations of "pure form" do not explain the vortex, and on the other, Turner is not merely representing nature. Although he continues to insist on the truth to nature of all of his representations, and probably believed this, the fact is that in the large RA compositions, and even to some extent in the sketches directly from nature, he shapes nature to an a priori pattern. This I believe is one reason that he habitually depicts the most fluid of subjects, sky and sea, mist and haze, and so frees himself to produce his swirling vortices—the one stable element of which is the sun.

The Sun

The sun is a presence in almost every Turner landscape. It may make itself felt only through a medium of mist or clouds, but often Turner's storms seem to evoke the whirlwind of Ezekiel with "a fire infolding itself, and a brightness . . . about it, and out of the midst thereof as the color of amber, out of the midst of the fire" (1:4). Sometimes the sun is palpable. To quote one contemporary viewer writing of the *Regulus*, "Standing sideway of the canvas, I saw that the sun was a lump of white standing out like the boss on a shield."[7] It is safe to say that the sun is most prominent when the scene is most symbolic and least descriptive.

Turner chose as pendant to his *Dido building Carthage* one of the few Claude landscapes in which the sun itself appears as a palpable object not diffused by haze or off to the side casting oblique rays; and yet it looks dim compared to his own. We look directly into his sun: not to the right or left of it but straight into it, which means at the source of light and energy—or alternatively into the void, in the sense that the sun splits the picture down the middle, dissolves the stable Claudean harbor in a vortex, opens it at the bottom and leaves us as viewers no place to stand. Then in *Regulus* (1828–29, Tate) the significance of the sun in relation to Carthage moves toward extremity. The Carthaginians' revenge on the Roman general was to cut off his eyelids and take him into the sunlight,

6. *Turner: His Life and Work* (London, 1966), p. 163.
7. Sir John Gilbert to Sir George Sharf, quoted in Gage, *Colour in Turner*, p. 169.

blinding him;[8] and the Carthaginians are here—with the barrel of spikes prepared for the next stage of Regulus's punishment—being themselves swept away by the sun. We the viewers are Regulus: this is what *he* sees as he is blinded. The sun, as the fall implicit in rise and the darkness in light, is already destroying Carthage, rolling away all the Carthaginians who are torturing Regulus, as they simultaneously disappear in his coming blindness.

Over a large number of paintings this sun becomes associated with fruition, warmth, and energy on the one hand and with plagues and apocalyptic conflagrations on the other. It rises and sets, it burns and lights, it is the source of color, life, and energy, the ultimate fulcrum of the vortex, the colorless white in front of which opaque substances produce warm colors—the yellows and reds and oranges that define the vortex. Its shape and the shape of its emanations eventually determine the shape of the canvas itself, replacing the normal rectangle of a landscape with squares and even circles. Everything in the picture, from the waves to the clouds and the people, is determined, both created and destroyed, by this source of energy.

To see where the sun of *Dido building Carthage* leads, we can add to *Regulus* three other paintings. *Ulysses deriding Polyphemus* (1829, National Gallery, London) shows that the blaze of the sun is both the rising of Ulysses' sun and the setting of Polyphemus's sun. I should add that the sun was originally superscribed (the lines are now almost lost) with Apollo's chariot of the sun—an indication perhaps of a typical unwillingness to let the sun do its own work. Turner still, at this point, needed the horses of Apollo (indeed the horses of the sun on the Parthenon frieze) as well as the actual sun.[9] In the various paintings of the burning of the Houses of Parliament (1835) the sun has become a literal fire destroying the center of English government in the gesture Guy Fawkes had once planned. And in *Slavers throwing overboard the Dead and Dying—Typhon coming On* (fig. 53) the setting sun smears the sky with blood corresponding to the fate of the slaves cast overboard and devoured by sharks; at the same time it creates a long slender funnel which presages the avenging typhoon of the title.

Of the many proverbial senses of the word *sun* available to Turner I single out four: sun as a metonymy for life, as in "I 'gin to be weary of the

8. See ibid., p. 143.
9. Ibid., p. 131.

sun," Macbeth's words at the news that Lady Macbeth is dead and Birnam Wood is coming to Dunsinane; closely related to this is the sun as source of all power, as god. Turner is supposed to have said shortly before he died, "The sun is God."[10] Then there is Lucretius's warning, "The sun will blind you if you persist in gazing at it" (*Sol etiam caecat, contra si tendere pergas*). These senses are connected by the Jewish God whose countenance is like the sun: "Thou canst not see my face: for there shall no man see me, and live."[11] And they are connected by the sun of Plato's myth: the man is forced to leave the darkness of the cave, where he sees reality only as shadows cast by a bonfire, and look straight into the sun. First, Socrates tells us, he will be blinded, but then he will be able to make out objects with far greater clarity than before, as he will be able to see and understand the sun itself. In Ripa's *Iconologia* the sun is Truth, which has to be veiled—the truth of the poet which must be obscured with allegory. There is a sense, not too purely metaphorical, in which the haze, Turner's "medium," as Hazlitt called it,[12] is the veil of allegory which covers and conceals Truth, which, like Turner's sun, is blinding to ordinary eyes. This sun is nourishing, but when it does occasionally break through the veil, becoming palpable, the result is apocalyptic.

The locus for the congruence of blindness and insight for Turner's generation was the pair of suns in Milton's apostrophe to his blindness in the invocation to book 3 of *Paradise Lost*. Like the bonfire and the true sun in Plato's myth, Milton's external sun, to which he is blind, is contrasted with "thou Celestial light / Shine inward . . . that I may see and tell / Of things invisible to mortal sight." The confrontation of man and sun is also clear in Satan's apostrophe to the sun (book 4): he is regarding and being regarded by the sun (God), as both conscience and sign of all he has lost, and the exchange brings him closer than at any other time to self-realization.

The sense of duality is apparent in the fourth sense of the word *sun*, as rising/setting (in common parlance phrases attached to declining politicians: "more worship the rising than the setting sun," etc.). With Turner

10. Ruskin, *Works*, ed. E. T. Cook and Alexander Wederburn (London, 1903–12); 37:543.

11. Exodus 33:20; cf. Revelation 1:16, where at the Last Judgment God's "countenance was as the sun shineth in his strength."

12. "On Imitation," in "Round Table," *Examiner*, 18 February 1816, in *Collected Works*, ed. A. R. Waller and Arnold Glover (London, 1902), 1:76 n.

this is the sense, fully developed by the early 1800s, that the rising sun implies the setting; indeed, that the apparently rising sun is in reality setting, as in the *Dido building Carthage.*

So far we have placed Turner's sun in relation to the verbal structures of the proverb. We need to examine a number of other contexts beginning with political imagery. Turner grew up during the upheavals of the 1790s in France and (dimly reflected) in England. The crises of the 1830s and 40s, which seem to have upset him, found their expression in the imagery first set out by the French Revolution.[13] The traditional meaning of the sun followed from its being source of light and warmth and power, as God and therefore as his vicegerent the king. At the outset of the eighteenth century Louis XIV surrounded himself with the imagery of Apollo and called himself the Sun King. Around the middle of the century, by a kind of deconstruction, the sense of light was shifted by the philosophes to "enlightenment," the individual human reason, and the king and church became the darkness (and so ignorance) which the light attempts to penetrate and dispel. (Or perhaps we should say that the philosophes grafted onto the sun as God the iconographical tradition of the sun as Truth chasing away the shadows of the mind.) In the French Revolution the most commonplace set of associations revolved around this contrast of light-enlightenment-freedom and darkness-ignorance-imprisonment. Tom Paine always wants to place his views "in a clearer Light," wants us "to possess ourselves of a clear idea of what government is, or ought to be," as opposed to the obscurity and rhetoric of Burke; Mary Wollstonecraft argues that "True morality shuns not the day"; and in James Mackintosh's words, "we cannot suppose that England is the only spot that has not been reached by this flood of light that has burst in on the human race." Sir Samuel Romilly puts it this way: "a kingdom, which the darkest superstition had long overspread" now greets "the bright prospect of universal freedom and universal peace [which is] just bursting on their sight." And when the Revolution inevitably disappointed these sanguine expectations, we hear Hazlitt referring to the hopes for kind feelings and generous actions which "rose and set with the French Revolution. The light seems to have been extinguished for ever in this respect."[14]

13. Lindsay comments on Turner's growing interest in fires and other conflagrations in the political context of the 1830s (*Turner*, pp. 179–81).
14. Paine, *Complete Writings* (New York, 1900), 1:277, 278: Wollstonecraft, *Vindication of*

The aesthetic context naturally summons up Edmund Burke, for whom darkness is sublime and light is not: "But such a light as that of the sun, immediately exerted on the eye, as it overpowers the sense, is a very great idea. . . . Extreme light, by overcoming the organs of sight, obliterates all objects, so as in its effects exactly to resemble darkness."[15] And so again, as in *Regulus*, sun and total darkness are one. This same fierce glare, this power or uncontrolled energy seen as sublime in his *Philosophical Enquiry* (1757), becomes thirty years later in his *Reflections on the Revolution in France* (1791) the enlightenment rays that have been intensified by the revolutionaries into "this new conquering empire of light and reason" which dissolves all "the sentiments which beautify and soften private society," and indeed (as the metaphor shifts for him) rudely tears off "all the decent drapery of life" first from the queen and then from society. The true sun, as he sees it, enters

> into common life, like rays of light which pierce into a dense medium, [and] are, by the laws of nature, refracted from their straight line. Indeed in the gross and uncomplicated mass of human passions and concerns, the primitive rights of men undergo such a variety of refractions and reflections, that it becomes absurd to talk of them as if they continued in the simplicity of their original direction.[16]

His image of man's intricate and complex nature as the essential reality to preserve in society is precisely the opposite of the revolutionary's view of man as an obstruction to the beneficent glare of human liberty. By implication, Burke posits two suns: the royal or natural sun which is, in England at least, refracted through the prism of human nature or human possibility; and the false usurping sun of the human reason, which he sees is "not the light of heaven, but the light of rotten wood and stinking fish—the gloomy sparkling of collected filth, corruption, and putrefaction."[17] This is the false light cast by Swift's enthusiasts and

the Rights of Men, 2nd ed. (1790), p. 131; Mackintosh, *Vindiciae Gallicae* (1791), p. 345; Romilly, *Thoughts on the Probable Influence of the French Revolution on Great-Britain* (1790), pp. 2–3; Hazlitt, from *The Memoirs of Thomas Holcroft*, in *Collected Works*, 2:155.

15. *Philosophical Enquiry into the Origin of our Ideas of the Sublime and Beautiful*, ed. J. T. Boulton (London, 1958), p. 80.

16. Burke, *Reflections on the Revolution in France*, ed. W. B. Todd (New York, 1959), p. 73. Burke's comments connecting the sun with the stripping off of clothing: pp. 92–93, 105–06, 110.

17. House of Commons, 18 February 1793, in *Speeches* (1816), 4:120.

Pope's dunces, the light of the "new philosophy" which its adherents perceive as a "glorious blaze."

Burke is reacting against the metaphor for revolution formulated by the Reverend Richard Price shortly after the fall of the Bastille:

> I see the ardor for Liberty catching and spreading. . . . Behold, the light you have struck out, after setting America free, reflected to France, and there kindled into a blaze that lays despotism in ashes, and warms and illuminates all Europe! Tremble all ye oppressors of the world! . . . You cannot now hold the world in darkness. Struggle no longer against increasing light and liberality.[18]

Price raised the imagery of enlightenment into one of conflagration, which Paine developed in the opening of his notorious chapter 5 of *Rights of Man*, part 2 (1792): "From a small spark, kindled in American, a flame has arisen, not to be extinguished." But, he added, "Without consuming, like the *Ultima Ratio Regum*, it winds its progress from nation to nation, and conquers by a silent operation," and the fire ends sublimated into the sun's warmth, the natural burgeoning of plants, and the universal spring of revolution.

We can sense in Turner's sun something of Burke's sublime (as we can in his playing upon Burke's emphasis on the ocean "as an object of no small terror" and his emphasis on vastness and obscurity),[19] but also the revolutionary stripping away of veils and mists from the face of the naked sun, which becomes a source of heat as well as light. The artist and the patriot join, trying to make men see what they have seen by looking directly into the sun (while other artists look into the cave and see only shadows cast by marionettes by the light of a bonfire). One way to explain Turner's landscape structure is to say that he has returned to the world of the cave to tell us what he has seen out there and to force us to look at it ourselves.

Turner's poetic alter-ego was William Blake, whose etching *Albion*

18. Sermon, 4 November 1789, to the Society for the Commemoration of the Glorious Revolution, published as *A Discourse on the Love of Our Century* (1789).

19. John Dixon Hunt has recently argued that the "empty center" of the Turner landscape has to be seen as Turner's demonstration, in response to Burke, that a painter can be just as indefinite and suggestive (i.e., as "sublime") in his representations as a poet. My own evidence, however, suggests that Turner's intention cannot be described as offering us "the opportunity to participate ourselves in creating its final meaning." ("Wondrous Deep and Dark: Turner and the Sublime," *Georgia Review* 30 [1976]:141, 144, 153.)

Rose (dated 1780) shows England rising out of slavery as a youth bursting Scamozzi's textbook diagram of the proportions of the human figure—breaking the circle in an expansive sunburst, his hair twisted into flamelike points, much as Turner's sunburst destroys the perspective box of the Claudean landscape. In Blake's *The French Revolution* (1791) the king is still the sun, but obscured by clouds, and a new dawn is rising to replace him. The imagery is of the sun of democracy versus the night of the old order, whose false "light walks round the dark towers of the Bastille." Lafayette, the new light, is "like a flame of fire," and when he lifts his hand "Gleams of fire streak the heavens, and of sulphur the earth."

The two suns of Plato and Milton are thus either the natural sun versus the philosopher's deluding light or the aged setting sun of monarchy versus the young rising sun of democracy. As these alternative interpretations might lead us to suspect, with the disillusionment following the French Revolution the sun became a radically ambiguous symbol. In *America* (1793) Blake already shows "fiery Orc" (the spirit of revolution) amidst flames, either—depending on the coloring in different copies of the book—standing out from the flames like Albion or being engulfed by them: either emergent or being consumed. In Shelley's *Triumph of Life* (1822) "the [natural] Sun sprang forth" in a world of spring and sunlight, and all things responding "Rise as the Sun their Father rose." But the world of the poet's dream is sunless, plantless, and dead, with only "a cold glare, intenser than the noon, / But icy cold [which] obscured with blinding light / The sun." This is the chariot leading the triumph of life, its light inadequate to direct its way; and this wandering chariot drags behind it the Enlightenment heroes—in particular Rousseau, their spokesman—who have outlived their ideals.

Burke's true sun has become in Coleridge's *Rime of the Ancient Mariner* (1798) the sun-of-reason which "now rose upon the right" when the Mariner has killed the albatross, and which the sailors take to be a sign that the Mariner was right to kill the bird "that brought the fog and mist." It is the sun of reason or practical convenience, which carries the mariners to the sea of death, wherein, as Robert Penn Warren expressed it, "the sun itself, which had risen so promisingly and so gloriously like 'God's own head,' is suddenly 'the bloody Sun,' the sun of death—as though we had implied here a fable of the Enlightenment and the Age of Reason, whose fair promises had wound up in the blood-bath of the end

of the century."[20] On the other hand, Burke's false light, "the gloomy sparkling of collected filth, corruption, and putrefaction," becomes precisely the slimy snakes in the moonlight—the light of the imagination—the acceptance of which leads to the Mariner's rehabilitation.

Turner makes use of similar lighting effects (which include gleaming serpents) but his sun is all-sufficient and requires no moon as complement.[21] If he thought about Coleridge's sun I am sure it meant to him God's wrath and the Mariner's conscience, bloodying the sky in *Slavers* or exploding it in *Regulus*, aimed at the Mariner as the "glittering eye" of the "bright-eyed Mariner" himself is leveled at the wedding guest. The sun's significance depends on whether the viewer is sinner or penitent, and consequently on whether the sun itself is external or internal. The literary sun which influenced Turner, if any did, was the sun that beats down upon the monk Ambrosio in M. G. Lewis's *The Monk* (1795). Following scene after scene of immurement within dark churches, monasteries, and dungeons, the sun finally bursts forth. Ambrosio is plucked from his Inquisition dungeon and cast down to the ground under the glaring, burning, punishing sun, which takes on the attributes of a stern and angry God to whom Satan has relinquished his victim: "The Sun now rose [not as in the *Ancient Mariner* "upon the right" but] above the horizon; its scorching beams darted full upon the head of the expiring sinner." And with it comes myriad insects and eagles from the sky—and we are told of Ambrosio's ambiguous end that it took him "six miserable days" to die, and on the seventh a violent storm arose and he expired in the midst of a deluge: the order of Genesis reversed and the general structure of a great many Turner canvases adumbrated.

I refer not only to Turner's paintings of the Deluge itself but to the way in which his paintings repeat the order of Creation. Hazlitt's hostile criticism is pertinent: "The artist delights to go back to the first chaos of the world," he said of Turner, "or to that state of things when the waters were separated from the dry land, and light from darkness, but as yet no living thing nor tree bearing fruit was seen upon the face of the earth.

20. *Rime of the Ancient Mariner* (New York, 1946), p. 93.
21. From the mid-eighteenth century onward painters explored the possibility of representing the source of light itself. But for a painter like Wright of Derby the subject was an artificial (human) source of light, and off to the side, much less central, was the natural source, a sun or moon. Painters contemporary with Turner tried, according to Charles Stuckey, to evoke eternity by representing both sun and moon in the same scene (*Temporal Imagery in the Early Romantic Landscape* [Ann Arbor, Mich., University Microfilms, 1972]).

All is without forms and void." Contemporary accounts of how Turner
built up a painting on Varnishing Day show the same pattern.[22] Starting
with an emphatic *fiat lux*, Turner separates land from sea, painting dark
over (or up from) light in precisely the reverse of the conventional
procedure followed by painters in oil, who start with dark glazes and
work up to the high points of light.[23] But he stops short of finished
creation, or at least suggests a precarious point of time at which chaos is
about to reassert itself. Carthage is both abuilding and declining, de-
stroying Regulus and itself.

I have postponed until now discussing the actual practice of the
landscape painter, expressed in his need to control and arrange his
natural materials. Jay Appleton, in his recent book *The Experience of
Landscape*, notes that the sun can either illuminate a landscape or partici-
pate as a component of it; but the latter is difficult because "the eye
cannot contemplate it except at the risk of great discomfort and even
physical damage" and it "obliterates everything else," is "so blindingly
bright that we can see nothing. Some limitation must be placed on its
brilliance so that it approaches the same scale of light intensity as the
landscape it illuminates."[24] To make it manageable, the artist reflects it
on surfaces of other objects (clouds, trees, buildings) or interrupts the
passage of its light, partially or totally, by placing objects between sun
and observer. Both possibilities, however, depending on the size of the
object or the degree of its opaqueness, can deprive the viewer of the
unimpeded prospect to the horizon which determines the Claude land-
scape and which Appleton sees as one of the psychological functions of
landscape. The sun is, in Appleton's terms, the "supreme prospect
symbol," as "not only by far the most powerful source of light but . . .
also symbol of distance on a supra-terrestrial scale." Prospect allows a
way of escape; the observer himself tends to be in a shaded foreground
(the Claudean coulisse), seeing but not seen, so that "prospect and
refuge can be at least partially achieved simultaneously."

22. For Hazlitt, see above, note 12. Cf. E. V. Rippingille's description of a Varnishing
Day at the British Institution: "The picture when sent in was a mere dab of several colours,
and 'without form and void,' like chaos before the creation"—which Turner then worked
up (*Art Journal* [1860]:100; but of course possibly influenced by Hazlitt's comments); or the
one by W. Fawkes, quoted by G. W. Thornbury, *Life*, 2d ed. (1904), 2:52.

23. Of course, in one sense Turner is simply applying a technique learned from
watercolor painting to oil painting. But its significance is too great to be explained only by a
mechanical consideration.

24. *The Experience of Landscape* (New York, 1975), p. 110; also pp. 109, 77.

 This whole process is reversed by Turner, who confronts his viewer
with the sun, giving him total prospect but depriving him of any refuge
whatever in the foreground or middle distance. The sun penetrates to
his innermost refuge, leaving him naked and without a place to stand, let
alone conceal himself. He is face to face with the ultimate, whether we
call it God or Truth or Self.

 The sun in a landscape can be regarded—certainly was so regarded by
earlier painters—as the divinity that suffuses the "Book of Nature." Its
influence is comparable to the Christian doctrine of the Incarnation, as
God descends into man and man receives "a measure of divinity which
brings him within reach of God."[25] It is important to remember that
behind Burke's sublime lies John Dennis's, which was powerfully sun-
oriented. The most sublimely terrible idea, says Dennis, is that of an
angry god, and involved in the idea of the sublime is the desire for
engulfment. The sublime, he says,

> gives a noble Vigour to a Discourse, an invincible Force, which
> commits a pleasing Rape upon the very Soul of the Reader; that
> whenever it breaks out where it ought to do, like the Artillery of
> Jove, it thunders, blazes, and strikes at once. . . .[26]

Here the sun and the sublime are connected with God the Father and
sexual attraction/compulsion and we are back to the theory that Turner's
vortex derives from the sexually embroiled bodies in his erotic drawings.

 Dennis and, later, Burke leave little doubt that the sun (like other
sublime objects) is a sublimated symbol of the father. As Freud pointed
out, in most languages the sun is male, as opposed to "Mother Earth."[27]
In terms of this verbal contrast, the basic Turner composition is a
penetration of earth by sun, an overpowering ("a pleasing Rape") of the
earth, which opens up before it. If a vortex is the central informing
principle, the general composition takes the form (and often the repre-

 25. Ibid., p. 110.
 26. "The Grounds of Criticism in Poetry," *Works*, ed. E. N. Hooker (Baltimore, 1939),
1:339, 356, 359. Dennis contrasts the sun in ordinary conversation, "a round flat shining
Body, of about two foot diameter" with the sun in meditation, "a vast and glorious Body,
and the top of all the visible Creation, and the brightest material Image of the Divinity"—
which expresses the ambiguity of Turner's feelings as well as explaining Blake's comment
in *A Vision of the Last Judgment* that he saw in a sun the size of a guinea "an Innumerable
company of the Heavenly host."
 27. Though not in German. See Freud, *Complete Psychological Works*, Standard Edition,
12:53–54.

sentation) of a harbor, illuminated and indeed defined if not scooped out by the sun. If a paint rhythm can project a metaphor, we might say that existence is a harbor, a fringe of awed spectators. We are also now perhaps able to explain the power of the train image in *Rain, Steam, and Speed.* For once the form is black. As a reflection of the iconographical tradition, this is a modern version of a dragon roaring out of its cave; as a great black phallic serpent heading straight at us, it is the negative of Turner's sun which, we have seen, equates total light and total darkness.

What does it mean then for Turner to compel his viewers (and himself) to look straight into the sun? Addison distinguishes beautiful from sublime as a passive response to experience from an active one. If it is "but to open the eye" to experience beauty, sublimity satisfies our desire "to be filled with an object, or grasp at anything that is too big for its capacity" (the "thing too great" is defined as the "Supreme Being"). The end recommended is submission, but the process begins with an active gesture, and to Addison the sublime is liberating, aggrandizing, and exhilarating. If Burke finds it alienating and diminishing, it is because he is afraid of it at the same time he is drawn to it. But both agree that it refers us forward to ultimates, to confrontation with and exercise of power, while the beautiful refers us nowhere beyond the self and a regression into the repose of infantile rest.[28] Turner, in these terms, is pitting the viewer against the landscape and its Creator and finding himself sharing the roles of both viewer and Creator.

In discussing the sun as father symbol, Freud recalls the myth of the eagle who, because of his close relation to the sun, tests his offspring by making them look into the sun "and requires of them that they shall not be dazzled by its light." He is thus behaving, Freud tells us, "as though he were himself a descendent of the sun and were submitting his children to a test of their ancestry"—that is, a "mythological method of expressing his [own] filial relation to the sun."[29] One way to "grasp at" or be "filled with" the father-god-king is metaphorically to take his place, calling yourself the individual human reason and him the darkness; or to

28. *Spectator* No. 412. To compare the case of Gainsborough, whose vortex is a plunging diagonal, see my discussion in *Emblem and Expression* (London, 1975), pp. 218–31. I believe that Gainsborough is thinking in terms of the beautiful, associated by both Addison and Burke with regression and return to a womblike peace; Turner, thinking in terms of the sublime, repels or pushes back his viewer from the vortex, and accompanies this with his attempts to coerce him.

29. Freud, *Works,* 12:80–81.

identify with him, taking the quality of pure power and altering it to something comprehensible like the creative energy of the revolutionary or the artist. In the same way Turner's homage to Claude, Rembrandt, and Watteau transformed each artist into a Turner. And so with the sun he takes on the greatest of all natural authority symbols, removes its veil, makes it his own artistic subject/signature, and sees himself accordingly as creator/destroyer, parallel to its positive and negative aspects.[30] There is in the sun as the "eye of God" the sense that when the artist paints the sun he is painting himself, and Turner's sun-centered landscapes may be, as Lindsay has suggested, self-portraits.[31]

Thus far we have seen what the Turner sun as an image could have meant to a contemporary who looked at Turner's pictures, and—to judge by a number of these pictures—to Turner himself. We also know that Turner *wanted* contemporaries to understand these things but despaired of communicating them. (Turner's human figures are shown either recoiling or thrust away from the light; they are neither illumined nor enlivened, just as they are never drawn toward it.)

In the late painting *The Angel standing in the Sun* (fig. 54), Turner superscribes the sun with the figure of a seraphic angel, highest of the nine orders (burning with ardent desire for God).[32] But, while the picture plainly represents the Angel of the Sun, and this is supported by the title, the epigraphs appended in the RA catalogue tell us it is the avenging Angel of Revelation and the Angel of Darkness in Samuel Rogers's poem *The Voyage of Columbus*. Like those earlier Turner suns, this is a sun and no sun, light as darkness (or blindness). But the angel is also, quite literally, Turner himself, superimposed on the sun as a near congruence of both mythologizing and gloss. His arms are raised and one brandishes a sword which makes a semicircular arch like a rainbow in the air, with birds flying in the track of the arch. Ruskin had described

30. Were we to carry the discussion from Turner's works into his life, we would have to note his identification with his father against his mother, his references to the RA as a mother rather than a father (as in the story in which he said Haydon "stabbed his mother"), and his taking the role of father in relation to his own father in later years. His paternalism extended to his pictures: he refused to part with them, tried to buy back pictures he had sold, and desired in his will that his works be kept together. "What is the use of them but together" and "Keep them together" are phrases that recur, suggesting the father's need to control and maintain intact the family group (Thornbury, *Life*, 2:98–99; and Lindsay, *Turner*, pp. 92–93).

31. *Turner*, p. 213.

32. The kind of engrossment employed by Turner echoes such biblical images as the angel-sun at the center of the whirlwind or the fiery chariot wheel (Ezekiel 1).

Turner three years before in *Modern Painters* (1843) as "Standing like the great angel of the Apocalypse, clothed with a cloud, and with a rainbow upon his head, and with the sun and stars given into his hand." The passage was picked up a year later by the Reverend John Eagles and parodied savagely in an attack on Turner in *Blackwood's Edinburgh Magazine.*[33] Turner has represented this angel, and below it he has inscribed smaller pictographic figures related to the Reverend Eagles and other detractors whom we can make out to be Cain fleeing from the body of Abel over which Adam and Eve mourn, Delilah bending with her scissors over a sleeping Samson, Judith contemplating the head of Holofernes, and—enigmatically—a chained serpent.

All the revolutionary overtones of the sun are subsumed under this personal, artistic significance. Blake for the same reason chose to depict the revolutionary figure of Albion as a sunburst breaking not political but aesthetic rules, the doctrine of the Vitruvian circle. But Blake's Albion is still Albion (England); Turner's angel brandishing the sword on the Day of Judgment is only an emblematized version of the Turner who smears the sky with appropriately bloody sunset and predicts vengeance on the slavers or who sets fire to the Houses of Parliament.

The Vortex

From an investigation of Turner's sun it is apparent that the graphic image itself has beneath it, waiting to be exhumed, puns, proverbs, and other verbal structures. There is a sense in which a verbal structure may be at the nucleus of a Turner painting as well as on its periphery. The vortex clarifies the issue while also projecting us into pure speculation. Art historians would tell us that Turner found this form in Thornhill's Greenwich ceiling or Rubens's Banqueting House ceiling—in short, in the experience of baroque art. There is, however, no vortex of this kind in either ceiling, or in any other English ceiling he could have seen.[34] If

33. Ruskin, *Works*, 2:254 n.; *Blackwood's Edinburgh Magazine* 54 (Oct. 1843): 492. See Charles Stuckey, "Turner, Masaniello, and the Angel," *Jahrbuch der Berliner Museen* 18 (1976): 161–63. See Graham Reynolds, *Turner* (London, 1969) pp. 200–01 for a contrary opinion; and for one supporting, see Lindsay, *Turner*, p. 213.

34. The late circular or square pictures may, of course, owe something of their composition to baroque ceilings Turner would have seen in Italy.

In a lecture delivered at the Yale Center for British Art, 8 December 1977, Andrew Wilton argued that the Turner vortex is in fact in origin a Poussinesque device for radial

Lindsay's thesis about the vortex's origin, that it might be traced back to the doodles in the sketchbooks which become representations of entangled, copulating bodies, is correct, the first impulse may be either a form that engendered, suggested, or took the shape of copulating bodies; or a representation of a primal scene that engendered the form; or even the word itself—to copulate, to join, to unite, or the simplest copula, *to be*—that lies behind both of these, initiating the characteristic Turnerian enjambment of different times, places, and fates.

Charles Stuckey has argued that the vortex may find its confirmation in Turner's own name; that there is a graphic movement corresponding to the verbal one from "Turner" to "turn" to "wheel," "circle," and of course "cycle," and even to "ring" (as in the *Undine giving the Ring to Masaniello* [Tomasso Aniello, or "ring"] of 1846).[35] This would not, however, be merely a significance Turner read into the vortex late in his life, but rather the origin of the form itself in the child's concern with its own name. Indeed, it would join the primal scene and the pun of the copula *to be* with the earliest self-identification.

We know Turner's adult penchant for punning—not only using "hare" for Harold Harefoot but signing his own name with a sketch of a mallard (for his second name Mallord).[36] But the primal pun would have established itself before Turner ever took up a brush. We know that Farington heard him remark that the father of his rival Girtin was a

perspective that probably begins with *Bonneville* (1802, Butlin and Joll, *The Paintings of J. M. W. Turner* [New Haven and London, 1977], pl. 15). The particular Poussin in question may be *Landscape with a Roman Road* (Dulwich Gallery). What Wilton overlooks, I believe, in the very Poussinesque *Bonneville*, is that this vertical recession is crossed, blocked, and closed by repeated horizontal planes intersecting in the form of shadows and the paperthin chateau and mountain ranges, which resemble nothing so much as the flats of a stage set. In so far as it derives from painting, the Turner vortex is an intensification of Claude's sunset. But, as I have shown, the elements of the vortex, besides the presence of the sun itself, are the sense of infinitude rather than closure and the twisting and "turning" of the horizontal planes into curves. In paintings like *Calais Pier, Mortlake Terrace, Rome from the Vatican*, even *Hero and Leander* (Butlin and Joll, pls. 16, 223, 217, 348), Turner includes both channels, double or alternative perspectives down which the eye moves at different speeds. One, usually on the left or right side of the picture, is man-made (a pier, road, arcade, or loggia), cut across by horizontals, and closed; the other, which is usually more central, is a natural force almost always emanating from the sun. (The conception of two channels may be related to the two sources of light, one natural and the other artificial, in many Wright of Derby paintings.)

35. "Turner. Masaniello, and the Angel," pp. 171–72.
36. P. Cunningham, "Memoir," in J. Burnet, *Turner and his Works* (London, 1852), p. 33.

turner. His own father was *not*—he was a barber, but with the vortical pattern of the barber pole as his sign.[37] The point is that there is a verbal source for the vortex in the name Turner, and a visual source in the father's barber pole, and they come to the same thing. Obviously somewhere in the dim past there had been an ancestral turner, prior to the name, whose sign would have been a coffee-grinder or a Saint Catherine's Wheel or some turning device.[38] The heraldic sign or the shopsign originates as a name on which a visual pun is made, and the name itself—Turner, Baker, Smith, or Miller—goes back to a metaphor, a trope of some kind. One can only cite Alain Grosrichard on "the transference of the need to name the world to the prior need of naming oneself. To name the world is to make the representation of the world coincide with the world itself; to name myself is to make the representation that I have of the world coincide with the representation that I convey to others."[39] In practice this becomes the naming of the Other— the sun or the vortex made by (or which creates) the sun, which can be named in terms of the surrogate sun (or son) who is the creator (painter) named Turner. Thus, as Rousseau realized, "man's first language had to be figurative" and there is "some degree of conceptuality (or metaphor) from the start, within the very act of naming."[40] The real point of origin for any kind of communication is not the image in nature (as representation) but the subject expressing himself in relation to the Other: "That is a giant to me; like me the sun is also a Turner," and so on.

Thus a Turner is "one who turns or fashions objects of wood, metal,

37. A. J. Finberg, *The Life of J. M. W. Turner, R. A.*, 2d ed. (London, 1961), p. 55. The barber's pole came into existence through the barber surgeon's habit of giving the patient a pole to grasp during the blood-letting operation "in order to make the blood flow more freely.... As the pole was of course liable to be stained with blood, it was painted red; when not in use, barbers were in the habit of suspending it outside the door with the white linen swathing-bands twisted round it. . . ." By the end of the eighteenth century the barbers were using the pole alone, the surgeons with the addition of a gallipot and red flag. See Jacob Larwood and J. C. Hotten, *The History of Signboards* (London, 1908), pp. 341–42, and for an example, Hogarth's *Four Times of Day: Night* (1738).

38. See Ambrose Heal, *The Signboards of Old London Shops* (London, 1947), pp. 173–74; Larwood and Hotten, *History of Signboards*, passim; and Arthur Charles Fox-Davies, *A Complete Guide to Heraldry* (London, 1949), pp. 301–02, fig. 556; see also pp. 5, 80.

39. "Gravité de Rousseau," in *Cahiers pour l'Analyse*, 8:64; quoted, Paul de Man, "Theory of Metaphor in Rousseau's *Second Discourse*," in *Romanticism: Vistas, Instances, Continuities*, ed. David Thorburn and Geoffrey Hartman (Ithaca and London, 1973), p. 98.

40. De Man, "Theory of Metaphor," p. 101; see Rousseau, *Essai sur l'origine des langues* (published 1817).

bone, etc., on a lathe" (*OED*)—a maker or craftsman, but one who operates through, or shapes by means of, rotation of the object. With the noun go all the senses of the verb: rotation, a spinning around something, a twist (perhaps also the turning implicit in the coupling of lovers); a convoluted form corresponding to one whole revolution; and so a change of direction or course ("the wind has turned"), a deflection or deviation from a course, and change or transformation. What we see is a number of senses which allow for the connotation of a turner as a revolutionary, in the sense of both an artist transforming his art and a man his society, reversing the order or arrangement of the object, upsetting, deranging, or unsettling, and hence rebelling ("the worm will turn"). If the vortex form originates in a pun, its meaning—layer upon layer—would go something like this: Turner, my name; a maker or artist; a constructor of vortices in particular; a revolutionary; He who revolves the earth ("as the world turns"). We have already examined the conjunction of artist and God; with revolutionary and God we are at the heart of the vortex itself, a tension of conflicting forces, an ambivalence toward the sun, and a need both to change the order and maintain it.

We have established a verbal impetus, therefore, before as well as after the graphic image has been made—and this second verbalizing is then an attempt (on the part of the artist, in Turner's case) to recapture an original meaning, obscured by the graphic image which has become what Gombrich calls an "open sign"—[41] with almost unlimited significances or interpretations. To this process we might compare Coleridge's addition of a prose context, a preface, to his fragmentary poem *Kubla Khan.*[42] He seeks to express, or in fact to change, the meaning of the poem by the contiguity of another "text" rather than by active revision of the object itself. Coleridge, however, does this to free or open up the fragment to meanings beyond itself, while Turner tries to define and close off the limits of meaning. With his marginal glosses to *The Rime of the Ancient Mariner,* Coleridge projects the idea of a symbol, locating and acknowledging the source of meaning in the object. Turner consciously turns his symbol into an allegory, suggesting that he feels an

41. See E. H. Gombrich, *Symbolic Images: Studies in the Art of the Renaissance* (London, 1972), pp. 18, 159, 182; and my critique of Gombrich, which builds on the argument of the present essay, in "Iconography Revisited," *Modern Language Notes* 92 (1977): 1052–66.

42. I am indebted for this analogy and the remarks on Coleridge to Jean-Pierre Mileur. For the aesthetic background, see Roy Park, " 'Ut Pictura Poesis': The Nineteenth-Century Aftermath," *Journal of Aesthetics and Art Criticism* 28 (1969): 155–64.

object has meaning only within the context supplied by the superimposed interpretation.

For what Turner demonstrates is an attempt to absorb the natural object in the subject, or make it a symbol for his own state of mind; but at the same time he acknowledges the existence of the gap within a failed language. Perhaps for Turner, as for Coleridge, the essential problem expressed in all his work is to reconcile "I am" and "it is," the inner and the outer life. Turner as painter demonstrates the problem even more sharply and poignantly than Coleridge. One has to suppose that for him the painting was an incomplete object symbolizing a self that he recognized as his own yet felt alienated from. His own very shaky sense of selfhood had to be materialized constantly in paintings plus their explanations, and all of them hung in a gallery where his self was thus aspiring to a state of completeness which reached out to his instructions that only finished paintings be shown. One must suppose that the great "unfinished" pictures made him uneasy of a self not yet grasped—and of course his studio was stacked with these, which we now think are his masterpieces. Even the finished ones—the *Dido building Carthage* and the rest—were ignored; visitors report that Turner could not bear to look at them, and we know they rotted and mildewed and flaked. And yet he continued to prepare them to signify in the Turner Gallery that was to be attached to the National Gallery.

Thus Turner in his visual phase produces a number of marks on a canvas, transforming what is present into a symbol of something much greater but fundamentally inaccessible. This is the act of painting in which the "it is" becomes the "I am." But the self that engendered the graphic image seems as distant from "I am" as Descartes' subject from its object, and now the "I am" has to be further reconceptualized by words into an "it is." The gap is between the experience of the conception in the mind and the result as it exists as an object; and this entails a further attempt to recapture the origin of the image in either experience or concept: by recreating its inner personal significance at the moment of its creation, or perhaps sometimes finding one for it after the fact. To do this Turner is willing to sacrifice the freshness of the experience (recorded in the sketchbooks, even painted on the canvas) to what is more respectable, the reconstruction of the concept, the emotion, the "I am" which pretended to be "it is."

We cannot leave unsaid the possibility that he is not trying to express

the truth at all but only to repress the original meaning and give one he feels is more public and respectable, one he may have discovered in the painting of his picture or after the fact. Perhaps the correct analogy is not with Coleridge's *Kubla Khan* but with Richardson's revisions of *Clarissa*, which patently demonstrate his conviction that something had surfaced in the first edition that needed covering up. We can see Turner too seeking to impose an acceptable meaning—one that includes even the very personal allusions he seeks to communicate in the late paintings—as a way of concealing a true, somehow discreditable meaning he senses is expressed in the object, while, like Richardson, unconsciously exposing himself.

Turner seems to interpret the incomplete, even fragmentary quality of the painting (what is not present, not shown, not carefully or completely defined) as an indication either that the actual vision or its experiential quality has been lost, and that what remains—or has been transmitted—is at best a shadow of that vision; or that something made him stop before he completed the representation and now makes him disguise it. To complete it, to recreate it, as it ought to have been, he believes that verbal forms are required, perhaps to show that it began (or should have begun) as words in the sense of concepts or poetry, rather than of perceptions or personal trauma.

R. F. STORCH

Abstract Idealism in English Romantic Poetry and Painting

I

Our liveliest clues to the creative psyche have come from the Romantics' openness in their arts and their speculations concerning undercurrents, underconsciousness, and other "unknown modes of being."

> The truth is, that Images and Thoughts possess a power in and of themselves, independent of that act of the Judgment or Understanding by which we affirm or deny the existence of a reality correspondent to them. Such is the ordinary state of the mind in Dreams.[1]

Ruskin, referring to Dante, Scott, Turner, and Tintoretto, wrote of "the kind of mental chemistry by which the dream summons and associates its materials" and admitted that it is "utterly inexplicable."[2] If therefore we can get close to the deeper affective life of the individual poet and painter, or to put it another way, learn to see more clearly the whole range of the affective life and feel more at ease in characterizing the imagination by a "mental chemistry" other than "Judgment and Understanding," it would seem to follow that a *comparison* of poet and painter would be equally deep-searching, uncovering to us affinities at a level close to dreams.

Such affinities have probably been intuited by students of Shelley and

1. To Daniel Stuart, 13 May 1816. *Collected Letters of Samuel Taylor Coleridge*, ed. Earl Leslie Griggs (Oxford, 1959), 4:641.
2. *The Works of John Ruskin*, ed. E. T. Cook and Alexander Wedderburn (London, 1903): *Modern Painters*, 4:41–42.

Turner: the two seem to make a natural pair. But comparisons have tended to deal with superficies, similarities in colours and other aspects of description. And yet it is not difficult to go deeper, if only because the characteristic work of both men already resembles a self-autonomous mode that is remarkably akin to dreaming. To be sure, Shelley is the more obvious example of this tendency. One has, in fact, only to think of names like Arnold's or Leavis's to recognize that there exists a long tradition of uneasiness about the essential quality of Shelley's imagination in relationship to the "real" world. But although Turner today might appear to be exempt from the kind of criticism which has long been leveled at Shelley, it is my belief that an examination of the psychic factors most deeply at work in Shelley will also help us to understand Turner in a fashion somewhat different from the current vogue of near-veneration for his work. My critical method, then, will draw openly upon the resources of psychoanalytic inquiry; and if I begin with Shelley, it is largely because the language of literary criticism more nearly approaches the domain of psychoanalysis than does that of art criticism.[3]

In any event, literary historian and psychoanalytic critic would agree that all art, especially all Romantic art, works with a certain amount of regression, and that a common aspect of Romantic poetry and painting is a willingness to forego the security of conventional patterns of experience and expose the artist himself to the dangers of disintegration. The creative benefits of regression and the dangers of disintegration go hand in hand. Coleridge knew that the secondary imagination "dissolves, diffuses, dissipates, in order to recreate," and he also knew that the poet, "described in ideal perfection, brings the whole soul of man into activity" (*Biographia Literaria*, chapters 13 and 14). But he did not put these two insights together to recognize that the whole soul of man, engaged in the imaginative work of dissolving, diffusing, and dissipating, would itself undergo disintegration and recreation. The Romantic landscape in poems and paintings symbolizes these psychic processes. Landscape may indeed be a misnomer, since the Romantic universe of things is very unlike the landscape compositions of eighteenth-century poets. Their visual coherence, the carefully controlled plan of the conventional landscape, is taken apart by the Romantics into what seems initially a mere list of things. Wordsworth's "spots of time" are evident examples: a stone, a

3. The psychological aspects of Wordsworth's and Constable's more realistic imaginations are briefly considered in the last section.

wall, a single tree, a sheep, a pool, a beacon, are fused into a meaning without obvious poetic means, and remain mysterious to poet and reader alike.[4] The "mental alchemy" and the dreamlike processes noted by Ruskin and Coleridge become operative when the regression towards relatively primitive states and events has occurred. Here, then, we have the major terms—regression, disintegration, primitivism, and rein-tegration—which describe the paradigm of the Romantic imagination, whether in poetry or painting.

II

For Shelley life is an illusion, a painted veil hiding reality. Because reality is hidden, the poet must assume a realm of ideals, where alone his spirit will find happiness. However extreme such idealism may seem in the abstract, in Shelley's poems it has provided emotional satisfaction for many readers and has evoked their intellectual assent. The tradition of Platonism is evidence of deeply seated emotions that can, at times, be felt by all. Shelley's poetry, though, lies not in his Platonic ideas, but in patterns of unconscious affects, manifested in themes, images, and metaphors.

Of these the image of the veil is crucial. It is the image of separation and desire for reunion. Through its proliferation we can trace the affects that agitated Shelley's imagination. The earlier poems most strongly suggest the primary meaning of the image: the veil hides the body of a desired though mysterious woman:

> A vision on his sleep
> There came, a dream of hopes that never yet
> Had flushed his cheek. He dreamed a veilèd maid
> Sate near him, talking in low solemn tones.
> Her voice was like the voice of his own soul
> Heard in the calm of thought; its music long,
> Like woven sounds of streams and breezes, held
> His inmost sense suspended in its web
> Of many-coloured woof and shifting hues.
>
> [*Alastor*, ll. 149–57]

4. W. K. Wimsatt, in "The Structure of Romantic Nature Poetry" (*The Verbal Icon* [Lexington, Ky., 1954]), seeks the "imaginative structure" distinctive to Romantic nature poetry, but is unable to say what significance the poet has given to descriptive details or how they are made to cohere.

She sings of knowledge and truth and in the fervor created by her song kindles an ecstasy of erotic images. The veil becomes transparent so that her "glowing limbs beneath" are visible. The episode ends in sexual consummation.

The eroticism is intensified at the expense of a fuller relationship because the desired object is distanced by the painted veil. Idealization and eroticism are signs of the same emotional impoverishment, in which fear and aggression are stronger than love. The cumulative force of Shelley's poetry has its origins in a hunger for love, a denial of loss, and a destructive hatred. At his best Shelley is able to bring these deep passions into imaginative tension with each other; at his worst he tries to evade them by erotic fantasies. In *Epipsychidion* the productive tension is felt most of the time. In two other poems, "The Sensitive Plant" and "A Vision of the Sea," the negative feelings are more evident. The sense of loss and the denial of loss is especially prominent in "The Sensitive Plant." The companionless being in the midst of an undefiled paradise of other plants lacks their beauty or expressive love. Look, it says, I am totally unworthy, but all the more in need of love:

> For the Sensitive Plant has no bright flower;
> Radiance and odour are not its dower;
> It loves, even like Love, its deep heart is full,
> It desires what it has not, the Beautiful!
>
> [ll. 74–77]

Its heart is full, but of a strange sort of love. The mixture of self-denigration and totality of longing is not what Plato meant by man's desiring what he lacks. The noble aspiration of the last line disguises an underlying spiritual supineness, which is revealed by the sensitive plant's claims for itself. Because it is the feeblest it is the favorite of the "power" ruling over the garden: a female figure who attends to all the plants with maternal care: "If the flowers had been her own infants, she / Could never have nursed them more tenderly." But she dies in the autumn; everything in the garden withers and the sensitive plant turns into a leafless wreck. Having pleaded weakness the plant received maternal love, only to lose it again in a world devastated by death. This ultimate experience of loss is then negated by a "defense" against unbearable pain, idealism. The "Conclusion" argues that since everything in life is deceptive and we are shadows of a dream, we may assume that death

itself is an illusion. In the end we sense that the plant and the guardian are identified with each other: they die together and also gain immortality together. By denying the mortality of the maternal image, the sensitive plant, too, seems assured of eternal life.

"The Sensitive Plant" was written in March 1820. In "A Vision of the Sea," written very soon after, a woman sits at the helm of a storm-tossed bark nursing her child:

> While the surf, like a chaos of stars, like a rout
> Of death flames, like whirlpools of fire-flowing iron,
> With splendour and terror the black ship environ,
> Or like sulphur flakes hurled from a mine of pale fire
> In fountains spout o'er it.
>
> [18–22]

The woman is again idealized, being more fair than heaven. All the mariners have died, but there are two tigers on the vessel who have broken loose but whose ferocity is strangely subdued. When the storm abates and the blue heavens smile on the waves, the black ship of hate splits and disintegrates. One of the tigers writhes in mortal struggle with a sea snake. A shark waits to gorge itself. A boat approaches, and someone on it shoots the other tiger, which has thus far saved itself from snake and shark. At that moment the woman goes down, grasping a spar with her left hand and holding aloft her "fair infant" in her right:

> Death, Fear,
> Love, Beauty, are mixed in the atmosphere,
> Which trembles and burns with the fervour of dread
> Around her wild eyes, her bright hand, and her head,
> Like a meteor of light o'er the waters! her child
> Is yet smiling, and playing, and murmuring; so smiled
> The false deep ere the storm. Like a sister and brother
> The child and the ocean still smile on each other
> Whilst—
>
> [161–69]

And there the poem abruptly ends. The images of extreme cruelty—tigers, snake, and shark—whatever their specific symbolic meaning may be here, are announced by the mixture of fire and water and sulphur, a truly Turneresque seascape, and rounded out by the cynical touch of

having the boat split at the moment when safety seems at hand. The child's uncomprehending and unfeeling smile seems to light up with the malice of the elements themselves, producing the eerie effect of his triumphing over his own mother's destruction. It is as if the child had succeeded in isolating his mother from the rest of the world so that he could witness her death. A similar sadistic strain is discernible in "The Zucca," written in January 1822. It is closely related to "the Sensitive Plant," but its sadism is more overt. The plant, "Like one who loved beyond his nature's law," is in despair and dying. "The Heavens had wept on it, but the Earth / Had crushed it on her unmaternal breast. . . ." The rest of the stanza Shelley was unable to write.

In the free fantasy of *The Witch of Atlas* (August 1820) the mother becomes insubstantial, dissolving away as she is kissed by the sun and turning into a vapor, clouds, a meteor, and finally a star. The witch herself, daughter of the dissolving mother, is idealized in light: she becomes the perfect woman, the ideal mother. Her death is again denied (stanza 71). Mary Shelley's note to the poem (*Posthumous Poems*, 1824) is useful:

> Shelley shrunk instinctively from portraying human passion, with its mixture of good and evil, of disappointment and disquiet. . . . and he loved to shelter himself rather in the airiest flights of fancy, forgetting love and hate, and regret and lost hope, in such imaginations as borrowed their hues from sunrise and sunset, from yellow moonshine and paly twilight.

Instead of human passions he portrayed fantasies of pure and perfect maternal love on the one hand, and sadistic fantasies against the hateful mother on the other. Shelley's poetry is not devoid of love and hate, as Mary may have thought; the passions are there, but split into sadomasochistic fantasies and defensive idealizations.

The narcissistic regression of Shelley's fantasies is often exceptionally thorough. At other times, when he feels less deprived and narcissistic consolation is less urgent, he can address a real woman. In *Epipsychidion*, the idealization of the female imago and of the self (the two being identified) is fused with Emilia Viviani; and in the midst of spiritual mysteries there occur lines against conventional marriage. The poem begins with an apostrophe to a caged nightingale, meaning the poet. When the poet does turn to another being, her rather metaphysical

glories are said to be "Youth's vision" made perfect, and we are not surprised to read ". . . I am part of thee." These and the following lines suggest a search for ideal consolations, not for a real being. The sensuous images with which this beatific being is described do not make for concreteness; they are abstracted from anything we might recognize as a real woman. Her limbs tremble with brightness, she is under a cloud of dew embodied in a windless heaven like the moon, from her lips drop liquid murmurs like honeydew. This kind of sensuousness is removed from reality because it is pleasure experienced by a child still enclosed in the sensory life and capable of only very limited relationships with people. The images have another oddity, in that they are of pleasure-giving objects in a world which in earlier lines had been called "the eternal curse" and "lawless Universe!" (15–16). This poem reveals that to Shelley the earth with its sensuous gifts is the mother's body in images conveying not only specific gratifications of the baby's needs, but also a total embrace, so that the effect is of ". . . one intense / Diffusion, one serene Omnipresence, / Whose flowing outlines mingle in their flowing . . ." until all single sensations are ". . . in that Beauty furled / Which penetrates and clasps and fills the world." This diffuse, enveloping mother, becomes then "An image of some bright Eternity."

The poem is replete with narcissistic fantasies in various phases: I single out merely one or two of special relevance. The landscape in which the ideal being is first met, and which gives her the aura of idealism, reminds one of the dreaminess of Claude and of the color harmonies of Turner:

> In the clear golden prime of my youth's dawn,
> Upon the fairy isles of sunny lawn,
> Amid the enchanted mountains, and the caves
> Of divine sleep, and on the air-like waves
> Of wonder-level dreams, whose tremulous floor
> Paved her light steps. . . .
>
> [192–97]

She appears in every "form, Sound, colour"—"in whatever checks the Storm / Which with the shattered present chokes the past." "The shattered present" is a succinct phrase for the threatening disintegration which regression to the past is supposed to mitigate. The ideal being is not of course from the real past, but from the child's fantasies of

perfection. This is the only meaning we can give to that ideal which is supposed to save the spirit from "this cold common hell, our life," or "the wintry forest of our life." As for real women, they are poisonous, deceiving, false, and they break faith: he must not allow himself to love them because he can never depend on them absolutely. The stormy landscape described at line 308 is followed by a death by ice and that again by an earthquake. All this is smiled on by the white moon. Shelley is groping for images adequate to sadomasochistic fantasies; the stormy billows are both inside and outside the self.

After these catastrophes there appears at length the Vision. Here the writing is at first trite and mawkish, but then gives way to something unprecedented: "Soft as an Incarnation of the Sun / When light is changed to love . . ." (335–36); and then "felt the dawn of my long night / Was penetrating me with living light." The light of the sun is the incarnation, so to speak, of the father's spirit entering the son. At the moment of greatest poetic elan, the transubstantiation of the ideal female into the Vision, she is turned into the father-imago, that is, from the moon into the sun, and Shelley gives us a classic account of inspiration— the son's passive reception of the divine spirit. The passive earth, ruled by "Twin Spheres of light," is now "this world of love, this me." Both the parents appear in the poet's heaven:

> And, as those married lights, which from the towers
> Of Heaven look forth and fold the wandering glove
> In liquid sleep and splendor, as a robe;
> And all their many-mingled influence blend,
> If equal, yet unlike, to one sweet end.
>
> [355–59]

The married lights and the towers symbolize the united parental love and authority. This moment of integration is echoed in a later image:

> And, day and night, aloof, from the high towers
> And terraces, the Earth and Ocean seem
> To sleep in one another's arms, and dream
> Of waves, and flowers, clouds, woods, rocks, and all that we
> Read in their smiles, and call reality.
>
> [508–12]

Against this mature vision of parental harmony, helping the child toward a sense of reality, we must set an intervening passage of narcissistic

destructiveness in which the self is projected into a comet, drawing "the heart of this frail Universe" toward its own and bringing about convulsion and disintegration (368–72). And because fusion with the female cannot be total, she must be thought of as "a vestal sister": bodies are mere "dull mortality" (ll. 389–90). The dissociation of body and soul (the lesson now forgotten of married lights and Ocean and Earth sleeping in one another's arms) must be complete and the dissociation from the objective world paid for. The union is now not between me and mine, but between me and me.

When Emilia and the poet's spirit embark for the isle of love, the intended meaning is of course a Platonic heaven, but the poetry speaks of an edenic feeling of total indulgence. The texture is heavily sensuous, tactile, oral, and olfactory. The isle is "cradled" and completely dissociated from the horrors of life: famine, blight, pestilence, war, and earthquake—there is no intermediary ground between absolute good and absolute evil.

> And from the sea there rise, and from the sky
> There fall, clear exhalations, soft and bright,
> Veil after veil, each hiding some delight.
>
> [470–72]

Once more, then, the dominant image of the veil; it hides and at the same time suggests what lies behind it: ". . . the isle's beauty, like a naked bride / Glowing at once with love and loveliness / Blushes and trembles at its own excess." Shelley's ideal world reveals its sexual source, but the desired woman can be obtained only in fantasy. The idealization of woman is a defense against repressed ambivalence towards his mother. The veil separates him from his mother's body while at the same time provoking intense fantasies of fusion and oral incorporation: "We shall become the same, we shall be one / Spirit within two frames" (573–74) and "In one another's substance finding food" (580). The fusion ends in "one annihilation" (587) and the poem necessarily ends in despair: words cannot take the poet into the sphere of pure love, the fantasy of omnipotence and total fusion can never become reality.

III

Art critics have lately seen in Turner the precursor of such abstract painters as Kandinsky, Klee, and Rothko who purified the aesthetic

realm of reference to the ordinary world and gave it a mystical aura. It seems to me that abstraction and idealization are indeed important aspects of Turner's work, and that they signal, as in Shelley, a divided self and defenses against destructiveness. In Turner as in Shelley the role of the female imago seems to me decisive. In both there is violent alternation among states of aggression, despair, disgust, and a fantasied, totally enveloping love. The tendency towards abstraction in Turner's work, culminating in his Color Beginnings, is the equivalent of Shelley's disembodying the objects of his love because of the destructiveness he feels towards them. The aggression is defended against by a withdrawal from the real world into a realm of increasing "purity" and diffused feeling, the "indistinctness" which Turner said was his forte. Because of this split between the abstract ideal and the real world (the latter hated and feared), the split between good and evil becomes absolute and Turner is seldom able to reconcile them in one and the same painting. Regression that manifested itself in Shelley in terms of narcissistic satisfaction, including infantile sensuousness, becomes in Turner the enjoyment of abstracted colors and diffused light. Where in Shelley there is a veil or mist of light, Turner literally covers his paintings with a crystalline wash, the technical specifications of which he kept a secret. His observations on Rembrandt apply to his own work: "—Nay more, his forms, if they can be called so, are the most objectionable that could be chose . . . but over each he has thrown a veil of matchless colour, that lucid interval of morning dawn and dewy light on which the eye dwells so completely enthralled, and it seeks not for its liberty, but as it were thinks it a sacrilege to pierce the mystic shell of colour in search of form."[5] Turner also said of Rembrandt, "He threw a mysterious doubt over the meanest piece of common." And Gowing comments, "*Doubt* was one of Turner's favourite words; it was his own word for what Mr. Lennox called indistinctness." The technique of indistinctness and the word *doubt* both indicate the defensive measures Turner took against forms that threatened him.

It will be helpful to survey briefly the kinds of abstraction and idealization to be seen in Turner. They occur primarily in three distinguishable groups of paintings. The most obvious of these comprises the later oils and washes, sometimes called Color Structures and Color Begin-

5. Quoted in Lawrence Gowing, *Turner: Imagination and Reality* (New York, 1966), p. 31.

nings. A. J. Finberg, early in our century, still thought of them as beginnings or sketches preliminary to finished paintings. Our more recent sensibility finds them to be complete and fully satisfying as they are. In their lyrical use of color and light they give only the merest hint of a landscape. A broad wash and a few dabs and squibbles are sufficient to evoke a sense of revelation, a penetration into essentials. The second group of works are more distinctly seen landscapes, though still bathed in a light haze and again appealing primarily through lyrical harmonies of color. These works have their origin in Turner's first visit to Italy, and especially in the atmosphere of Venice; but the paintings of the interiors of Petworth, with rooms, furniture, people barely visible in floods and pools of light, are similar in feeling. Thirdly we find a group of paintings in which form and content are extremely violent. The earliest example is the melodramatic sea and sky of *Calais Pier* (1802–03); perhaps the crudest is *Snow Storm: Hannibal and his Army crossing the Alps* (1812) (fig. 52). It is, however, the violent canvases of his later years that the modern sensibility has especially admired: *Fire at Sea* (1834), the paintings depicting the burning of the Houses of Parliament, *Slavers throwing overboard the Dead and Dying* (fig. 53), *Snow Storm,* and *Rain, Steam and Speed—The Great Western Railway* (1844). These later paintings of the ferocious and destructive elements are contemporary with lyrical works tending towards abstraction and breathing a diffuse and all-enveloping love. In the violent paintings, too, the abstractness of design reduces the complexities of life to a simple dimension, this time of terror and destructiveness. The most characteristic design is the vortex by which the world is swallowed or dispersed. Equally uncompromising is the figure of a huge maw, or the death-dealing swell of the sea. Such stark forms of elemental destructiveness necessarily break the canons of classical landscape design. Aesthetic pleasure is provided by the colors, which without embodiment in complex forms become abstract and emotionally dominant.

In brief, these canvases achieve artistic integration in a new way: color, design, and tonality are made to cohere according not to the rules but to some inner necessity. This aesthetic unity has to be paid for, and the price is a narrowing of affect as well as a remoteness from the concrete details of the world. Of course a stepping back from too obvious a pattern of reality is necessary for all creative effort; the question is whether this dissociative and disintegrative moment leads back to reality.

In Shelley we noted that sadomasochism and idealization were two sides of the same coin, and that they lay behind the intensities of his poetry. With this model in mind we can try to solve the first part of our problem, the appeal of Turner's art. We shall take our clues not from narrative, fictional characters, verbal imagery, and diction, but from symbolic shapes and colors, as well as texture. It was in fact the increasingly odd texture of Turner's paintings as well as their "unnatural" colors that offended the painter's contemporaries. Let us at least provisionally acknowledge the obsessive elements in color, form, and design, thus by-passing Ruskin's attempts to set up defenses against their libidinal effectiveness. The question for us, then, will be no longer whether they accurately reproduce the appearances of nature, but what part of the viewer's psyche they activate.

The evidence for the oral and sadomasochistic traits in Turner's imagination, so prominent in his works, as well as in Ruskin's response to them, cannot be properly documented here. This much, however, is plain: these traits make themselves felt in Turner's art in three diverse ways. He depicts a world that is ferocious and destructive; or he dissociates himself from the world by creating an abstract one in his color studies; or he sees the world through the eyes of an admired master whose conventions he emulates and at the same time transforms into his own symbolism. It seems to me that Turner's appeal is explained by his keeping strictly apart the ferocious and the abstract lyrical modes, each being kept "pure," that is, unmixed with complicating feelings. By separating these modes Turner may be said to exemplify in his *oeuvre* a schizoid regression. Unable to bring into harmony good and bad, love and hate, because of the intensity of his oral-sadistic fantasies, he has to seesaw between depicting the raging elements and escaping into the abstract idealism of his color studies.

For instances of oral-sadistic fantasies one turns to the great canvases depicting elemental chaos and destruction, storms at sea and on land: *Snow Storm—Steam-Boat off a Harbour's Mouth* (1842), *Rain, Steam and Speed—The Great Western Railway* (1844). The subject appears already in much earlier works, for example *Calais Pier* (1802–03), though there it does not go beyond a rather contrived exercise in baroque energy on a "sublime" scale. Much more expressive is *The Wreck of a Transport Ship* (c. 1807). But it is not until the vortices of the later paintings that Turner has found the appropriate form for his regressive fantasies. The most

terrifying of his visions show fire and storm and sea joining their destructiveness, as in *Fire at Sea* (1834). Even without a storm, fire on water inspired overpowering visions: the burning of the Houses of Parliament is recorded in a number of drawings and paintings. In *Slavers throwing overboard the Dead and Dying—Typhon coming on* (1840) the fiery sky is integrated with the destructiveness of the sea monsters ravening on human flesh. These works are visual experiences of various complexity in which design, color, and subject reinforce one another towards a symbolic statement. A more primitive form is seen in *Snow Storm: Hannibal and his Army crossing the Alps* (1812); it depicts a huge maw about to swallow the army which is already being savaged by marauders. At first sight the snowstorm might be mistaken for a huge wave, but even a wave would be a more complex shape; the simple arc is a primitive rendering of a mouth closing down, while the rocks scattered in the foreground resemble the teeth of a shark.

If we now consider the so-called color studies in which earth, water, and sky are dissolved in a luminous mist we might at first question their issuing from the same mind that produced the fantasies in violence. But in 1840 Turner painted both *Slavers* and *Heidelberg*, the latter a watercolor of delicate tints which removes the scene into an ideal world where violence is inconceivable. The best known canvases and watercolors of this period and type are of Venice. Other examples are *Ehrenbreitstein* and *Norham Castle, Sunrise* (c. 1840–45). All these exquisite color harmonies, almost devoid of solid terrestrial elements, were once thought of as studies in atmosphere. Today we delight in them as we do in a Kandinsky or a Rothko, and exempt them from all verisimilitude. And yet it is there, the truthfulness to nature: the nature of the human psyche. The pleasure we take in abstractness or idealization is derived in large part from their remoteness from fantasies of violence. Idealization and abstraction are defenses against inner destructiveness.

In a third group of Turner's work the extremes of sadistic violence and abstract idealism are overcome by a calmer spirit that leans for reassurance on the tradition of Claude Lorrain. In *Crossing the Brook* (fig. 55) he achieves the finest balance of a fresh look at the English countryside and a Claudean sensibility.[6] In other landscapes of this group the

6. For the strictest emulation of Claude one might cite *The Festival upon the Opening of the Vintage at Macon* (1803), which echoes *Landscape with Jacob and Laban* (1654–55), or the earlier *Aeneas and the Sibyl, Lake Avernus* (c. 1798).

natural world is kept at bay by mythological subjects—the story of
Aeneas and Dido exercising a peculiar fascination, presumably because
it tells of the hero's abandoning the woman by divine command and
pursuing his imperial destiny inspired by his father's ghost—and is given
an Italianate aura. Turner's debt to the Claudean tradition may also be
seen in several exercises in classical motifs leading up to *Crossing the
Brook*. The weight of this tradition allows for a reconciliation of the
artist's psyche and the world. Sadistic fantasies are replaced by libidinal
symbols of harmony. The result is a complexity of feeling not found in
the works of violence or abstraction.[7] The brook and the sunlit strand in
the foreground are continued by what appears to be a wider river in the
valley below, which is spanned by a bridge of eight or more arches. The
brook must be imagined to descend through a narrow cleft which re-
mains hidden but is symbolized by the shape of a V which links brook
and river. This V shape of water, brightly lit and overarched, is a
repeated motif.[8] It appears most dramatically in a watercolor of 1802,
The Devil's Bridge, Pass of St. Gothard, more lyrically in another watercolor
of 1795, *Falls of the Anio at Tivoli*, and most revealingly in *A Bed: Drapery
Study*, of the series of Petworth drawings.

In *Crossing the Brook* the symbolic meaning of the shape is integrated
with other features of the landscape; it replaces the hidden cleft between
brook and river, and it is overarched by the bridge, which links the left
and the right sides of the painting. At the right end of the bridge there is
a square building. The two watercourses are framed by a silhouette of
rocks with trees jutting up like a fountain. On the other side of the
bridge a wood contains a dark cave or tunnel which is on the same level
(on the canvas, not the imagined landscape) as the bridge. The design is
therefore pivoted on the bridge which links the cave with the jutting
trees; and at its very center is the cleft of bright water. The affective
contents of the two arches or openings—one flooded with light, the
other hidden in gloom and set back in a wood—is obvious, even if we
discount the sexual symbolism. The one is a source of life, gushing forth,
the other a threatening and consuming void.

7. For the genesis of *Crossing of the Brook* see Gerald Wilkinson, *Turner Sketches 1802–20,
Romantic Genius* (New York and London, 1974), and A. Cornwell-Clyne, "The Birth of a
Masterpiece," *Country Life* 117 (1955): 974 ff.

8. The strong sexual symbolism in Turner's scenes is noted by Jack Lindsay, *Turner: His
Life and Work* (London and New York, 1966).

In this painting Turner has surmounted the crude splitting into destruction and ideal love and has been able to find the iconography for a balanced, harmonious vision of life. The overall impression of the painting is still rather ideal and Italianate, but compared with a Claude it is much richer in feelings. The crossing of the brook significantly occurs halfway between the dark cave (out of which a rough track emerges) and the luminous left side. The girls have come from the cave; one now sits by the placid water, perhaps looking at her reflection, which is visible to us; the other girl has almost crossed over. The line of the crossing is completed by a dog. This continuous line of the crossing in the foreground is the equivalent of the bridge in the distance. Both these "bridges" lead to the side which holds the male and the female symbols (fountainlike trees and luminous cleft) in a kind of marriage, for which the bridge itself is a universal symbol.

In *Crossing the Brook*, then, the affirmation of libidinal life is beautifully symbolized by features in the landscape. For Turner the libidinal affect is nevertheless only possible at some distance from familiar nature and with a degree of idealization. Although the river scene is based on a view in Devon, Turner was unable to catch the spirit of the English countryside. He needed the Italianate convention to defend him against the destructive impulses provoked by real places.

Convention is quite absent in Turner's color structures, and this is their great power. The creative mind has left behind conventional forms and designs and colors in order to open itself to fresh perceptions and organizations. But the resulting emotional content is extremely limited. When he was not emulating the older masters, Turner split his creative effort into two separate phases, the violence of some of his canvases and the abstract lyricism of the color studies. Each springs from one dissociated part of his personality, and each is the poorer for its isolation from integrated wholeness. They represent extreme and unbalanced visions because the artist could not mediate between his deep impulses and the demands of life. Either aggression against the mother-image is allowed to fill the world, which then appears as vortex, maw, or monster-filled sea, or the aggression is so completely repressed that a fantasy of perfect and total peace results in abstractions. Let me conclude, however, with a brief, illustrative contrast suggested by two quite different "Romantic" artists.

IV

Constable said that he wanted to "give 'to one brief moment caught from fleeting time' a lasting and sober existence."[9] The striking word is *sober*: is it not appealingly modest, an admission of limited aims and a cautious imagination? Most readers would probably think so. I believe sobriety should be seen as the clue to Constable's great achievements and as his claim that he has freed himself from illusion and self-regarding heroics. This would hardly be a modest claim, but I take it to be a just one, and I see it as the necessary starting point for an adequate response to Constable's work, as well as a central point of reference for the Romantic imagination. What we miss in Constable is not imagination but illusion. Constable did not confuse the "lasting" existence of a painted world with a pseudo-religious consolation or with the eternity of transcendent art. His sobriety sets him apart from the Keatsian strain and much else we call Romantic. His work does not dramatize infinite hopes and abysmal disappointments; it does not spurn the real world in order to merge with an ideal one. Such mixtures of gloom, anguish, anger, on the one hand, and of fantasied ideals on the other, are much more characteristic of Shelley and Turner. Their works are often strident with self-advertised heroism. Finding the world for the most part lost to vulgarity and cruelty, they see no alternative but to transcend it in their pure imagination. But this purity is spurious, illusionary. No man can escape the given world and its impact on his personality. Constable's sobriety is closer to a purified imagination: the love of the world shining in his paintings has been cleansed of illusions.

> A descriptive painter? If delight
> Describes, which wrings from the brush
> The errors of the mind, so tempered,
> It can forego all pathos. . . .[10]

A similar maturity is found in Wordsworth; his sobriety, too, has been mistaken for lack of poetic intensity. J. S. Mill called him the poet of

9. Constable's introductory note to *Various Subjects of Landscape Characteristic of English Scenery* (London, 1829), quoted in Basil Taylor, *Constable* (New York, 1973), p. 220. The mezzotints by David Lucas were made after a selection of Constable's studies and finished pictures.

10. Charles Tomlinson, "A Meditation of John Constable," in *Seeing is Believing* (London, 1960).

unpoetical natures and said that there "is an air of calm deliberateness about all he writes which is not characteristic of the poetic temperament."[11] Wordsworth was not only very much in control of his fantasies, but repeatedly traced how he won that control. Nature allowed him to experience even in boyhood "that calm delight / Which . . . surely must belong / To those first-born affinities that fit / Our new existence to existing things, / And, in our dawn of being, constitute / The bond of union betwixt life and joy."[12] Whatever meaning we may give to nature, the passage shines with the same trust in existing things and our relations with them that we find in Constable's paintings. In later years that trust becomes a reverence for

> A Power
> That is the very quality and shape
> And image of right reason, that matures
> Her processes by steadfast laws, gives birth
> To no impatient or fallacious hopes,
> No heat of passion, or excessive zeal,
> No vain conceits, provokes to no quick turns
> Of self-applauding intellect, but lifts
> The Being into magnanimity.
>
> [*Prelude*, 12:24–32]

"Tintern Abbey" is the first account, partly elegiac, partly jubilant, of the growth from the days of "aching joys" and "dizzy raptures," when he had been "more like a man / Flying from something that he dreads, than one / Who sought the things he loved," to a finer integration of fears, hopes, and desires, when "with an eye made quiet by the power / Of harmony, and the deep power of joy, / We see into the life of things." The eye that is made quiet is the imagination which joins man and the real world, "the life of things," and which is given power by a harmony at the "deep" level of joy. This recurrent association of nature, power, reason, and joy tells of Wordsworth's and Constable's mature imagination.

This full engagement with real things (a universe with so much life of

11. "Thoughts on Poetry and its Varieties" reprinted in *English Critical Essays: Nineteenth Century*, ed. Edmund D. Jones (London, 1935), pp. 398–429.

12. Wordsworth, *The Prelude*, ed. Ernest de Selincourt, second ed. revised by Helen Darbishire (Oxford, 1959); the 1805 version, 1:580–85.

its own that it is *active*) is a pinnacle of maturity on which Wordsworth and Constable maintained themselves only with difficulty. The spontaneity celebrated by Wordsworth, the freshness of life depicted by Constable, are often at the mercy of a severe internalized authority. The moral weight of the poet and the unmitigated weightiness of the things in Constable's world (whether we find them dulling to our spirits or infusing health and strength) have their source in the original "depressive position." Wordsworth suffered from hypochondria and Constable from severe bouts of anxiety; their moments of creative joy signal the overcoming of these debilities. Wordsworth's poetry often demonstrates his tolerance of severe anxieties, that is, his ability to live through them and put them to good use in relations with the real world. And Constable's progress from initial sketch to painting ready for exhibition usually records a gradual conquest of anxiety.[13] Wordsworth's tolerance of anxiety seems to have become subverted by 1802: "Resolution and Independence" still shows the source of his mature imagination, for the old man is the father-image who admonishes and gives strength. But in the Intimations Ode Wordsworth's integrity and pyschological naturalism are weakened by an unimaginative use of Platonic myth which deserved Coleridge's level-headed censure. When the poem mourns the fading of the child's visionary experiences "into the light of common day" (76) it contradicts an earlier faith that beauty, "Surpassing the most fair ideal Forms," shall be found "A simple produce of the common day" (Prospectus to *The Recluse*, 42–55). When he was strongest Wordsworth heard both the "still, sad music of humanity" and "joy in widest commonality spread." By the time he finished the Ode his sober, balanced faith in man had taken the coloring of weary stoicism. "The Clouds that gather round the setting sun / Do take a sober colouring from an eye / That hath kept watch o'er man's mortality." Darkness likewise claims a place more frequently in Constable's work after 1830.

In Constable's characteristic paintings the familiar world of his childhood, his parental home, his father's occupation, and the workaday

13. Constable's letters often mention anxiety. His friend Fisher told him: "We are all given to torment ourselves with imaginary evils, but no man had ever this disease in such alarming paroxisms as yourself. You imagine difficulties where none exist, displeasure where none is felt, contempt where none is shown and neglect where none is meant." (R.B. Beckett, ed., *John Constable's Correspondence* [Suffolk, 1963], 6:209. The letter is from November 1825.) Subsequent quotations from Constable's letters will refer to this edition by volume and page number.

world of rural Suffolk are all seen with reverential love. Every detail is clearly appreciated and yet everything is unified by the total vision. The healthy vitality is felt in every brush stroke. Kenneth Clark thinks Constable the most revolutionary of Romantics, next to Goya, not only in subject but also in "the way his hand attacked the canvas."[14] Attack we certainly notice, and more so in the sketches than the finished paintings. In the *Study for the Leaping Horse* (c. 1825), the stormy sky, the horse about to leap, the wind-shaken trees, and of course the free, agitated brushwork are all evidence of dramatic energy. In the finished painting (also of 1825, and not much larger than the study) the energy has been calmed, though it is still felt to be there, ready to burst forth. The sky is threatening rather than windswept; everything on earth is sultry, brooding. The leaping horse conveys less of the aggressiveness of the brush work but is rendered as a complete, living object. In the study we saw and felt the energetic push of the bargeman against the diagonal pole. In the final version the mast of the barge is upright and the struck sails suggest calm, while the huge stumpy tree which had opposed the leaping horse is gone. Constable's words often indicate the aggressive impulse; in the process of painting *Salisbury Cathedral* he says: "I have done a better battle with the Church than old Hume, Grogham and their coadjutors have done" (6:115). Elsewhere he speaks of having "pacified" a landscape into unity of tone (letter to Fisher, 9 September 1826). The happiest moments in his letters describe the reconciliation of energy and calm: "It is a lively subject, of the canal kind, lively—& soothing—calm and exhilerating, fresh—& blowing . . ." (6:198); and again: ". . . it is all health—& and the absence of everything stagnant, and is wonderfully got together after only this one year" (6:200). Landscape paintings that lack this vitality Constable rejects as mere "pictures," very much the same spirit in which Wordsworth rejected mere literature in favor of the poetry of life.[15]

Constable was not afraid to open his imagination to the deeper layers of his personality and use what Ruskin was to call the mysterious "mental chemistry." As early as 1800 he experimented with Alexander Cozens's

14. *The Romantic Rebellion* (New York, 1973), p. 272.
15. Constable speaks of breathing "the stagnate sulphur of Turner—or the smell—of a public house skittle ground by Collins—or be smothered in a privy by Linnell or Mulready . . ." (*Correspondence*, 3:85); an intuitive understanding of the sadistic element in Turner as well as in conventional work of the period.

technique of free associations by means of ink blots. His dealings with
the common world were never a handicap to his imagination, but a
method for revealing his deepest feelings. The same is true of
Wordsworth. His most memorable figures are not idealizations of him-
self or fantasied females, but discharged soldiers, old beggars, shepherds
in economic straits, deserted or widowed women, and even an idiot. The
vital spirit he discovered in this world of the poor and neglected was a
personal strength and hope in life—personal to them and to himself, for
he drew on them for his self-integration and the deep power of joy.

The satisfaction we get from poets and painters depends ultimately on
the quality of their object-relations. Abstract idealism, whether in the
guise of Platonic defenses or of "pure" color structure, is the result of
dissociation. This does not necessarily lessen aesthetic intensity but it
does limit its scope; the narcissistic element inevitably impoverishes the
imagination. Once more a Wordsworthian phrase springs to mind—
"subservient . . . to . . . external things":

> A plastic power
> Abode with me, a forming hand, at times
> Rebellious, acting in a devious mood,
> A local spirit of its own, at war
> With general tendency, but for the most part
> Subservient strictly to the external things
> With which it commun'd.
>
> [*Prelude* (1805), 2:381–87]

The creative spirit does not buckle under the world's regular actions and
social norms, which are inhibiting as well as repressive. Walking with
nature means here an independence of spirit. The plastic power works
from within, but rebellion, in the sense of rejection or destruction, is not
the ultimate aim. Ultimately imaginative health must come from the
subservience of the spirit to external things, a kind of reality testing in its
richest moral sense. This is not pusillanimity: we must give full weight to
the context of the Wordsworthian phrase. It is preceded by an insistence
on the shaping powers of the mind and is followed by a faith in the
mind's auxiliary light. The subservience to the real world is a stance
which makes the *interaction* between creative mind and world possible.

Seen in such a light the sober realism of Wordsworth and Constable
speaks of a mature imagination at least as valuable as the "purer" de-

lights offered by Shelley and Turner. For the student of Romantic painting and poetry the depressive as well as the regressive stages in creativity remain absorbing problems. And it certainly is not a philistine insensibility to Turner's or Shelley's imaginative powers that makes us suggest that the aesthetic satisfaction we get from their works is paid for by a retreat from human sympathies. There is no denying our response to the deep ambivalence of dependence and aggression and to the defensive abstract idealism, which are the psychic dramas acted out in their poems and paintings. The truths uncovered by regression to the infant's ambivalence towards his mother, and by the adult's defensive strategies, can be felt by everyone and especially in our times.

MARTIN MEISEL

The Material Sublime:
John Martin, Byron, Turner,
and the Theater

It sometimes happens that one may learn something useful about works of art from translation into another medium, especially when these appear to be vulgarizations. My example is the translation of John Martin and J. M. W. Turner into theater, and, more broadly, the relations between their pictures and the theater of the nineteenth century. Both painters are thought of as Romantic artists, both shared stylistic and thematic qualities with contemporary poetry, and both reflect developments in one of the chief begetters of Romantic art, the eighteenth-century notion of the sublime. Their different versions of the sublime and the qualities they share with contemporary poetry turn out to be implicated in the translation of their work into theater, even into popular theater. The complex of these relations suggests a less fragmented, more entangled and interconnected model for the culture at large than one would gather from a more single-minded or fastidious approach.

I will not try to deal here with all the ways Martin and Turner relate to the theater nor with many of the ramifications of those connections I mention. For convenience I will start with Martin and the sublime, then pursue the theatrical realization—by way of Byron—of Martin's images, before taking up the transformations of Turner. Ultimately I will address the question raised by the difference in their histrionic fates. Turner and Martin were awarded antithetical assignments in the theater, with correspondingly different functions for an audience. Why this was so has little to do with the comparative excellence of the two paint-

211

ers; but it does bear upon the deepest psychological structures of their work and on the fundamental matrices of the viewer's response.

I

A good place to start is the ringing phrase with which Charles Lamb characterized the achievement of his contemporary, the painter John Martin. Martin's structures, he declared, were "of the highest order of the material sublime"—a gift phrase for anyone in charge of publicity, but not intended as a compliment. It appeared early in 1833 in an essay Lamb eventually called "The Barrenness of the Imaginative Faculty in the Productions of Modern Art," wherein he also compares *Belshazzar's Feast,* then Martin's most famous painting, to a "pantomime hoax."

The phrase pointed to some other condition of sublimity than "material"; but it also pointed to what Lamb conceived of as Martin's theatricality. Coleridge—who may have made it current before Lamb—certainly uses it to characterize a theater of spectacular effect. "Schiller," he observes, "has the material Sublime; to produce an effect, he sets you a whole town on fire, and throws infants with their mothers into the flames, or locks up a father in an old tower. But Shakespeare drops a handkerchief, and the same or greater effects follow."[1] That Martin was, figuratively speaking, a "theatrical" artist was often asserted during and after his lifetime, usually disparagingly. Sometimes, in an odd terminological leakage, critics argued whether his art was Legitimate or Illegitimate theater. Nevertheless, Lamb's phrase had a special appropriateness to the nineteenth-century stage and particularly to its insistent attempt to translate the sublime into the spectacular.[2]

The nature of the stage and its means simply ran counter to a fundamental Romantic endeavor: to free the sublime from material causes and

1. Lamb's essay appeared originally in the *Athenaeum,* 12 Jan.–2 Feb. 1833; *Works of Charles and Mary Lamb,* ed. E. V. Lucas (London, 1903), 2:226–34. Coleridge's remark appears in his table talk under 29 Dec. 1822, but was published in 1835, *Specimens of the Table Talk of the Late Samuel Taylor Coleridge,* ed. Henry Nelson Coleridge (New York, 1835), pp. 33–34. Keats also uses the phrase "material sublime" in his verse epistle "To J. H. Reynolds, Esq." (25 March 1818, printed 1848), in *The Letters of John Keats,* ed. Hyder Rollins (Cambridge, Mass., 1958), 1:261.

2. The issue of Martin's "legitimacy" is indignantly dismissed by the *Examiner* 25 (15 April, 1832): 244, reviewing his engraving *The Fall of Babylon.* See also the conclusion of Martin's obituary in *Gentleman's Magazine* 195 (1854): 433–36.

correlatives and to claim it as a subjective terrain. The shift that this entailed may be summed up neatly by juxtaposing Burke, who constructed his argument to establish a correspondence between external and internal events and predispositions, and Schiller (as philosopher rather than playwright), for whom the sublime occurs when we are reminded of our absolute transcendence of external nature and what relates to it.[3] The theater meanwhile strove mightily towards a material illusionism. Inevitably, inadequacy of means, failures in "realization," and the inescapable awareness of machinery—dramatic and theatrical—for the successful production of "effect" emphasized its "materiality" and its distance from a more psychic sublimity. Between matter and spirit, however, in popular imagery and philosophical speculation, was a bridge: light. One can argue that even in the theater this century of technical progress in the creation of a materially illusionistic stage would conclude antithetically, in the work of such scene-philosophers as Edward Gordon Craig and, especially, Adolphe Appia. The stage was dematerialized when Appia advanced beyond light as effect and even light as movement to the direct creation of dramatic space by light.

Meanwhile lurid light, incoherent light, the light that never was on sea or land, when it appeared in the other arts was declared "theatrical," and so was Martin. An enthusiastic reviewer of his *Destruction of Pompeii and Herculaneum* (1822) defends its rendering of light in the following terms: "The light, from its central energy on Vesuvius, is gradually carried off with exquisite judgment to the darkened extremities of the picture. . . . The whole scene has a red and yellow reflex of fiery light, that, terrible in its glory, makes the spreading ocean, the winding shore, the stately edifices, the vegetative plains, the gradually rising hills and mountains, with the astounded population, look like the Tartarean regions of punishment, anguish, and horror." To those who would object, he cites assurances that the "fiery effect" of the actual eruption "*cannot* be exaggerated." Nature herself is sometimes theatrical.[4] Objections, however, to the quality and control of Martin's light tended to disappear when the paintings were translated into engravings. Like Hogarth, Martin was his own chief engraver, in direct control of the medium through which he

3. See Burke's *Inquiry into the Origin of our Ideas of the Sublime and the Beautiful*, part 5, secs. 1 and 2, and Schiller's "On the Sublime," *Essays Aesthetical and Philosophical* (London, 1875).

4. *Examiner* 15 (7 April 1822): 219.

was chiefly known. His extraordinary contemporary reputation as, among other things, a master of effect through the control of light and dark rested on the black and white of his engravings. His gift here, however, was to create not light, but material darkness; Milton's "darkness visible."

The materiality of Martin's sublime chiefly lay in the features that excited most wonder: his renderings of space, multitudes, and perhaps above all architecture, his manipulation of perspective and scale; what Uvedale Price, summarizing the principal features of sublimity, had called "infinity; [and] the artificial infinite, as arising from uniformity and succession."[5] The immensity was not merely in these physical things, however, nor in the actual size of the canvases, but in events, which also have their scale. The characteristic event was nothing less than Apocalypse, and Martin early established himself as the chief painter of the Apocalyptic Sublime. But the apocalyptic strain is rampant in the first half of the nineteenth century; and among painters it is nowhere more important than in Turner, most obviously in his plagues, in his deluge paintings, in his *Angel Standing in the Sun* (fig. 54); but also in avalanche, shipwreck, storm and fire, and the reiterated consummations of things. In historical criticism it is Turner who unfortunately for Martin must furnish his chief foil; for in Turner of the apocalyptic imagination one sees the fullest transformation in painting of the sublime into a subjective terrain, the sublime as the affective dissolution of material forms in light.

It should be said that the charge against Martin that he was trapped in the material made no sense to most of his huge nineteenth-century audience, for whom he was an "ideal" painter whose greatest work served precisely to demonstrate the vanity of the material and of all earthly pomp and pride. His vast physical spectacles were thus redeemed by their catastrophic character, as well as by their embodiment of specifically biblical history (or prophecy); and so redeemed, made instru-

5. *A Dialogue on the District Characters of the Picturesque and the Beautiful* (Hereford, 1801), p. 11. Price, theorist and advocate of the picturesque, takes his summary straight from Burke. He lists "obscurity, power, all general privations, as vacuity, darkness, solitude, silence," as well as greatness of dimension and the two infinities, natural and artificial, a range of qualities with an evident appropriateness to many of Martin's best-known works. Burke had observed that "magnitude in building" often involves "a generous deceit on the spectators," vastness by effect rather than dimensions. "No work of art can be great, but as it deceives; to be otherwise is the prerogative of nature only." He so theatricalizes art and provides for its assimilation to the illusionistic stage (*Inquiry*, part 2, sec. 10).

ments of edification, they found their way into such unwitting nurseries of the Romantic imagination as Haworth Parsonage and pious and respectable households by the thousand. What one critic calls "the School of Catastrophe" took much of its character and imagery from Martin, as well as its continuing association with Christian melodrama.[6] Between 1816 and 1828 Martin painted seven major visions of catastrophe, five of them direct embodiments of biblical history: *Joshua Commanding the Sun to Stand Still upon Gibeon* (exhibited 1816), *The Fall of Babylon* (1819), *Belshazzar's Feast* (1821), *The Destruction of Pompeii and Herculaneum* (1822), *The Seventh Plague of Egypt* (1824), *The Deluge* (1826), and *The Fall of Nineveh* (1828).

II

The dematerialization of the sublime, its translation into subjective terms, doubtless found its most congenial medium in the poetry of the first third of the century. Shelley (for whom light had meanings and uses analogous to Turner's) carried the impulse furthest, into verbal and affective textures. But it was Byron, externalizing that within which passeth show, who swept Europe as the poet of the subjective sublime, of an inner drama set among scenes of glaring material sublimity and intermingled sordidness. The relation between these flawed and shadowed sublimities is often heavily ironic in Byron. But interestingly this poet of unaccommodating inner states and outer substances was found to be better partnered by John Martin than by anyone else when the time came to attempt to realize his conceptions in the theater.

The sublimation of spectacle in the theater and the materialization of the sublime in painting visibly converge in the biblical and Byronic stage productions that use the imagery of John Martin and his school. Both dramatic strains also reflect the contemporary interest in the imagining of apocalypse and the turn towards archaeological historicism. But an essential prior link between the two manifestations of sublimity, pictorial and theatrical, was forged by an earlier painter whose influence may be traced both in Turner and in Martin as well as directly on the stage:

6. See Curtis Dahl, "Bulwer-Lytton and the School of Catastrophe," *Philological Quarterly* 32 (1953): 428–42, and "Recreators of Pompeii," *Archaeology* 9 (1956): 182–91. Bulwer-Lytton's panegyric on Martin in *England and the English* appeared in 1833, and his *Last Days of Pompeii* in 1834.

Philippe Jacques de Loutherbourg, inventor of the Eidophusicon (1781), an illusionistic theater on a reduced scale, a theater of "effect," where moving and changing scenery temporalized by mechanical means and changing light supplanted entirely actor and play. One can argue that de Loutherbourg's influence lay behind most of those persistent attempts of the English nineteenth-century pictorial stage to endow itself with motion and ultimately to define itself by light.[7] His influence is clear, at any rate, in the first dramatic production that seems to reflect the particular creations of John Martin, W. T. Moncrieff's *Zoroaster; or, The Spirit of the Star* (Drury Lane, 19 April 1824). The highpoint was an "Eidophusicon, or Image of Nature, shewing The Beauties of Nature and Wonders of Art," really a moving diorama supplemented by its namesake's light changes and mechanical effects, painted by Clarkson Stanfield. It featured an eruption of Vesuvius; and its climax was "The City of Babylon in All its Splendour," giving way to "The Destruction of Babylon."[8] Martin's *Fall of Babylon* had been exhibited at the British Institution in 1819, where it drew sizable crowds. It was reexhibited in the Egyptian Hall in 1822, where the other chief attraction in this strictly commercial venture was Martin's new and sensational *Destruction of Pompeii and Herculaneum.*

Yet what redeemed paint and the still more chaste ink of a steel engraving to a pious and even evangelical eye could not redeem everything. It could not redeem the theater. Therefore, when a tide of pictorial "realization" in the theater set in in the early 1830s, there was some difficulty, apart from the merely technical, about realizing the biblical catastrophes of Martin and his school on the stage, at least in England. One hopeful attempt is rather reminiscent of the evasions of Davenant in the declining years of the Commonwealth, when all dramatic performances necessarily had to be called something else. In February 1833 Covent Garden presented *The Israelites in Egypt; or, The Passage of the Red Sea: An Oratorio, consisting of Sacred Music, Scenery, and*

7. The fullest accounts of de Loutherbourg's theatrical art are in Ralph G. Allen's dissertation, "The Stage Spectacles of Philip James de Loutherbourg" (Yale, 1960), and in Rüdiger Joppien's *Die Szenenbilder Philippe Jacques de Loutherbourgs, eine Untersuchung zu ihrer Stellung zwischen Malerei und Theater* (Cologne, 1972). See also Sybil Rosenfeld, "The Eidophusicon Illustrated," *Theatre Notebook* 18 (Winter 1963/64): 52–54.

8. Playbill for *Zoroaster* (19 April 1824), Enthoven Collection, Victoria & Albert Museum; and published text, 2d ed. (London, 1824). Before he became a respectable Royal Academician, Stanfield was regarded as a leading scene painter and the supreme artist of the moving "dioramic" scene in England.

Personation. The Music composed by Handel and Rossini. The Drama written, and the Music Adapted by M. Rophino Lacy.[9] The performance was sanctioned by the Bishop of London as well as by the Lord Chamberlain; and at least one reviewer poked fun at them both for allowing this drama while suppressing others on the grounds that the theater would profane a religious subject. This reviewer praises everything in the production but the scenery; for "two finer subjects, more completely marred, than the *Temple of Worship*, and the *Passage of the Red Sea*, never were exhibited at a booth."[10]

The second subject, important enough to furnish the alternate title, appears in the book of the play as follows:

Pharoah and the Egyptians enter the path among the Billows taken by the Hebrews. Moses, who, with the Israelites, has already gained the land, stretches out his hand over the Sea, when the waters furiously coming again together, the Egyptian Host is drowned; while the Hebrews, with a bright celestial glory beaming on them, are discerned on the opposite bank, returning thanks to the Lord for their miraculous preservation.

The conception sounds difficult to live up to; but an effective rendering was not beyond the spectacular resources available. The artists concerned, the Grieves, were certainly equal to their part. A pen-and-ink sketch for the scene survives (University of London); it bears a clear relation to Francis Danby's *Delivery of Israel out of Egypt* (1825), published as an engraving in 1829 under the title *The Passage of the Red Sea* (fig. 56). But a later maquette, with palmate wings and cutout waves, shows how the realization fell short, so that the audience, the reviewer tells us, condemned it as a "positive burlesque" (fig. 57). Francis Danby, who for a time managed to rival Martin on his own ground, here had anticipated Martin, and his picture was well known from all the printshop windows. Martin's mezzotint *The Destruction of Pharoah's Host* (1833) also has affinities with the Grieves' scene, with more sea in the foreground than in Danby's painting. It is conceivable that faced with the theater's attempt to do justice to these apocalyptic images, the Covent Garden audience responded less to any gross inadequacy than to the uneasiness

9. Published by W. Kenneth: The Dramatic Repository, [London, 1833].
10. Unidentified review, 24 Feb. 1833, Enthoven Collection, V&A.

that attended the mounting of a sacred subject on the English stage.[11] For the unembarrassed realization of biblical catastrophe as stage spectacle in this period one must go to France.

The unmistakably popular taste in the French theater for what Théophile Gautier always benignly related to the "Biblical enormities sketched [*ebauchées*] by Martynn"[12] had its severe critics in England. Thackeray, for example, who was most English when abroad, seethes with indignation at a *Festin de Balthazar* in June 1833, though he must give credit where credit is due:

> At the *Ambigu Comique* is an edifying representation of "Balshazzar's Feast." The second act discovers a number of melancholy Israelites sitting round the walls of Babylon, with their harps on the willows! A Babylonian says to the leader of the chorus, "Sing us one of the songs of Zion"; the chorus answers, "How can we sing in a strange land?" and so on; the whole piece is a scandalous parody of the Scripture, made up of French sentiment and French decency. A large family of children were behind me, looking with much interest and edification at the Queen rising from her bath! This piece concludes with a superb imitation of Martin's picture of Belshazzar.[13]

The theatrical impresario Alfred Bunn, fresh from the imperial maneuvers that would unite Covent Garden and Drury Lane under his leadership in the fall, visited Paris that summer, and like Thackeray felt the urge to display his national colors. He notes in a journal: "Went afterwards to *L'Ambigu Comique,* to see *Le Festin de Belthazzar* [*sic*], and a

11. A conflicting but circumstantial report on the effect of the scene appeared in the *Times*, 23 Feb. 1833, p. 5: "The scenery, which is entirely new, is beautiful and striking, and the last scene most remarkably so. It represents the Iraelites pursued by Pharoah and his host, and saved from destruction by their miraculous passage through the Red Sea. The pursuers hang upon their rear, and rush after them into the water. The waves then close up, the clouds descend, and the Egyptian army is ingulfed. After a few moments the clouds clear off, and the Israelites are discovered on the opposite bank, returning thanks to the God whose power has rescued them, while the sea is strewn with the trophies of the discomfited host of their enemies. This is so well managed as to render it one of the most effective scenic representations we ever remember to have seen." Among the many dioramic exhibitions in London during this period (regularly reviewed in the fine arts columns) was a physiorama which, in 1832, included views of Danby's *Passage of the Israelites* [*sic*] and Martin's *Joshua*.

12. *Histoire de l'art dramatique en France depuis vingt-cinq ans* (Paris, 1858–59), 2:309. See also 1:180, 333–34, reviewing *David et Goliath, Le Massacre des innocents*, etc.

13. "Foreign Correspondence," *National Standard*, 6 July 1833; in *Stray Papers*, ed. Lewis Melville (London, 1901), p. 37. The play, by Robillard d'Avrigny et al, opened 15 May.

precious mess of blasphemy and impiety it is!"[14] Nevertheless, he was soon to give proof that he had not escaped unscathed.

Through the thirties and forties Thackeray often refers to the insidious advance of German religious art, the "Catholic Art" of Overbeck and Cornelius. He sees it making its way in France and hopes (in the spirit of Hogarth) that the roast beef of Old England will keep it out. He relates what he calls the "Catholic Reaction" in France to English Puseyism and complains that it is this fashion which has produced "not merely Catholic pictures and quasi-religious books, but a number of Catholic plays"— such as *Belshazzar*.[15] The representative paranoia in this complicated but most intelligent Englishman, his vivid sense of an insidious international conspiracy engaged in a calculated corruption of the young and weak-minded, goes far to explain the reception of the Pre-Raphaelites in the late forties. It is curious that Thackeray finds no significance in the fact that the painter most likely to be "realized" in this profaning theater was John Martin, as true a sprig of the English Protestant imagination as John Milton, or John Bunyan, or Martin's three brothers: the prophet, the poet on biblical themes, and the incendiary of York Minster.

Bunn began his reign, like many another Napoleon, with the need to do high-toned things "by way of being extra legitimate," as he himself put it. One promising avenue had been opened up by his predecessor in the management of Covent Garden. "The impression," Bunn writes, which "the dramatic representation of the *Israelites in Egypt* had made upon the town, now led to the preparation of another sacred subject, *Jephtha's Vow*, on precisely the same scale." But pressure from what Bunn calls "persons high in authority" led him to withdraw the *Vow* suddenly. Moreover, repetition of the *Israelites in Egypt* itself was interdicted; and the licenser made clear that all oratorios "to be represented in character and with scenery and decorations" would be excluded in the future.[16] If anything resembling a striking and edifying sacred spectacle were to be realized, it would have to be managed indirectly. Inspired, perhaps, or at least supported by *Le Festin de Balthazar*, Bunn turned to the notably profane drama of Lord Byron.

In April 1834 Bunn mounted a production of *Sardanapalus* at Drury

14. Alfred Bunn, *The Stage: Both Before and Behind the Curtain* (London, 1840), 1:128.
15. See his *Paris Sketch Book* (1840) passim, but especially "French Dramas and Melodramas," "On the French School of Painting," and "Mme. Sand and the New Apocalypse."
16. Bunn, *The Stage*, 1:134, 176–77.

Lane, with Macready and Ellen Tree. The *Examiner* thought that the end, with its homage of the soldiery and the raising of the pyre, bordered on the ludicrous as well as the horrible; "and if it had not been for the concluding scene—a scene worthy of the imagination of MARTIN and the execution of STANFIELD—they might have proved fatal to the piece." The *Athenaeum* reported:

> The burning itself, and the disappearance of *Sardanapalus* and *Myrrha* were capitally managed, and drew down shouts of applause. There was rather too much black smoke in front, which in some measure marred the effect of the discovery of the burning city; but this may be easily obviated in future. We believe we need not inform our readers, that the last scene is a copy by Mr. Stanfield, from Mr. Martin's picture of "The Fall of Nineveh" [fig. 58][17]

Success was not likely to give pause; and management therefore was not yet through with the team of Byron and Martin. In 1827 Martin's remarkable illustrated *Paradise Lost* began to appear, issued in parts and in two sizes, engraved by himself. There was an affinity between Martin and Milton, that greatest practitioner of the Material Sublime, creator of the Heavenly Artillery; and Martin's illustrations, if not as independently intriguing as Blake's, are still probably the best that Milton ever got. They were certainly Martin's own finest achievement. The illustrations had great success, and in April 1829 Burford's Panorama in Leicester Square advertized a "View of PANDEMONIUM, as described by MILTON, in the first book of 'Paradise Lost' . . . the whole forming the most sublime and terrific Panorama ever exhibited." The accounts of the architecture, with its overwhelming scale, its "huge masses and endless repetitions," make clear the influence of Martin.[18]

In England, Dryden had set his Restoration hand to a dramatized version of *Paradise Lost,* and there was at least one oratorio version; but no nineteenth-century licenser would have permitted a staging of *Paradise Lost,* nor—more to the point—would public notions of propriety.[19] Therefore any attempt to realize theatrically illustrations to

17. *Examiner,* 13 April 1834, p. 231; *Athenaeum,* 12 April 1834, p. 276.
18. *Spectator* 2 (April 1829): 255, 267.
19. *A Paradis perdu* by d'Ennery and Dugué (1856; in *Le Théâtre Contemporain Illustré,* series 43, Paris, 1856) proved the climax of spectacular scriptural illustration in the French theater. It was eclectic in its images as well as in its text, which (as Dickens pointed out) mixed Milton with Byron's *Cain* (John Forster, *The Life of Charles Dickens* [London, 1872], 3:108). A deluge scene evokes Martin, Danby, and Girodet, and the play

Paradise Lost had to be in a strictly pictorial mode, like Burford's (whose vision of Pandemonium de Loutherbourg had anticipated by half a century); or it had to be in a dramatic context that bore no direct relation to sacred history. In the fall of 1834 Bunn's Covent Garden replied to the success of *Sardanapalus* at Bunn's Drury Lane with an even bolder venture, the production of Byron's *Manfred.*

A mediocre actor named Denvil had the success of his career in this first production of *Manfred*, though the great attraction was necessarily—in the words of a reviewer—"the beauty of the scenery, its music, and its mechanical and scenic effects, which are equal, if not superior, to any thing ever yet seen." The first-night playbill had proclaimed a measure unusual in those days of bright auditoriums: "In order to produce the necessary effects of Light and Shade, the Chandeliers around the Front of the Boxes will not be used on the Evenings of the Performance of *Manfred*." The review continues: "The Messrs. Grieve have exhibited some of the most beautiful specimens of their art; the Jungfrau Mountains, the Cataract of the Lower Alps, and a Terrace of Manfred's Castle are exquisite pictures, & the Hall of Arimanes, a copy of Martin's Pandemonium was terrifically grand." The Grieve drawing for the last mentioned scene confirms this pleasurable recognition (figs. 59 and 60).[20]

Better known as *Satan Presiding at the Infernal Council* (when issued as a separate engraving in 1832, it was called *Satan in Council*), Martin's picture illustrates the opening of book 2 of *Paradise Lost*:

> High on a throne of Royal State, which far
> Outshone the wealth of *Ormus* and of *Ind,*
> Or where the gorgeous East with richest hand
> Show'rs on her Kings *Barbaric* Pearl and Gold,
> Satan exalted sat, by merit rais'd
> To that bad eminence. . . .

realizes unmistakably Prudhon's allegorical *La Justice et la Vengeance divine poursuivant le Crime* (1808), now in the Louvre, and Martin's *Satan in Council*, discussed below. Cf. G. H. Lewes, *On Actors and the Art of Acting* (London, 1875), pp. 204–06.

20. Playbill for 29 Oct. 1834, and unidentified review, Enthoven Collection, V&A. See also the *Observer*, 2 Nov. 1834, and the *Times* and *Morning Chronicle*, 30 Oct. 1834. The last, the only severely critical notice, finds Denvil "little more than the showman of a series of splendid scenes painted by the GRIEVES; and as the house was kept in darkness, the effect was quite dioramic." Cf. Henry Crabb Robinson, *The London Theatre, 1811–1866*, ed. Eluned Brown (London, 1966), p. 145: "it should be called a show in which grand pictures are explained by words."

But even more does it illustrate act 2, scene 4 of Byron's genuinely undramatic but eminently pictorial dramatic poem, published ten years before the Milton engravings. Byron's stage direction reads: *"The Hall of Arimanes—Arimanes on his Throne, a Globe of Fire, surrounded by the Spirits."*

Though he liked to profess ignorance of Milton, Byron had him somewhere in mind in writing this scene. He also had Beckford's *Vathek* (1786) in mind, on the evidence of the most striking addition to his Miltonic scene, the globe of fire. When Vathek and Nouronihar penetrate to the center of the Hall of Eblis, they enter a "vast tabernacle" where numberless bearded elders and armored demons "had prostrated themselves before the ascent of a lofty eminence; on the top of which, upon a globe of fire, sat the formidable Eblis." Beckford also remembered Milton's Satan, as the description of Eblis makes clear: "His person was that of a young man, whose noble and regular features seemed to have been tarnished by malignant vapours. In his large eyes appeared both pride and despair: his flowing hair retained some resemblance to that of an angel of light." He bears the marks of the thunder, and, like Milton's Moloch (and Byron's Arimanes), is a scepter'd king.[21]

Martin also may have drawn on Beckford and his illustrator Isaac Taylor for his Miltonic Pandaemonium (fig. 61).[22] Martin's architecture often seems like an embodiment, in real space and geometry, of the vast platforms, towers and multitudes, perspectives, courts, columns, and arcades, of "an architecture unknown in the records of the earth" in Beckford's Eastern gothic fantasy. But Martin unquestionably drew directly and frequently on Byron, not only for a sense of the gorgeous East and her Kings Barbaric, but also for his sense of apocalyptic ironies. Martin's *Fall of Nineveh*, which Stanfield recreated for the Drury Lane production, drew some of its initial inspiration from Byron's *Sardanapalus*, discernible in the foreground melodrama. His *Last Man* (1833, 1849), among other canvases, owes a great deal to Byron's extraordinary poem "Darkness" (1816), as well as to works by Mary Shelley

21. William Beckford, *Vathek*, 4th ed. (London, 1823), p. 209. E. H. Coleridge notes the "throne of Eblis" parallel in *The Works of Lord Byron, Poetry*, vol. 4 (London, 1901), p. 113 n. See also Thomas Medwin, *Conversations of Lord Byron*, ed. Ernest J. Lovell, Jr. (Princeton, 1966), p. 258: " 'Vathek' was another of the tales I had a very early admiration of. . . . What do you think of the Cave of Eblis, and the picture of Eblis himself? There is poetry."
22. Jean Seznec, *John Martin en France* (London, 1964), pp. 19, 20. Seznec notes that the frontispiece of the 1815 London edition of Vathek "annonce le *Satan présidant le Concile Infernal.*" For Martin's direct connections with Beckford, see William Feaver, *The Art of John Martin* (Oxford, 1975), pp. 60–64.

and Thomas Campbell. The self-conscious temporal structure of *Belshazzar's Feast* has affinities with Byron's "Vision of Belshazzar" (1815). In the description of his own *Deluge,* Martin refers to "that sublime poem," Byron's *Heaven and Earth* (1821), which ends with the wonderful stage direction: *"The waters rise: Men fly in every direction; many are overtaken by the waves; the Chorus of Mortals disperses in search of safety up the mountains; Japhet remains upon a rock, while the Ark floats towards him in the distance."* And shortly before producing his Milton illustrations, Martin painted *Manfred on the Jungfrau* (1826). A later version in watercolors (1838) shows a diminutive figure among fantastic peaks and gorges seized at the moment he is about to spring into oblivion. A companion painting, *Manfred and the Witch of the Alps* (1838), possibly took more from the theatrical embodiments of the scene than it gave to them.[23]

Manfred was twice revived during the century for London audiences, both times with considerable success as the embodiment of the sublime as spectacle. Phelps put it on at Drury Lane in 1863, sharing the stage management with William Telbin, the scene painter and designer. The music was the same that Henry Bishop had provided for the first production: Weber or in the style of Weber. The costumes were billed as "from designs by R. W. Keene, Esq., and from Flaxman's illustrations of Classical and Mythological conceptions." The reviews had much to say about the history of the poem and play, its present classic status, its reflection of the French Revolution and the years of reaction.[24] The *Spectator,* however, makes it clear that what has "drawn crowds every night during the week has unquestionably been the scenery." The writer praises especially Telbin's Alps; "but the great sensation scene is, of course, that in the second act, 'the dwelling of Arimanes in the nether world,' the idea being taken from Martin's celebrated picture. Arimanes is seated on a globe of fire, in the centre of a vast amphitheatre filled with a lurid glare, and peopled by thousands of indistinctly seen spirits." The

23. Reproduced in Feaver, pp. 153–54. Cf. *The Illustrated London News* 43 (17 Oct. 1863): 389.

24. See *Lacy's Acting Edition*, vol. 60, and the newspaper announcements of the production (10 Oct. 1863) for the costume note. The long notice in the *Illustrated London News* 43 (17 Oct. 1863): 384, makes much of "the impulses and influences that were set in motion by the French Revolution." These of course affected Martin no less than Byron. Carlyle quotes a description of the meeting place of the Jacobins by a contemporary witness that explains much of the feeling and some of the imagery that Martin brought to his infernal scenes. Cf. *The French Revolution* ("The Jacobins"), Everyman's Library edition, 2:78. Cf. Shelley, *The Revolt of Islam*, 1:xlix–lvii.

sublimity of it all, however, seems not to have overcome this reviewer. He goes on: "The effect is decidedly appalling; but it is difficult to avoid comparison between the globe of fire and a monster plum-pudding, and the fiend at the top, with outstretched wings, resembles at first sight in no small degree the sprig of holly which usually surmounts the Christmas dish."[25] It was by no means the first time one of Martin's conceptions collapsed before the tendency of the human eye and spirit to assert a more comfortable and more human scale. Nevertheless, the realization was repeated at the Princess's theater in 1873 with the intended awesome effect, in a further revival that met with the now usual "enthusiastic applause of a crowded audience" and "a very complete success."[26]

The advantages of *Sardanapalus* over *Manfred* were not only that *Sardanapalus* was written with half an eye to dramatic requirements and, dispensing with spirits, it incorporated a pair of villains, a pair of interesting female parts, and a domestic triangle. The advantages were also that *Sardanapalus* borders on sacred history without actually invading it; and that it culminates in an apocalypse physical in nature and staggering in its scale. *Manfred* also was given a visible apocalyptic ending in the theater. The last scene is described in the 1834 playbill as "THE GLACIERS OF THE UPPER ALPS! / PARTLY / Borne down by a violent THUNDER STORM, / And exhibiting in their Ruins, the Evidences of / *Crime & Punishment, with the Moral of the Drama.*" Sherwyn Carr, in his essay entitled "Bunn, Byron and Manfred," tells us, from the musical score, what was exhibited: "Rocks fall, & discover [once more] at the back the Palace of Arimanes." The good and evil spirits then do battle, and the good spirits win. This external combat and apocalypse runs quite counter to Byron's end of *Manfred*, from which the spirits are scornfully dismissed, like plebeian interlopers, and whose point is the irrelevance of Manichaean angel and demon to one who "was my own destroyer, and will be / My own hereafter." For an audience with a factual, material, historical appetite, however, a *real* apocalypse was much more satisfying than such an objectified allegory of subjective experience.[27]

25. *Spectator* 36 (17 Oct. 1863): 2631. The batlike wings "Amateur" describes do not show in the illustration realized, but appear in other engravings in the series. Danson and Sons rather than Telbin were immediately responsible for the scene.

26. Dutton Cook, *Nights at the Play* (London, 1883), pp. 199–202.

27. Carr's article appears in *Nineteenth-Century Theatre Research* 1 (1973): 15–27. The reconstructed ending, quoted in full in Carr, puzzled most of the reviewers, who were not

When Charles Kean produced his monumental *Sardanapalus* in 1853, extraordinary advantages had accrued in historical and archaeological research. Austen Layard's *Nineveh and its Remains* had appeared in 1848–49, and a popular abridgement was selling in the railway stalls by 1851. His *Discoveries in the Ruins of Nineveh and Babylon,* based on a second series of excavations, appeared in 1853. Paul-Emile Botta had published his alternative account of Nineveh, in France, and H. C. Rawlinson and others had deciphered Persian cuneiform. Winged lions now sat in the British Museum, and the Crystal Palace was acquiring a Nineveh Court. But the material remains of the past had not yet diminished the fascination of apocalypse. If anything, the fascination had been reinforced and authenticated by the work of the archaeological resurrection men, as Kean's treatment of Byron's text makes plain. Byron's text hastens to an end after Sardanapalus mounts the pile and Myrrha, at his signal, fires it:

> *Myrrha:* 'Tis fired! I come.
> (*As Myrrha springs forward to throw herself into the
> flames, the Curtain falls.*)

The last direction in Kean's version reads:

> MYRRHA *springs forward and throws herself into the flames; the smoke and
> flames surround and seem to devour them—the Palace bursts into a general
> and tremendous conflagration—the pillars, walls, and ceiling crumble and
> fall—the pyre sinks—and in the distance appears a vast panoramic view of
> the Burning and Destruction of Nineveh.*[28]

The record of the scene Kean's artists made for him shows a wall collapsing in flames, and a background of Martin-like structures, but no realization of Martin's painting, which in a sense had been superseded by the discoveries it may have helped to provoke. Nevertheless, Martin's vision can still be felt, here and in the grand scene that precedes it, "The Hall of Nimrod," where the scale, the perspective, the repeating elements, even some of the detail that the archaeologists had not yet

sure whether Manfred (forgiven by Astarte) was damned or saved. See also Boleslaw Taborski, *Byron and the Theatre*, Salzburg Studies in English Literature (Salzburg, 1972), p. 211.

28. *Lacy's Acting Edition*, vol. 11. Kean's interest in *Sardanapalus* antedated Layard's discoveries.

managed to supply, show the underlying paradigm of Martin's material sublime.[29]

In his playbill *apologia* Kean takes every opportunity to invoke the proximity of his subject to sacred history, while making clear that the relation to sacred history is merely ancillary and illustrative. At least one of the reviewers goes further, crediting the historicity of the production to not merely the "pictorial" but also the "scriptural authorities recently brought to light," thus innocently invoking a branch of archaeological and historical thinking that was causing some uneasiness in Christendom.[30] But for Kean—who actually drilled himself and his company in the attitudes found on the Assyrian reliefs—there are no such problems, and he can scarcely contain his joy at the coincidence of truth and beauty, the scientific and the exotic spectacular, the material and the sublime. "In decoration of every kind," he declares, "whether scenic or otherwise, I have rigidly sought for *truth*"; and Layard himself had approved. And the truth (in Kean's illuminating phrase for the ruins of empires past) is "the gorgeous and striking scenery, that has been so unexpectedly dug from the very bowels of the earth."[31]

III

Turner had his catastrophic and infernal side, and Martin his paradisal side: Turner his sea monsters, death ships, plague, avalanche, and typhoon, not to mention his versified "Fallacies of Hope"; Martin his blooming Edens and his vast *Plains of Heaven* (1853), perhaps the truest embodiment of a Sunday School heaven ever painted. A large proportion of Martin's illustrations for *Paradise Lost* and the paintings he developed out of them necessarily have to do with the earthly or heavenly paradise, and a student of the whole history of Milton illustration finds him the only artist to portray Adam and Eve fully in the setting Milton

29. Both in the department of prints and drawings, Victoria & Albert Museum. Frederick Lloyd's "Hall of Nimrod" is reproduced in Sybil Rosenfeld's excellent *Short History of Scene Design in Great Britain* (Oxford, 1973), p. 127, and (as a wood engraving) in the *Illustrated London News* 22 (18 June 1853): 493. The *Athenaeum* reported (18 June 1853, p. 745) that the Hall of Nimrod was "so managed in its perspective that it appears endlessly extended in a lateral direction, with an infinite number of square projections guarded with winged lions, and decorated with figured frescoes."

30. *Illustrated London News* 22 (18 June 1853): 493.

31. Enthoven Collection, V&A; the playbill was adapted as an "Introduction" in Lacy's acting edition.

provides for them.[32] Yet, as seen through the curious prism of the theater—a type of the popular eye—Martin is *par excellence* the infernal, catastrophic artist, and Turner the paradisal one. The reason, apparently, lies not so much in differences in subject but rather, more interestingly, in differences in the use and rendering of form, color, and light.

A pictorial theater concerned with the translation of brush work into "effect," and aiming in some of its moods at enhancing the magical character of its illusions, had much to learn from Turner. One of the leading scene painters in the latter part of the century wrote, concerning his art and its requirements:

> The boy crossing the stile in Turner's vignette to Rogers' "Poems," exquisite as it is, would be too delicate and modest in effect, but the same painter's "Dido building Carthage," "Ulysses deriding Polyphemus," "Bay of Baiae," are magnificent lessons to the scene-painter in colour, composition, and poetry. How many times have not his compositions of "Tivoli," "Ancient Rome," "Modern Italy," "The Temple of Jupiter," and a host of others, been copied for act drops, for which they are, indeed, the "beau ideal," or been the inspiration for—well, perhaps a little *less* satisfactory "original" compositions?[33]

The world of the stage lay between act drop and backdrop. The backdrop extends that world, dissolves its limits; the act drop conceals it, but also transforms the space it shuts away, apparently opening it to the eye and epitomizing the place of magic and beauty that lies behind it.

Paradise in the nineteenth-century theater—apart from its ironic reference to the part of the auditorium that held the "Gods"—was to be found in pantomime, fairy-play, and extravaganza, that cluster of related forms. When a pantomime began in hell, as it often did—the cave or other grim abode of some malevolent spirit—the visual analogies with Martin's art were often striking. But a grim opening and a dark scene, and the garish malevolence of a horde of imps and demons, served to set off the paradisal character of what everyone knew was to come and had come to see, whose climactic visual achievement became the underlying rationale of the form. What is important through all the shifts and

32. Marcia R. Pointon, *Milton and English Art* (Manchester, 1970), p. 179.
33. William Telbin [the younger], "Art in the Theatre I—Scenery," *Magazine of Art* 12 (1889): 95–96.

changes of these nineteenth-century forms is, first, the constancy of *transformation,* and second, the progressive designation of pantomime and Easter spectacle as an ideal entertainment for children. As such, it still gave liberal scope to broad mischief; but the formal heart of it was a manifestation of the prelapsarian world, full of beauty and wonder and benign influences and overgrown vegetation, like the first panel of Thomas Cole's allegorical *Voyage of Life* (1839).

The scene painter who supposedly had most to do with this spectacular achievement was William Beverley. Joseph Harker, resurrecting him as he feels from undeserved oblivion, thought that "Beverley, without a doubt, owed much to the influence of Turner's supreme art, and excelled in depicting scenes of atmospheric and poetic beauty." But beauty wasn't all:

> It is to the magic brush of Beverley that we owe the invention of what came to be known as Transformation Scenes—marvels of intricate design and development, of subtle changes of light and colour, that were created to decorate the fairy-plays of Planché for Madame Vestris at the Lyceum, and gradually crept into successive pantomimes for many years as their culminating glory.[34]

Movement and light, color and change, wonder that was not mimetic and material, but magical and atmospheric—these things form the basis of what Harker sees as Beverley's debt to Turner.

Metamorphosis itself—the spectacle of form in flux—was essential to wonder; not the disruption of form in the mill of cataclysmic energies, as in some of Martin, but a liberation of form in the flow of light and color. Harker describes the transformation scene as belonging "to an era of scenic art in which the audience was content to watch one stage picture gradually grow out of another in mysterious fashion, thanks to the ingenuity and fancy of the artist. Today we sit in the dark, while one scene is hustled into another by violent and noisy human agencies of a different kind," clearly a fall from an angelic to a demonic world, from innocent wonder to cynical knowledge.

Metamorphosis was also much on the mind of the irreverent reviewer in *Blackwood's* who turned to a spectacular entertainment, a variety of

34. Harker, *Studio and Stage* (London, 1924), p. 166. Harker saw himself as the heir and end of the tradition.

"magic lantern," in order to characterize Turner's contributions to the 1842 Academy exhibition:

> They are like the "Dissolving Views," which, when one subject is melting into another, and there are but half indications of forms, and a strange blending of blues and yellows and reds, offer something infinitely better, more grand, more imaginative than the distinct purpose of either view presents. We would therefore recommend the aspirant after Turner's style and fame, to a few nightly exhibitions of the "Dissolving Views" at the Polytechnic, and he can scarcely fail to obtain the secret of the whole method. And we should think, that Turner's pictures, to give eclat to the invention, should be called henceforth "Turner's Dissolving Views."[35]

A few months earlier, a reviewer in the Christmas-day *Examiner* finds little to choose between the technical magic of the dissolving views and the wonders of the pantomime as a family entertainment. He is enraptured at the dissolving views by the transformations: how the "opening glory of the Bosphorus went gliding into a valley of Sweet Waters, from which there rose, as by enchantment, the richest scenes of the great city—with all its fantastic mosques and spires, its gorgeous palaces, and glittering bazaars." The educational and topographic features are clearly swallowed up in the marvelous, and Turner's Venice is perhaps not remote.[36]

It was Turner who provided the fundamental image in Charles Kean's most notable attempt to realize the paradisal world, as the magical moonlit wood of *A Midsummer Night's Dream* (1856). That Shakespeare's version of the wood has something of hell and madness in it—as Fuseli knew—was here suppressed, in keeping with the Victorian domestication of fairyland. Three years earlier, however, Kean had been capable of reminding his audience that they were about to witness, in the

35. [John Eagles], *Blackwood's* 52 (July 1842): 26. It is worth recalling that a *Blackwood's* review of 1836 first sent Ruskin to the defense of Turner, and that one of the reviews of this same exhibition of 1842 provoked him into beginning *Modern Painters*. The first volume was attacked at length in *Blackwood's* 54 (Oct. 1843): 485–503; and Ruskin replied savagely in the preface to the second edition, citing *Blackwood's* 1842 exhibition review as evidence of incompetence. The pictures exhibited were *Snow Storm—Steam-Boat off a Harbour's Mouth*; *Peace—Burial at Sea*; *War: The Exile and the Rock Limpet*; and two Venetian paintings.

36. *Examiner*, 25 Dec. 1841, p. 823.

Nineveh of Sardanapalus, a living picture of an age "long since passed
away, but once as famous as our own country for its civilization and
power." With a somewhat similar thought for present glory, he now set
his paradisal wood in the frame of an Athens restored to its Periclean
magnificence. Reviewers mostly recognized that in so dealing with the
Athens of Theseus, Kean had gone beyond the "illustrative and histori-
cal accuracy" identified with his system, though they did not always grasp
the significance of the contrast between the architecture of an imperial
civilization at its height and the beautiful world of innocent imagination,
defined by light, atmosphere, music, and metamorphosis, where

> the perpetual change of scene and incident, the shifting diorama,
> the beams of the rising sun glittering upon the leaves, the gradual
> dispersion of the mist, with the hosts of fairy beings who are there
> discovered, light and ethereal as gossamer, grouped around the
> unconsciously sleeping mortals; these, and an endless succession of
> skilfully-blended pictorial, mechanical, and musical effects, bewilder
> the faculties with the influence of an enchanting vision.[37]

The scene that epitomized this protean world (act 2, scene 1) was
W. Gordon's "A Wood near Athens," a recreation of Turner's *Golden
Bough,* with the evidence of man's cultural presence omitted (figs. 62
and 63). Transposed to moonlight, it united classical and romantic
landscape, and substituted for the claustrophobic maze of the wood
near Athens Turner's central avenue to infinity by way of water and
light.[38]

Turner had sent the painting to the Academy exhibition in the spring
of 1834, precisely when Byron's *Sardanapalus* and Martin's *Fall of
Nineveh* might be seen in their first joint realization at Drury Lane, and
Manfred at Covent Garden was in the offing for the fall. A reviewer in the
Athenaeum, impressed with the brilliance of Turner's contributions to the
exhibition, especially *The Fountain of Indolence* (after Thomson) and *The
Golden Bough,* tried to come to terms with what might best be understood
as the sense of a difficulty in seeing; that is, a difficulty in standing

37. *Illustrated London News* 29 (Oct. 1856): 393. William Gordon's splendid scene of
Athens from Theseus's palace is reproduced in Rosenfeld, *Short History,* p. 123.
38. The relation of Gordon's scene as recorded for Kean by his artists (V&A) to
Turner's painting was observed by Martin Hardie, *St. James's Gazette,* 17 Apr. 1902.

outside the pictures in the role of conceptualizing observer and being sure of boundaries, surfaces, identities. The problem lay deeper than a rivalry of line and color, and he explains the seeming contradiction as a fault, a slovenly neglect of finish, an absence of the "last touch." But the difficulty in "seeing" remains oddly paradoxical, something associated not with darkness but with light. He suggests as much in his description of *The Fountain of Indolence:* "the scene is magnificent—golden palaces, silver fountains, romantic valleys, and hills which distance makes celestial, are united into one wondrous landscape, over which a sort of charmed light is shed, that is almost too much for mortal eyes." *The Golden Bough* is even more perplexing: "almost dim through excess of brightness."[39] Thus, the paradox of Martin's "material sublime," which found an appropriate content and analogue in the "darkness visible" of Milton's hell, had its true antithesis in Turner, and in Milton's heaven, where the "Fountain of light, thyself invisible . . . Dark with excessive bright" irradiated creation.

Why was Martin given the infernal and apocalyptic assignments in drama and Turner the paradisal ones? I can only venture a suggestion.

In Martin the perceiver empathizes with the represented experience of scale, with the radical duality of the miniscule human and majescule inhuman. In Turner the perceiver is implicated in the dissolution of boundaries and objects, in the unity of perception and experience. The attempt to discriminate often has to be abandoned at a given point, and one is drawn into the vortex or the path of light. Discrimination gives way to sensation as a source of affect, a reassertion of the primal order. It is profoundly infantile.

In Martin the structure is one of separation, alienation, diminution of the ego in the face of cosmic or physical reality. It represents the nightmare of annihilation and humiliation, but with a persistent kernel of bounded identity. It is adolescent or perhaps even menopausal (I am put in mind of the catastrophic "Maturity" panel in Cole's *Voyage of Life*). It represents not state or process but climacteric.

In Turner the self is already dissolved in cosmos—in light, or in the vortex of the elements, or in the landscape itself. Even in storm, there is a paradisal identity of self with the universe of perception, of experi-

39. *Athenaeum*, 10 May 1834, p. 355.

ence, of imagination, and of process. Experience, in and of the paint-
ing, is kinesthetic, and the pictorial image is liberated from the
"imaginable"—from the abstraction of bounded forms in a projected
and time-fixed Euclidean space. The "structure" may be infantile, but
the achievement reconstitutes the paradise we have lost.

Illustrations

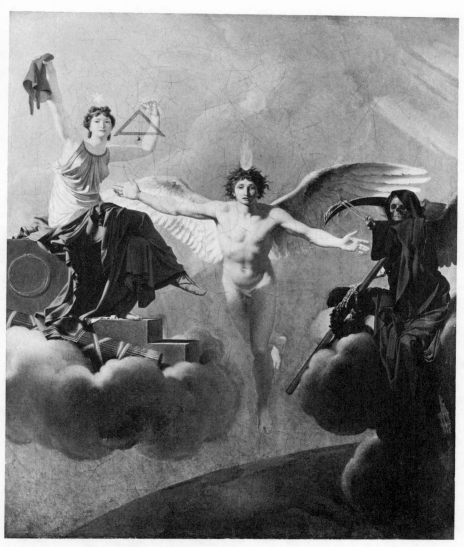

1. Jean-Baptiste Regnault, *Liberty or Death*

2. Hubert Robert,
Liberation from Prison

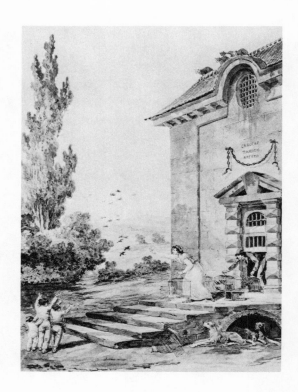

3. Nicolas Lancret,
The Imprisoned Bird

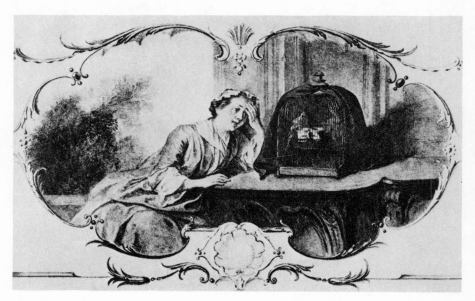

4. Joseph-Marie Vien, *Loves for Sale*

5. Joseph-Marie Vien, *Love Fleeing Slavery*

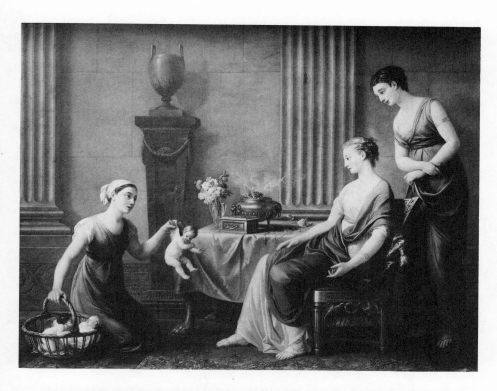

6. *"Liberte,"* Fayence Plate

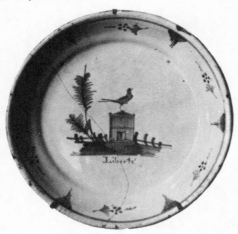

7. Joseph Wright, *The Synnot Children*

8. William Hogarth, *The Graham Children*

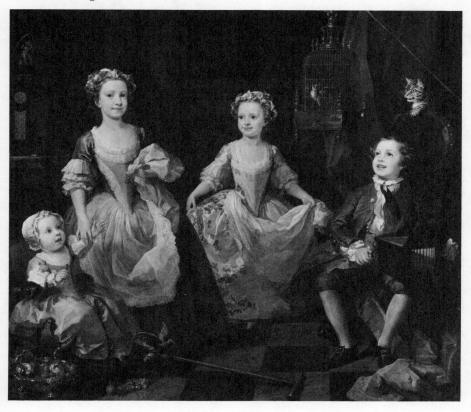

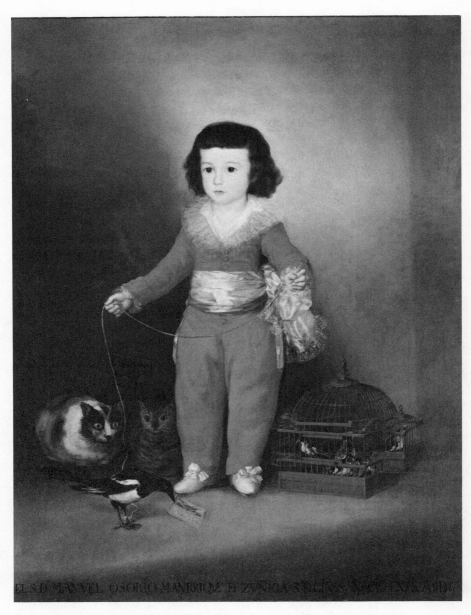

9. Francesco Goya, *Don Manuel Osorio*

10. Jean-Baptiste Greuze,
The Dead Bird

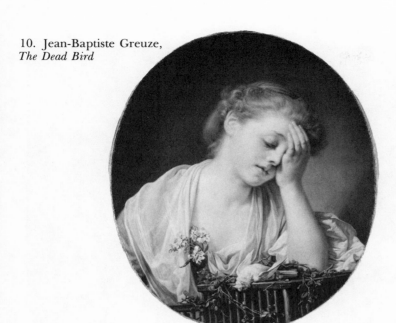

11. Louis Gabriel Blanchet, *The Age of Innocence*

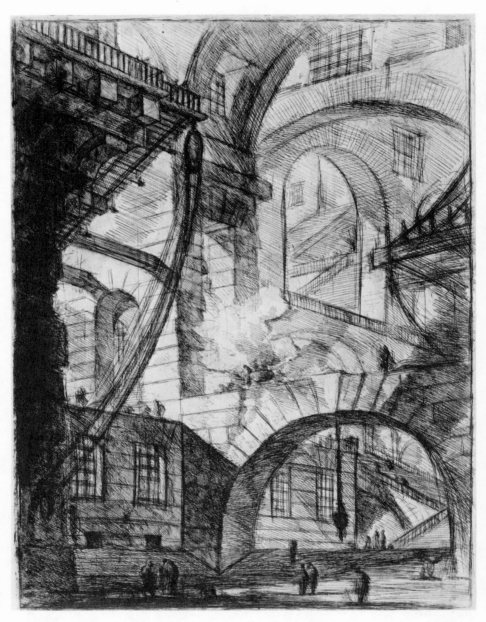

12. Giovanni Battista Piranesi, *Prison* (plate 6 of the *Carceri*)

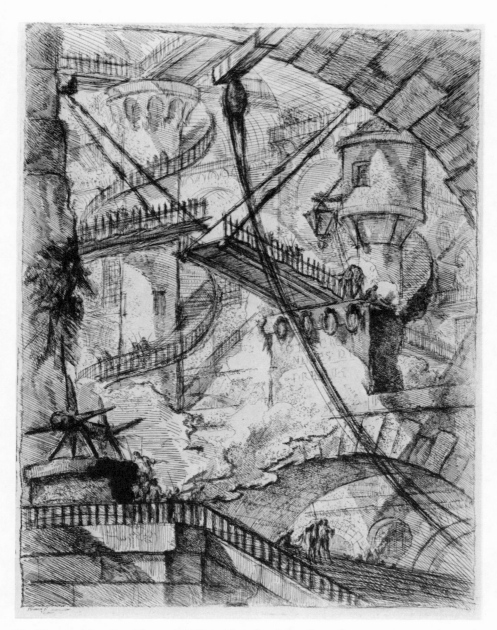

13. Giovanni Battista Piranesi, *Prison* (plate 7 of the *Carceri*)

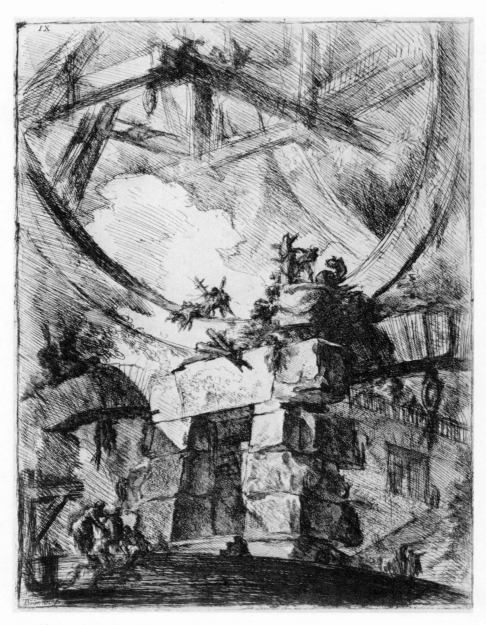

14. Giovanni Battista Piranesi, *Prison* (plate 9 of the *Carceri*)

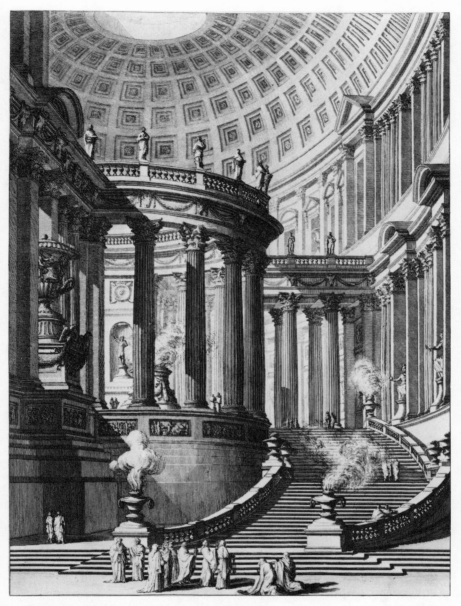

15. Giovanni Battista Piranesi, *Tempio Antico*

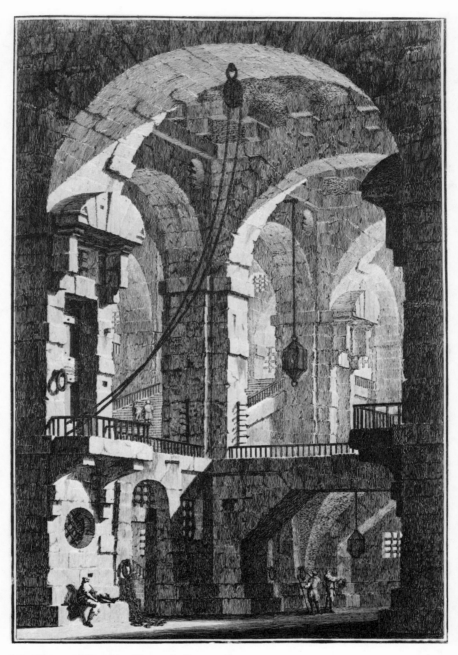

16. Giovanni Battista Piranesi, *Carcere Oscura*

17. Giovanni Battista Piranesi, *Fantasy of Ruin Fragments*

18. George Dance, *Newgate Prison*

19. C. N. Ledoux, *Prison for Aix en Provence*

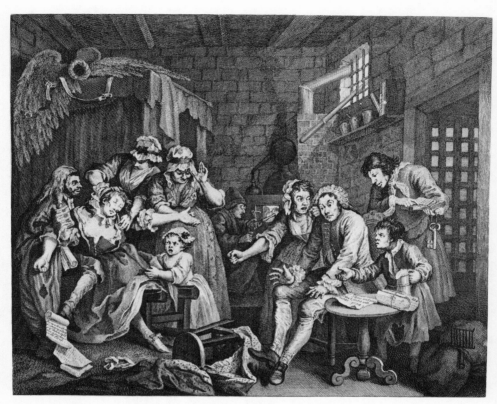

20. William Hogarth, *The Rake in Fleet Prison*

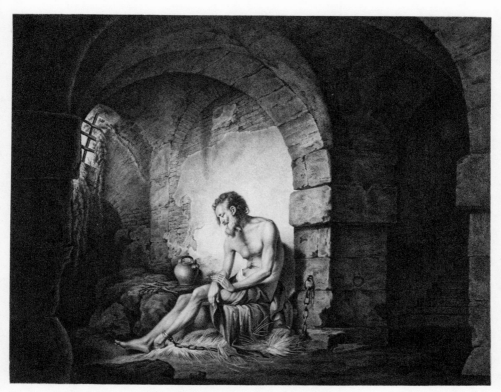

21. Joseph Wright, *The Captive from Sterne*

22. Francesco Goya, *Prisoner*

23. Francesco Goya, *Seated Prisoner in Chains*
(Tan barbara la seguridad como el delito)

24. George Romney, *John Howard Visiting Prisoners*

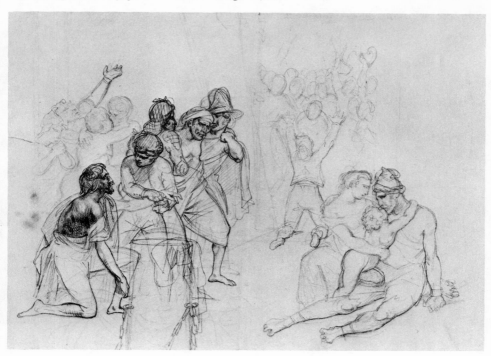

25. Théodore Géricault, *The Opening of the Doors of the Inquisition*

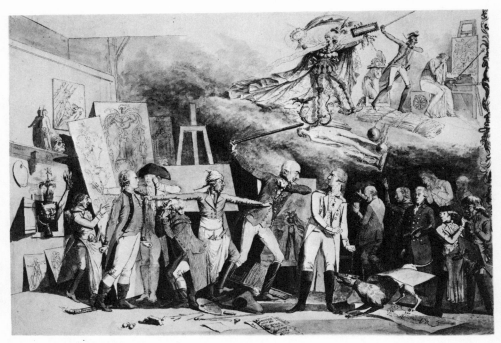

26. Joseph Anton Koch, *Satire on the Stuttgart Academy*

27. Jean Baptiste Camille Corot, *Homère et les bergers*

28. George Romney, untitled drawing

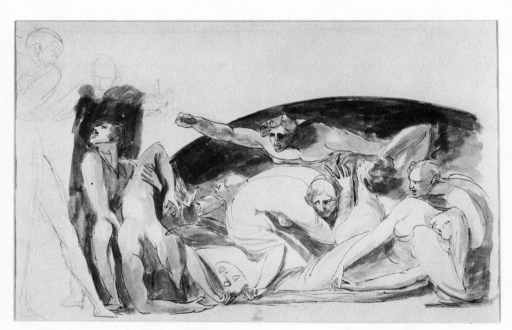

29. George Romney, untitled drawing

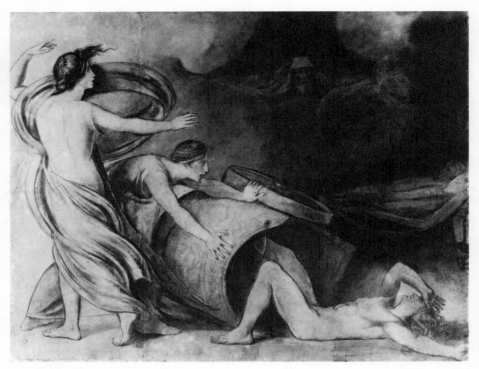

30. George Romney, *Atossa's Dream*

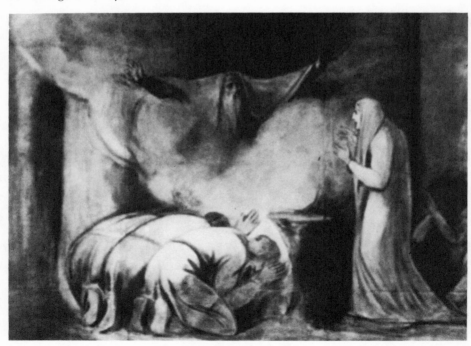

31. George Romney, *The Ghost of Darius Appearing to Atossa*

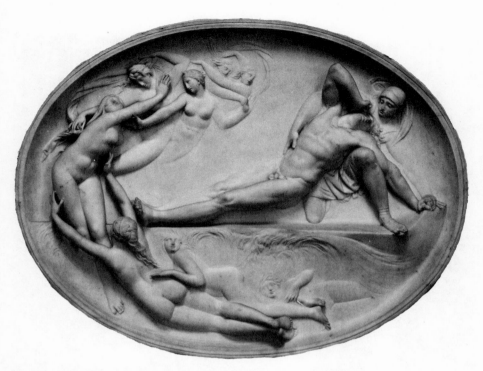

32. Thomas Banks, *Thetis and Her Nymphs Consoling Achilles*

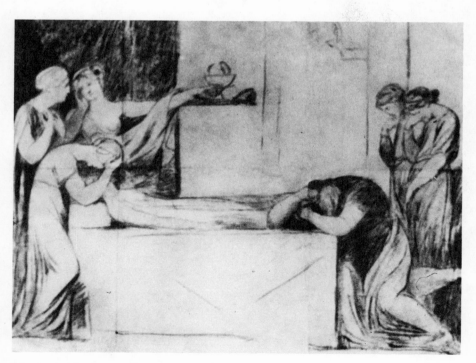

33. George Romney, *The Death of Cordelia*

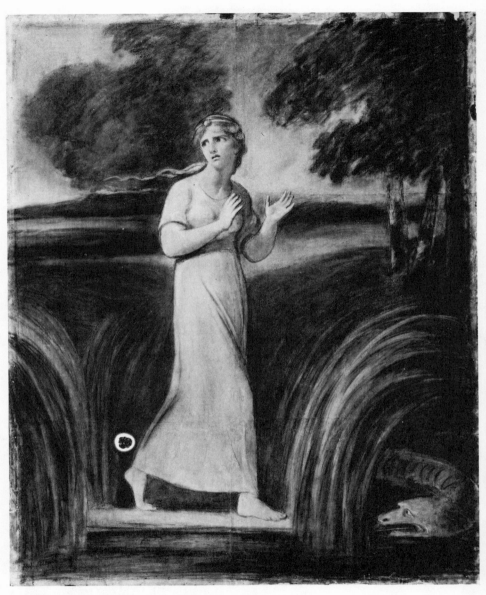

34. George Romney, *Eurydice Fleeing from Aristaeus*

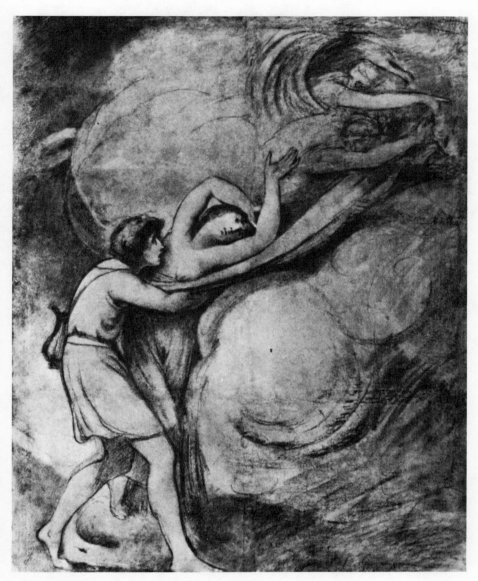

35. George Romney, *Orpheus Embracing Eurydice*

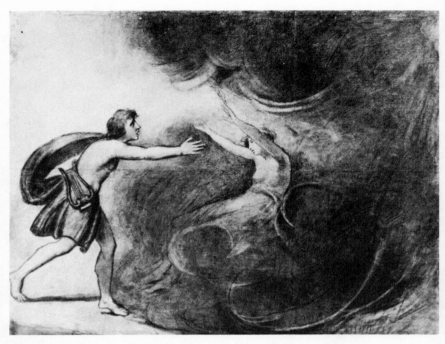

36. George Romney, *Orpheus Saying Farewell to Eurydice*

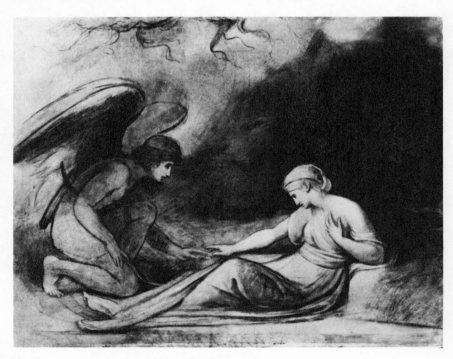

37. George Romney, *Cupid and Psyche*

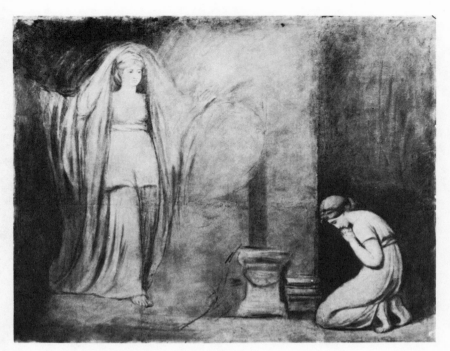

38. George Romney, *Psyche Supplicating Juno*

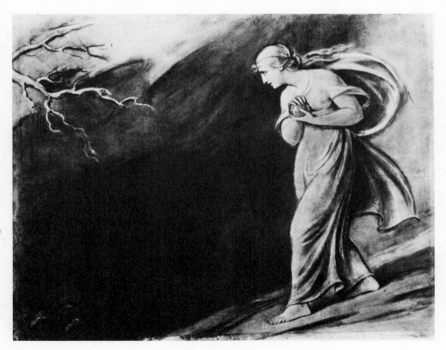

39. George Romney, *Psyche by the River Styx*

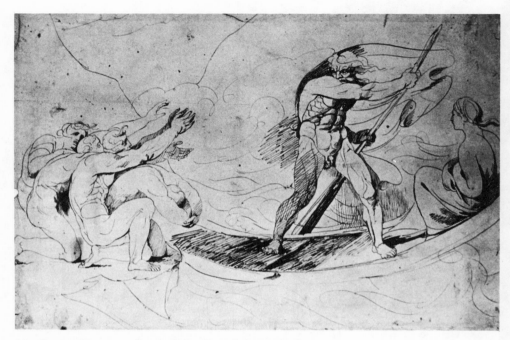

40. George Romney, *Psyche Being Rowed Across the Styx*

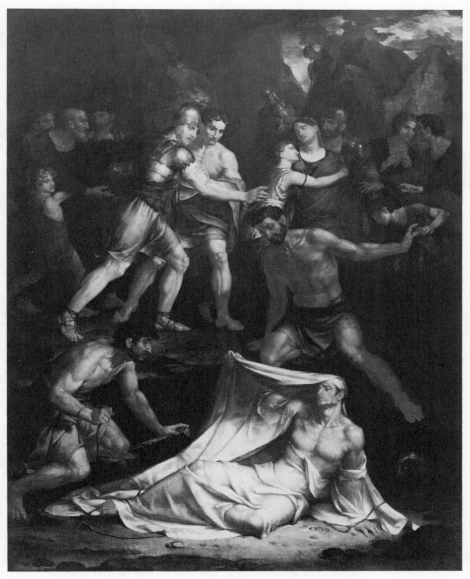

41. Washington Allston, *The Dead Man Revived by Touching the Bones of the Prophet Elisha*

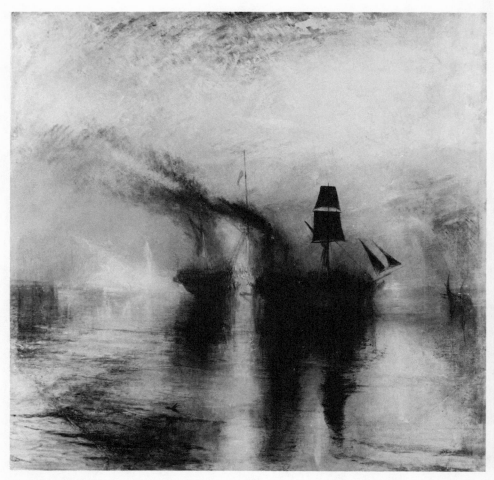

42. J. M. W. Turner, *Peace—Burial at Sea*

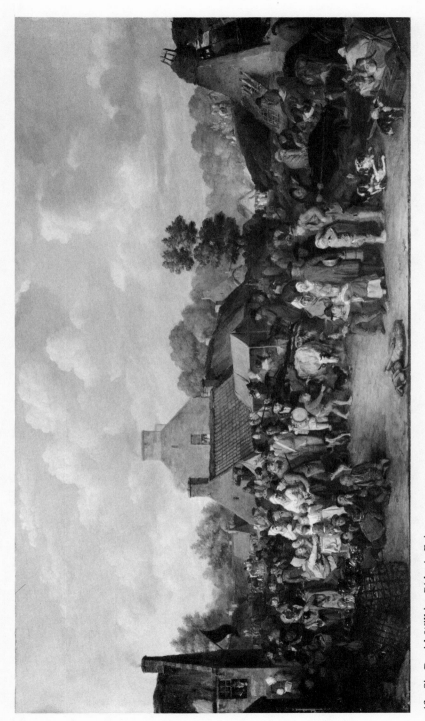

43. Sir David Wilkie, *Pitlessie Fair*

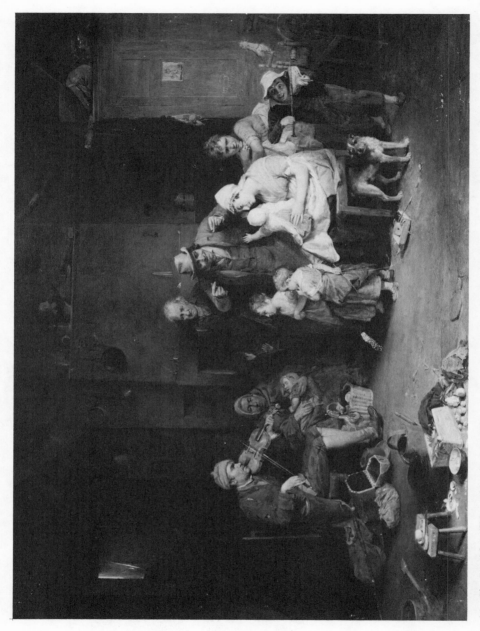

44. Sir David Wilkie, *The Blind Fiddler*

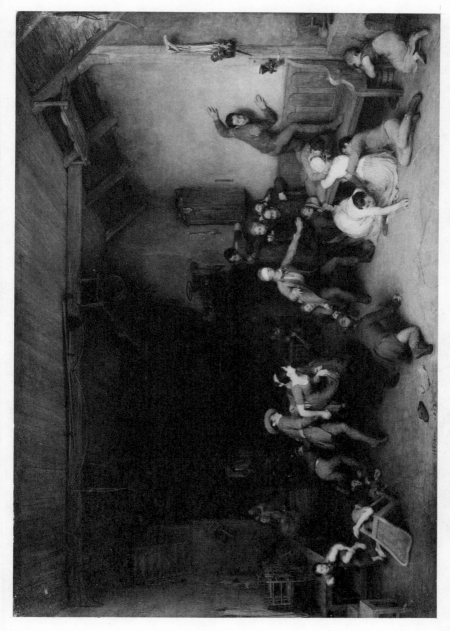

45. Sir David Wilkie, *Blind Man's Buff*

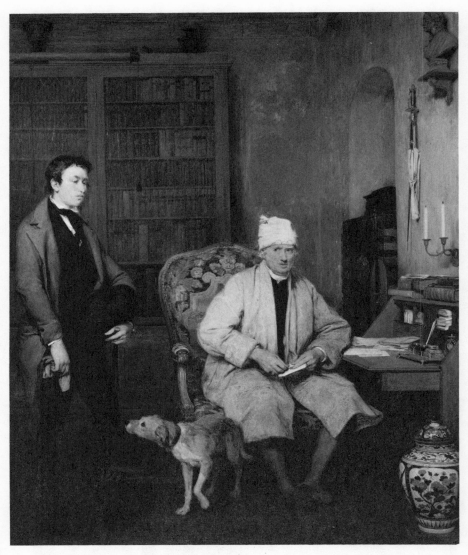

46. Sir David Wilkie, *The Letter of Introduction*

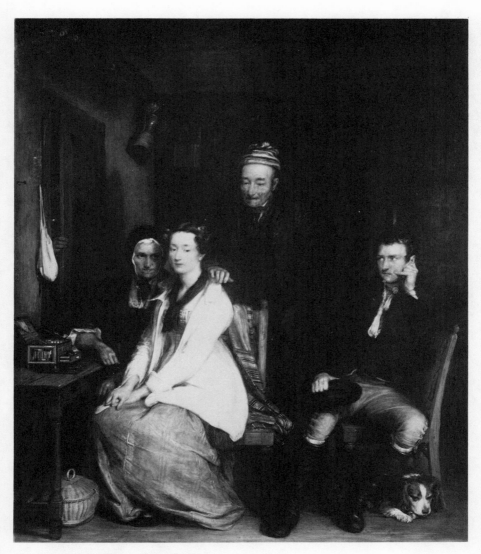

47. Sir David Wilkie, *The Refusal*

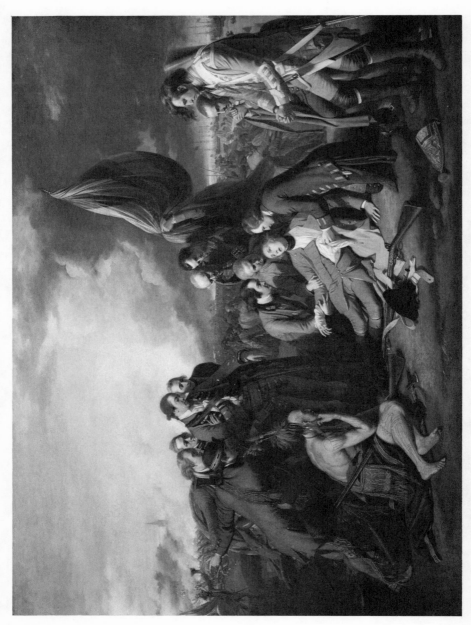

48. Benjamin West, *The Death of General Wolfe*

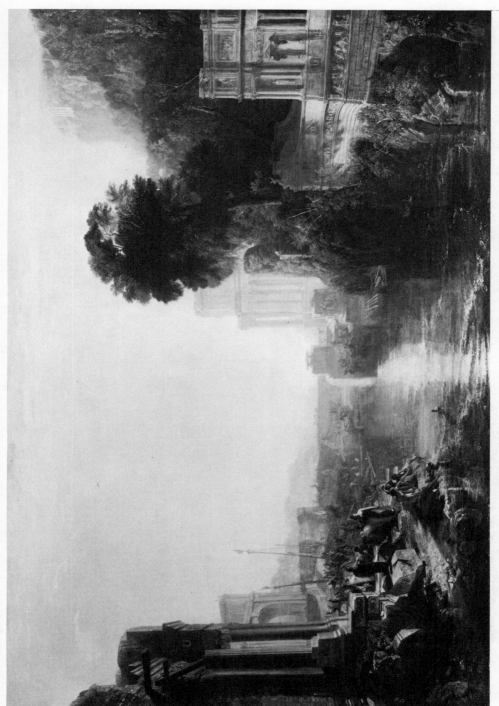

49. J. M. W. Turner, *Dido building Carthage; or The Rise of the Carthaginian Empire*

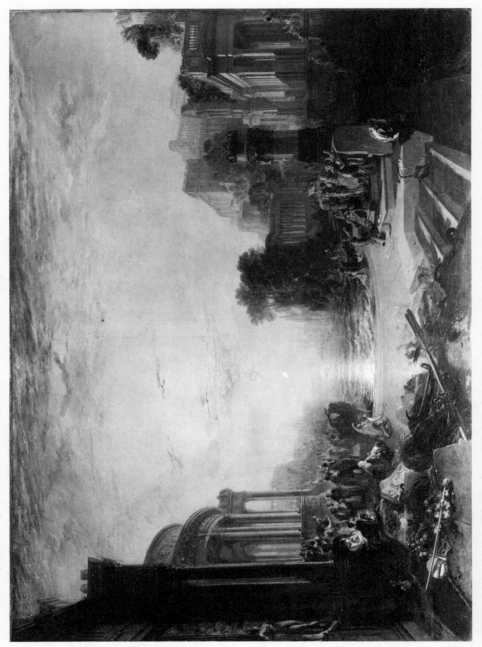

50. J. M. W. Turner, *The Decline of the Carthaginian Empire*

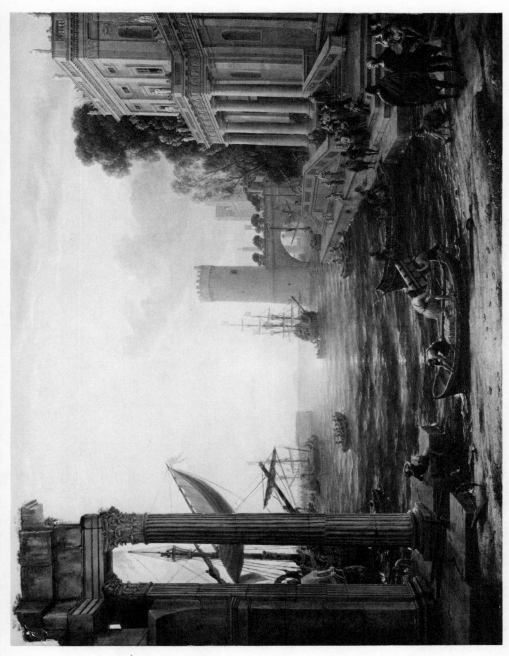

51. Claude Lorrain, *Seaport: Embarcation of the Queen of Sheba*

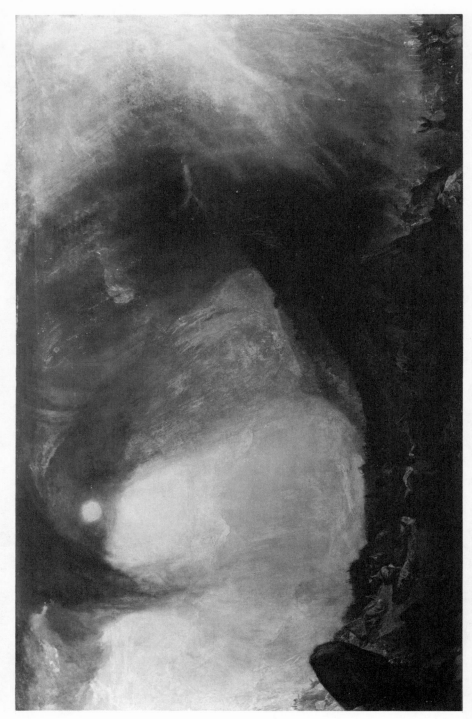

52. J. M. W. Turner, *Snow Storm: Hannibal and his Army Crossing The Alps*

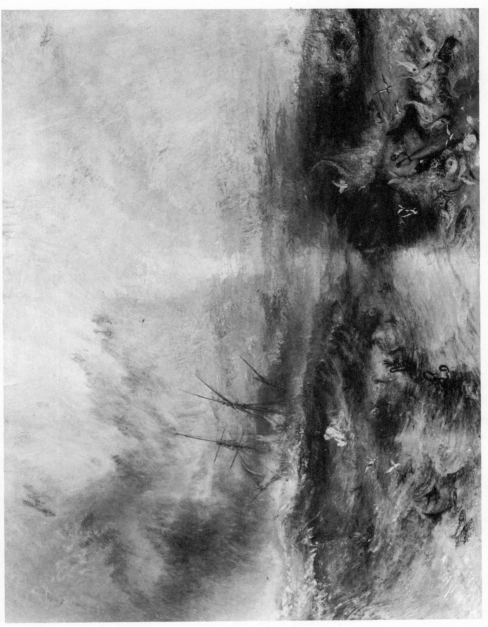

53. J. M. W. Turner, *Slavers Throwing Overboard the Dead and Dying—Typhon Coming On*

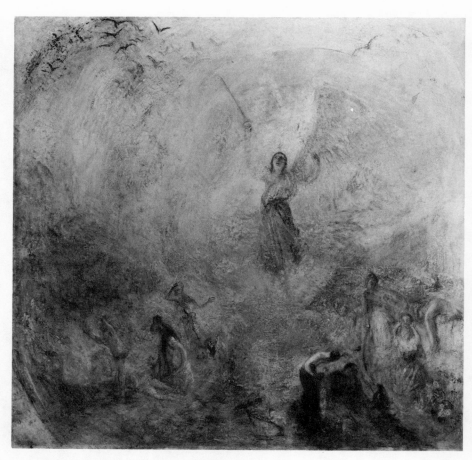

54. J. M. W. Turner, *The Angel Standing in the Sun*

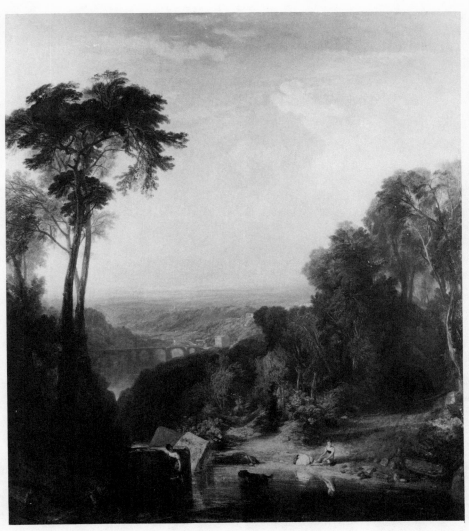

55. J. M. W. Turner, *Crossing the Brook*

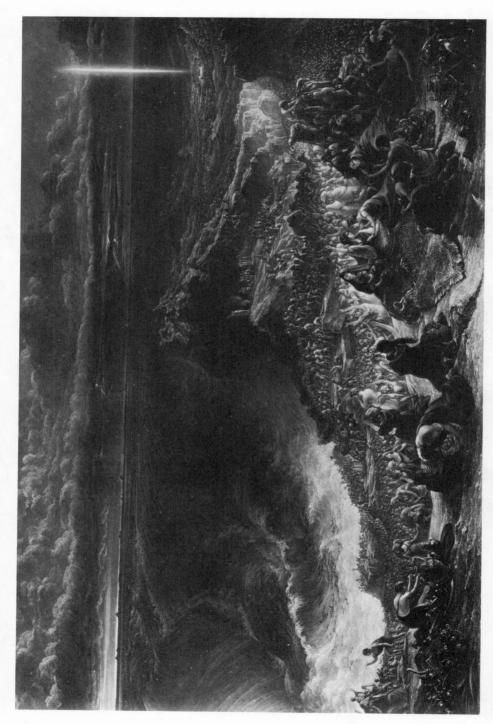

56. Francis Danby, *The Passage of the Red Sea*

57. Family Grieve, scene for *The Israelites in Egypt*

58. John Martin, *The Fall of Nineveh*

59. John Martin, illustration to *The Paradise Lost of Milton*, book 2, line 1

60. Family Grieve, scene for *Manfred*

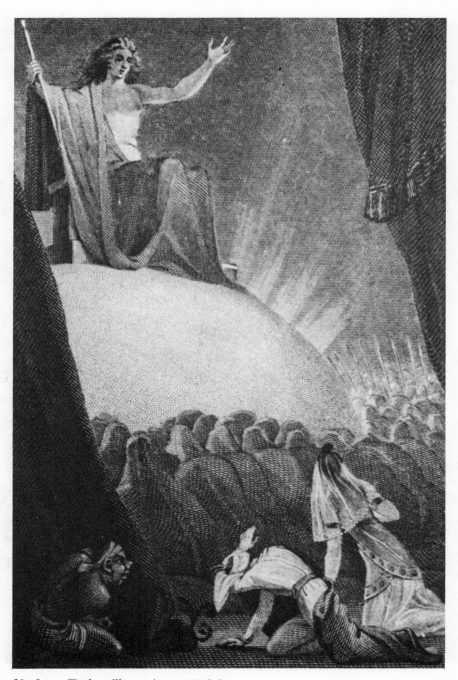

61. Isaac Taylor, illustration to *Vathek*

62. William Gordon, scene from *A Midsummer Night's Dream*, act 2, scene 1

63. J. M. W. Turner, *The Golden Bough*

Contributors

Rudolf Arnheim, Professor Emeritus of Psychology of Art, Harvard University, and at present Visiting Professor, University of Michigan

Lorenz Eitner, Chairman Department of Art, Stanford University

Jean H. Hagstrum, John C. Shaffer Professor of English and Humanities, Northwestern University

James A. W. Heffernan, Professor of English, Dartmouth College

Karl Kroeber, Professor of English, Columbia University

Martin Meisel, Professor of English, Columbia University

Ronald Paulson, Professor of English, Yale University

Jean Starobinski, University of Geneva

Rudolf F. Storch, Associate Professor of English, Tufts University

L. J. Swingle, Associate Professor of English, University of Kentucky

William Walling, Professor of English, Rutgers University

Carl R. Woodring, George Edward Woodberry Professor of Literature, Columbia University

Index